For
George Anyamele Oguibe
and
Margaret Chinyere Ufomba

The Culture Game

The Culture Game

Olu Oguibe

University of Minnesota Press ▶ Minneapolis▶ London

See page 191 for information on previously published material in this book.

Every effort has been made to obtain permission to reproduce art in this book. If any proper acknowledgment has not been made, we encourage copyright holders to notify the publisher.

Published by the University of Minnesota Press
111 Third Avenue South, Suite 290
Minneapolis, MN 55401-2520
http://www.upress.umn.edu

Library of Congress Cataloging-in-Publication Data

Oguibe, Olu, 1964-
 The culture game / Olu Oguibe.
 p. cm.
 Includes bibliographical references and index.
 ISBN 0-8166-4130-7 (alk. paper) — ISBN 0-8166-4131-5 (pbk. : alk. paper)
 1. Postcolonialism and the arts—Africa. 2. Arts and society—Africa. 3. Arts, African. 4. Multiculturalism in art. I. Title.
 NX180.P67O48 2003
 701'.03—dc22

 2003020877

Printed in the United States of America on acid-free paper

The University of Minnesota is an equal-opportunity educator and employer.

12 11 10 09 08 07 06 05 04 10 9 8 7 6 5 4 3 2 1

Contents

Acknowledgments

MOST OF THE ESSAYS in this book have gone through several revisions before settling into the versions that appear here. I am grateful to all who have opened the way for them at one point or another. My earliest writing, besides journalism, was published with Rasheed Araeen and Jean Fisher at *Third Text,* which was perhaps the most significant avenue for multicultural discourse in Europe in the 1990s. This book owes immeasurably to both Rasheed and Jean.

I came to critical writing rather unintentionally. In 1983, as I pondered my options as an art student at the University of Nigeria, Nsukka, I was summoned to the office of my faculty adviser, Dr. Ola Oloidi, who, along with my painting professor, Obiora Udechukwu, informed me that my choices had already been made for me. Instead of painting, which was my preferred major, my concentration would be in art history. Their logic was that Africa was in desperate need of serious art scholars and critics who could articulate its cultural history from within, and though no judgment was being passed on my prospects as a painter, it was their decision that I could make a real difference as a scholar. I was both flattered and flabbergasted. As a young college student I was already publishing art, literary, and theater criticism in the popular press, but only as a pastime. My real goal was to be a successful painter. So, quite characteristically, I rejected the professors' suggestion and proceeded to complete a major in painting, with a minor in the history of African American art in the twentieth century. The fury with which I pursued painting as a profession in the late 1980s and early 1990s, with at least two solo exhibitions every year and practically on every continent, might have owed to that career-counseling session in 1983. Nevertheless, I did promise that day that I would not depart from scholarship or the critical vocation, and that at the right time I would equip myself with the necessary qualifications, which I did by obtaining a doctoral degree in art history from the University of London nine

years later. I must mention Professors Ola Oloidi and Obiora Udechukwu for making me believe in the critic's ability to make a positive difference. Without them this book might not exist.

The book would also not be possible without the enthusiasm and encouragement of Jennifer L. Moore, formerly of the University of Minnesota Press, who first read it in its earliest, inchoate form, or the patient help of Carrie Mullen, executive editor of the Press, who saw it through. Finally, I would like to mention Esiaba Irobi, Daniel Faust, Koan-Jeff Baysa, Melinda Brown, Cindy Etoh, Jude Akudinobi, Donald Odita, and Iké Udé for their invaluable friendship and unwavering faith.

Clinton Hill, Brooklyn
March 2003

Prologue

*T*HE *CULTURE GAME* brings together thirteen essays, notes, and interviews that represent select aspects of my contributions to debates on culture and theory, especially in the visual arts, over the past ten years. Many of the essays have proved significant and had considerable influence on the appreciation of contemporary art in recent years. Others have generated unforeseen controversy. Many have appeared in diverse publications over these years, and are on the required or recommended reading lists of several humanities and social-sciences programs in America and Europe. *The Culture Game* is aimed in part at making them available in one convenient volume.

The idea is to present these writings as a body of work that, though evidently evolving, remains consistent and measured in its critical and uncompromising scrutiny of the structures and institutions of contemporary cultural politics, especially as seen from the point of view of a practitioner and participant whose traditional place is not the center or dominant platform of global cultural discourse. The essays address some of the key questions that have held my attention over these years, among them the disparities and inconsistencies that characterize contemporary culture brokerage; the difficulties these inconsistencies throw in the way of non-Western and minority artists, especially those who live and practice in the Western metropolis; and the nature and peculiar concerns of contemporary non-Western art, especially as it deals with the ramifications and residues of the colonial encounter, as well as its own historical and cultural past.

Despite the myth of civility usually associated with the arena of culture, contemporary art is nevertheless a theater for an elaborate game of maneuvers in which institutions, patrons, brokers, and promoters peddle not only art but the careers, loyalties, and fortunes of artists also. Between visibility/success and obscurity/failure, artists in

turn struggle to find their place while seeking to maintain a level of control over their practice. Also, broad, perennial social and cultural prejudices are just as significant in the equation, especially in the West. Certain artists are placed in double jeopardy because the cultural establishment remains deep-dyed in prejudices. Ironically, the contemporary art "world" is one of the last bastions of backwardness in the West today, which makes it an uneven playground, a formidable terrain of difficulty for artists whose backgrounds locate at the receiving end of intolerance.

The book takes its title from a brief essay, "*Double Dutch* and the Culture Game," which I contributed to a catalog published by the Museo Hendrik Christian Andersen and the British School in Rome in 2001.[1] In the essay I use a single painting by the British artist Yinka Shonibare to explore the peculiar predicament of artists who come to the global contemporary art arena from backgrounds outside the West only to discover that the most valued attribute required of them is their difference. Often, such artists come with a diametrically opposite understanding of the premises of international practice and visibility. Often they are trained in the West, or at any rate are thoroughly familiar with metropolitan conventions and discourses into which they expect to segue like the rest. In many instances they are, in fact, born in the West, citizens whose only distinction is that somewhere in their ancestry a link points outside the narrow perimeters of the dominant culture. "*Double Dutch* and the Culture Game" uses one such artist's experience to pry open the game of expectations and desires these artists are confronted with, and to show how its unsightly rules and parameters determine their fate on the global stage.

The culture game operates on a number of related levels. There is the systemic, structural level where it is methodically implemented and perpetuated by contemporary art institutions through acquisitions, programming, criticism, and general discourse. On this level the game may take the form of minimal exhibition allocations for art that comes from a particular provenance or constituency. Such slots, it appears, are rationed over ten-year periods, and because the opportunity to display is so rare, it becomes the tendency to seek to remedy the situation by consigning all such work to humongous, inchoate, and badly conceived group or period exhibitions, after which heroic gestures institutions return to their regular, clinical programming, satisfied that they have paid their dues. In other words, every ten years over a designated season, there are huge African, Asian, or Latin American exhibitions after which the pained rhetoric of institutions becomes, *Well, but we just had an African or Asian or Latin American show!* Having staged the routine decade shows, museums and galleries feel no further obligation to touch any art or artist from these provenances, especially since all the major artists would have had a corner in the continental group fair. Then it is safe and supposedly logical again to say, *But we just exhibited that artist!*

Acquisition of work by artists from such backgrounds operates the same way. Rather than be seen in their own right as individual artists worthy of acquisition, these artists are thought of as representative of their backgrounds or regions and acquired accordingly. A museum that purchases a painting by Ouattara, for instance, thinks of itself as having bought some African work, despite the fact that the artist is

a New York artist. This becomes an excuse not to look in the direction of any other artist of the same background for a while. *It wasn't so long ago since we bought some African paintings!* In this meaningless game the individual Other is always saddled with the burden of the group, for better or worse. Ultimately, things degenerate to a game of numbers: *We had five Africans in the biennial, seven Chinese, two Southeast Asians, even two Australian Aborigines. We did our very best to ensure that this year's exhibition was representative.* What is masked in such a seemingly liberal gesture is that Western artists are seldom subjected to the same game of numbers, unless, of course, they too belong outside the mainstream: folk artists, Northwest artists, Native Americans, self-taught artists, prison artists.

By engaging in this game—which in recent times has become the popular device for institutions to fulfill statutory diversity requirements for funding, especially in America—the art establishment institutionally maintains the dominant constitution of the mainstream while appearing to dent or even rupture it. The dent is kept to the facade, and kept as minimal as not to matter at all. The face of art history is kept intact without the threat of an influx of aliens clutching their gods, as T. S. Eliot would put it.

There are further ramifications beyond maintaining the face and integrity of art history, so to speak, or institutional observation of cultural-diversity statutes. Lest we forget, non-Western contemporary art is also a commodity, and like any other commodity, especially those that originate or have affiliations outside the West, must be regulated in the global culture market. In effect, dealers and gallerists in New York, London, and Munich, to name a few centers of contemporary art, must keep a firm grip on the entry and flow of this art into the market. They must carefully ensure that there is no deluge of non-Western artists on the scene and that only a handful may gain access and visibility at any given period. Since the global art market was flooded in the 1970s and 1980s by Australian Aboriginal dreamtime bark paintings, a great deal of which now languishes in basements from New York to Dresden, dealers have been more selective in their patronage and promotion of non-Western contemporary artists, and careful to ensure that no undue number have the opportunity to circulate at any one time. In effect their "discovery" is scrupulously managed and promotion firmly and methodically rationed to avoid an influx, while a fierce but silent competition rages between dealers as each battles to ensure that his or her non-Western artist, his or her "global native," as a Moroccan artist once put it, stays ahead of the game.

Unbeknownst to the natives, they are constantly lodged in a hidden battle against one another for the few, predetermined places and opportunities designated for them on the contemporary art stage. In addition to micromanaging the work such artists produce and bring to the market, dealers are quick to drop those who are considered too willful or independent of mind and therefore constitute questionable business risks. They are methodically taken off the solo-exhibition rosters and eventually off even the annual gallery stable group exhibitions until they are ultimately discarded in favor of new discoveries.

Some may retort that such treatment applies to all contemporary artists, an argument that has verity to it, but there is a relevant distinction to be observed, which is

that far fewer non-Western artists are ever micromanaged *into* the system, considering their numbers, irrespective of conventions that apply across the board. For instance, China arguably has far more contemporary artists of one persuasion or another than the whole of Europe and the United States put together, and inasmuch as the work of such artists could be argued not to appeal readily to the global/Western art market, such an argument would be invalid because there are no set boundaries of taste on the global culture market, and any work, style, or tendency could be filtered into that market and accorded prominence if it is so determined by Western culture brokerage. In other words, there are still far more marketable artists out of China than the three or four who are routinely funneled into and circulated through the art market every five years. The nature or form of art being made on the outposts of the global culture mainstream is, therefore, of less consequence than the ideological and market factors that underlie Western disposition to cultural production from the outside.

While we touch on the role of institutions and the market in the global culture game, it is important too to bear in mind that institutional predilections, though structured, methodical, and self-regenerating, are nevertheless inseparable from the broad cultural dispositions that inform them, and in this regard the attitude of cultural institutions, the market, and the critical establishment toward non-Western contemporary artists is only a reflection of deep-seated, firmly entrenched predispositions within Western society itself. At the turn of the twenty-first century, the truth remains that exoticism of the most pristine kind shadows Western perspectives on non-Western contemporaneity. In the eyes, heart, and mind of the West, by which one implies not simply the average individual but even the most enlightened no less, there is still a seemingly insurmountable desire for quaintness on the part of the so-called Other. Despite the myriad bloody and cataclysmic copulations that have taken place across cultures, especially in the twentieth century, and the numerous geographical faults that were bridged both willingly and otherwise, the idea of a shared contemporaneity remains opaque at best in the imagination of the West. Not even its ubiquitous cultural presence throughout the rest of the world is enough to convey to the paradoxically, essentially provincial Western mind that the customary quest for cultural essences no longer retains the logic of previous epochs. On the broad interface of cultural response, therefore, there lies a residual yet significant translucent layer of primitivism, behind which the possibility of parallels and similarities dissolves and difference remains an essence that neither reality nor the imagination seems able to dislodge.

The global culture game is therefore a game of difference, and its economy of signs is structured around the principle of irreducible difference. While this game may manifest most insidiously in institutional patterns and policies, such patterns are nevertheless devised and perpetuated by desires, notions, and perceptions at the individual level that rivet on a need for difference: unambiguous, perceptible, and ultimately marketable. At the turn of the twenty-first century, the struggle that non-Western contemporary artists face on the global stage is not Western resistance to difference, as might have been the case in decades past; their most formidable obstacle is Western obsession with and insistence on difference. As some have already pointed

out, it is not that any would want to disavow difference, for we are all different one way or another, after all. The point is that this fact of being ought not constitute the crippling predicament that it does for all who have no definite ancestry in Europe.

In the course of my work as a writer on culture as well as a practicing artist who has lived on three continents, numerous other matters have caught my attention over the years besides the politics of perception, reception, and patronage in contemporary art. However, I have also found that certain related issues have preoccupied me more than others, and for that reason I have gathered here a few essays that appear to touch on common themes. In the first section of the book I have assembled essays that deal principally with the demand for difference and its ramifications for non-Western artists, as well as for broad relations between cultures and societies in a supposedly globalized world. This theme returns in the last section of the book, where I have approached it from the uncharted angle of new information technologies. In two essays and an interview, I have addressed the realities of connectivity or access to new information technologies in what I have called the Digital Third World, a global territory that does not tally with the old, geophysical delineations of First and Third Worlds but cuts across those to unite a broad array of humanity who are virtually displaced today by the same technologies and network systems that unite others and lend credence to the notion of a globalized world. In these essays I argue that the faults that tore through the fabric of the old, ideological predigital world can only deepen with the rise of the network society unless steps are taken to extend the reaches and humane uses of new information technologies. It is my contention that the dangers of a global network can be mediated only if this powerful technology is in the hands of more than just the West, and that its benefits can transform our epoch only when its reaches are broadened to include those who are presently forsaken.

The midsection of the book speaks less of cultural prohibitions than it does of cultural affirmations. The essays in this section deal with issues from the affirmative appropriation of Western aesthetic principles under colonialism, which laid the grounds for transition to modernity and, eventually, modernism in the colonies, to ways in which artists in different parts of the world, whose cultures share the experience of colonial incursion or violation, have transformatively applied their media to what I call the project of memory. Rather than reclaim and inter memory in tropes of permanence, I argue, these artists have instead sought to demonstrate their understanding of the nature of memory as a complex and fragile element that may be retained only through iterative, ritual perpetuation.

It is pertinent to point out that these essays were not written with a book in mind, and therefore retain the peculiar looseness and inconsistencies of the essay as a form. In the introduction to their recent book *Relocating Postcolonialism*, David Theo Goldberg and Ato Quayson observe that "the essay, as a form, generates a particular kind of knowledge."[2] Condemned to the constraints of brevity and polemical efficacy, essays inevitably are only propositions rather than treatises, and may only sketch the contours of their subject rather than posit the author's final thoughts. Because these essays were written on different occasions for different reasons over the course of

a decade, they may only cohere at the level of shared concerns rather than structure and must be approached as such. I hesitate to make any further comments in their defense, and would rather the reader relate to them individually and collectively as traces of one artist's reflections at different stations of the cross. I have done my best to preserve the integrity of each essay so as to reflect the spirit and mood in which it was written. I have made no attempts to revise my positions within the essays, though I may no longer hold the firm conviction that inspired some of those positions when I recorded them.

No doubt many will come to this book with expectations, and to the extent that such expectations are met, I am gratified. Any issues I have failed to address in these essays I have addressed or hopefully will address elsewhere.

Part I
Terrain of Difficulty

In "The Heart of Darkness"

I

Prehistory. History. Posthistory. It is evidence of the arrogance of Occidental culture and discourse that even the concept of history should be turned into a colony whose borders, validations, structures, and configurations, even life tenure, are solely and entirely decided by the West. This way history is constructed as a validating privilege that is the West's to grant, like United Nations recognition, to sections, nations, moments, discourses, cultures, phenomena, realities, and peoples. In the past fifty years, as Occidental individualism grew with industrial hyperreality, it has indeed become more and more the privilege of individual discourses and schools of thought to grant, deny, concede, and retract the right to history. Time and history, we are instructed, are no longer given. Indeed, history is to be distinguished from History, and the latter reserved for free-market civilization, which, depending on the school of thought, would either die or triumph with it. Though they both share a belief in consolidating systematization as a condition of historicism, Francis Fukuyama in the 1980s and Arnold Gehlen in the immediate post-Nazi period differ on specifics of the question. While Fukuyama believes that the triumph of free-market systematization over regulated economies marks the end of History,[1] Gehlen and the subsequent school of post-Nazi pessimism posit that the triumph of liberal democracy over fascism marked the end of History and the beginning of *Post-Histoire.*

In both cases what comes out clearly, despite fundamental differences that define and preoccupy the discourse on the fate of History, is the consignment of the rest of humanity outside the Old and New West into inconsequence. For Gehlen, who had a better and stronger sense of history as well as intellectual integrity than Fukuyama can claim, the entirety of humanity was victim to a universal syncretism that subverts the essence of history. For Fukuyama this universality is to be taken for granted, although

3

the majority of humanity is indeed, factually and historically speaking, hardly strictly subject to liberal democracy. For Fukuyama and many others, humanity, to a great extent, is synonymous with the Group of Seven and Eastern Europe. Under Reaganism-Thatcherism, even the spatial definition of history severely retracted to the Pre-Columbian.

The contest for History is central to the struggle for a redefinition and eventual decimation of centrism and its engendering discourses. Without restituting History to other than just the Occident, or, more accurately, recognizing the universality of the concept of History while perhaps leaving its specific configurations to individual cultures, it is untenable and unrealistic to place such other temporal and ideological concepts as Modernism, Modernity, Contemporaneity, and Development in the arena. If Time is a colony, then nothing is free.

II

Premodernism. Modernism. Postmodernism. For the West erase Premodernism. For the rest, replace with Primitivism. It is tempting to dwell on the denial of modernity to Africa or cultures other than the West. However, the underlying necessity to consign the rest of humanity to antiquity and atrophy so as to cast the West in the light of progress and civilization has been sufficiently explored by scholars. But for the continuing and pervading powers and implications of what Edward Said has described as structures of reference, it would be improper to spend time on the question. It is important to understand that while countercentrist discourse has a responsibility to explore and expose these structures, there is an element of concessionism in tethering all discourse to the role and place of the outside. To perpetually counter a center is to recognize it. In other words discourse—our discourse—should begin to move in the direction of dismissing, at least in discursive terms, the concept of a center, not by moving it, as Ngugi wa Thiong'o has suggested, but superseding it.[2] It is in this context that any meaningful discussion of modernity and "modernism" in Africa must be conducted, not in relation to the idea of an existing center or a Modernism against which we must all read our bearings, but in recognition of the multiplicity and culture-specificity of modernisms and the plurality of centers. The history of development in African societies has metamorphosed quite considerably over the centuries, varying from the accounts of Arab scholars and adventurers, as well as internal records of royalties and kingdoms, to the subversive colonialist narratives and anthropological meganarratives. Recent times have witnessed revisions in earlier texts and a growing willingness to admit the shortcomings of colonialist narratives. Countering discourses have begun to place history, with all its inconsistencies and vulnerabilities, back in the hands of each owning society, and shown how carefully we must tread.

III

It is equally in the above light that the concept of an African culture, or an "Africanity," which is often taken for granted, is problematic. It seems to me that we cannot discuss

an African modernity or modernism without agreeing first on either the fictiveness of Africanity or the imperative of a plurality of modernisms in Africa.

Of course, one may well be wrong here. Yet it is to be recognized that, like the entity and idea called Europe, the specifics of which are still in the making and the collective history of which does not date earlier than Napoleon—the idea of Rome and Greece is dishonest—Africa is a historical construct rather than a definitive. Many have argued, prominent among them the Afrocentrist school, the antiquity of a black or African identity, an argument that falls flat upon examination. On the other hand, history reveals the necessity for such unifying narratives in the manufacture of cultures of affirmation and resistance. The danger in not recognizing the essential fictiveness of such constructs, however, is that a certain fundamentalism, a mega-nationalism, emerges—all the more dangerous for its vagueness—which excises, elides, confiscates, imposes, and distorts. Some will argue that history, after all, is perception; in other words, distortion. But if we were to accept this wholesale and without question, we would have no business trying to "correct" history, unless to correct is merely to reconfigure, to counterdistort.

We already recognize the dangerous potential of such fictions in the hands of the invading Outsider. The spate of pseudoscholarly interest in "African" life, culture, and art during and immediately after colonialism illustrates this. While in the beginning the totalizing construct was employed to underline the peculiarity of the "savage" mind and thus justify Outsider intervention, it has continued to be in use in justifying the changing face of that mission. From redemptive Christianity to salvage anthropology, it has remained essential to maintain this invention. Indeed, the need seems greater now than ever before as the collapse of colonialism and the rise of contesting discourses place anthropology, the handmaid of Empire, in danger. Anthropology's crisis of relevance, coupled with characteristic Western career opportunism, has necessitated the gradual reinvention of a singular and unique Africanity worthy of the Outside Gaze. The new manufacture finds ready clients in scholars, policy makers, and nongovernmental and aid organizations seeking objects of charity. Unless there is a singular Africanity, distinct and doomed, how else would they justify the pity that puts them ahead and on top? If the Other has no form, the One ceases to exist. It is in order to retain and maintain this Other that recent Western texts on African culture remain only extensions and mild revisions of existing fictions. To undermine the idea of The African is to exterminate a whole discursive and referential system and endanger whole agendas.

IV

The history, or histories, of what we severally refer to as modern or contemporary "African" art illustrates the previously mentioned problems and dangers. From the point when it became acceptable to speak of a "history of contemporary African" art, attempts at this history have run into often unacknowledged tight corners by ducking into the safety of earlier fictions of Africa. The most obvious manifestation of this is in

the seeming racio-geographical delineation of The African, which, we are often told, basically refers to sub-Saharan Africa. The obvious intent of this definition is to distinguish the African from the Arab, although the spatial boundaries specified by the register sub-Saharan effectively ridicule this intent. A less apparent intent, and indeed a more important one, is to place the Arab a notch above The African on the scale of cultural evolution.

It is sufficient not to question this intent here, but to point out that the signifying register proves grossly inadequate. Not only does it wholly ignore the impossibility of hard edges between cultures and societies in the region it describes, and the long history of Arab-Negro interaction, together with all the subtleties and ambiguities of racial translations, indeed the impurity of designates, it equally ignores internal disparities within the so-called "African" cultures. To play on the surface, it is never quite clear where East Africa fits on this cultural map of Africa, given not only the territorial problems of locating Somalia below the Sahara, but also of eliding Zanzibar's long history of Arabization. In a significant sense, then, the construction of a "sub-Saharan" Africa not only ignores geographical inconsistencies but equally ignores accepted discursive positions in the West that not only recognize the triumph of History as impure but underlie the construction of Europe.

We see double standards here, but that is hardly the most important point. We also find that essential tendency to ignore indigenous historical perceptions and constructs. The Outsider, whether Occidental scholarship or Diaspora Negro discourse, quickly established delineations without acknowledging the possibility that these may not be shared by those whose histories are at the center of discourse.

Then again, perhaps what we see are not double standards at all but a consistent referent, for when we examine the continual construction of Europe such discrepancies are equally apparent. The most interesting examples are the ready admission of Israel into Europe and the struggle to exclude Turkey. In other words, in the end the use of the designation "sub-Saharan" in the definition of The African is only a cheap ruse masking other, less innocent referents. The bottom line is not only race but history as well—History as vassal.

Needless to say, white people in South Africa and Asians in Uganda, as well as other Diaspora populations and communities, fall outside of this narrow, Negro-specific definition, although in the specific case of South Africa, the settler minority, like the Europeans in Australia, has been able in the past half century to negotiate its way back into Europe. At any rate, cultural Africa may no longer be contained by the lame composite sub-Saharan, which now would require a further qualifier—"excluding white (South) Africans"—to make sense. Then again, how would the Outside justify its condescension toward Africans, or its employment of The African to satisfy its need for the exotic, if Arabs, with their "long history" of civilization, or white (South) Africans were to be included in that construct?

On the political front, however, arguments have been stronger on the side of an all-embracing Africanity that supersedes disparities and differences and aspires toward the construction, not invention, of a new and credible Africanity. This is the position

of Kwame Nkrumah's Pan-Africanism, and remains the ground argument of the Pan-African movement. Culturally, the argument is to recognize a plurality of Africanities but aspire toward the active formulation of a singular African identity, somewhat along the lines of Pan-Europeanism and the construction of the West.

V

For the African cultural historian, the problems here are plenty. For instance, based on the previously mentioned construction of Africa, it is increasingly fashionable to begin the history of modern, or so-called contemporary, art in Africa from the turn of the last century; that is, from the Nigerian painter Aina Onabolu. However, earlier practitioners of modern art exist in the Maghreb and Egypt, and strains of modernism are discernible in the art of white South Africans from earlier than Onabolu. Also, if "African" is a race-specific qualification, it would be proper to remember that artists of Negro descent were practicing in the contemporary styles of their time in Europe and America much earlier than the turn of the century. Where then does one locate the break with the past that the idea of a modernism insinuates? In discussing modern African art, does one continue to exclude half the continent? Is it realistic, otherwise, to discuss a modern culture that defies existing invented boundaries? Are there grounds in the present, which did not exist in the past, to justify a unifying discourse, or is it safer to pursue a plurality of discourses? Along what specific lines must such discourses run? Or shall we merely conclude, like Anthony Appiah, on the fictiveness of a singular cultural identity?

VI

Several other problems and questions hinge on the preceding concerns. If, after all, we reject the "sub-Saharan" qualifier, we effectively subvert a host of other qualifiers and paradigmatic premises. The "peculiarities" and particularities attributed to "sub-Saharan" art, which in turn sustain temporal and formalistic categorizations, become untenable. Such conveniences of Outsider scholarship as the "problems of transition" from the "traditional" or The African to the modern, or the question of Africa's "identity crisis" and concern over the endangerment of "authentic" African culture, all prove problematic indeed. If Africa is not some easily definable species or category that yields to anthropology's classifications and labels, neither are its cultural manifestations.

"Transition" from antiquity to the modern ceases to amaze and eroticize or evoke voyeuristic admiration or pity because antiquity ceases to exist. The supposed distress of Africans caught in a no-man's land between Europe and their "authentic" selves becomes a lot more difficult to locate or explicate. Ethnographic categories usually applied with ease to sequester "African" culture into temporal boxes are no longer easy to administer. What, for instance, would we qualify as "transitional" art in contemporary Egypt or Cameroon that we cannot locate in Spain? What is "client-driven art"—to use an infamous tag introduced a few years ago by American museum

practitioners—within the minority community of South Africa that is so peculiar it may not be found in SoHo, New York? How easily would we lament the "corrosive influences" of Europe on the Somali of the northern East African coast if we turned our backs on the obsession with "sub-Saharan" Africa?

That is to pull one leg from the stool. In strict discursive terms, of course, none of the categories, delineations, and constructs mentioned thus far has any relevance even within the context of a delimited "Africa," especially since none is ever applied in the description and study of Europe or the West. African scholars could have bought into any of them, and indeed still do, but that is hardly the issue. The point, instead, is that such constructs that sequester specific societies and cultures and not others emanate from less innocent structures of reference, the briefs of which are to create foils and negations of the Occident. Thus, we can speak about "transitional" art in Africa, but never in Europe. We may speak of "Township" art in Africa, or at times of "popular art," and these would connote different forms and manifestations from those in Europe. We may qualify nearly a century of art forms in Africa as contemporary while applying the same term to only a strain of current art and discourse in Europe. We may take modernism in Europe for granted and have great difficulty recognizing or acknowledging the same in Africa. We may consider the assimilation of non-Occidental formal aesthetics into European art as the most significant revolution of its time, while the reverse is bemoaned in Africa as a sign of the disintegration and corrosion of the native by Civilization. Alternatively, we may pat Africans on the head for making a "successful transition" into modernity. Why, whoever thought they could emerge unscathed!

To employ the "problems" paradigm in discussing modernity and modernism in Africa is simply to buy into existing structures of reference, which not only peculiarize modernity in Africa but also forebode crisis. What needs be done is to reject that peculiarization and all those structures and ideational constructs that underlie it.

VII

To reject the exoticization of Africa is to destroy an entire worldview carefully and painstakingly fabricated over several centuries. This is the imperative for any meaningful appreciation of culture in Africa today, and it would be unrealistic to expect it easily from those who invented the old Africa for their convenience. It dismisses an existing discourse and signifies a reclaiming process that leaves history and the discursive territory to those who have the privileged knowledge and understanding of their societies to formulate their own discourse. This is not to suggest an exclusionist politic, but to reassert what is taken for granted by the West and terminate the ridiculous notion of the "intimate Outsider" speaking for the native. It recognizes that there is always an ongoing discourse and that the contemplation of life and its sociocultural manifestations is not dependent on self-appointed outsiders.

Otherization is unavoidable, and for every One, the Other is the Heart of Darkness. The West is as much the Heart of Darkness to the Rest as the latter is to the West. In-

vention and contemplation of the Other is a continuous process evident in all cultures and societies. But in contemplating the Other, it is necessary to exhibit modesty and admit relative handicap since the peripheral location of the contemplator precludes complete understanding. This opacity is the Darkness.

Modernity as a concept is not unique. Every new epoch is modern till it is superseded by another, and this is common to all societies. Modernity equally involves, quite inescapably, the appropriation and assimilation of novel elements. Often these are from the outside. In the past millennium the West has salvaged and scrounged from cultures far removed from the boundaries that it so desperately seeks to simulate. The notion of tradition also is not peculiar to any society or people, nor is the contest between the past and the present. To configure these as peculiar and curious is to be simpleminded. It is interesting, necessary even, to study and understand the details of each society's modernity, yet any such study must be free from the veils of Darkness to claim prime legitimacy. To valorize one's modernity while denying the imperative of transition in an Other is to denigrate and disparage. The West may require an originary backwoods, the Heart of Darkness, against which to gauge its progress. Contemporary discourses hardly depart from this tradition. However, such darkness is only a simulacrum, only a vision through our own dark glasses. In reality, there is always a lot of light in the Heart of Darkness.

1993

Art, Identity, Boundaries: Postmodernism and Contemporary African Art

N AN INTERESTING COLLECTION of interviews and plates, American critic Thomas McEvilley[1] asks Ivorian painter Ouattara,[2] "When and where were you born?" The artist answers with vaguely suppressed irritation. For many, McEvilley's would seem an innocent and ordinary enough question, especially where the obvious intent is to present to us an arguably relatively little known artist. It would appear in order, therefore, that McEvilley should proceed as he does, inquiring after details of the artist's background. Asks the critic next, "In 1957, was Abidjan a big urban center, like today?" To which Ouattara also duly provides an expected answer. On the page there is a picture of the artist, his face aligned against the text of the interview, his broody countenance writing most eloquently and visibly to his impatience with the critic's line of inquiry. One can sense a building tension within the artist. Reading closely, one also notices that McEvilley, to the contrary, is relaxed. For him the chat is going well, and he is comfortable. And when he is comfortable, everyone else is comfortable. As he maps the artist with his eyes, his mind retrieves from its cabinet of tourist post-cards an image of an African mammy-wagon with a line of popular wisdom inscribed on its side panel: *No Hurry in Life*. It is the way of these people, he reminds himself: generous, charitable, accommodating. They take life easy. And so his mind drifts back to Ouattara's studio, hardly taking notice of his quarry as the artist shifts uneasily on his stool, muttering under his breath. Quite predictably, the white boy fails to read the sign on the native's face. For him the gestures of the native are an invisible sign.

The critic runs his pen across his bushy face, and, as if speaking to a child on his first day at school, asks: *Would you tell me a little about your family?* There! Ouattara explodes. But only within. Like a gentleman. The ultimate signifying monkey. He understands—he is brought up to understand, everything in his history and in his

experience prepares him to understand and to accept—that in dealing with the power that McEvilley represents, he is engaged in an ill-matched game of survival, a game that he must play rather carefully if he must avoid profound consequences, a game that he must negotiate with patience to avoid his own erasure, his own annihilation, a game that he must ultimately concede in order to live. Living in New York, Ouattara understands too well how, beyond the boundaries of colonial ethnographic displacement, the introduction of digitization in our time has also sanitized erasure and transformed it into a messless act. He understands how the mark of deletion, the ugly sites of cancellation and defacement, the crossing out, the scarred page, the marginal inscription, that which in the past testified to the processes of obliteration and through this testimonial actively subverted erasure, are things of the past, and the object of the obliterative act now disappears together with the evidence of its own excision, making erasure an act without trace. This knowledge further underlines the ominousness of his location. Ouattara understands how much he needs McEvilley, how much he stands to gain by making friends of him. He recognizes, albeit painfully, that the terrain he occupies, the terrain to which he is perpetually consigned, in which he is confined, is one under surveillance, where every utterance, every gesture, carries with it implications of enormous weight for himself as an African and for his practice as an artist. Even more important, he recognizes this terrain as an outpost, a location on the peripheries of the principalities the critic represents, a border post at which McEvilley is the control official. This is the locale of the African artist dealing with the West irrespective of her domicile. This I call the terrain of difficulty.

And so, holding his breath firmly and gritting his teeth and silently but vigorously crossing out the dozen F-words bombing his brain while warning himself to take it all with calm, Ouattara stakes his final but ultimately futile claim: *I prefer to talk about my work.*

Really? Well, not quite. The artist's polite caution does not wash with the critic. Deftly and firmly McEvilley waves Ouattara's protest aside and proceeds with his line of questioning. He feels in command, he must be seen to be in command. *If he hollers let him go,* reads an old, American plantation saying. But no. McEvilley is not fazed by the native's protests. This time the master will have his way. Describing the women of Huxian in *About Chinese Women,* Julia Kristeva images the native as a silent presence.[3] In reading Ouattara's moment with McEvilley we are reminded of a different silent presence, closer perhaps to the obliterated presence that Chinua Achebe identifies in Joseph Conrad's *Heart of Darkness,* the native whose silence is an objectifying projection, what we may refer to as *significant silence.* Though this silence is not literal, it is nevertheless made palpable, for in the arena of engagement between the One and his Other, between the dominant subject and the object of his interrogation, beyond the preferred narrative and that specified rhetoric that reiterates palatable constructs of Otherness, the native's utterances are not speech. They are relegated and deflected to the site of the guttural, the peripheries of sense, the space of the unintelligible, where words are caught in a savage struggle and sounds turn into noise, into the surreal

mirror image of language. In this void of incoherence, utterance becomes silence because it is denied the privilege of audience. And without audience there is no speech.

Sprawled out like Roland Barthes in Tangier, or prowling through a market in Abidjan, the esoteric goulash of native utterance is, of course, the ultimate locale of Occidental desire, the last hunt for exotic pleasures. But this is not a pleasure trip. McEvilley has a book in mind and *must* have his story. Under the circumstance, native aspirations to desire and the dialogic *(I prefer . . .)* and native pretensions to power and sophistication *(to discuss my work . . .)* are quickly displaced in a hegemonic withdrawal of audience that reestablishes the hierarchical position of the Self over the Other, of the Western critical and artistic establishment over the African artist. On this stage of simulacral dialogue there is only one voice that counts. The other can exist only as a projection, an echo, as the displaced sound of percussive fracture.

And so McEvilley drives his conversation with Ouattara toward realization of his preferred narrative, with questions not intended to reveal the artist as subject, but rather to display him as object, an object of exoticist fascination. *How big was your family? What school did you go to? What language was spoken in your home? What religion did your family practice? Did it involve animal sacrifice?* In the end, his vision/mission fulfilled, McEvilley triumphantly announces to Ouattara: *I don't have any more questions. Do you have anything more to say?*

For Ouattara, though, the game is already over. It was over even before it began. It was over from the moment he was born, from the moment he was destined to be—designated as—an Other. In answer he fumbles within for something deep and philosophical to say, something original, something in his and not the master's voice, some desperate utterance in the narrow passage of sanction accorded him, something that represents his, rather than the preferred version, the master narrative. He struggles to speechify, to repossess his body and reinvest it with humanity, with language, with articulation. He struggles at the borders of subjecthood.

Aligned to the text at this stage is another picture of the artist, as if in conclusion. But this time the strength of determination, even defiance, that we glean from the portrait at the beginning of the text is gone. Ouattara's countenance no longer projects a brooding tension, it no longer *projects,* that is, it no longer aspires. His disposition no longer indicates a willingness to dare, to utter with Frantz Fanon, *Get used to me; I am not getting used to anyone.*[4] Instead, he stares into space, his face is sunk and forlorn, his anger turned to despair, his attempts at the contested territory of the voice thwarted by McEvilley's hegemonic devices. Failed is his effort to shift the critic's gaze unto his work, to specify the latter as the rightful focus of contemplation, and, in so doing, to claim *author*-ity. Clearly, against his will, Ouattara finds himself repositioned in the frame as the object. And though he is coerced to sketch the contours of this object, to narrate himself and to trace the ethnography of his body, he is equally made to do so within confines defined by another. He is forced to strip for McEvilley's pleasure.

McEvilley's interview with Ouattara in many respects defines the limitations of appreciation and expectation, or what we might call the confines of perception, within which African artists are either constructed or called upon to construct themselves.

It speaks to a discourse of power and confinement in current Western appreciation of modern African art, a discourse of speech and utterative regulation, which, by denying African artists the right to language and self-articulation, incarcerates them in the policed colonies of Western desire.

In his inaugural lecture at the Collège de France, Barthes identifies speech as a code of legislation and notes that utterance, language, that which we speak or write—and, one may add, paint or sculpt—all that we produce as a body of text, as a composite of signifiers, enters the service of power upon coming into being. Though this power may aspire to Barthes's definition as the desire to dominate, *libido domini,* its most fundamental nature, nevertheless, is as a condition for the articulation and definition of the self, as *author*-ity. When the artist creates or the musician composes, the most fundamental intent is to replicate and reiterate herself as a being, to impact herself upon reality, to assert her author-ness, her authority. When Ouattara paints or sculpts, the primary intent of the act is to establish on the specific sites of his appointment the contours of his being, his history, his experiences, his existence as a participatory element in the constitution and cartography of reality. His intent is to imprint his being on Time: his loves, his philosophies, his originary or existential circumferences. And if we should agree with Barthes that enunciation is the code of legislation,[5] it becomes clear that its essence is to define the rules of interaction and interrelation between people, to set the limits of intervention and dominative incursion, of encroachment upon the sites of our individuality and subjectivity, to present ourselves and establish our authority over not only our creativity, but most important, over ourselves also. It is enunciation, the ability to reiterate *our* power over *our* selves that subjectivizes us. It is this ability and freedom to enounce, too, which precludes us from dominance by others, which takes us, as it were, beyond the bounds of power.

To place enunciation, be it utterance, writing, or art, under surveillance, therefore, is to impair this code. And once this happens, once the code of legislation and self-cartography is defaced, impaired, or vetoed, the stage is set for others to infringe on those sites of reality where we define ourselves. To check the creative act, whether through institutional or critical sanction, is to transgress the borders of the individual's autonomy, to quarantine them within the boundaries of subjugation, within the bounds of power.

Autonomy. Self-articulation. Autography. These are contested territories where the contemporary African artist is locked in a struggle for survival, a struggle against displacement by the numerous strategies of regulation and surveillance that characterize Western attitudes toward African art today. Within the scheme of their relationship with the West, it is forbidden that African artists should possess the power of self-definition, the right to *author*-ity. It is forbidden that they should enounce outside the gaze and free of the interventionist powers of others. And it is this contestation of their complete subjectivity and their right to co-legislate patterns of interaction that we find in McEvilley's interview with Ouattara.

To veto enunciation is to disenfranchise and symbolically incarcerate, for it is within the contested territories of enunciation, and the ability to elect or assert, that

power and franchise reside. The body upon which such veto is exercised loses self-possession and slips into vassalage. To further confirm this state, this body is often forced to confess to a narrative of self-denigration, to provide the ultimate authority through self-Otherization. Thus is Ouattara forced, in the interview in question, to iterate and endorse a bio-narrative of savagery, and thus to wedge his savaged body into that requisite margin between nothingness and subjecthood where he transfigures into the object of his possessor's desire, into an inert Polaroid image.

In vetoing Ouattara's right to self-articulation, in placing a sanction against his preferred site of discourse, McEvilley effects a paradigmatic reiteration of ventriloquy as a structure of reference for Western attitudes toward African artists. This frame has its origins in colonial ethnography and the colonial desire for the faceless native, the anonym. The faceless native, displaced from individuality and coalesced into a tribe, a pack, demands and justifies representation because she is a lack. In the event authority is appropriated and transferred from her. This authority is subsequently exercised in constructing her for Occidental consumption. Also, defacement consigns the native to the category of the unknown. Displaced to the befuddled corners of obscurity and rudimentary *epistēmē,* the native is made available for discovery, and this discovery transforms the discoverer into an *authority,* this supposed privileged knowledge often translating into the right to represent.

Even more specifically, the imposition of anonymity on the native deletes her claims to subjectivity and works to displace her from normativeness. Not only does anonymity conveniently underline her *Otherness,* her strangeness, her subalternity, anonymity equally magnifies the invented exoticism of her material culture, which in turn becomes a sign of her constructed exoticness. For long ethnography, in order to emphasize the Otherness of non-Occidental cultures, applied a different rule of attribution to art from such cultures, effectively denying the identities of artists even where these were known. The figure of the individual genius, that element that more than any other defines enlightenment and modernity, was reserved for Europe while the rest of humanity was identified with the collective, anonymous production pattern that inscribes primitivism. Until recently works of classical African art were dutifully attributed to the "tribe" rather than to an individual artist, the latter thus effectively erased from the narrative spaces of art history. In contemporary discourses, critics like McEvilley represent the continuation of this practice, whereby novel strategies are employed to make African art anonymous either by disconnecting the work from the artist, thus deleting the *author*-ity of the latter, or by constructing the artist away from the norms of contemporary practice.

From Ulli Beier's pioneering work on contemporary African art in the 1960s to André Magnin's more recent presentations of the neonative African artist, there is a split between the author and the work that effectively depletes individual credit to the artist. While Beier, like McEvilley, focused on details of ethnic and biographical difference, others dwell on the peculiarity of the work, often constructed within a simulacral ambience of esotericism and fractious submodernity. In each case the gaze is deflected unto utopia, unto the significance of the Other. McEvilley directs us to the

existence of animal sacrifice and voodoo in Ouattara's or Moustapha Dime's background rather than to their contributions to, and discursive place in, contemporary sculpture and installation art. Ulli Beier contends with Twins Seven Seven's identity as a spirit child and village chief rather than with his work as a graphic artist. Chéri Samba is rarely articulated within the discourses of contemporary satire; instead he is presented to us as symptomatic of a kitschy mimicry that is characteristic of the disintegration of African contemporaneity. In each case these misrepresentations are made possible by first crossing out the subject's ability to self-articulate, to not only enunciate but also expatiate, to fully exercise their *author*-ity.

The African artist thus effaced, the faceless, anonymous native, is the correlative of Fanon's "palatable Negro," the tolerable, consumable Other who, stripped of authority and enunciatory autonomy, is opened to the penetrative and hegemonic advances of the West. The appeal of the faceless, anonymous native is that she is also a pornographic object, a docile, manipulable object of desire and pleasure. Pornography as a strategy rests on the localization of desire and the intensification of pleasure through the effacement of the subject, the detachment of the locality of desire from the web of subjective associations and reality that impinge on the possessor's sense of social responsibility. In other words, its principal device is the objectivization of the source of pleasure. For maximum derivative effect, the purveyor as well as the consumer of pornography must detach and frame the object, this act enhanced through the combined mechanisms of magnification and erasure, of filling the frame with only that which satisfies the specifications of desire. This is aided even further by positioning the object within an appropriate narrative, the right sound, the further from speech the better, all of which, by playing on the extremes of perversion and provocation, sufficiently hold it within the frames of the spread. Of course, the erasure of the subject, or her transfiguration into the fantastic, consolidates the purveyor's fiction of ownership and thus of power. And power, the ability to possess unquestionably, to exercise uncontested authority and to manipulate at will, is the essence of pornography.

Andrea Dworkin has described the pornographic object as a colony, the terminal site of the colonized body. In Occidental discourses, African artists and African art in turn continue to occupy this site. Decoupled and anonymized, each is turned into a silent colony, a vassal enclave of pleasure and power. Each is fragmented and projected in close-up sequences and pastiches that magnify pleasure for the all-knowing critic or collector who assumes the identity and privilege of an "intimate outsider" who enjoys a positive relationship with the objects of his fantasy. Each is parceled and packaged to suit the West's machinations and taste, to satisfy its desires and fit within its frames of preference.

Even the pricing of contemporary African art and artists on the international art market continues to analogize them with the cheap, pornographic object. Once, a friend who is an African art dealer received a painting by Ivorian artist Gerard Santoni from one of the leading galleries in New York, with a price tag that would be considered modest in a graduate exhibit. Santoni is a well-regarded artist whose work has been shown at the Biennial of Venice and other reputable international and

contemporary art spaces. He has practiced for several decades and his works would be generally considered of the highest standard. But Santoni's work is undervalued because he and his work are forced into the frame of the pornographic as mere objects of pleasure and fascination. They are positioned on those peripheries of creative genius where the aesthetic experience fails to cohere with great material value. Porn is recyclable and its appeal is temporary. For this reason porn is cheap, and the object of pornographic consumption even cheaper. And both belong not in the great spaces of culture but on the supermarket shelf, on the sidewalk, in the quirky fringes of normative taste. When projected on contemporary African artists and their work, as they often are, these attributes displace them to the lowest rungs of a strictly multitiered contemporary art market from which upward mobility is almost impossible.

This perverted, pornographic desire manifests itself most significantly, however, in the continued preference in the West for that art from Africa that is easily imaged, not as art *as we know it* but as a sign of the occult, an inscription of the fantastic. The childlike crayon drawings of septuagenarian Felix Bouabré would not ordinarily represent great creative talent in the West, and would not ordinarily draw the attention it has in the West but for its evocation of the unsophisticated and unfamiliar, indeed for its veneer of crudity and juvenility. Bouabré's drawings are today preferred in the West to those that could be considered more familiar precisely because the artist's works fall outside conventional Western standards, and thus inadvertently fit dubious, perverted notions and expectations. As form they represent a slip from the normative, they signify a coveted distance between the West and the African, they satisfy the desire for the fantastic, they are open to pornographic translation, they are strange. A few decades ago this pornographic desire for the abnormal was fulfilled by Outsider art: the art of the blind, the autistic, the mentally disabled, the clinically insane. Today that desire is projected on Africa, and it is this perversion that locates works like Bouabré's within the boundaries of preference.

The implications of the preceding for creative practice are numerous and far-reaching. Working within the reaches of distortional, regulatory strategies, African artists find themselves vulnerable to potentially destructive pressures. The demand is for them to produce to specification, to affect anonymity, to concede the ability to enounce within the sites of normativeness. Even more significant is the fact that, for these artists, access to criticality in contemporary discourses is regulated by this demand for the subnormative, and here lies the importance of Thomas McEvilley's interview with Ouattara. For not only do McEvilley's devices illustrate one critic's incarcerative projections on an African artist, even more significantly they speak to the segregationist criticality and general ambivalence of Western, so-called postmodernist contingents in the discourse of Others, a criticality bound by an interceptive demand for the identity of the Other by the query, "Where were you born?" They speak to the fact that within this discourse postmodernism remains, to a remarkable extent, a mere rehash of entrenched modernist attitudes and methods, "a continued reproduction," as Peter Hitchcock has suggested, of "the logic of Western cultural critique that fosters the 'Othering' of the so-called 'Third World Subject.'"[6]

These are peculiar obstacles, of course, which work outside the perimeters of limitation/transgression. The challenges they pose require of artists resistive rather than transgressive strategies. More important, they pose an even greater challenge for contemporary cultural theory and for postmodernism as a critical culture. To bring its object into crisis is the duty of criticism, and postmodernism must extend this responsibility to contemporary African art, and even more so to the logic that regulates its contemplation of non-Occidental contemporaneity. To engage meaningfully with the contemporary, a credible postmodernist criticism must place its own ambivalence under crisis, and extend the borders of criticality beyond the demand for identity and the subnormative.

1995

Play Me the "Other": Colonialist Determinism and the Postcolonial Predicament

Playing the Kid

William Wilson is a Togolese painter who lives in France. He makes charming, child-like drawings with crayons and pastel on paper. His figures and characters allude to diverse sources, including comics and popular cartoon imagery. Wilson's childlike style is deliberate and has taken his work into well-known galleries and other exhibition spaces around the world, from Austria to the United States. On the face of it, Wilson's style is not entirely peculiar. He is not the first or only adult professional artist to draw like a child; in fact, many would describe a huge portion of modernist art in the twentieth century as essentially childlike, rightfully or otherwise. Recently, a handful of major artists have worked in related styles, among them the Ivorian Felix Bouabré, who works with a personal vocabulary of quaint signs, and the American Francesco Clemente. Perhaps the most influential artist to work in like manner in recent times was the American painter Jean-Michel Basquiat, arguably one of the most influential painters of the late twentieth century. As Basquiat's friend the hip-hop artist Fred Brathwaite (Fab 5 Freddy) recalls in the British documentary *Shooting Star,* Basquiat decided in the late 1970s that he would begin to produce drawings and paintings that resembled his work as a child and that such work would ultimately pave his way into art history.[1] The drawings that came out of this resolve, which, ironically, differ remarkably from his more intricate and polished high-school drawings, did in fact bring him to the attention of New York dealer Anina Nosei in the early 1980s and, just as he predicted, ultimately earned him a name as an icon and a figure in art history. Legend also has it that on seeing the drawings, a prominent African American museum official felt compelled to comment that Basquiat would do well to return to school and take drawing lessons. At the time she was apparently unaware of the

studied sophistication of Basquiat's draftsmanship as a child. To arrive at the mannerism of his mature years as an artist, however, Basquiat set out to do the opposite. He decided to unlearn the skills of verisimilitude that he learned in high school in order to achieve the energy and succinctness that came to distinguish his work. He sublimated the superficial accuracy of observed verity and convention in favor of greater immediacy and a different, metaphorical truth.

Ordinarily it would not matter whether Brathwaite is right regarding Basquiat's disavowal of conventional verisimilitude, whether in fact Basquiat did *consciously* return to his childhood or instead, like Bouabré, he invented a new, formal language that some identify as childlike for want of a better qualifier, especially since Basquiat's late drawings do not look like his childhood drawings. What is evident in the work that Basquiat created in the short decade of his career, and what clearly distinguishes him, and Bouabré, from Clemente and Wilson, is that he was compelled by an innate force to invent a language of the sign, a peculiar iconography and calligraphy suited for the sophisticated conceptual narratives he executed in his work. William Wilson and Francesco Clemente, on the other hand, infantilize their work in the classic tradition of the mimic, the trickster and performer who adopts a language and persona or wears the guise of pristinely Otherness so as to draw attention or sustain a career.

Even so, there is a significant difference between Wilson and Clemente, and it is that difference that is of interest to us here. It is the fundamental difference between subjecthood and its lack, between choice and contingency, between the artist who is free to elect the content and direction of his practice without the inordinate pressures of a culture other than his and one who exists and practices in that terrain of difficulty where his success and future are subject to the demands and expectations of another culture to which he does not fully belong but must nevertheless answer to, where he is required to wear his difference and Otherness like a badge or run the risk of disregard, ignominy, and failure. The difference is that whereas Clemente, who is Euro-American, may choose of his own free will between sophistication and affected naiveté in his work, and may freely step across cultures and geographies in search of inspiration and form without fear of the charge of appropriation, the Togolese William Wilson may not. As the postcolonial *native*, Wilson is compelled to don the persona of the infant as the price of his ticket through the gates into the culture hall of fame.

Wilson's predicament represents the condition of the postcolonial artist, especially in the Western metropolis, which is a condition not of choices but of contingency, where every move has consequences, and success and survival hinge not only on the ability to affect required gestures, but to produce to a certain taste and expectation also. As a perpetual outsider in the West, a postcolonial artist like Wilson is required by Western viewers and clientele to produce work that easily reminds them of the presumed facts of his origins, work that makes a neat and unsullied demarcation between him and the West. However, since by their nature signs of origin bear neither certainty nor clarity, clearer signs of difference are invented and projected on the artist whose duty it is, then, to accept, reflect, and perpetuate them, or reject them at the risk of professional occlusion.

As an African artist in Europe, Wilson is expected to wear his Africanness on his sleeve, to shout his *Afritude*. Although he is trained in Europe, and lives and works among artists of all nationalities and backgrounds for whom the locale of practice ought to constitute a common geography, and although the same demands are seldom made of those artists whose origins are in Europe to place their work under the shadow of myths of origin, such is the infirmary of desire and sanction in which Wilson and his kin must perform. For the West, Wilson and his art must be seen to indicate that he is *not one of us*. And because his *difference* is more a construct than a truth, he is compelled to invent a myth of Otherness and adopt a corpus of signs to translate this Otherness. Better still, he must accept ready-made myths of his peculiarity, those myths invented around his race long before he made his way to France. He may be "post" colonial, but the yoke of the past he must still bear. He must play the stranger to find a little corner of acknowledgment in the center.

It is this contingency that drives William Wilson to make pictures that he calculates would meet the expectations of patrons in the West. In *The New Subjectivism: Art in the 1980s* Donald Kuspit argues that eccentricity represents individual authenticity and an element of intimacy in the postmodern era. Such eccentricity is well regarded and respected, even expected. When Francesco Clemente makes naive drawings and paintings, they are seen as evidence of an artist in the process of evolving a new, personal language that advances the overall language of form. Eccentricity becomes a marker for self-discovery and actuation predicated on volition, and the style that emerges from it represents the physiognomy of the artist's mind.

However, Wilson's naive, childlike style is not an eccentricity; it is a condition. It is an induced effort at cultural authenticity that is far from individual or intimate. As a non-Western artist Wilson is required to represent not himself as a creative individual but *his* culture, defined by the fiction of a supposed origin *elsewhere*. It is this expectation, this conditionality, that informs his use of a formal device that ridicules the conditionality itself by the transparency of its pretenses, and that ultimately robs him of a different kind of authenticity without which the creative individual is lost: authenticity to oneself and one's art.

To describe Wilson's predicament as a condition is, of course, to imply that his success as an artist or his ability to break through the barriers that regulate cultural mobility in the Western metropolis is invariably dependent on his willingness to fulfill the peculiar demands made of him and his work, and that, precisely, is the case. Galleries, curators, collectors, and critics all come to his work, as indeed to those of all contemporary artists whose backgrounds are supposed to be *elsewhere,* with the same expectations: that they prove their difference rather than share in the contemporaneity of their location in the metropolis. In art academies across the West from Paris to London, New York, Philadelphia, and Los Angeles, art students with names that imply origin *elsewhere* are automatically expected to produce work or pursue interests that refer to that *elsewhere,* rather than show logical affinity with their immediate colleagues in the West or enjoy the same freedom to explore and discover at will. Many a young artist in the making has been confused, frustrated, and nearly destroyed by

this, and hardly any of them is able to survive the experience without a scar. They are made to understand, at a critical stage in their development as artists, that their perceived Otherness is of greater interest than the mere ability to excel as creative individuals, and that to exist and practice in the West or expect appreciation and serious attention they must bear the extra burden of origins.

This is inevitably lodged in their psyche, and often begins to condition their form, creative concerns, and strategies of self-actualization. At best, there is a realization that this expectation is a permanent challenge to be engaged, negotiated, accepted, or reconciled with, and that to ignore or reject it is to come to terms with certain consequences, principal among them being that the artist has greater difficulty attracting the necessary and decisive attention of culture brokers, critics, and clients, and for a professional artist this is decisive and does determine whether the artist survives and succeeds in the profession. Many promising young artists abandon the profession because they are unable to reconcile themselves with the idea of producing the manner of work demanded of them, and those who stay the course do so at the price of frustration. At worst, these artists are forced to devise pragmatic strategies to contend with this challenge of producing to the new colonial taste, often adopting subjects, formal languages, and philosophical pursuits that otherwise would be of less immediate or personal interest to them, but which they realize would place their work and careers in better stead before the culture establishment. Having determined that Otherness is a preferred commodity on the global culture market, and that their individuality as artists is of less interest than their Otherness, they decide to play *the Other*. So William Wilson makes little, witty, childlike crayon drawings that satisfy his clients' desire for something "African" and convince them that he has not lost touch with his origins.

Beyond the pragmatics of demand and production, however, there is a deeper, psychological implication. One may ask: True that the global contemporary art establishment expects Wilson to produce an art of Otherness rather than according to his own understanding or desire; true that curators, critics, individual collectors, museum acquisition personnel, and even art historians come to his art with a definite idea what it should be about or look like, and seldom show interest when it fails to meet their presumptions; true that these culture brokers determine his chances of success as a professional artist working in the metropolis and their lack of interest invariably equates expurgation from the realm of the mainstream: but given all the foregoing, is it possible that Wilson could take the risk of professional frustration rather than acquiesce to the exoticist demands of the West? Is it possible that he could pursue the dictates of his taste and desires as an artist rather than seek to meet expectations that override and invalidate his creative and philosophical interests? Can he navigate the terrain that he must without accepting, reflecting, and perpetuating false myths that ultimately relegate him to subalternity? Can he ignore the demand to perform and face the challenge to resist, since to resist rather than exist is the condition of the postcolonial? Must he indeed play the Other?

To describe Wilson's predicament as a condition is to imply also that it is a complex. As Chinua Achebe rightly notes in *Home and Exile*, "The psychology of the dispossessed

can be truly frightening."[2] There is a level at which the determination to produce to expectation or play the Other, such as we find in Wilson's paintings, goes beyond professional pragmatism and becomes conviction, and an artist like Wilson begins to believe in the pretend identity he or she is compelled to assume in order to meet the expectations of an exoticizing gaze. Given that the original sensibility of the artist and that of his host culture are fundamentally opposite, in order for his art to fit Western expectations and satiate the demand for difference, the art must cease to represent his sensibility, that is to say, his normal thought processes, desires, and understanding of his role as an artist, and begin to represent the details of those projections. This requires that he make a mental shift to accommodate the other for at least the duration of the creative process, from conception to realization. For a professional, creative individual, this means that for a substantial portion of his time he must evacuate his mind to assume this state, given that the creative process requires more than a quick moment in the studio or in front of the canvas or paper. In other words, he must inhabit a state of conceit until such conceit becomes routine and begins to reshape the contours of his mind. The result is that his art ceases to be merely exoticized and becomes exotic, while he too becomes transformed into the object of his patrons' fantasies. He ceases to play a role and begins to live the role. He becomes the Other, mentally and practically.

The terror of Wilson's example is that he is not alone. His example merely illustrates how postcolonial culture in expatriation is shaped by desires and machinations outside of itself.

Give Mungo What He Wants

The practice of producing to the taste and specifications of colonialist desires is not peculiar to postcolonial artists working in expatriation under the pressures and demands of determinist patronage and cultural structures in the Western metropolis. In fact, its territory of prevalence is the postcolony itself, where tourism has transported the West and its desires and brought the same pressures to bear on the culture market.

At a conference in New York in 1995, Zairean scholar T. K. Biaya made a revelation that left quite a few people in the audience visibly shaken.[3] Among the group of art historians, anthropologists, art dealers, and African-art enthusiasts that gathered for the conference panel, most of them American and quite a few of them avid collectors of different forms of African art, including the contemporary, Biaya stated that the Zairean popular painter has two clients: the white client derisively referred to as Mungo, a new term in place of the older, more subservient colonial term Massa[4]; and the local client known as "our own." A painter approached by an African client would offer the client a choice between work that is made for "our own," that is, for African clients, and work that is made for the outsider, or Mungo, and such an offer comes with a choice of prices also. At the higher "Mungo price," the client could purchase work made in a particular style with a specific kind of imagery and narrative as well as a mannerism that comprises conceptual and technical devices intended to satisfy

the known desires of the Western clientele. At a lower price, for the same size of material and same medium, the African client has access to a greater variety of imagery and themes made without canonical constriction or false deference to the demands of Western taste.

Ironically, the work that the artist offers his African client is the work he makes at his own leisure, that is to say, at his own professional discretion, to his own taste, and in accordance with his own aesthetic and thematic inclinations. It is the work that contains and transmits him at his most genuine, and therefore bears that individual authenticity and intimacy that Kuspit refers to. It is work that the artists produce outside the demands, pressures, and expectations of others in the process of wrestling with their own selves and in the serenity or turbulence of their own solitude; that work that they produce when they have no need to be *serious.* It is in such work also that we find the truest moments of an artist's career and his or her most relevant contributions to culture. Which is why, for the Zairean popular painter, it is referred to as work made for *our own.*

For the Western collector of popular African painting, a genre that has been eagerly sought by Europeans and Americans for the past three decades, the journey is short-circuited. Because their intention is to find narratives and imagery that represent a specific construct and vision of postcolonial Africa—rife with crisis, corruption, and death—it is not long before the mission of discovery turns into one of complicity, with the client stipulating and specifying for artists what to produce or represent. In this problematic process, regional canons are established and mannerisms engendered in the different centers of postcolonial art production. Once artists identify the specifics of Western expectations and realize how profitable it is to perform as required, there is a silent resolve to produce to those specifications, to satiate those desires. One positive spin is to maintain, as Biaya does, that despite this propensity to create to the specifications of Western patronage, artists in the postcolony continue to produce a parallel form of art that adheres to local aesthetic and thematic ideals. The result of this parallel performance would be a culture with a masked face that is ready to take advantage of a narcissistic patron, and be taken advantage of as it engages in the duplicitous service of lending material form to colonialist projections while somehow retaining its integrity. One is compelled to speculate that behind the mask lurks a culture hidden from the ruinous touch of the outsider, a culture consciously nurtured beyond severe harm, in which case one could argue that postcoloniality, like coloniality, appears to manifest itself as a condition of duplicity, a condition of performative duality, a locale of the seemingly impossible.

It would be glorious, of course, if all things were so simple. In his subsequent essay, "Popular African Painting as Social Drama in the Western Media,"[5] Biaya confronts us with the infinite complexity of the postcolonial condition, and reminds us that postcolonial subversion of Western desire and the inevitable frustration that this generates for the West are indeed not the rule. Often impervious to the duplicity of the native, the West pursues its goals to conclusion, and is able to sustain and perpetuate its chosen narrative by the sheer intractability of its sense of infallibility and

proclivity for the insidious. It does happen that often the Zairean popular painter is recruited or commissioned by Western clients to play the role of "historian and producer of anthropological knowledge," as Biaya aptly puts it, and to illustrate Western constructs of a debased postcoloniality in a "social drama (that is) neither destined for nor consumed by the Zaireans."[6] The litter of paintings of prostitutes, compromised politicians, and social anarchy that proliferates collections and exhibitions of popular art from Zaire, Kenya, and indeed the rest of Africa is in large part a result of this deterministic patronage. Such paintings and the drama they illustrate serve to confirm ready-made myths of postcolonial rupture. In return, the native who collaborates in the production of this stage-managed, neo-ethnographic drama is rewarded with moderate success and acceptance in the West. By projecting its predetermined visions of the postcolony through native artists, the West also manages to transfer responsibility for these notions to the artists in what may best be described as a process of culture laundering. At any rate, with the reward system that Western patronage insinuates in favor of specific representations of postcolonial reality, direct commissions are no longer necessary to induce native proliferation of such representations. The ideas follow the money, and so does the politics. Ironically, the same visions induced by Western patronage are eventually misinterpreted by social scientists as representative of local convictions. In effect the West ultimately reaps what it sows, but the injury is on the postcolony, for not only does it develop a culture shaped by outside ideas, desires, and matching patronage, ultimately this culture comes to overwrite and displace it in the eyes of the West. Like the artist who progresses from being the object of exoticist projection to become truly exotic, the postcolony shifts from being the site of Western projections to reinvent itself in the image of those projections, at least in the eyes of the West. In the process of giving Mungo what he wants, the postcolony finds itself twice overwritten.

Night of First Ages

In Zaire the most prominent native hand in this politics of postcolonial enunciation is the painter Chéri Samba. As an artist Samba enjoyed considerable prominence early in his career. Samba is not only one of Africa's most widely known artists, at least in the West, he is also among the most readily exhibited and enthusiastically promoted. Discovered in the 1980s by French and Canadian culture brokers, he produces satirical paintings that are stylistically inspired by serial comics and use a combination of image and text to illustrate a certain account of life and politics in his country. Often acerbic in its dark humor, and hardly sparing of either the local elite or colonialist interlocutors, Samba's narrative of life in his country is nevertheless mediated by a transparent enthusiasm to satiate the inebriate desires of Western patrons for a cataclysmic narrative of the postcolonial condition.

Because Samba also attacks Western dealings in Africa in his paintings, some would argue that an artist who is unsparing of Western culture brokers and colonialist power players alike could not possibly be dismissed as a mere vehicle for dubious,

colonialist ideas. Yet looking closely through Samba's oeuvre, it becomes easily discernible that the pervading tenor of his narrative is consistent with popular Western narratives of postcoloniality, complete with all the rhetoric of debasement and rupture that pervades such narratives. The postcolonial society we find in Samba's paintings is a society without virtue, corrupt beyond salvation and destined to remain in its absurdities. This society we recognize as readily in the op-ed pages of the popular news media in the West as in the visions and predictions of the savants of Empire or the doomsday novels and travelogues of V. S. Naipul.

In the rare instances when Samba attempts to locate himself as a border figure between histories, with a history of colonial trespass on one hand and a history of indigenous impasse on the other, his favored illustrations of imperial misdeed are often simplistic and cliché. They show Europe carving up Africa or the World Bank discussing how to bleed the continent. However, such futile pokes, though potentially irritating, are largely amusing and add to the curio value of his paintings. They are to be laughed at and ultimately ignored because they are harmless, even charming, and therefore do not in any way discourage the keen interest of Western culture brokers to market and disseminate his more salacious critiques of the self. Sometimes his comic, self-mocking critique is executed from a remarkable authorial distance. At other times Samba appears in his own narratives while maintaining a haughty distance from which to pronounce on his subjects. He usually sits himself magisterially, pays detailed attention to his posture, and emphasizes his higher state through the size of his figure in relation to others. He is the cool dude who is head and shoulders above the rest. In either case, Samba's rhetoric appeals to Western patrons. His work is supremely exportable, and, as T. K. Biaya aptly puts it, it "speaks to and pleases the Mundele."[7]

Samba is the native who enjoys the role of authenticating and affirming Western rhetoric of postcolonial debasement. It is hardly surprising, therefore—uncanny, as it certainly is—that he should also play this role on celluloid. In a documentary film on Zairean painters predictably titled *Maîtres des Rues* (1989),[8] directed by Belgian documentary maker Dirk Dumon, Samba descends from a balcony and walks as if in triumphal entry through the streets of Kinshasa toward a market square. Biaya's reading of this scene is worth quoting at length:

> The artist descends towards the market, evoking the national television's image of Mobutu, the "Messie of Zaire," descending from the clouds. Ironically, it presents, fifty years later, the image of Tintin *[Tintin au Congo]* setting off for adventures in the Congo/Zaire. This young reporter, getting on board a train, finds himself on the departure track surrounded by a group of journalists and curious Belgians. Arriving in Zaire, he gets off the train amidst a crowd of jubilant "natives." The departure and arrival tracks serve as the "grand marché," and the image of the artist's deployment from the balcony to this public square—delivered by the camera—corresponds to the path of the boat. Just like Tintin (arriving) at his destination, Cheri Samba advances towards the discovery of a contemporary Zaire in crisis.[9]

Biaya's analogy is most apt indeed, for in the film Samba assumes the task of a post-colonial narrator, and while in this role distances himself from the rest of his society to become the voyeur whose duty it is to service the demand for subaltern images. He positions himself above his subjects and becomes the single, if dim, ray of light in the Heart of Darkness. In the film, Samba is shown as he majestically advances toward the marketplace where he is destined to deliver a final, devastating declaration on the worth and fate of his countrymen. He cuts through the masses and the detritus to reach this great theater of the absurd, the ultimate site of subaltern excess, the very end of the world and of civility, the *point nevralgique*. In the subaltern marketplace with its raucous cacophony, the ordinary westerner is seized with the most elemental fear of drowning in the disorder; he is panic-stricken by fear of death and interment in the belly of chaos. For Samba, master of the terrain or lord of the streets *(maîtres des rues),* however, the scene is one of heady excitement and spectacle as he calmly carves his way through the forest and debacle, illuminating the path as he passes through, around him hordes of admiring natives jubilant and ecstatic, held in trance. The post-colonial becomes the Massa, or, more accurately, the puppet in Massa's ventriloquist act, and while in that role he surveys the melee around him. He is Conrad's Marlowe and Tintin, the colonial master and adventurer, all transfigured and rolled into one. The film's running commentary summarizes the setting thus:

> Kinshasa, *un peuple se regarde, il sourit ou ricane dans le concert de bruit setachent pour qui veut entendre le murmure, le sarcasme, le cri.* (Kinshasa: a people watches itself, smiling or snickering in the debacle of noise where can be discerned, by those who care to hear, murmurs, sarcasm, cries.)[10]

The terrain that our postcolonial describes in this interesting documentary is familiar, with inarticulate natives and their subhuman babbling, "snickering in the debacle of noise" with their "murmurs, sarcasm, cries." The language is familiar and has the unmistakable ring of Belgian imperial condescension and spite, even as it projects itself as innocent and comic. Like Samba's carefully managed gestures and posturing in the documentary, the language reveals the imagination behind the documentary, which merely agrees with Samba's on some level but is not exactly identical to his. The bedlam the camera frames him in, crammed with "snickering" natives, the messianic "native-done-good" triumphal journey that the director takes Samba through, the references to the Zairian dictatorship contained in the documentary's iconography, all create a powerful semblance of verity, but they are just as stage-managed. The drama may appear quintessentially postcolonial, but it unmistakably comes straight out of the colonialist imaginary, the "Heart of Darkness." It is Conrad's "night of first ages."

Even so, Samba's role as an articulate, postcolonial artist whose willing complicity countersigns and fortifies this jaundiced representation of his postcoloniality is not to be ignored. It certainly reflects the strategy of giving Mungo what he wants and shows that the practice of postcolonial acquiescence to the desires and preconceptions of the West is not a mere imperative of postcolonial expatriation but a common malaise. As with William Wilson, it also shows that two things are at work: on one hand, the

pressures of Western desire applied through inducements and, on the other, willful postcolonial complicity that issues from a damaged psychology that readily identifies with the postcolonial as imagined by the West.

The Existential Other

Samba's performance in *Maîtres des Rues* as the native who relieves the West of the burden of history is not peculiar to art or visual culture. We find it in other areas of postcolonial culture, also—in literature, music, cinema, and theater. A common example is the postcolonial writer who revels in self-castigation and rifles his or her work with a preponderant, willfully constructed existential malaise that, in its hyperbolism and irrevocability, does more to conform to colonialist expectations of postcolonial reality rather than approximate that reality. In his seminal essay, "Africa and Her Writers," a work of exceptional insight and candor whose relevance still holds a quarter of a century after it was written, Chinua Achebe raised questions around this practice of self-immolation by revisiting the early work of Ghanaian novelist Ayi Kwei Armah, especially the classic, *The Beautyful Ones Are Not Yet Born*. In the novel, Armah uses an unnamed protagonist, a rail clerk simply referred to as The Man, to investigate and reflect upon the fate of an early postcolonial society in which bribery, corruption, and nepotism govern every affair and no one is spared, either as victim or accomplice. In *The Beautyful Ones,* the novelist portrays his society as the ultimate abyss in the Fall from Grace, a society so consumed in filth and corruption it has no hope or respite on Earth. Caught between the rot and the almost inexistent possibility of decency, The Man chooses the middle road of paralysis, neither yielding nor resisting, complacent and comatose. In this moribund and compromised society, the only route to salvation is debasement in penance. At the end of the novel, the author sends his protagonist, The Man, and Koomson, a tropic character who represents the epitome and congealment of the society's disgrace, through a manhole to save the latter's soul.

Armah's novel was one of the earliest to address the social and moral condition of the late colonial, immediate post-Independence African society, following Cyprian Ekwensi's *People of the City* and Chinua Achebe's *No Longer at Ease* and *A Man of the People,* all of which deal with the threat of corruption in the new societies. However, if Armah's novel has drawn criticism for its portrayal of postcolonial malaise, it is because it differs significantly in vision and purpose from Achebe's or Ekwensi's novels. In Achebe's *No Longer at Ease,* which is set in the twilight of British colonial rule in Nigeria, the protagonist, Obi Okonkwo, newly returned from England where he studied classics on a scholarship provided by his hometown, finds himself steadily drawn into the web of temptation that an emerging culture of corruption spread in the civil service. As a character points out early in the novel, this corruption is not limited to the natives; it obtains also among the white, colonial administrators. Obi returns from England with sharpened morals and a determination to steer clear of the debilitating pit of corruption that he found upon return, but in the end, he trips

and accepts a bribe of twenty pounds for which he is publicly tried and sentenced, his act bringing disgrace to himself and his town union. As the president of his town union put it, "It was a thing of shame for a man in the senior service to go to prison for twenty pounds."[11] Thanks to a series of traumatizing incidents in the weeks leading to Obi Okonkwo's act of shame, among them the death of his mother and the breakup of a long, romantic relationship, he suffers a surprising loss of focus on his determination not to be contaminated by the growing corruption, and though this transformation left him cynical about morals, judgment, and the prospect of disgrace, he recovers his sense of integrity as the judgment is read and he breaks down in tears, realizing how disappointing was his act. Also, heavily indebted and disgraced, he finds succor in his kin and town union who, though disappointed, nevertheless decide to rally round and provide support on the redeeming philosophical ground that even a disgraced son must count on the strength and support of his kin, who may then chastise him afterward. Obi Okonkwo falls to corruption and the enticements of a materialistic, modern society, but what remnant there is of his dignity is shored up by an intact communal moral of redeeming kinship.

In *A Man of the People*, Achebe returns to the corrupt new society, explored this time mostly through politics. One of the main characters, Chief, the Honorable M. A. Nanga, M.P., a postcolonial politician and federal minister, is thoroughly corrupt and pompous—typical of his class of emerging, postcolonial autocrats. His nemesis, however, is a former pupil turned rival, Odili, who retains the idealism of a sane, decent society and tries through politics to reinstate that ideal in place of Chief Nanga's. Odili fails but he is not alone. At the end of the novel, when it seems Chief Nanga and his corrupt ilk would prevail, a military coup takes place and they are toppled from power. Now, to those who are unfamiliar with the story of the novel itself, this would seem a convenient, romantic visionary resolution to the conflicts raised in it, except for the fact that as Heinemann's printers were binding copies of the novel, ready for publication, a group of visionary young army officers carried out a coup in Nigeria and successfully brought the corrupt First Republic to a bloody end. Achebe was wrongfully accused of prior knowledge of the coup.

There are clear differences between Achebe's and Armah's representations of the troubled postcolony. In Achebe's novels, especially *A Man of the People*, the author recognizes the threat of social malaise in the body politic of emerging nations, but is able also to accurately reflect what he has described in a different context as the "hidden corner" of light or hope in the face of a threatening avalanche of corruption. In both *No Longer at Ease* and *A Man of the People*, as indeed in Achebe's next novel, *Anthills of the Savannah*, written twenty years after *A Man of the People*, there is putrefaction and human failure aplenty, as there is in Armah's *The Beautyful Ones Are Not Yet Born*. However, Achebe's novels seem to argue, quite rightly, that no society is without prospect of redemption, now matter how slim the sliver of hope, whereas Armah's novel occludes any such possibility.

In its unremitting finality, Armah's verdict on early postcoloniality reflects a viewpoint expressed aptly by Mr. Green, a British character in Achebe's *No Longer at Ease,*

as the guilty verdict is passed on the novel's main protagonist, Obi Okonkwo, for accepting a bribe. Giving voice to colonialist cynicism and determinism, Mr. Green assures his mostly white audience at the Lagos Club that the root of Mr. Okonkwo's fall ought not to be a mystery at all because they are to be found in his genes as an African destined to corruption and failure like the rest of his kind. This irrevocably predestined condition he refers to as "facts." According to Mr. Green, "The African is corrupt through and through," and so because of the "fact that over countless centuries the African has been the victim of the worst climate in the world and of every imaginable disease. Hardly his fault. But he has been sapped mentally and physically. We have brought him Western education. But what use is it to him?"[12] While it might be a stretch to argue that Ayi Kwei Armah personally shares that Western view of the postcolonial condition, his representation of that condition in *The Beautyful Ones,* however, seems to lend it credence. In the novel, the society we are presented with is without a speck of active dissension from the prevalent malaise; it is without a patch of decency, or the slightest prospect of redemption. Instead, it reminds us in a harrowing way of the last days of the cities of Sodom and Gomorrah utterly immersed in filth and debauchery, when the Hebrew god throws his servant Lot a challenge to find four souls beyond reproach in the whole twin cities, and he would spare the population his avenging wrath. Like Lot in Sodom and Gomorrah, Armah searches through his Ghana in *The Beautyful Ones Are Not Yet Born* and finds not a single soul worthy of the bountiful mercy of the Lord, except, of course, the unnamed protagonist who is stoic in his moral paralysis, alone in a wilderness of rot but dumb and numb as well.

Also in the Achebe novels the author establishes the dialectic between preexisting conditions and the emergent social debasement in the postcolony, and so is able to outline a causal proposition other than genetic or cultural predisposition. In other words, the postcolonial in Achebe's novels is not naturally predisposed to corruption and failure; he is the product of a historical dynamic inasmuch as he is responsible, ultimately, for his role within this dynamic. Obi Okonkwo is not genetically disposed to bribery and neither is Chief Nanga, each being only a player in a larger sociohistorical atmosphere of transition from cohesive communal structures and norms to a modernity of alienation and diminished individual commitment to the collective. Even so, each one is ultimately responsible for the extent to which he is willing to succumb to this. There is room for subjective exertion to resist, navigate, or counteract this malaise, either through individual visionary effort or through communal evocation of residual mores. In Armah's novel, however, the validity of cause as well as possibilities of redemption are displaced by existential inertia. As the sea of filth and putrefaction swirls around, beneath, and above him, the novel's unnamed protagonist drifts with it in a complete paralysis of will, which suggests that agency is redundant in the face of a predestined condition. Even as the novel bristles with the author's anger against his society, as it wallows in the filth that he describes, one can nevertheless hear the voice of Achebe's Mr. Green saying, *Let us face facts; it is hardly their fault. These are Africans, impaired beyond repair.*

In the event, one is compelled to reexamine the devastating and unsparing moral

contempt behind Armah's critique and, even more so, his creation of a postcolony void of agency: a people doomed to failure without respite. Even as one recognizes the deep moral anguish in the narrative—for there is, after all, ample verity to the charge of corruption we see in Achebe's novels as well—one nevertheless must conclude that the denial of agency and the invention of a sterile existentiality that is at the heart of *The Beautyful Ones* is more performative than faithful to the reality of the postcolony. Rather than a considered contemplation of the society of its focus, Armah's novel of abjection was executed in a particular style and tone to meet the requirements of a genre, and as the author slashed at his society, he inevitably drew the attention of the West, which was quick to applaud. Because he presented himself—that is to say, his society—hopelessly muddied, as he is *expected* to be, and portrayed his society in that state that the West believes should be its logical fate, critical acclaim followed. *Had not everyone predicted, after all, that the natives would be no good on their own if independence were granted them, which is the reason it was ordained in the first place, that a mission be undertaken to rule and save them? And wasn't this evidence of the unfailing accuracy of those predictions!* The West could look at Armah's narrative of filth and feel vindicated in its false convictions. After all, *he is one of them and he most certainly knows and understands his own people.*

In subsequent novels, Armah would try to bring more complexity to his critiques of the postcolonial condition, even shift some of the historical blame as in *Two Thousand Seasons,* where he engages the silent history of Arab conquests in Africa. Yet nothing would equal or remedy the vitriolic self-mutilation in *The Beautyful Ones,* and, quite predictably, none of the subsequent novels would enjoy the same level of acceptance and critical acclaim in the West. There is another caste of postcolonial writer who delivers on Western expectations by serving as the native "spice hawker," vendor of the ancient, Arcadian wisdom and magic of the natives, who offers the "world" those refreshing insights only the native is endowed with: rhythm, spirituality, heady violence, and originary cadences of the night of first ages. This writer enjoys ready acceptance in the West because he or she provides a literature of Otherness that underlines and reinforces the detailed contortions of colonialist fantasies about Africa while relieving the West of the task and responsibility of mapping the native in *his* place. The writing is predictable: steamy with tropical uncertainty, even as it rocks and rolls with otherworldly listlessness. It is almost always crowded with otherwise dispensable characters for whom speech is an eternal chore of philosophizing, the lot being minor poets of sorts, and every setting is crammed full of expected scents, smells, moans and groans, and ample darkness. The sense of plot is often severely compromised as narratives mushroom and rigmarole and ramble out of control, as if to suggest that in the postcolony, life itself is a rambling narrative. With all these attributes in place, it is predictable also that the West should single out such writing for *capturing the essence* of its provenance. However, for those who are familiar with its setting, as Amitava Kumar points out with reference to contemporary Indian writing in English, it is often "obvious that the literary goods in question have been stamped 'For Export Only.'"[13]

In recent literature from Africa, these charges have been brought against the

Nigerian Ben Okri, perhaps Africa's most prominent novelist of the postcolonial generation. Okri has been faulted as an example of a writer whose work fits these parameters, spiced as it is with magic, fantasy, and the timely interjection of nuggets of ancient wisdom. Okri, it is argued, fulfills Western demand for difference by presenting societies irrevocably caught in a paradoxically romantic quicksand of destiny, in which he assumes the role perhaps not of V. S. Nightfall (as Derek Walcott describes the guru of this genre, the Trinidadian V. S. Naipul), but a kind of Salman Rushdie meets Deepak Chopra.

Okri has received tremendous praise and recognition for his writing, which is considered avant-garde in African literature, albeit inaccurately. In the *New York Times Book Review* in 1989, the critic Henry Louis Gates Jr. singles out Ben Okri for praise as representative of an emergent phase of experimentalism in African literature, a phase that is unprecedented. This view is, of course, wrong because, compared with earlier writers such as Amos Tutuola and Armah, the Sierra Leonian Syl Cheney-Coker,[14] or even Chinua Achebe in his use of vernacular or Naguib Mahfouz in his narrative schemes, Okri's writing is hardly spectacular beyond precedent. For Okri's generation, also, many would point to the late Dambudzo Marechera as a more daring experimentalist. The question then arises: How did he become the unassailable figurehead of the African literary avant-garde?

One explanation points to Okri's emergence as a purveyor of native insights, the literary sage and shaman from the Dark Continent. In *The Famished Road*, arguably his finest novel to date, Okri brings the world to us through the eyes and experiences of a spirit child in an enchanting medley of the surreal and the supernatural, so mellifluously woven as to leave us bewitched. In the story, time flows as endlessly as the novel's pages. Humans grow into trees and trees become birds and birds merge with the clouds and reemerge in rapture. Besides this Arcadian marvel, however, the rest is nothing but predictable: violence and rupture, violence so palpable and occasionally unnecessary it grates: a perfect Other story like nothing *we* in the West are exposed to! In other words, it is not inaccurate to categorize *The Famished Road* as a performance. In his mature writing Okri has consistently produced work that could be seen to play to the taste for Otherness, as well as provide the expected spiritualist foil to the West's postindustrial alienation, civility, and democratic orderliness. When it is not drowning in humidity or unrivalled, visceral violence, Okri's Africa teaches "rhythm to a world that has died of machines and cannons," and for this Okri is instantly unique and endearing.[15] His novels offer Otherness that is not only unmistakable but in character also, and for the West this Otherness, built as it is on the twin pillars of savage violence and Arcadian earth wisdom, overshadows whatever intricate or subtle other preoccupations the writer might be engaged in. In novel after novel, as well as in his essays and aphorisms, it appears that Okri has shown consistency in occupying the place of the irrevocable Other who peddles palatable difference, and his persistent performance has begun to rob his novels of integrity.

Much of the popular criticism leveled at Okri has come from his own country, Nigeria, but has been unwilling or unable to engage in the complexities of Okri's

condition as a postcolonial writer, especially one who lives and works in the Western metropolis where he must deal with the strictures and structures of a literary establishment and culture that requires Otherness of him. To dismiss Okri is to fail to acknowledge how this requirement and cultural proclivities, as well as institutional and market structures that produce and sustain it, inevitably impact postcolonial cultural production.

If the preceding examples point to a condition of postcolonial complicity and acquiescence, it is important to point out that even certain oppositional strategies of postcolonial response are just as condemned and overwritten by this insidious predicament. In literature, for instance, we find that much of the writing that was produced in Africa in the immediate postcolonial period or at the twilight of colonial rule is devoted to the reassessment and disavowal of colonial misrepresentations of the colonized. Because such misrepresentations were so tightly woven into the whole fabric of imperial narratives, as Edward Said demonstrated in *Imperialism,* they required no less than devoted and direct engagement to unseat, and the earliest postcolonial literature out of Africa—Achebe's *Things Fall Apart* and *Arrow of God,* Ngugi wa Thiong'o's *Weep Not Child, The River Between,* and *A Grain of Wheat,* Mongo Beti's *Mission to Kala* and *The Poor Christ of Bomba,* and much more, an entire genre, as a matter of fact—was consumed by this task. It appears, then, that postcoloniality is ensconced in an iterative back-and-forth with the West, in which the postcolonial is condemned to respond, actively or passively, in opposition or acquiescence, to the West and its machinations.

The Postcolonial Predicament

From the foregoing, it is clear that the postcolonial predicament is not one that allows for easy options. What is pertinent, however, is the extent to which outside expectations are invoked as paradigms of postcolonial cultural expression. Western insistence on a set vision of postcoloniality is nestled in an economy of meaning and praxis, a game of difference in which the postcolonial artist is precariously situated. By yielding to this economy of Otherness, postcolonial culture jeopardizes the possibility of constructing autonomous subjectivities. However disguised, playing the Other inevitably implies complicity in a subjugatory relationship. It fosters mythic identities and "realities" by converting difference into formula and promoting a culture that seeks its significance solely in quaint peculiarity. Not only does this define postcoloniality as lack, by extension it institutes a self-perpetuating charade that banishes the complex of postcolonial social and historical experiences to the fringes of validity and integrity.

1997

Double Dutch and the Culture Game

F OR THOSE WHO COME TO IT from backgrounds outside Europe (the "ethnics," "postcolonials," "minorities," all those who have ancestry, connections, or affiliations "elsewhere"), the arena of mainstream cultural practice in the West, at least in the visual arts, is a doubly predictable space—first, because it is a game space and you have to know the rules of the game, and second, because unlike any other game, such aspirants have a limited chance of success because it is predetermined they should fail. Though they may know the rules—and most who have the patience to understudy it do, bitterly so—the game is nevertheless inherently stacked against them because their presence, and worse still their success, causes a fault through an outwardly stolid wall of history that ought to bar them as serious contenders. Of course, the understanding is that they belong in a different space, should create work of a particular flavor, deal with a certain set of themes, exhibit in particular avenues in particular locations outside the mainstream, or be prepared to offer work of a particular nature to earn momentary mainstream acknowledgment, after which they are quietly returned to obscurity.

Predetermined spaces leave few options because the rules are set, and players in such spaces must engage them on the set terms, avoid or ignore them as viable spaces of practice, or seek ways to circumvent or subvert those terms with all the ramifications. With regard to artists in the Western metropolis whose backgrounds are "elsewhere," the rules of engagement are a straitjacket of history and expectations, which often leaves them with rather stark options: to take a fall with as much grace as the doomed can muster, or to self-exoticize and humor the establishment for a chance at that brief nod, or else fail the hard way. It would be inaccurate to imply that no such Outsiders have met with mainstream success, at least momentarily, and one can easily produce the short list for contemporary art, from the Pakistani Iqbal Geoffrey

in Britain in the 1960s to a smattering of young British artists who, at the turn of the century, have gained considerably visibility: Steve McQueen, Chris Ofili, Isaac Julien, and Yinka Shonibare, among others. These successes notwithstanding, since they are exceptions rather than the rule, the inevitable question remains: What does it take to break the code of this culture game and the cycle of predetermined obscurity and failure to which such artists are otherwise condemned? How do artists engage or circumvent the disabling rules of the game so as to prevail with integrity and a sense of self-fulfillment? What is the price of the ticket?

One might find answers in the success of painter and installation artist Yinka Shonibare, who made steady progress in the late 1990s in his contest for visibility within the mainstream British art world and who at the turn of the century continues to consolidate his place within that space. Shonibare first came to attention in the mid-1990s by devoting himself to a thorough understanding of the language of the metropolis, or, perhaps more accurately, the devices and strategies of its culture game, and especially the peculiar rules of the game with regard to the place and destiny of the postcolonial outsider. Paying rigorous attention to the critical debates of the day, especially postmodernism and its minority discourses, Shonibare understood that to break into the culture game he had but few cards, few choices, few avenues, or few guises, all of which inevitably required him to submit to a test of difference, and to pass that test.

In the heady days of the Thatcher years, when conservative nationalism held sway over British politics and culture and all counter-reason was consigned to the marginal corridors of protest politics, Tory minister Enoch Powell spoke of a certain test of difference: the cricket test, whose purpose was to prove the questionable loyalty of postcolonials to the British nation, and in essence the irrefutable difference that disqualified them from claims to Queen and country, by proffering evidence that their sporting loyalties lay not with Britain but elsewhere in the former colonies whence they came. On any given day, Powell maintained, the average West Indian (as British citizens from the Caribbean and their descendants are still known in England) would side with the West Indies cricket team against that of England. This was proof that they were irremediably different, and in a culture that dwelled on difference in loyalties, ideologies, language, class, and color of skin rather than the commonalities of history, the market, and football, this difference was sufficient to dislodge such groups from the grace and glory of Empire. In Powell's Britain, this difference in loyalties foreclosed the postcolonials from any form of belonging in the British nation.

However, as Shonibare would find, difference, or at least the guise of difference, does not always fit Powell's narrow definition, nor does it always have so definite a consequence as the venerable lord proposed. It does not always amount to worse neighborhood services for certain polities and groups, or their exclusion from British society, or worse still, expatriation from the kingdom. A culture that dwells on difference also distinguishes between forms and categories of difference because it operates on an economy of difference. It demarcates between what one might call tolerable difference and intolerable difference, between benign and profitable difference, as

it were, and dangerous Otherness. For such a culture, difference is tolerable when it satiates the society's appetite for amusement and entertainment, or even more especially when it serves that eternally crucial purpose of propping and sustaining the society's illusions of superiority and greatness. On the other hand, difference that confronts the society's narcissism with cynicism, or challenges its claims to primacy and grandeur, or threatens to deface or dislodge its symbols of uniqueness and perpetual relevance, the society will make every effort to expurgate, radically and surgically, from its body politic. In other words, difference that merely services the civic and pleasure industries, difference that provides labor for the utility systems and for cleaning city offices, sidewalks, and coaches on the public transit system, difference that appears to lend clarity to the futile logic of the center and its "elsewhere," even difference that by its presence lends credibility to the society's claims of equity and tolerance and offers proof, if it was needed, that the Empire has room and heart enough for difference, that there is a speck of black in the Union Jack after all, that the metropolis is, to use the parlance of the day, multicultural. Such difference is granted a place of indispensability in the translucent cartography of a culture of difference.

This requisite difference can also serve as fertile ground for the sharp, Outsider imagination intent on taking a chance and charting its course through the labyrinths, barricades, and minefields of the culture game. Over several centuries, generations of England's Outsiders have understood this, and understood it far better than the native himself, for, as James Baldwin pointed out about America, the other culture of difference—those who are displaced and threatened with effacement but who nevertheless are tolerated on the strength of the same arguments that are employed to displace them—understand best the illogic behind their condition. Because they are required to prove themselves otherwise worthy of the generosity of acceptance, and must endlessly be on their guard because of the treacherous nature of their condition, and must devote energy and time to unravel the curious psychology of their detractors in order to unravel the intriguing complexities of their common destiny with this detractor, they have the onus of sensitivity, criticality, and self-reflexivity because the burden of the cross is always upon them.

Only those who must engage in a constant battle to exist commit themselves to strategizing for their existence, and thus must dwell on, and in time understand, the ground rules of that engagement. In contrast, those who are privileged to take being and existence for granted have no need to understand either themselves or those others who are deprived such privilege. Because the Western metropolis has less need to question structures and patterns of existence that have served it so well, the burden of understanding does not fall on it, but on those who are served less well, which is why England's Outsiders excel in understanding the variegations of difference and its layers of ramifications, and especially in the knowledge that even the Quarantine of Difference to which they are condemned sometimes offers those who are intent on escaping it the very key for their escape. The door may be narrow and fraught with risks, for to defy or subvert the illogic of difference, often the Outsider must begin by exaggerating this difference. Often he must accept that difference exists, even where or

when it does not, and that this difference exists in the exact form that the host culture perceives it; in other words, he must play to the gallery of difference and take a fall. He must bear his cross in full light if he must be relieved of it, and may slip out only under the darkness of his own nakedness. Because the path is narrow and the ground treacherous, few are able ever to succeed at this game without becoming, in the end, nothing but that which they set out to escape, which is what they are meant to be in the first place and to remain ever after. The Outsider who must insert himself in the guarded spaces of the Western metropolis must do so only by playing the card of tolerable difference in the hope that it serves as a guise for his intentions and schemes rather than as the straitjacket that perpetually defines his being. Such is the price of the ticket.

While this conditionality is commonplace knowledge among outsider citizens of what remains of the Empire (as Britain still prefers to think of itself), Shonibare, though born in London of African parents, was nevertheless raised in Lagos, Nigeria, within a culture and among a people whose pride and self-confidence border on arrogance and whose understanding of citizenship and belonging run diametrical to that of the British. Later in life, this self-assuredness has served him well as he negotiates his place in contemporary British culture.

One may dwell a little on the significance of Shonibare's upbringing in Lagos, one of the world's liveliest metropolitan cities. In the 1970s, Lagos was the capital city of one of the wealthiest nations in the Third World, which, though it had just emerged from a bitter, thirty-month civil war, nevertheless commanded respect in the community of nations, thanks to its newfound oil wealth and its determination to turn this wealth into political mettle. Because the theater of Nigeria's civil war was far away in eastern Nigeria, Lagos was spared the ravages of war and moved quickly to recuperate from the momentary instability that was its only loss in the war. With the cessation of the civil war, the nation's military leaders regained the reigns of power, and the highly entrepreneurial former rebels in the east surged back into the city, which then threw its doors open to the world with the promise of stability, money, sophistication, and the charm of the new. Academics from all corners of the Third World, from India and Indonesia to Brazil and Guyana poured into the country, and so did construction engineers from Germany and oil experts from France and America, investors and merchants from Syria and Lebanon, immigrant workers in their millions from across the entire West African region, as well as Diaspora Africans keen to witness the rise of the miracle nation where a young army officer still in his thirties had crushed a rebellion and appeared determined to build Africa's greatest modern nation and restore the glory of his race. Lagos played host to leading artists and performers from around the globe, including country-and-western stars from America, the most prominent African American performers of the day, and an emerging crop of new pop headliners from different parts of the African continent. The movie theaters were flooded with Indian Bollywood romances and Asian and American kung fu action flicks, and every child knew his Jimmy Cliff lyrics and Bruce Lee kicks. Elsewhere around the country, a burgeoning popular culture was taking shape around a shared spirit of supreme confidence and optimism. The laid-back high-life music style that

headlined in the 1960s yielded momentarily to a new form of guitar-and-lyrics-driven funk and rock music before reinventing itself in an equally hard-driven, rock-influenced new high-life as bands proliferated from city to city and the youth reveled in their new freedom.

There was every reason to believe that a scheme was in place to transform Lagos into the capital city of the black world. New museums and cultural complexes went up, vast constructions that ran on a seemingly depthless oil purse appeared all over the city, vehicle assemblies around the country trucked in throngs of automobiles to claim the new highways. As if to prove its determination to turn it into a global city, Lagos hosted the first World Festival of Black Arts and Culture (FESTAC) in 1977, which attracted thousands of Africans and Africans in the Diaspora from hundreds of nations, including a political and cultural delegation from the United States led by the American ambassador to the United Nations, Andrew Young. As Nigeria's young military leaders put it, money was "no object" and exuberance was the order of the day.

Even so, Lagos was more than a mere, young Third World metropolis aspiring to world-city status. It was a city with a rich and complex history. The site of numerous political intrigues and face-offs between the natives and colonial authorities in the nineteenth century, and one of the richest benefactors from trade with Europe, including the slave trade, the city still had a centuries-old monarchy and numerous solidly established colonial institutions, from a whole island named for Queen Victoria to colonial grammar schools, government-reserved areas (GRAs), gentlemen's social clubs, and cricket and polo courts that sat in the middle of the bustling city like oases of tranquility. Politicians and expatriate oil executives milled around with street performers and hawkers of "Indian" charms, Yoruba and English mingled with every other West African tongue, bulletproof limousines shared the streets with tricycle rickshaws, Elton John and Dolly Parton records were as ubiquitous as those of Fela Kuti and Bongos Ikwue, and Amitabh Bachan and Bruce Lee were folk heroes among teenagers.

This was the city of Shonibare's youth, as of celebrated British writer Ben Okri, and a youth who grows up in this environment with access to popular culture from all over the world and a highly globalized consciousness without a sense of marginal self or questionable identity obviously develops a psyche quite different from the scheming and understated marginal postcolonial unconscious that Britain fashioned in its Outsider citizens. Moving from Lagos to London, therefore, was like moving from a free territory to a colony under cultural mandate, a city of pretenses where people know their places and live out their destinies under the powerful, ever watchful panopticon of the state.

Shonibare returned to London as a teenager, and upon return had to relearn the rules of belonging because he was no longer the black British boy who left; he was now the aristocratic youth from Lagos come back to reclaim his citizenship in a country where neither his aristocratic ancestry nor his birthright to citizenship translated to the privilege of acceptance. He spent his years in the British art academy resisting and defying the perpetual demand for difference, struggling to refuse and refute the

orthodoxies of his supposed peculiarity. Rather than produce art that represented or signified an "elsewhere," as he was required to, an art that would separate him from the rest of his contemporaries and lend credulity to distracting fictions of difference, he instead produced art that spoke to his affinities with the rest. In the early stages of his professional career in the late 1980s he might have moved too quickly to seek his place alongside his peers, to make his claim on nation and station. He failed.

No matter. Still possessed of that far more metropolitan consciousness that Lagos imbued him with, Shonibare produced early work as a professional artist in England that transcended the minuscule, navel-gazing preoccupation with the immediate that was the predilection of his peers. He made work that was not simply in line with the period obsessions, but spoke to issues and concerns beyond the miniature territory of *en vogue* British and contemporary European art, work that dealt with nuclear disasters in Eastern Europe, minority experiences in America, issues in the Third World, all of which was in character with his upbringing in that metropolitan "elsewhere." However, the formal idiom of his work was no different from that of his contemporaries, and in the culture game of the Western metropolis, this was not a winning strategy, as many other, highly talented British artists of like background have discovered. Three decades earlier, another young artist with origins in the colonies, the painter Frank Bowling, had dwelled on the same preoccupations and themes with the mind to exercise the same creative liberty to speak to all that speaks back to him as an artist, unfettered by constraints of period obsessions or institutional and cultural expectations, again perhaps too quickly. Eventually he came to the same realization that to aspire beyond those creative territories earmarked for the metropolis's Others without careful strategizing was to deal a losing hand in the culture game.

Raised in British Guiana, Bowling studied in the same graduating class as David Hockney at the Royal College of Art in London, where, he is convinced, he was deliberately passed up for the gold medal in 1962 (which went to Hockney) and was awarded the silver medal instead. Like the young Shonibare, Bowling in the 1960s had interests that also extended beyond the largely mundane preoccupations of his peers—Hockney's obsessions with Cliff Richard, for instance, or Ron Kitaj's formal experiments. Instead, his focus was on the great, historic events taking place in the colonies, the same events that inspired young radical intellectuals such as Frantz Fanon. Bowling was more interested in representing the collapse of Empire, the epochal confrontations between the French and the Algerians, the emergence of modern nations in Africa and Asia, the events in the Congo and the death of Lumumba, the revolutions in Latin America—although at the same time he was eager to marry these large and global concerns with the same formal experiments his peers were engaged in. As Bowling has stated, although his subject matter was Lumumba rather than Marilyn Monroe, and although some of his work was inspired by Chuck Berry and Little Richard rather than Cliff Richard, it was nevertheless important to him that his work be understood and recognized as pop art, just like Kitaj's or Hockney's or Andy Warhol's in America. However, since Bowling was the Outsider of his generation of British artists, the art establishment saw his work lacking in clarity because it did not

sufficiently emphasize his difference, thematically and formally. Safer and more exotic subjects such as Caribbean carnival scenes might have worked better in his favor, for then that would be different as well as tolerable. That his postcolonial, more global-ized consciousness led to Lumumba and the Congo was fine, but to make pop art like the rest or new expressionist work like Kitaj's, or color-field paintings as he did later in New York, was to attempt to obliterate the distance between him and the rest, and so a new category was created for his work—"expressionist figuration"—into which he was quarantined alongside a spent Francis Bacon and a handful of fellow Outsiders. Bowling lost the culture game and was eventually terminated as a contender in British contemporary art.

A generation after Bowling, another crop of young outsiders tried to break through the barricades of the British art establishment, among them Yoko Ono, David Medalla, and Rasheed Araeen. Ono was a pioneer of performance and sound art, Medalla was a pioneer of conceptual art, and Araeen, trained as an engineer, began with minimalism before venturing into performance art and situations in the early 1970s. Again, these artists tried to circumvent or prevail over the establishment by defying the rules of engagement and refusing to play the card of difference. Because their strategy was no different from Bowling's, and their formal idioms were avant-garde without signify-ing the distance of difference or acknowledging difference as conditionality, they too received only a nod from the art establishment before they were evacuated into the margins. It was not until recently that revisionist histories have tried to recuperate and acknowledge their contributions to contemporary art.

Shonibare's challenge, therefore, was to devise a strategy by which he could break the code of this historical relationship, and by so doing break the cycle of consignment to the margins. He had to find a way to pass the test of difference by engaging and outwitting it rather than confronting or defying it, and at the same time hope to break through the ranks and into the sacred space of acknowledgment without condemn-ing himself to irremediable self-immolation and caricature. This he did in 1994 with a group of paintings called *Double Dutch*. In the paintings Shonibare used stretched everyday fabric for his support, having bought the particular line of fabric from Brixton Market in South London. The paintings were presented as an installation, wall-bound against a pink background, and as individual pieces would eventually migrate to other formations and installations, such as *Deep Blue* in 1997. But the for-mal postmodern devices, the use of installation, or the conceptual status of the color pink as an empty signifier mattered not at all, whereas the loud "tropical" design of the support meant everything. A considerable amount of literature has been generated around Shonibare's choice of fabric for *Double Dutch* and the fact that the wax-print fabric on which the paintings are made is customarily machine-spun in Indonesia or other locations in the Far East, then patented and marketed by firms in England and the Netherlands, but is nevertheless historically identified as African because it is widely used across postcolonial Africa, especially in the former British colonies of West, East, and South Africa, where it is part of everyday apparel. And so for good reason, because the fabrics and *Double Dutch* attracted instant attention, especially

in England as galleries, museums, and curators embraced work and medium as direct references to Shonibare's "African identity." Finally, the artist had endorsed the fiction of his own Otherness, and in choosing an "African" signifier and idiom for his work, in coding his work with what appeared to be a transparent ethnicity, he had retracted his claim to a place at the center of the Western metropolis and restored the distance between himself as the Outsider and those who rightly belong in the center. Or so it seemed.

Shonibare's *Double Dutch,* understated and misunderstood as it is, must nevertheless stand as one of the most important works of cultural contestation in the late twentieth century because, far more than any other work in contemporary British art, it succeeded in outwitting and subverting the desires and machinations of the culture of difference that is at the heart of the global contemporary-art machine. Formally, *Double Dutch* is a pleasant and lively work, not at all extraordinary in this sense and lacking in any engaging iconography that can be gleaned from the surface of the support. Yet this formal ordinariness aside, rarely is a work so carefully assembled, every aspect so thoroughly worked out, every element of signification so meticulously articulated, every ramification so clearly calculated and anticipated. As mentioned, Shonibare found his "idiom of difference," the wax-print fabric, in Brixton, South London, which is known for its diverse demography but even more so as the capital of black Britain. Although numerous other black communities exist in London and such other British cities as Birmingham and Manchester, Brixton bears the added exoticism of a transposed tropical bazaar with its bold storefronts and hand-painted signs, its stocks of so-called ethnic foods and culinary accessories, its syncopations and cacophonies that remind the stranger of the complexities and allures of Babel, its costumes and apparels, its myriad skin hues and class complexities. Obviously Brixton registers the existence and presence of communities and sensibilities far more complex and alive than the black-and-white chiaroscuro of mainstream narratives, yet on the surface Brixton is the cliché of Otherness: reducible, classifiable, transparent, *différence par excellence.* Where better, then, to locate the marker of Shonibare's peculiarity than in this cardboard capital of difference? And how better to do so than to find this "African" fabric no other place but within the heart of metropolitan England itself, conceived, manufactured, marketed, and consumed without stepping across the border to any exotic ancestral homeland elsewhere? With his choice of the wax-print fabric Shonibare subtly but clearly pointed to the fact that the connection between this piece of British textile mercantilism and the Otherness that is ascribed to him is tenuous indeed. The signifier that would denote and inscribe his Otherness is, after all, entirely British and has little or nothing to do with Africa or Elsewhere.

Shonibare's choice of title for the work itself clearly indicated that he was engaged in a game, one he was confident he could win because he understood its intricacies and pitfalls. Again, in this regard, one may not find a more aptly, more carefully titled work in all of contemporary art. So far most critics have pointed only to the possibility that Shonibare's title, *Double Dutch,* must refer to the fact that a brand of the wax-print fabrics used in the paintings is known as Dutch wax. However, Shonibare's title

resonates with several, more significant meanings. In recent times the term has come to stand for the high-profile revival of a children's game of rope-skipping originally found among African Diaspora populations. The game double Dutch was taken to the New World from Africa and long remained a neighborhood or front-porch pastime. Today it features in international competitions. The rope-skipper stands between two people with a rope between them, sometimes two ropes, and as they repeatedly flip the rope above the skipper's head and down again with lightning speed, she skips from one foot to the other to allow the rope to pass underneath to complete an arc without getting caught by it. This is repeated several dozen times a minute, each arc completed in a split second while the player skips repeatedly between loops of the rope.

Rope-skipping is a gymnastic game in which nimbleness and agility of body, sight, and mind are requisite. The rope-skipper must not only be visually alert to the point where this becomes instinctive, her mind and body must also work with the lightning speed and rhythm of the rope if she must avoid a terrible fall. Often the rope-skipper faces only in the direction of one of the flippers, from whom she must read her cues, and only with the most acutely honed instincts can she contend with the flipper behind, whom she cannot see. Unlike most other games where players are matched, the rope-skipper, or double Dutch player, is caught in the middle of things, between the flippers as between the ropes, between the brisk circle of the arc, between standing, jumping, and, if not careful or agile, having a bad fall. She is like a chess player who faces two opponents at once, or better still, like the lone individual who must contend with the cyclical turns of history and the establishment in a culture of difference. She must know how to skip without stumble.

Less known to most people today, double Dutch also refers to a largely extinct language game much like pig latin, which was popular among boys at different periods and in different parts of the world throughout the twentieth century. In this language game, players applied a set of code combinations to encrypt their speech. In many cases the code involved the replacement of certain elements of syntax—all consonants in a word, for instance—with a whole word or prefix, such that the original words became not only incomprehensible to the noninitiate but almost unpronounceable also. In order to speak intelligibly in this idiolect, double Dutch speakers had to be agile, mentally and verbally, to be able to insert the right letters in all the right places with sufficient speed to form speech. They had to know, almost encyclopedically, where the requisite consonants or vowels occurred in the spelling of each word as they spoke, making this adolescent's pastime one of the most challenging language and mind games possible. Like rope-skipping, linguistic double Dutch was also a performative art, perhaps more cultic and rarefied, in which players had to be smooth with their elocution, carry themselves with the exclusive airs of a high-minded cult, and have flawless command of the diction of their esoteric circle.

As a metaphor, therefore, Shonibare's title was a sleight of hand, referring as it does to cultural acrobatics in which the players are masters of the game. In choosing his title, Shonibare indicated his readiness to engage the culture game of the Western metropolis and to bring to it the necessary mental and performative sophistication. He

would proffer a fiction of difference, like the devil's hand in a card game, and he would play with the nimble fingers and mind of a master card player, yet ultimately his winning card would not be from his sheaf of cards but from his opponent's. *Double Dutch.*

In the history of contemporary British culture, Shonibare is unique because, though he is not alone among Britain's Outsider citizens in submitting to the test of difference, he is nevertheless one of only a few artists who have engaged and passed this test by consciously offering a critical paradox of difference. Among his contemporaries a few other artists come to mind in the past decade or so who have also played the difference card, but did so by not only offering difference, but also insisting on the "fact" of such difference. Earlier we made mention of Chris Ofili, another British painter of African descent, who has gained even greater visibility than Shonibare within the British mainstream. In the mid-1990s Ofili quickly rose to fame by making dot paintings prodded on balls of elephant dung. Ofili's dot paintings, different as they were from his powerful early paintings, were largely inspired by exposure to contemporary Australian Aboriginal paintings, especially after the latter were shown in an exhibition of contemporary Aboriginal art called *Aratjara* at London's Royal Festival Hall. His use of elephant dung was also directly inspired by the work of American conceptual artist David Hammons, who had used elephant dung in his own work several years earlier, especially in his 1978 piece, *Elephant Dung Sculpture.* However, as part of his narrative of difference, Ofili attributed his source of inspiration to a brief trip to Zimbabwe, where, according to the legend, he witnessed elephant dung in use. In truth there are no traditions of use of elephant dung in Zimbabwe, but by making this fictitious, exotic connection to Africa, Ofili succeeded in establishing the distancing difference he needed to gain a safe place in contemporary British art.

The less careful reader might find Ofili's game of difference to be analogous to Shonibare's. Clearly both artists had outwitted the art establishment by playing to its exoticist desires. Both had employed false signifiers in the form of elements found within Europe itself, although Ofili further convinces his viewers by flying in his dung "from Africa." However, when more careful attention is paid to each artist's narratives of his practice, a significant distinction appears between the two. On one hand, Shonibare makes every effort to remind the viewer that the so-called African fabric he introduced to his work with *Double Dutch* is not, in fact, African at all, but a pretend marker of exotic distance that was conceived and manufactured outside Africa. As he has pointed out in *Yinka Shonibare: Dressing Down* (1998), "African fabric, exotica if you like, is a colonial construction. To the Western eye this excessive patterning (Difference) carries with it codes of African nationalism . . . a kind of modern African exoticism." On the other hand, Ofili makes a point of insisting on the authenticity of his trope, the elephant dung, by repetitively tying it to Africa, the land of animals where the people are believed to venerate animal dung, as the director of the Brooklyn Museum in New York argued in Ofili's defense in 1999 after the painter's work came under attack for profanity and bad taste. Might there be an element of irony or critique in elephant dung placed under paintings in the gallery space? The potential certainly exists, but Ofili undermines any such potential by insistently associat-

ing Africa with the dung, which is to say, with wildlife, savage practices (the venera-
tion of dung) and abjection to the point where his own complicit exoticism becomes
apparent. Born and raised in England with little or no experience of Africa, Ofili is
sufficiently detached to share in the conventional, European fantasies of the continent.
In his references one finds an easy willingness to participate in and perpetuate those
fantasies. While Shonibare's trope of difference is not only transparently fictitious but
also critical of the demand for difference, Ofili's insists on its authenticity in an exer-
cise of self-exoticization that merely reinforces that demand. Ofili lends credence to
the fiction of his Otherness even as he believes himself to outwit the establishment on
that account. His iteration of the narrative of difference becomes evidence of willful
self-immolation, which is the price of his ticket through the gates of the mainstream.

One might argue then that Shonibare's approach to the conditionalities of the
mainstream cultural space was one of active engagement through an idiom that bore
an element of critique, one of positive subterfuge where the intentions are so apparent
as to produce an effective ridicule of those conditionalities and the culture of differ-
ence. In contrast Ofili's approach, with its repetitive narrative and its underlying inse-
curities, can only be described as acquiescent in spite of itself because it does submit to
the demand for difference without an element of irony or critique. As Cuban curator
Gerardo Mosquera has aptly observed, "Self-exoticism reveals . . . the passivity of the
artist as complacent at all cost." Complacency here implies compliance with the rules
of the game, and not with the intent to subvert, expose, critique, or instruct, but with
the sole intent to earn notice.

To find a close parallel to Shonibare's masterful subterfuge in *Double Dutch,* one
might look elsewhere, to another era and another culture where difference was re-
quired of the Outsider citizen as a condition for acceptance. In 1927, the young Duke
Ellington received a contract to perform with his band at the celebrated, whites-only
revue in Harlem, New York: the Cotton Club. To sell the band, his manager, Irving
Mills, billed Ellington's music as a new form of exotic revelry called jungle music.
Under the guise of this label, however, Ellington, who, by the way, disapproved of
the label, was determined to prove to America that not only was the music far from
primitive or savage, he as its purveyor was in fact America's most sophisticated and
innovative composer of his time. It was while headlining his music at the Cotton Club
as jungle music that Ellington composed his first master opus, *Black and Tan Fantasy,*
a complex blues odyssey in which he paid tribute not to the all-white Cotton Club,
where people of color could play yet could not be served or entertained, but instead to
Harlem's mixed-race dance clubs known as Black and Tan, where all the complexity
of America could come together and manifest without forced distance or emphasis on
difference. Ellington, so-called king of jungle music according to the Cotton Club, never-
theless concluded his composition with a quotation from Frédéric Chopin's *Funeral
March,* which was to prove prophetic with regard to the fate of America at the end of
the 1920s. In composition after composition Ellington paid tribute to the complexity
of America and in turn critiqued the jaundice of hierarchizing categories of the races.
He strived to prove that his music was America's music, the chronicle and tablature

of America's experience and history, and not the music of "others" straight out of the jungle. Like Shonibare's "African fabric" nearly a century later, jungle music was his trope of difference, but with that trope he would consistently and articulately critique the culture of difference.

Having broken the code of the culture game, Shonibare subsequently transformed his fabric into a signature, a product identity, again manifesting his sophisticated understanding of the devices of success in the metropolitan culture industry. This signature he has freely applied to the interpretation of a broad gamut of themes, from his fascination for the figure of the style-conscious, smart, and conniving outsider of Victorian society, the dandy, which in itself is significant, to reinterpretations of classics of Victorian art, literature, and taste. Having earned the liberty to circulate and contemplate within the spaces of the mainstream, which is indeed unique liberty, Shonibare quickly moved on from the preoccupation with difference, a theme that, in fact, never had priority in his work, and has since ranged from visual essays on science fiction and space travel to contemplations of communal memory and in-between. To get to the depth of his subsequent work will require another essay. However, it was *Double Dutch*, the Outsider's token of difference, which made everything possible. In *Double Dutch*, his most important work to date, Yinka Shonibare broke through the displacing barricades of metropolitan exclusionism and became able to claim his place as a citizen by simply saying, "I am."

2001

Nation, History, Image

Nationalism, Modernity, Modernism

Reverse Appropriation as Nationalism

One interesting theater of nationalist struggle in Africa at the beginning of the twentieth century was the changing space of visual culture. More interesting still was the nature of this struggle, which resided not in a direct political confrontation between the colonized and the structures of colonial authority, or in the details of imagery and representation, but was written through a strategy of formal appropriation of the language and idioms of Western visual expression by the colonized.

In the second half of the nineteenth century, Christian missions began to establish schools in Africa. The missions needed interpreters and minor teachers, while growing colonial business concerns required cheap, semiskilled labor and law-enforcement cadres. This specific necessity determined the scope of the school curriculum. As A. D. Galloway observed, the "early mission schools [were] somewhat uninspired in their conception and excessively utilitarian in their concentration upon Reading, Writing, and Arithmetic (the Catechism being printed alongside the multiplication tables in their text books)."[1] In Nigeria, for instance, this was the case until the Reverend Birch Freeman's school timetable of 1848 departed slightly from the narrow scheme and included geography. Art education was not considered necessary or indeed useful in the scheme of colonial education. In his history of art education in Nigeria, Uche Okeke concludes that, with the colonial Christian mission, "cultural and creative education was not considered important for the converts."[2]

Beyond the functionalist logic of this argument lay a more fundamental principle at the heart of colonial policy, the goal of which was to perpetuate the fiction of difference between the European and the colonized upon which the colonial project was constructed. One crucial device toward this end was that colonial authority inserted and institutionalized a corridor of slippage that granted the colonial only partial

access to the possibility of transition and transformation, for it was feared that if the native should become like the European or prove to be of like endowment, that would undermine the fallacies upon which she was deemed inferior and deserving of colonization. This boundary of possibility, which Sir Edward Cust identified as the cornerstone of colonial policy, allowed the colonized only a mimic representation of imperial culture, enough to advance from the extremities of backwardness that colonial discourse ascribed to her to a station at the crossroads of barbary and civilization.[3] Behind this device, remarked Cust, lay a "fundamental principle . . . in our system of colonial policy, that of colonial dependence." For as long as the colonized was precluded from acquiring full mastery of European ways, for as long as a passage of difference was maintained and the colonized remained confined to a state of aspirant inferiority, colonial dependence could be guaranteed. To undermine this dependence was to endanger the project of Empire and risk the loss of colonies.

Early colonial education was conceived, therefore, to ensure this dependence by encouraging only specific skills for the service of Empire, and certainly not those that ascribed full humanity to the colonized by acknowledging the native's creative abilities. For Europe, the possession of an aesthetic sensibility was a crucial signifier of the civilized station, and the absence of this sensibility or of creative abilities on a par with that of Europeans constituted an unbridgeable gulf between savagery and culture. The purported absence of artistic ability among natives, like the absence of language, symbolized the inherent and irremediable lack that relegated the colonized in the hierarchy of the imperial text. Writing in the *Blackwood Advertiser* of January 1918, for instance, the colonial governor of the Gold Coast, Sir Hugh Clifford, deposited:

> The West African Negro has often been reproached with his failure to develop any high form of civilization. It has been pointed out *ad nauseam* that he has never sculptured a statue, painted a picture, produced a literature, or even invented a mechanical contrivance worthy of the name, all of which are perfectly true.[4]

This underprivileging fiction translated into a pedagogical principle that questioned the introduction of art into the colonial curriculum. As a certain George Fowler noted in the visitors' book of an artist in Lagos, Nigeria, in 1938, "Teaching an African the art of a white man is not only a waste of time but also a misplaced value."[5] In line with this conviction it was further argued that "rather than impose on them (Africans) what will end up being a torturing load, (i.e. art), they can be taught some aspects of European crafts which will be useful to various missions in the colony."[6]

This substitution of crafts for art on the curriculum was projected as an act of philanthropy when in truth it was part of a complex colonial strategy of iterative exercise of power over the colonized. However, at a meeting of the staff of Achimota College, Gold Coast, in March 1928, G. A. Stevens, a colonial functionary, strongly deplored this policy and argued for the recognition of the equal creative and mental capabilities of Africans, and the acknowledgment of their rich creative heritage, by introducing meaningful and nondiscriminatory art courses in schools in the colonies.[7] But in the general scheme of early colonial relations, such arguments could only be dismissed as

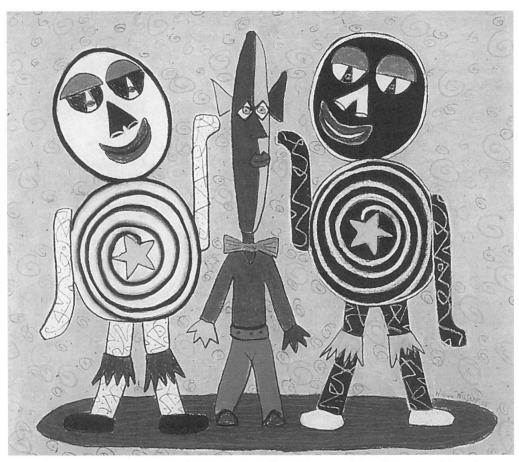

William Wilson, *Les Jumeaux*, 1993. Pastel on paper, 56 x 76 cm. Courtesy of Leroi Coubagy.

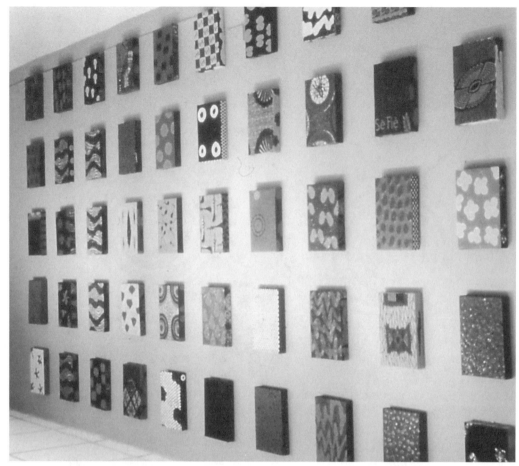

Yinka Shonibare, *Double Dutch*, 1994. Emulsion, acrylic on textiles, 50 panels. Overall size 332 x 588 cm (131 x 231½ inches). Courtesy of Stephen Friedman Gallery, London. Private collection, United States.

Yinka Shonibare, *Deep Blue,* 1997. Emulsion, acrylic on textiles, 25 panels. 250 x 250 cm (98 x 98 inches); each panel 30 x 30 x 5 cm (12 x 12 x 2 inches). Courtesy of Stephen Friedman Gallery, London. Collection of Worcester Art Museum, Massachusetts.

Yinka Shonibare, *Diary of a Victorian Dandy: 19.00 Hours,* 1998. C-type print, 122 x 183 cm (48 x 72 inches). Courtesy of Stephen Friedman Gallery, London. Commissioned by inIVA.

Uzo Egonu, *Boy with a Budgerigar,* 1963. Oil on canvas, 70 x 91 cm.
Courtesy of Hiltrud Egonu.

Uzo Egonu, *Northern Nigerian Landscape, "B,"* 1964. Oil on board, 107 x 178 cm. Courtesy of Hiltrud Egonu.

Uzo Egonu, *Portrait of a Guinea Girl,* 1962. Oil on canvas, 64 x 76 cm. Courtesy of Hiltrud Egonu.

Uzo Egonu, *Woman (Nude) Combing Her Hair*, 1964. Oil on canvas, 92 x 122 cm.
Courtesy of Hiltrud Egonu.

Uzo Egonu, *Battle,* 1966. Gouache on paper, 51 x 76 cm. Courtesy of Hiltrud Egonu.

Uzo Egonu, *Bombed House,* 1968. Oil on canvas, 56 x 76 cm. Courtesy of Hiltrud Egonu.

Uzo Egonu, *Stateless People: Musician,* 1981. Oil on canvas, 126 x 154 cm.
Courtesy of Hiltrud Egonu.

Jacob Lawrence, from the *Migration* series *(14. Among the social conditions that existed which was partly the cause of the migration was the social injustice done to the Negroes in the courts.)*, 1940–1941. Tempera on masonite, 30.4 x 45.7 cm. Courtesy of Museum of Modern Art, New York, and the Jacob and Gwendolyn Lawrence Foundation.

Jacob Lawrence, the *Migration* series, installation view, Museum of Modern Art, New York, 1944. Courtesy of Museum of Modern Art, New York, and the Jacob and Gwendolyn Lawrence Foundation.

Amir Nour, *Grazing at Shendi*, 1969. Stainless steel, 202 pieces, dimensions variable. Collection of the artist. Photograph by the artist.

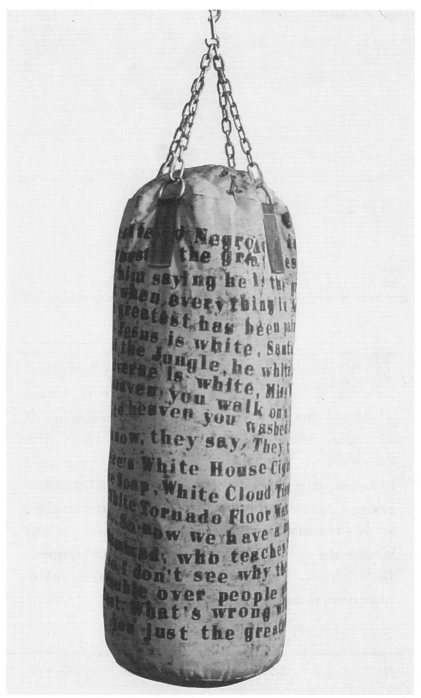

Byron Kim and Glenn Ligon, *Rumble, Young Man, Rumble*, 1993. Paint stick on canvas punching bag, 106.7 x 35.6 x 35.6 cm. Courtesy of Glenn Ligon.

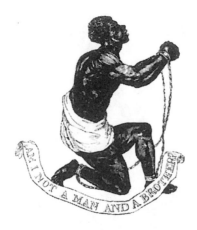

RAN AWAY, Glenn. Medium height, 5'8", male. Closely-cut hair, almost shaved. Mild looking, with oval shaped, black-rimmed glasses that are somewhat conservative. Thinly-striped black-and-white short-sleeved T-shirt, blue jeans. Silver watch and African-looking bracelet on arm. His face is somewhat wider on bottom near the jaw. Full-lipped. He's black. Very warm and sincere, mild-mannered and laughs often.

Glenn Ligon, *Runaways*, 1993. Excerpt from portfolio of ten lithographs, each 50.8 x 40.6 cm. Courtesy of Glenn Ligon.

dangerous and not at all mindful of what Edward Cust further described as "the folly of conferring such privileges on a condition of society that has no earthly claim to so exalted a position."[8] It is against this background that Africans began their contest for modernity at the turn of the twentieth century.

Contested Territories

In his essay "On National Culture," Frantz Fanon rightly notes that a "national culture under colonial domination is a contested culture whose destruction is sought in a systemic fashion."[9] Rey Chow has equally observed that "in many critical discourses, the image is implicitly the place where battles are fought and the strategies of resistance negotiated."[10] It is understandable, therefore, why visual culture and the productive ambiance of the image should constitute a crucial territory of contests between the empire and the colonized. While the colonial curriculum ignored art education and discouraged teaching art to the colonized so as to preclude the emergence of new forms affined to the European tradition, the Christian missions equally engaged in the deprecation and destruction of existing art traditions in the colonies. Art practice in traditional idioms was condemned as idolatry and violently combated, with tons of art objects seized and destroyed in bonfires. Converts were warned in damning language of the harsh and irrevocable consequences of either creating or keeping indigenous art forms.

The scheme to obliterate native claims to culture was carried out through the combined devices of textual erasure, material vandalism, and cultural protectionism. The deracination of material cultures in the colonies, on the one hand, and the prohibition of access to Western academic art on the other, provided perfect conditions for the manufacture of utilitarian craftsmen who had no confidence in the worth of their own art traditions and no access to imperial Enlightenment either. At the same time, it created only two possibilities of resistance, two possibilities for its own negation. One was to persist with the indigenous forms that colonialism condemned and sought to obliterate. The other was to hack—to use a most appropriate colloquialism—into the exclusive space of the antipode, in other words to possess the contested territory by mastering the forms and techniques of Western artistic expression to cross out or invalidate the ideological principles resident in its exclusivity.

To persist with traditional forms was to repudiate European insistence that these forms were heathen and that the cultures and worldviews that produced them were inferior. To retain them and remain faithful to the social and cultural institutions for which they were made, in spite of the demonization by the Europeans, was to consciously reject and defy that imposition, and this was considered an affront, especially by Christian missionaries who found it frustrating. In a sermon in Esa Oke, Western Nigeria, in 1935, the Reverend Glover, a Catholic apostate, cited African sculptures as a stumbling block for his mission in the colonies, describing them as "the wretched, irritating and grotesque woods . . . this annoying block . . . the shade that dims the light of faith that is already burning in the hearts of so many natives."[11] The "shade"

over Glover's light, however, was much more than the wooden sculptures; the shade was that the persistence of these objects and images constituted a blot on the progress report of the colonizing mission, and their perpetuation indicated determined resistance by the natives and symbolized the germ of fragmentation and dissolution in the body of the colonial project.

Equally, to take the opposite tack of appropriating and mastering the forbidden language and idioms of European visual expression was transgressive because it broached an even more desperately contested terrain that helped define the purported uniqueness of the white race: namely, the intellect and skill to make art. Since the colonial position was that only art produced in the European manner—that is to say, in the mimetic idiom according to classical and Enlightenment ideals—was art, and that only white people had the natural endowment to produce such art, it was particularly aggravating that the natives should aspire to prove this wrong by showing themselves equally capable of producing such art, for then it would no longer be valid to ascribe to Europeans the inherent and unique ability to make art or generate culture. They could no longer be argued to be superior by nature, and therefore entitled to bring enlightenment to others. To remain superior to the natives it was crucial that white people should retain this ennobling peculiarity and that a proven gulf of difference should remain in place, but if the natives should prove themselves equally capable in such rarified matters as art, then that gulf would disappear.

Between these two options, namely native adherence to tradition in defiance of European efforts to demonize and obliterate it, and native appropriation of European idioms, it is usual to see resistance in only the former and to discuss the latter within the frame of acquiescence, mimicry, and fracture. In fact, native acquisition of supposedly exclusive European skills and manners is seldom discussed as appropriation, which is an active, positive gesture, but instead as a desperate and helpless effort to escape a disparaged identity and instead *become* the white man, in which case, of course, it is deemed pathetic and futile. The notion of the mimic colonial has so far pervaded studies and theories of colonial and postcolonial culture with little criticism or challenge, but by dwelling on Fanon's summation of the colonial predicament or condition in the opening chapter of *Black Skin, White Masks,* it ignores and occludes the element of agency and conscious strategy in native appropriation of colonial gestures.[12] It was precisely this idea of agency, rather than acquiescent inferiority or mimic desires, that characterized the earliest modern African artists to usurp and domesticate the prohibited techniques of European art.

Nationalism and Modernity

The advent of a new artistic idiom akin to that of Europe in parts of Africa at the turn of the twentieth century was not intended to prove the equal competence of the colonized as an end in itself, but instead to undermine the ideological foundations of the colonial project and to overwrite, as it were, the colonial text. In West Africa the artist generally accepted as the earliest to draw and paint in the modern idiom began this

practice without formal training.[13] Aina Onabolu (1882–1963) most probably was not the first West African to practice painting and the graphic arts in the mimetic language of the Western tradition, but he is the earliest recorded in colonial West Africa to ignore the curricula restrictions of the colonial education system and begin a modern art practice by teaching himself. Onabolu began to draw as a schoolboy in Ijebu Ode, Western Nigeria, in the 1890s, copying out illustrations from European religious and business literature.[14] Though formally educated in a mission school, Onabolu received no art instruction in school because the curriculum offered only crafts and no art, nor was he encouraged in his artistic interests by his teachers.[15] Between 1900 and 1906 when he finished school and took up a job with the colonial marine department in Lagos, Onabolu worked on his own, improving his skills in draftsmanship and the use of watercolors. He channeled his earnings into obtaining materials from England, and applied his resources not only to art practice but also to teaching art.[16] At the time he was alone in the region in his peculiar fascination.

For Onabolu the canons and devices of mimesis, like the science of perspective for which he became widely known all over Lagos as "Mr. Perspective," were not the exclusive reserve of Europe but a universal artistic idiom that is the rightful heritage of all cultures. It is important to note here that mimetic and figurative realism were part of Onabolu's own artistic heritage as a Yoruba, in the form of the realist traditions of classical Ife court art. In pursuing mimetic realism, therefore, Onabolu was not merely mimicking Europe and could validly contest the exclusive ascription of that tendency to the genius of European Enlightenment. His choice of idiom, therefore, despite its immediate inspiration or sources, was in a way only a translation of this realist heritage, a reinstatement or continuity rather than mimicry.

In this pursuit Onabolu was actively discouraged and often subtly threatened by Europeans. Ola Oloidi observes that the colonial authorities failed to distinguish between the classical African forms, which they condemned as heathen, and Onabolu's modern work.[17] Oloidi further notes that this "can be considered a deliberate action, for the Missionaries, especially, did not want any artistic mode that could remind the Africans of the age-old traditional art which these missionaries rejected." Oloidi's explanation, of course, fails to equally observe that the contempt shown toward Onabolu's art was not extended to the very examples of European art that served as his primary models. In other words, while the colonial authorities disparaged and discouraged Onabolu's work, they did not show the same disapproval for the European forms that inspired his art, which clearly indicates that their disapproval was not for European or mimetic art, but for native involvement in the production of such art. This prejudice was predicated on a perceived conflict of authorial identities, a contest over authority. Clearly Onabolu's work, though produced in the same verisimilar idiom as much European art in the colonies at the time, was unacceptable for the simple but significant reason that they bore the authorial sign of a native. Rather than "remind the Africans of the age-old traditional art which these missionaries rejected," as Oloidi explains, Onabolu's work reminded the Europeans of the fallacy of their construction of the colonized as incompetent savages who were inherently incapable of making Art,

that is, art in the language and idioms of Europe. There was a native who was prov-
ing himself—and by extension his race—capable of making Art. Within this frame,
Onabolu's ability to draw like the European signified both civility and argument for
equality beyond dispute. That he could acquire this ability by himself through self-
tuition even further undermined the notion of the irremediably inferior native, and,
just as significantly, the possibility of a native acquiring this skill outside the regula-
tory structures of colonial authority represented a crack in the imperial scheme. It
signaled the possibility of native independence from Europe and foregrounded the
dangers that Cust identified when he warned that a colony "would not be a colony
for a single hour if she could maintain an independent station."[18] Thus the veiled
threat in this letter from J. Holloway of the Nigerian Railway, Lagos, to Onabolu in
October 1910:

> I am happy you yourself realize the danger of going your forefather's way . . . by creating
> the type of art that our church can quarrel with . . . I came back from Abeokuta a few
> days ago, and I must here bring to your knowledge what the Rev. in our church said.
> This Rev. gentleman strongly rebuked the congregation for their stubborn devotion
> to their idols which he regarded as heathen objects. They were considered ungrateful
> people who could not appreciate what God had done in their lives . . . Though you once
> said that your own art is special . . . I am not trying to discourage your type of art for
> the colony, but knowing your potential very well, you may have to think well about its
> acceptance in the colony.[19]

Reading the coda of contest in this stance, Onabolu became more determined to prove
that the arts of drawing and painting were not culture specific and could not, by their
very nature, manifest the superiority of one culture or people to another. He saw the
practice and propagation of the new artistic tendency not only as an opportunity to
emphasize its universality, but also as a chance to affirm the capabilities of his people,
to restate his equality with the European. By proving his mastery of the mimetic
tradition, Onabolu sought to challenge and negate colonialist illusions of supremacy.
His intentions were not to achieve validation in the eyes of the white man, as Fanon's
theory of the "anomalies of affect" suggests, but to invalidate Europe and the un-
proved and unfounded convictions upon which its civilizing mission in the colonies
was founded.[20] If the African could do equally well what Europe prides itself on pos-
sessing the sole ability to do, then the former cancels out the tropes of ascendancy and
puts Europe in its proper place.

Between 1900 and 1920 Onabolu made a consistent and relentless effort to per-
suade the colonial education department to introduce art in schools, but this was
met with little or no enthusiasm as was clear from correspondence between him and
the deputy director of the department in Lagos in 1919. On the advice of a few mis-
sion head teachers, Onabolu had written to the department to grant him permission
to teach art in a number of schools in the Lagos area. In his letter, he pointed out the
great advantages of introducing what he described as "the prestigious art of drawing
and painting," and referred to his already proven ability in it, enclosing commenda-

tions from highly placed figures in the colony. He also attached his curriculum vitae as well as the names of three referees. However, in his reply of April 3, 1919, the acting deputy director of education in the colony, L. Richards, regretted that he was not disposed to grant the permission sought, referring Onabolu back to the head teachers. He did, however, point out, with not a little touch of sarcasm, that it was doubtful that the head teachers would need Onabolu's services.[21] Onabolu did not despair. Instead he collected willing enthusiasts and began to give them private tuition. Eventually some of the head teachers engaged him, and at some point he was teaching in four schools around Lagos.

Over several years of distinguished practice Onabolu produced numerous drawings and portraits of Lagos elite, including colonial officials.[22] Among his portraits from this period is the 1906 watercolor *Portrait of Mrs. Spencer Savage,* which many consider a masterpiece of early modern African art. In 1920 Onabolu went to England to study art at St. John's Wood College, London. According to his son, Dapo Onabolu, his mission in England was to acquire "whatever he could of the sciences of painting, perspective, anatomy and the other specializations and ancillary disciplines which characterize European art education."[23] Since he had already proved himself competent in these skills before 1920, a more logical reason for Aina Onabolu's sojourn in Europe was to obtain a teaching diploma with which he stood a better chance of gaining entry into the colonial education system. It was his calculation that a teacher's qualifications would more easily gain him the official approval that he needed to introduce art into schools.

Onabolu's example represents a phase in cultural nationalism in Africa when the space of colonial education became a theater for the colonized to unravel the mystique of colonialism preparatory to its dislodgment. In his early novels Chinua Achebe details a narrative of differing strategies among the colonized that coalesce in the logic of confronting Europe on its own grounds by mastering it.[24] This has been qualified as anthropophagy, or the digestion of the West.[25] However, the mastery of Europe speaks to a tactic of overdub rather than one of cannibalism. The appropriation of the European mimetic tradition in painting and the graphic arts that Onabolu introduced was a significant part of a process of crossing out Europe's texts of exclusivity rather than merely imbibing forms and surfaces.

Quest for Modernity versus Colonialist Constructs of Authenticity

After his return from Europe in 1922, Onabolu eventually received official approval from the colonial administration to teach art in schools within Lagos and its environs. By 1926 the teaching load was understandably too heavy for one teacher, and Onabolu requested of the education department that another art teacher be appointed. Not having candidates in the colony, the administration brought in Kenneth C. Murray from England.[26] The young Murray had little art education and no experience in studio practice, but the colonial administration, still disturbed by the colonized ascent that Onabolu represented, felt more comfortable with the new British art teacher.

Murray was accorded "an almost exclusive recognition (and given) many powerful responsibilities (as) art teacher, traveling teacher, art supervisor, education officer, and, though unofficially, preserver of Nigerian antiquities, all duties performed almost at the same time."[27]

Murray's appearance signaled a new contest over modernity, a contest that was replicated eventually in other parts of Africa in an increasingly addled rhetoric of iteration. He admonished his students to ignore the formal concerns that Onabolu emphasized, and to occupy themselves only with portraying scenes from their rural lives as a means of preserving and perpetuating their own identities. He dismissed Onabolu's themes and methods as too steeped in the European tradition and taught his students to eschew what he considered alien to their natural sensibilities. Instead of life studies and keen understanding of anatomy, chiaroscuro, and the science of depth and perspective that Onabolu enjoined his students to acquire, Murray encouraged his own students to concentrate not on the acquisition of skills but on the subject matter of their daily life and environment. He encouraged them to produce romantic images of village life: men fetching firewood, women going to the stream, children sweeping the yard or climbing trees. Such images, he contended, though naive and lacking in technical finesse, were more authentic and representative of the natives than Onabolu's portraits, life drawings, and exercises in perspectival representation.

Murray's understanding of what should constitute an appropriate response to Europe by the colonized thus differed markedly from Onabolu's, as well as represented a tactical shift in the colonialist stance, one that was both political and generational. The European was moving from complete denial of colonial creativity to constructing, and preserving, an *authentic* native. Recognizing the certain futility of its original regulatory strategy, the colonial project seemed to have progressed from trying to efface or even erase the colonized and their claim to culture. Its new strategy, manifest in Murray's different approach to the creative abilities of the natives, seemed intent instead on producing what Fanon describes as the "palatable" Negro, the admired, authentic colonial who must be protected from the corrupting influence of civilization.

Murray dedicated himself to preserving his ideal of the cultures that he met. He failed to understand their predilection for transformation, and seemed to loathe their strategy of selective appropriation. This manifested in undue zealotry and colonialist fervor on his part—Murray was reputed to possess the energy and restlessness of five men[28]—and a pontifical conservationism. By checking the acquisition of the skills of observation and representation that Onabolu insisted on, Murray produced a strange, new form of naive art that had little to do with the classical traditions of his pupils' backgrounds or with the modern tendencies resulting from the appropriation and domestication of European principles.

During the same period, the discourse of authenticity that Murray's methods introduced was replicated in other parts of Africa, especially South Africa. In *The Neglected Tradition,* Steven Sack's study of South African art, he notes that a "kind of prescriptiveness, and a desire to keep the artist 'tribal' and untainted by outside

influence is reiterated time and time again."[29] Quoting Tim Couzens, Sack recalls the experience of John Mohl, one of the earliest black South African landscape painters:

> Mohl was once approached by a white admirer and advised not to concentrate on landscape painting, but to paint figures of his people in poverty and misery. Landscape, he was advised, had become a field where Europeans had advanced very far in perfecting its painting.[30]

Mohl's response brought the subtext of contested identities running through this narrative to the fore. He challenged the rhetoric of fixity and hierarchization, and the construction of the colonized as a lack by advancing a teleological argument that significantly prefigures the postcolonial articulation of difference. "But I am an African," Mohl replied, "and when God made Africa, He also created beautiful landscapes for Africans to admire and paint." Mohl recognized the attempt to relocate him within the frames of palatability, whereby the hegemonic position of the European is acknowledged and upheld. To defy such stipulative borders was to break free of this hegemony, and in Mohl's case landscape painting, remarkably, was the contested territory that he must possess to achieve this. Mohl verbalized his objectives in terms almost identical to Onabolu's:

> I wanted the world to realize that black people are human beings and that among them good workers can be found, good artists and in addition to that I wanted to lecture indirectly or directly to my people of the importance of this type of thing [modern art], which to them is just a thing.[31]

Though Mohl's rural and urban landscapes were in themselves hardly distinguished, they nevertheless spoke to a clear discourse of cultural defiance. By painting landscapes he effectively transgressed beyond the frame of imperial fiction and expectation of the native.

Gerard Bhengu, a contemporary of Mohl's and a particularly talented naturalist painter, could not match his evident talent with the skill that would be expected of a white artist of his endowment and creative dedication. Bhengu, according to Sack, "was denied the chance to acquire formal training."[32] Bhengu's story parallels those of many early artists in the postclassical manner in different parts of Africa. Though his work benefited considerably from the patronage of European benefactors, Bhengu was nevertheless considered unfit to possess the same skills as a European. The University of Natal rejected a recommendation that he be allowed access to formal training on the grounds that he should "work in his own way and develop his own technique."[33] Unlike Mohl, however, Bhengu was unable to move his practice beyond colonial acceptability, and although he commanded considerable respect till the 1960s, his work remained restricted to pastoral illustration. In contrast Gerard Sekoto, another South African artist who emerged during the same period, would not restrict himself to the stipulations and restrictions that thwarted Bhengu's aspirations. In 1947 he left South Africa for France in pursuit of his career goals.

Whereas Onabolu identified academicism as *the* visual signifier of colonialist identity, Sekoto identified expressionism as the proper space of contest for modernity in the 1940s. In his determination to occupy a place in modernity, he drew on post-impressionism and Fauvism, despite the disregard by white authorities and the lack of patronage. In some of his early work Sekoto referenced Vincent van Gogh, and Sekoto's undated *Girl with Orange,* probably from the same period, directly quotes Paul Gauguin. Although the extent of Sekoto's influence on art in South Africa is rather uncertain since he had chosen to spend the rest of his life in France, his private pursuit of modernist subjectivity represents an important contribution in the contestation for modernity in African art.[34] His *Self-Portrait* of 1943 stands as one of the most remarkable examples of early modern art in Africa.

Sekoto belonged to a generation of black South African artists that chose expatriation and relocation to the European centers of modernist practice as a way to not only escape the machinery of white supremacy at home, but also challenge and defy it. For a handful of artists of that generation, proving themselves in Europe was a more effective response to that dominance than trying to combat it from within its damaging reach.

Whereas African artists were considered only good enough for woodcrafts and media like clay, Sekoto and Mohl defied this limitation. Even when the range of allowed media extended to watercolors, the medium in which Bhengu did much of his work, Sekoto and Mohl dismissed that stereotype and worked in oils instead, just as Onabolu had in Nigeria. It is interesting that while watercolors were generally considered an amateur, drawing-room medium in Europe, it was the conceded medium in which the colonized in both West and South Africa were expected to work. Murray's students in Nigeria worked exclusively in craft or cheap watercolors and drawing media, and it was the same media that the authorities encouraged in art courses in South Africa.

The significance of artists like Onabolu, Mohl, and Sekoto in the construction of modernity in Africa is best understood when we compare their work with the art produced by several "workshops" and art centers that later sprouted all over the continent under the direction of European art teachers. In all cases the art was predictably naive and unaccomplished, which for the Europeans represented the limits of African ability to portray African reality. Only artists who understood the ideological underpinnings of such art actively contested those underpinnings, and produced work of an accomplished quality as part of Africa's aspirations for change through modernity.

To ensure the authenticity of the natives, the same aesthetic distinctions that were forced between black and white artists in South Africa were equally put in place in Rhodesia under Frank McEwen, a former fine-arts representative of the British Council in Paris in the 1950s. An acquaintance of the Cubist school and the critical establishment in Europe at the time, McEwen went to Rhodesia in 1954 on the advice of the art historian Herbert Read.[35] Like Kenneth Murray in Nigeria, having helped found the National Gallery of Rhodesia, McEwen became its director in 1955 and the next year instituted an "informal gallery workshop" for museum staff and visitors.[36]

The products of this "informal" workshop he began to push vigorously through powerful, highly placed friends in the art world. Soon an international clientele developed under McEwen's fostering, and he was able to move the workshop outside the gallery. This was the beginning of contemporary "Shona" or Zimbabwe stone sculpture.

One account of this significant episode is revealing. According to Michael Shepherd, it was after McEwen had listened to folktales by Shona laborers at the site of the gallery in Salisbury that he "infiltrated potential artists into the security and curatorial staff . . . (and gave) them crayons and paint."[37] Shepherd records that afterward, "the urge to carve and sculpt—long forgotten in Zimbabwe and virtually without surviving traces—emerged again *spontaneously,* without his (McEwen's) planning it."[38] This narrative of colonial "spontaneity" nevertheless fails to explain how McEwen's rogue curators and security men came to entirely occupy their new sculptural tradition with the same folktales they related to McEwen, all without the latter's intervention. McEwen was even more revealing when he declared in 1968, "Once again in the history of art, an umbrella of protection has allowed dormant genius to revive."[39] But of greater importance to us is McEwen's obsession with "purity and authenticity" in the tradition he fostered, and his exaltation of "untutored craftsmanship" in "an unspoilt people."[40] McEwen's mission in Rhodesia was to produce the new noble savage quite popular in Parisian thought of the period, the Surrealist reconstruction of the innocent native, the savage savior of the world. The product of this reconstruction was a fetish, an object of European fantasy and containment. Before he left Paris McEwen was already convinced that "a new wave of 'Trivialism' was overtaking the world center of creative art."[41] He had come to the conclusion that if "some vital new art exists or is about to exist . . . it may occur elsewhere, in a different walk of life with a different raison d'etre: prompted by a new environment."[42] It was this environment and this new art that he reified in Rhodesia. Having constructed his "unspoilt" native, McEwen proceeded to fetishize it, and would spend the rest of his life defending its "authenticity" and struggling to provide it with an "umbrella of protection."

In the 1960s McEwen's experiment was repeated by the young British artist Georgina Betts in Oshogbo, Nigeria, where, beginning in 1964, she and her German partner, Ulli Beier, ran four-week workshops that drew participants from a traveling theater in the little Yoruba town. As the claim goes, the previously untrained participants were instantly transformed into competent, professional artists by the workshops.[43] Writing about the experiments, Beier noted that the most significant thing about the "shortcut" artists from the workshops was that they "worked in a kind of euphoria. They did not have any conception of what an 'artist' was and they did not agonize about the meaning of 'art.'"[44] Though Beier maintained that the relationship between Betts and her students was one of "mutual trust (and) not authority," he nevertheless admitted that she exercised discretion in "spotting and pinpointing each artist's very own personal vision."[45] We find the same process of hegemonic replication, as was evident in McEwen's workshop, played out in both the conceptualization of the Oshogbo experiment and the language and methods of its affirming narrative.

The McEwen workshop echoed Murray's methods in constructing the "untutored"

as the "authentic" colonized. The reiteration of this fiction of colonial discourse provided a matrix of relevance for its fragmentation, for the continual disruption of colonialism's constructed identities. In several parts of Africa similar workshops and centers sprang up where Europeans fostered their ideals of the "authentic" natives, and vigorously marketed whatever art these creatures produced. In many such centers or their fringes, tendencies emerged that represented an adoption of a mercantilist strategy that split the fiction of identities and authenticities. This had little nationalist pretension. It was within the context of crossing out the manufactured identities mentioned earlier that a nationalist discourse sited itself, and it was there that the work of Onabolu, Mohl, and Sekoto assumed their nationalist significance.

A New Nationalism

Of the pioneer South African modernists, one deserves mention for representing a different strategy to those of Onabolu, Mohl, and Sekoto. The new strategy, evident in the work of Ernest Mancoba from the mid-1930s, involved a redefinition of African modernism by electing classical African art as its model. It displaced the iconography of the European Enlightenment and chose African sculpture and forms as the source of inspiration, the point of departure and yet the frame of reference. Its goal was to develop a new aesthetic appropriate for a new phase of modernity. Conceptually, this new aesthetic also would explore the confluence of European and African modernisms by writing African art as the common frame and subtext of all modernisms. Rather than quote premodernist Western principles, as did Onabolu and Mohl, or Western modernism as did Sekoto, Mancoba referenced African sculpture on the specifically modernist principle of formalist articulation.

Ernest Mancoba received early instruction in wood sculpture, and, although he eventually studied at the University of Fort Hare and the University of South Africa in the 1930s, received no further formal art training beyond this early introduction. Eventually he left South Africa and was later associated with the COBRA group in Europe. Mancoba, like most African artists in South Africa of the period, began by producing ecclesiastical pieces in wood, commissioned by the Christian missions. About 1936, however, a noticeable change occurred in his sculpture. According to Steven Sack, Mancoba "turned away from ecclesiastical and European sources in exchange for a keener interest in the sculptural tradition of Africa."[46] Sack quotes a contemporary newspaper report on Mancoba's development:

> Recently he came upon a book of primitive African sculpture. He was deeply stirred. . . .
> He was fascinated by the "pattern within the pattern," and the way in which the carvings nonetheless remained wholes.[47]

Mancoba's *Musician* of 1936 abandoned the pseudorealist finish of his earlier pieces, and of Makoanyane, Bhengu, and the others, for the planar surface of sculpture from the Congo Basin. In *Musician* he sought the peculiar dialect of the adze, phrasing his form in a staccato of cuts and geometric elements, a syncopation of surfaces. Instead of

academic realism he chose stylization, and thus was able to achieve the same strength and affective presence that European modernism sought in African art.

Yet Mancoba was not a traditionalist. His approach to African sculpture was not one of iteration or even direct quotation. Instead he employed the rhetoric of allusion. And other than the tactic of reaction that the colonial regulation of the contest for modernity dictated, Mancoba identified a different site of practice outside the boundaries of colonialist intervention. Conceptually, if not formally, his new aesthetic seemed to parallel the Negritude aesthetic, then in its formative stages among African intellectuals and artists in France. At the center of both was the relocation of colonial desire from the exclusivist and supremacist sites of Enlightenment aesthetics to the territory of African forms and paradigms. Negritude, of course, ultimately failed to extricate itself entirely from the enclosures of European contemporary thought and form. But the new aesthetic that Mancoba introduced existed outside those boundaries.

Mancoba's rejection of stipulated or preferred frames began a process of colonial self-redefinition that would take nearly three decades to fully realize. It prefigured an important turn in nationalist cultural response to colonial regulation in Nigeria in the late 1950s. By this period a group of young Nigerian artists began to question the praxis of reverse appropriation outlined by Onabolu, and to reassess strategies of response to colonialist hegemony. The artists felt that it was no longer of paramount importance to disprove colonialist superiority, other historical events having offered the colonized opportunities to do so effectively. The period of rigorous contestations over modernity was gone, and the imperative of nationalism, whether political or cultural, no longer was to engage in a contest for sites with colonialism, but to dislodge it.

Onabolu and his contemporaries pursued a strategy of humanist universalism. In contrast, the new generation of artists initiated one of mapped difference and set about defining and inscribing that difference. It was for this purpose in 1958 that the Zaria Art Society was formed by a little group of students at the College of Arts, Science, and Technology, Zaria—namely to rethink colonial attitude to European forms and devise a new aesthetic akin to Mancoba's that would shift the nationalist imperative from reverse appropriation of European principles, which was the condition for modernity, to the translation and foregrounding of native forms, the development of new national cultures, and ultimately a new modernism.

1995

"Footprints of a Mountaineer": Uzo Egonu and Black Redefinition of Modernism

N O TWENTIETH-CENTURY ARTIST can lay greater claim to representing a particularly significant yet hardly acknowledged constituency in the history of modernism in the West—namely, the nonwhite, nonformalist, and conceptually engaged theaters of modernist practice—than the painter and printmaker Uzo Egonu, who died in London in 1996 after living and working in England for fifty-one years. Though only one of a stellar cast of hugely talented, most accomplished, and inimitably sophisticated artists of non-European descent who made their mark in the West in the 1960s and 1970s, Uzo Egonu was the first of these artists to move there with the sole aim of becoming an artist.[1]

In his wake, important figures like Francis Newton Souza from Goa, Frank Bowling and Aubrey Williams from Guyana, and much later Avinash Chandra from India, Iqbal Geoffrey from Pakistan, and David Medalla from the Philippines would come to England[2] and establish themselves as artists and active participants in the making of late modernism as well as the beginnings of what would eventually be known as postmodernism.[3]

Background to a New Modernism

In 1945, as World War II drew to an end, Uzo Egonu left Nigeria for England. He was thirteen years old. The practice of sending children abroad to acquire knowledge and grounding in the ways of Empire and its people was increasingly popular among a new indigenous elite in the colonies at the time. From India, colonial Africa, and other parts of the European imperial realm, young men and women traveled to the center of Empire to study and prepare for leadership roles in their own countries. This practice proved particularly fatal for Europe, as many of the arrivals used the opportunity to

ready themselves for the most concerted challenge to colonial rule in history, a challenge that would in less than two decades bring about the collapse of the European colonial project.

Writing about the Guinean independence movement leader Amilcar Cabral, who also arrived in Lisbon in 1945 to study at the Higher Institute of Agronomy and eventually dealt a decisive blow to Portugal's colonial mission in Africa, Mario de Andrade describes the immediate postwar period in Europe as "the great era of the affirmation of differences, of cultural reclaim, of the defiance of those who, after admittance to the privileged enclosure of the alma mater of the dominant world, called it in question and thus opened the way to the challenge of that very world."[4]

In England, the challenge against imperialism took form under the leadership of George Padmore, and not long before the young Egonu arrived in England, the famous 1945 Pan-African Congress was held in Manchester. In attendance were two of the most influential figures in the collapse of British colonialism, Gold Coast politician Kwame Nkrumah and the future leader of independent Kenya, anthropologist Jomo Kenyatta. Two years hence, in 1947, Nkrumah returned to West Africa to begin what C. L. R. James described as "preparations for the revolution that was to initiate a new Africa."[5] In ten years, Nkrumah forced the most significant crack in the British Empire since its loss of India, one that eventually led to the loss of its colonies in Africa.

Egonu might be considered too young to have found much significance in these developments upon arrival. However, by his late teens, when he moved to London from Norwich to enroll at the Camberwell School of Arts and Crafts, he was ready to identify with a generation of what Andrade called "sensitive Africans," a new wave of young immigrants, mostly students, for whom the atmosphere of determined and organized global opposition to imperialism now served as a bedrock of pride and self-discovery. By 1949, the example of India and Nkrumah's persistent successes with the anticolonial struggle in the Gold Coast introduced a new feeling of empowerment to colonial subjects in the metropolis and engendered in them a new attitude toward the empire and themselves. They would no longer define themselves in the role of passive victimhood, but instead recognize their own active agency in the making of history.

Egonu described the period as one of great excitement and anticipation, during which he spent considerable time at the offices of the West African Students Union close to his student accommodation in Camden Town. The Union "was the place to read newspapers and get news from home, to engage in long discussions about the times . . . and generally feel at home."[6] As I have observed elsewhere, this association with the anticolonial struggle was crucial to the process of cultural self-definition for the young artist[7] and to his relationship with artistic practices in Europe. It was also to influence his attitude toward the Western canon and its negation through modernism.

Whereas earlier modern artists in Africa had affirmed European neoclassicism and Renaissance aesthetics as a way of validating their claim to universality and civility,[8] the political and cultural atmosphere under which Egonu emerged as an artist was different. It became unnecessary to employ such strategies of validation, demanding instead that the Western canon be brought to question, along with the

equally problematic canon of formalist modernism, especially as it was beginning to be defined in America.[9]

In addition to the political opposition that Nkrumah and the rest represented, the era was characterized by a new cultural awareness among the colonized articulated by the leaders of what came to be known as the Negritude movement. Aimé Césaire's uncompromising celebration of the Negro essence in *Cahier d'un Retour au Pays Natal* appeared in Paris in 1939. In 1945 Léopold Sédar Senghor published his collection of youthful poems *Chants d'Ombre,* quickly followed by *Hosties Noires* in 1948 and *Chants pour Naëtt* in 1950. Over the next decade and a half Senghor would follow these with a number of key essays and cultural interventions that defined a politics of cultural self-articulation, establishing considerable influence on expatriate Africans as well as the European modernist movement.

In *Cahier d'un Retour,* a formidable work of free verse, Césaire confronted the tradition by which Africans are disparaged or discountenanced as a race, playing between irony and validation and recasting aspects of that tradition in a positive and affirmative manner. The Negro may not be an inventor, he argued, but the Negro certainly has contributed, and continues to contribute, to global culture and human civilization. In *Cahier,* Césaire placed the Negro opposite the European, as humanity's source of spiritual rejuvenation, poetic and cultural knowledge, and wisdom. Africa, he elaborated, was the answer to the self-destructive proclivities of industrial Europe, the inevitable opposite of Europe's cultural aridity. In an interesting venture that would become and remain influential for the rest of the century, Césaire conceded science and technology to Europe while claiming dance, poetry, and rhythm for Africa, thus arriving at a balance he believed to be a reasonable and acceptable representation of the nature of things.

In *Chants d'Ombre,* Senghor reiterated this dichotomy as an act of affirmation, to inspire cultural pride and a love of the self in the Negro. As V. Y. Mudimbe points out, the original and overriding intent of these acts of affirmation and the movement that arose from them was cultural rather than explicitly political, complimentary to the anticolonial struggle of the period.[10] They would find precise articulation beyond the cultural and take on a political edge with Jean-Paul Sartre's intervention in 1948. In the essay "Black Orpheus," his introduction to Senghor's anthology of Negro poetry, Sartre defined the movement for the affirmation of Negroness, or Negritude as Césaire had christened it in 1939, as an anticolonial affront, a political gesture.

Another significant moment of articulation for Negritude was the founding of the journal *Presence Africaine* by Alioune Diop in Paris in 1947. Diop's journal provided an open forum for an intellectual and philosophical discourse, and the construction of Africanness in a climate of self-redefinition. Through their poetry, Césaire and Senghor gave formal expression to these nascent ideas of the cultural self, although they continued to draw heavily from European canons and traditions.

The effect, especially on young Africans in the metropolises of Empire, was re-markable. Negritude and its proponents indicated possibilities for the formulation of a cultural sensibility that was at once inspiring and liberating, ambiguous and eventu-

ally questionable though it was. Its greatest attraction and resonance lay perhaps in its origins in the centers and discourses of Europe itself, while it employed nostalgia as a thematic pivot.

Over the next decade, Senghor produced a string of essays that attempted to explicate and situate an African sensibility of otherness. Remarkably, this did not preclude or contradict his advocacy of significant elements of the Western tradition, such as his exhortation of French civilization, his promotion of European classics, or his adoption of Marxism.[11] Speaking to this years later in his contribution to debates at the first International Congress of Black Writers at the Sorbonne in 1956, Senghor pointed to the Cartesian sources of Francophone thought, including Negritude, noting that "much of the reasoning of French Africans derives from Descartes . . . [and that all] the great civilizations are civilizations that resulted from interbreeding, objectively speaking."[12]

Césaire's poetry, however, indicated a less compromising disposition toward Europe, even though politically he maintained a more conciliatory posture toward France, one that was in line with his country, Martinique, and its unique relationship with it. This marriage of cultural opposition and political pragmatism led both Senghor and Césaire and many other leading figures of Negritude into an ambiguous relationship with the European left. Through the relationship, however, they were able to exert a significant influence on some of the emergent forms and discourses of modernism. André Breton acknowledged this in his "Speech to Young Haitian Poets" in 1945, when he said, "The greatest impulses towards new paths for surrealism have been furnished by . . . my greatest friends of colour—Aimé Césaire in poetry and Wilfredo Lam in painting."[13] The alliance also encouraged the anticolonialist tendencies within the modernist movement.[14]

Negritude and Modernism

Through the interventions of the Negritude artists, an aesthetic emerged that, in spite of its political vagueness, constituted a decisive moment in modernist history; an appropriate entry into the history of black agency in European cultural history. It encouraged a decided look toward African culture. At the same time, it was positively disposed to select trajectories and elements from Western intellectual and cultural canons, just as it proffered cultural romanticism alongside political realism.

It can therefore be argued that the ultimate marker of black modernist expression in Europe may not be sought in the adoption of "Western," or conventional, formalist strategies by artists, but in the insertion of a decidedly black cultural agenda and the fabrication of an ambivalent rhetoric of difference and visibility. Negritude made black cultural nationalism an integral aspect of European modernism. It inscribed difference as a reconcilable and essential part of the avant-garde.

It may also be argued that this strategic plank of cultural difference worked hand in hand with the intensification of the anticolonial struggle. Its gains generated an atmosphere of creative and political excitement. Together they inspired a spirit of

nascent greatness and pride in black Europe. The milieu thus shaped and furnished young artists like Egonu, Andrade's "sensitive Africans," with a point of entry and an exploratory platform within the parameters of modernism. The participation of colonial expatriates—especially the Negritude writers—as key players in European modernism reaffirmed the movement's history as a project beyond form, a cultural and political sensibility built on dedicated social activism.

There is an emergent inclination to locate black modernist artists merely through the frame of formal affinities with the so-called modern masters.[15] One would argue, however, that this is far too simplistic, since it is almost impossible to articulate their oeuvre, or indeed their significance, within modernism, or their role in the advent of postmodernist aesthetics and practice, without proper awareness of the specific historic and political circumstances under which they arrived and began their professional interventions in Europe. Such careful contextualization allows us to discover the underlying and oft-enduring currents in their work, and their formulation of an appropriate aesthetic for individual practice within a nascent, postcolonial Europe in which the power of Empire is brought under considerable check, and with it the philosophical structures of Caucasian heroism upon which subsequent myths of modernism would be built.

Little surprise, then, that Egonu's earliest surviving professional work as a painter should replicate the themes of nostalgia and cultural nationalism that we find in Senghor's and Césaire's poetry and at the core of Negritude rhetoric—or that Egonu's initial grappling with these themes should draw its formal strategies from prevailing streams of modernist practice, framed, however, by a desire to negate the canons and demands of the Western tradition, just as we find in Césaire's surrealist free verse and in Senghor's combination of early modernist forms with those of West African orature.

Nation and Nostalgia

Uzo Egonu graduated from Camberwell School of Arts and Crafts in 1951, having studied painting and printing. At Camberwell he was instructed in the forms and canons of the Flemish school, which were favored by his instructors at the college. As he sarcastically said of the nature of instruction at Camberwell in a conversation with this writer in 1989, "Twenty years ago, they would insist that they look at things in a particular way, as if you were competing with second-century art. And you wonder, why don't they engage a photographer and be done with it?"[16] The instruction, though in line with the prevalent taste at such influential institutions as the Royal Academy and the Royal Society of Arts, was nevertheless inconsistent with developments in modern British art of the time. Also, they could not provide the young Egonu with the right tools to configure himself for a place within the frame of cultural nationalism as described above.

To extricate himself from the strictures of his training, Egonu decided to travel in Europe, visiting museums and collections where he came in direct contact with

major works from the Western tradition, as well as those from Africa and other art-producing cultures. He also wanted to acquaint himself firsthand with the work of the modernists beyond what he was exposed to in London. These trips took him to Paris and Rome and the Scandinavian countries between 1952 and 1958. They would prove instrumental in furthering his efforts at self-definition and his search for a proper voice within modernism, as much as his exposure to Negritude philosophy.

Egonu moved to Paris after his initial continental trip. There he lived and practiced for a year, paying regular visits to museums and galleries, especially the Musée de l'Homme, where he visited the African and Oceanic collections. Egonu's encounter with Paris, like Jackson Pollock's a decade earlier, had a decisive impact on his ultimate direction as an artist. Divergent and often conflicting as its influences were, he found them at once frustrating and challenging.[17] Though he paid attention to moments and figures from the Renaissance through to post-impressionism, cubism, and surrealism, he was also deeply fascinated by and dedicated to a methodical understanding of classical African sculpture.

During Egonu's period in Paris in 1956, Senghor's book of poems, *Ethiopiques,* was published along with a reissue of *Chants d'Ombre.* The same year, Senghor's definitive treatise on African art and aesthetics, "L'Esprit de la Civilisation ou les Lois de la Culture Negro Africaine," appeared in *Presence Africaine.* Senghor and the Negritude writers came closest to Egonu's personal circumstances as an artist and an African immigrant in Europe. For a young African artist searching for a place in modernism, Senghor's authority as a recognized figure within the movement and his articulation of the imperatives for the modern African artist, especially in "L'Esprit de la Civilisation," had the force of a revelation. Many of the themes and ideas that Senghor dealt with in his essay and his poetry would eventually appear in Egonu's work and long inform his thinking.

Egonu's travels in Europe and his acquaintance with these disparate art traditions, rather than inspire a cosmopolitan indifference to the fact of his Africanness, made him even more aware of it. His experiences challenged him to seek ways of forging a personal aesthetic informed by his new awareness. His contact with classical African sculpture prompted a more critical and comparative approach to the European tradition. For the young artist, confronting the wealth of the world's artistic heritage brought concreteness to the postulation already marshaled by the Negritude writers, namely that each artistic tradition rivets on itself and derives its greatness largely from within its own space and dictates. It also became clearer to him that, as Senghor had argued, such seeming ethnocentricity must be accompanied by a selective eclecticism for a culture to transcend its past and realize its modernity.

Egonu set up studio in North London in 1959 and went through a period of considerable turmoil as he struggled to give form to the cultural and conceptual resolutions he reached as a result of his travels. He destroyed numerous canvases, as many as thirty in 1959 alone, as he battled to pull it all together. However, by 1960, when he executed his first major commission, a market scene commissioned for the Nigerian government house in London, it would seem that he had resolved his creative crisis by

taking the route of nostalgia: a conscious appeal to memory and recollection as a tac-
tic of relocation while finding his form through the free chromatic and post-academy
strategies of the Fauvists, allusions to Gauguin, and, to a certain degree, formal refer-
ences to the Kitchen Sink school of British painting.

That same year he painted *Boy with a Budgerigar*, a filial homage that also served as
an attempt at "a return to his native land," to use Césaire's title. *Boy with a Budgerigar*,
Egonu explained, was inspired by memories of his father and brothers in Nigeria,[18]
the budgerigar representing his father's parrot that was much loved by the boys. Of
another painting from 1960, *A Boy Eating Sweet Corn*, he said, "I chose the subject
because of nostalgic feelings for my country; the feeling of being far away from home
evoked these images in my mind."[19] In using childhood memories as his frames of ref-
erence, these early works register the artist's rather tenuous yet crucial link with home
at the time. Over the next three years he painted *Village Blacksmith in Iboland* as well
as a series of celebratory, almost heroic portraits of African women, including *Portrait
of a Nigerian Girl* and *Portrait of a Guinea Girl*.

These genre pieces work at the level of the romantic, reclaiming and valorizing
"home." The portraits of African women inevitably remind us of Senghor's celebration
of the African woman in *Chants d'Ombre*, in which the woman, a figure of nostalgic
longing, metaphorically becomes Mother Africa. His choice of the metalsmith as sub-
ject, though inspired by recollections of his own childhood experiences in Igboland,
reminds us also of the prominence of the village metalsmith in another work inspired
in part by Negritude thought, Guinean writer Camara Laye's classic childhood mem-
oir *L'Enfant Noire*.

Egonu's choice of themes and subjects at this point reveal strong influences of
Negritude thought and imagery, and certain identification with Negritude roman-
ticism and its celebration of the pastoral. At the same time, it is important to note
Egonu's allusions to early modernist language, especially Fauvist expressionism. His
contours are woolly and his anatomy imprecise. In the works so far mentioned, he
makes an almost indiscriminate use of polychrome in a manner that also reminds us
of Henri Matisse. Like the Negritude poets, he selects his formal strategies from within
modernism, but brings to it those emblems of cultural difference and nationalist dis-
tinctiveness that characterized Negritude poetry.

In a number of works from 1963, Egonu turns to other themes prominently fea-
tured in Senghor's writings also. The use of African masks and musical instruments
to represent African culture and humanism is one. The mask, we may recall, is the
central motif and subject of Senghor's poem "Prayer to Masks" from *Chants d'Ombre*.
Speaking of his paintings, *African Masks* (1963) and *Still Life with Mask in Landscape*
(1963), in which he places masks against a pastoral background, Egonu described the
mask as a "symbol of the African past" and an inseparable part of African art. He
chose the subject, he further explained, because he was "thinking of the influence that
African masks (have) had on European modern art, especially on Cubism."[20] This
point Senghor had made strongly in "L'Espirt de la Civilisation," in which he pointed
out that, "after the failure of Greco-Roman aesthetics at the end of the nineteenth
century, artists and writers came at the end of their search to Asia, and even more

important, to Africa."[21] "Through Africa," Senghor argued, "they have been able to justify their discoveries and confer human value on them." While enjoining them not to "choose to betray not only Africa but our reasons for living," Senghor insisted that the logical and proper future of modern African artists lay in an awareness of African culture: "Insofar as they are aware of African culture and draw inspiration from it, they rise to international status. Insofar as they turn their backs on Mother Africa, they degenerate and are without interest."[22] Egonu's statement on the debts to Africa is both an acknowledgment and a claim on modernism. It indicates his growing confidence within its aesthetic, which he justifies in part through this reference to affinities. While he insists on the centrality of African sources to modernism, it is pertinent to note also that he does not refrain from making reference to the European tradition. It is this ambivalence, which is fundamental to Negritude aesthetics, that saves Egonu's propositions from descent into cultural essentialism.

Egonu's late nostalgic period in the mid-1960s prepared him for a progressive departure from many of the predictable problems associated with nostalgic evocation. By 1964, he had begun a discernible transition that formally distinguishes his subsequent work from the earlier paintings mentioned here. Evidence of this transition we find in a series of paintings interpreting familiar monuments of the British landscape. These included *St. Paul's Cathedral* (1965), *Westminster Abbey* (1966), *Trafalgar Square* (1968), and *Tower Bridge* (1969). Nevertheless, he also continued to draw from African traditions and influences.

For instance, while in *Woman Combing Her Hair* (1964) Egonu makes thematic reference to Degas and, as I have argued elsewhere, to Hogarth and his theory of "the line of beauty,"[23] his treatment of line and texture in the work indicates African references such as we also find in *Houses in Northern Nigeria* (1963). In the latter work, there is a strong consciousness of the nature and texture of northern Nigerian adobe architecture and the art of the Nok civilization that Egonu had begun to study by this period. His studies of Nok led to his unpublished treatise on the subject "The Reproductions of Nok Culture Terracottas Showing: Spherical shape, Cylindrical Shape, & Conical shape."[24] Though *Woman Combing Her Hair* indicates familiarity with Hogarth's theory of beauty, during this period Egonu nevertheless also spoke of the "aesthetic beauty" of Nok sculpture and how his observations of Nok pieces and the formal principles of the Nok artists inspired him to experiment.[25] In *Collage: Cuttings from Magazines* of 1965, he experiments with a quintessential modernist form, yet the piece is informed by his studies of geometric forms in Nok sculptures. Whatever his other sources might be at the time, therefore, it is impossible to ignore that his major intellectual preoccupation was to understand the complexity of classical African art and to use it as a frame of reference while employing contemporary techniques of the period.

It is important to observe that during the 1960s, several other artists in different parts of the world were also engaged in this *return to the source*. In Britain, artists such as Avinash Chandra and later Li Yuan Chia were preoccupied with factoring elements from their cultures of origin into modernist expression. Chandra fielded eroticism as a dominant trope, deriving his strategy from Indian religious imagery and thought, while Chia deployed the stringent economy and form of Chinese calligraphy. Aubrey

Williams, who enjoyed relative prominence at the time, was also in the process of introducing a new genre of abstractionism, informed by his studies of pre-Columbian Guyanese forms in the same way that many earthwork artists of the decade looked to pre-Columbian art for ideas and inspiration. For such artists, the ascendance of American high-modernist aesthetic and rhetoric, and its attempts to strip modernism of its humanist element, held little appeal. If anything, it made it more imperative for them to seek sources of deeper meaning for artistic practice after the midcentury.

In *The Other Story,* Rasheed Araeen calls our attention to the place and politics of humanism in modern art. He rightly points out that at different points in our time, artists have sought resolution, meaning, even profundity through humanism. Artists like Egonu, Williams, and Chandra, as well as those earthwork artists who shunned the analyticity of high-modernist sculpture, all reaffirmed a humanist sensibility within modernism, one that sought meaning not in pure abstractions or the formal sciences of the period, but in beliefs, knowledge, and forms from older cultures.

Egonu's preoccupation with Nok culture may be seen as a second phase of his cultural nationalism, by which time he had replaced nostalgic imagery with formal ciphers of difference. This was in line with developments in European modernism as well as in African art and literature of the period.[26] In his paintings, the lines became thicker and more prominent. Manipulation of texture and space also became conscious, formal principles. Though figurative still, Egonu's work nevertheless became more planar and decorative, relegating depth and perspective. This made his venture into printmaking in the 1970s a natural progression.

Compared with the work of indigenous, European modernists of the mid- and late 1960s, Egonu's work stands apart with those of Chia and a few others in consistently fueling elements of a different cultural identity and awareness into British modernism. If David Hockney's interpretations of home photographs represented the heights of indigenous, British figuration, and William Turnbull and Bridget Riley were the most prominent abstractionists, artists such as Chandra, Williams, and Egonu maintained a different cultural vocabulary and significatory richness within British modernism, even when their vehicle was only formal.

Egonu described his discoveries from studying Nok sculptures and other African art traditions as a "bridge" beyond which there was clarity and certainty of language. In his notes for an exhibition catalog in 1970, Egonu states, "My aim was to utilise the decorative symbols which I was used to as a child in Igbo-land, to express myself and to communicate my thoughts to others."[27] By articulating and adopting those formal strategies that appealed to him as an artist, he developed the freedom and confidence to approach the diversity of themes and subjects that would define his career while firmly locating himself within an identifiable sensibility in contemporary practice.

Modernism and the Globalpolitik

In the same manner that the Negritude poets brought the politics of race into early European modernism, so did artists like Egonu make the discourse of global politics,

and especially of the postcolonial condition, part of the humanist imperative of late modernism. Aubrey Williams had stated that pertinent to his work as an artist was "the human predicament, especially with regard to the Guyanese situation."[28] While this preoccupation may be regarded as the precursor to the wider concern with the global human condition in the work of European postmodernist artists of the late 1960s and 1970s, it may be distinguished from the latter, nevertheless, for its focused and personal nature. For instance, Egonu's work from the mid- and late 1960s, unlike much of the art of the 1960s that was inspired by a vague, flower-generation *Gestalt politik,* focused instead on the politics and human condition of a specific geography that had consistently factored in his formal and cultural strategies before that moment.

Egonu's transition from a cultural agenda to a political one was indeed less premeditated than it was imperative, hoisted upon him, as it were, by the rather precipitous if predictable collapse of Nigeria, his country of origin, in the late 1960s. In 1966 the military attempted to seize power to arrest widespread corruption and impending disintegration in the newly independent country. This was followed by a pogrom in which sections of the country turned against citizens from the eastern region, killing tens of thousands. Many of them were Igbo like Egonu. The massacre and ensuing chaos precipitated a great exodus of the persecuted to the east and the declaration of an independent state, plunging the country into civil war. The war between Nigeria and the new Republic of Biafra lasted three years and claimed more than two million lives.

These developments had a great impact on Egonu, who had great expectations for his country. Nigeria, the most populous nation in Africa, with the highest concentration of skilled manpower and significant natural resources, held significant promise as a postcolonial state. For reasons of its unique attributes, it came to represent an opportunity to prove the abilities of the African for successful self-governance and an opportunity to build a modern state out of the dislocations of colonialism. Like India, Nigeria represented a chance to prove the colonial project wrong and to encourage all those who sought self-determination from Empire. When the young democracy began to flounder, it threatened to put into doubt the validity of colonial disengagement. With a significant portion of the African continent still struggling for self-determination and independence from colonial domination, the example of Nigeria had many negative implications.

The civil war brought enormous human suffering. Many people in Biafra, including Egonu's family, were cut off from the outside world for the duration of the war (1967–1970). Some of his relatives were drafted to fight on the side of the fledgling republic. Others were casualties. This was an agonizing experience for Egonu. His partner, Hiltrud, suggests that the enormous anxiety Egonu went through during the period contributed in no small measure to his health problems in later life.

As an artist Egonu was equally faced with the question of how to respond effectively to the human tragedy. How does the artist maintain aesthetic integrity in the face of such trial? What are the moral and social responsibilities of the artist? Since

midcentury, modernist schools of thought had been deeply divided over whether art should be a solitary, individual spiritual pursuit or a vocation with broad social responsibilities. Even as dedicated and influential a propagator of social consciousness in art as Harold Rosenberg ultimately questioned the potency of art and the place of the artist in society. In one of his last essays in the 1970s, Rosenberg concluded that "taken by themselves . . . painting and sculpture are politically impotent."[29] This realization was nonetheless never enough to expunge social passion from modernist art because, as we have already observed, modernism had its beginnings in the humanist ideal and the recognition that the modern artist, free of all allegiance to king, state, or church, enjoyed more freedom than any other in history to engage issues of social import and the state of the human condition.

In the case of British art, the human suffering during World War II and the inception of the nuclear threat after the war had occasioned responses from artists as varied as Henry Moore, Paul Nash, and Graham Sutherland. In the 1960s, however, little of such social consciousness was to be found in British modernism.[30] The tragedy of the Nigerian civil war challenged Egonu to respond as one closely affected by the developments. Inadvertently, he succeeded in bringing into late British modernism a renewed interest in the human condition. Significantly, Egonu's war paintings still represent the only formidable body of work on the human condition in late British modernism.

Beginning in 1966 until the early 1970s, Egonu preoccupied himself with reflections on the war in his homeland: allegories on war and conflict, images of suffering and of the possibility of peace. Interestingly, despite global sympathy for the people of Biafra, the embattled republic failed to attract the same level of attention from artists around the world that the Spanish Republic achieved earlier in the century. Artistic response to the Biafra situation came to involve only a handful of artists, prominent among them Egonu himself, the novelist Chinua Achebe, and the dramatist Wole Soyinka, who was incarcerated in Nigeria for his opposition to the war. Some of Egonu's paintings from the period challenged the traditional dichotomization of art and politics, emphasizing instead the correlation between human tragedy and the language of its articulation. In *Thirty Thousand Dead* (1966) a skeleton represents victims of the 1966 massacres of the Igbo in northern and western Nigeria. *Blind Eye to Tragedy* (1967) combined skeleton motifs with the iconic image of mother and child, with Egonu employing the allegorical strategies in the tradition of Francisco y Goya and Honoré Daumier to capture the horror of the war. In other paintings from the period, Egonu moves freely between principles from both within and outside the modernist tradition to enhance effective communication in his work.

During this period, Egonu also produced his only known body of sculpture, a group of statuettes dominated by images of fallen figures. Together with some of his paintings on the war, these were exhibited in a solo show at the Upper Grosvenor Galleries in London in 1968. Proceeds from the exhibition were donated to a charity for humanitarian work in Biafra. Through this work, Egonu not only registered his personal anguish at the suffering of his people, but he tried to call the world's attention to that suffering with a passion and dedication that was rare in British modern-

ism. Such passion would remain rare even in contemporary British art until the late 1970s and the 1980s, when a generation of younger artists revitalized contemporary British art by injecting social consciousness into it. In this regard, Rasheed Araeen's work from the 1970s and that of Keith Piper, Eddy Chambers, Mona Hatoum, and their contemporaries in the 1980s follow in the tradition that Egonu began.

In the 1970s Egonu made another transition, this time from his contemplation of war and human suffering to philosophical and religious themes, as well as to an engagement with contemporary social experiences in Europe. In *Stateless People,* a series of paintings he produced in the early 1980s, Egonu reflects on the themes of being and nationhood. In the paintings he further underlined the humanistic underpinnings of his modernist vision by introducing a subject hitherto explored only in postcolonial literature, namely, the colonial immigrant in the Western metropolis. With statelessness and the virtual collapse of the postcolonial nation-state as foci, *Stateless People* prefigured contemporary concern for the postcolonial subject at home and in exile. In the series, Egonu represents the alienation of relocation and exile through his characters, lonely and nostalgic or herded into little groups, bonded by the tools of their trades yet very much adrift, each nursing an indeterminable loss.

In his last body of work in the 1990s, *Past and Present in the Diaspora,* Egonu produced a monumental reflection on slavery, the legacy of Christopher Columbus, and the indefatigable nature of the human spirit. Stepping back in time to engage history and its social and philosophical ramifications, he continued to make modernism responsive to both the past and the immediate. In his valedictory as an artist, Egonu chose, in his own words, to ponder "the bewilderment of human behaviour" and find the right metaphor to "represent spiritual strength."[31] The result is an impressive conclusion to a career dedicated to technical mastery, stylistic brilliance, and, most important, to the pursuit of meaning and historical relevance.

Conclusion

Egonu described his synthesis of formal principles from the cultures of his origin and those from modernist precedents as footprints, and likened his career as an artist to the progress of a mountaineer, with challenges as an expatriate, a colonial in the center of Empire, and a humanist at a time when modernism wavered between the formal vacuity promoted by American critics, ascendant triviality fed by popular culture, and the humanism of its beginnings. Like a mountaineer, he left his footprints on postwar British art by introducing a privileged understanding of those non-European sources that shaped its origins and informed his individual style.

Even more important, Egonu was a pioneer among those artists who made their entry into modernism from the outposts of Empire and remained dedicated to the humanist ideals that formed its initial platform. Egonu informed modernism with his experiences and passions as an African expatriate in Europe, a tradition rooted in the marriage of form and function and in the legacies of anticolonial struggle. He was able to use that tradition as a framework for the visual exploration of questions and

passions that at once spoke to his immediate experiences and environment, as they did to history. Idealistic, even stoic, his was a truly modernist vision anchored not in the evacuation of social concern or the indeterminate prevarication that have come to characterize postmodernist cultural production, but in the unequivocal idea of the artist as a visionary; as the propagator of a larger, more positive social reality.

Uzo Egonu—and artists like him—broadened the boundaries of modernism by representing a non-European contingent within it. They gave it edge, expanded its formal vocabulary, and ensured that it engaged a broad range of ideas and issues relevant to the human condition. Together with the formal innovations that they brought, they also made it invalid to ask: did modernism fail?

1999

Photography and the Substance of the Image

COMPARED TO ALL THE OTHER image-making techniques and preoccupations (what we loosely refer to as the visual arts), photography has come a long way in a short time. Today the contraption that George Eastman built in Rochester, New York, in 1888 to take advantage of the flexible celluloid roll film has so advanced and proliferated that we are offered models so inexpensive we can discard them after only one use, in same manner as sanitary paper, thus completely belying the fact that just over 150 years ago it required a bill on the floor of the French parliament, sponsored and promoted by some of the most powerful minds of the age, to obtain a commission from the government to acquire Louis Daguerre's photographic equipment.[1] And the ever-burgeoning business enjoyed by photo-processing laboratories and drugstore counters around the world today shows that our attachment to the photograph has not waned since that witty 1840 lithograph by Theodore Maurisset, *La Daguerreotypomanie,* in which he not only captures the craze for the photograph that caught Parisian society in 1839 but also predicts many of the developments that have since taken place in photographic history.[2] Photography has allowed us to share images of locations and sites as remote as the farthest corners of our galaxy and as intimate as the innards of our bodies, and has placed at our disposal records and likenesses of events and personalities both close and distant: the exhilarating moment of the first child's delivery as well as the sting of the hour of departure; the family group miniature for the office desk that signs our respectability, as well as images of the powerful that underline our own connections, or allegiance, to power.

Photography arrived in Africa on November 16, 1839, the same year that Daguerre announced his invention in France and less than two months after the English gentleman D. W. Seager made the first daguerreotype in America. And, but for the sabotage

of the painter and amateur photographer Horace Vernet, the man who made those first images in Egypt in 1839, the earliest photographic images by an African could equally have appeared in the same year, produced by Vernet's patron and benefactor, the Khedive and vice regent of Egypt, Mehmet.[3] Mehmet, who marveled at the image-making possibilities of the photographic process, lost little time in his desire to understand and take control of this process, to wrest from Vernet the power of the new technique, and to apply the same to the reproduction and preservation of the images of his numerous spouses. To this we shall return presently. Soon after Vernet's pictures of Egypt appeared in Europe, photography and the camera became a permanent part of European campaigns of exploration in Africa, sometimes with relative success but often woefully unsuccessful and remarkably vain. Nicolas Monti has indeed suggested, and with much merit, that the culture of tourism has its beginnings in the lucrative European trade in photographic images of Africa. As adventurers and colonial personnel applied the facilities of the photographic process to the graphic representation of aspects of African and Maghrebian life, many were drawn to the continent not only by the geography thus revealed but also by a new, more convincing, and eminently enticing portrayal of the alleged sensuality of the African. And so successful was this commerce of images that by the turn of the nineteenth century, American photographer F. Holland Day was manufacturing studio images of "Nubians" and "Ethiopian chiefs" shot in America and modeled by African Americans, a voyeuristic typecasting practice that would eventually manifest, in its worst form, in the junglefication of Africa that preoccupied Hollywood in the following century.

As the voyeuristic camera made its incursion into Africa, so did the camera as an instrument of war. By 1855 the English photographer Roger Fenton had established the place of the camera as a tool of war reportage through his photographic coverage of the Crimean War, and by 1861 Mathew Brady had applied Scott-Archer's collodion process to the pictorial coverage of the American Civil War, leaving for us moving images of loss and horror rather than records of triumph. In both cases the camera was arguably a journalistic instrument rather than part of a military campaign. In its earliest wartime use in Africa, however, the camera was a decidedly ideologically positioned tool on the side of incursion. In 1896 Edoardo Ximenes, Italian journalist and cofounder of the magazine *Illustrazione Italiana*, took war photography to Africa as a photojournalist on the Italian campaign in Abyssinia.[4] Accounts of Ximenes's exploits in Abyssinia, to which we come presently, indicate a position weighted on the side of the Italian infringement upon that African nation. And Ximenes was not the first to introduce the photograph to Ethiopia. The fellow credited with introducing photography and the camera to Ethiopia in 1859, the German missionary Henry Stern, had himself been imprisoned for "displeasing" Emperor Tewodros II, thus discouraging the use of the camera in that country until later in the century.[5] The camera would eventually play a fateful role in the politics of the great Abyssinian monarchy in the early twentieth century, ultimately leading to the fall of a monarch for the first time in world history and presaging the dubious employment of photography in the McCarthy era in America.[6]

Although Khedive Mehmet had acquired mastery of the daguerreotype process from Vernet shortly after its introduction in 1839, information on African photographers is scarce until the turn of the century. While this in itself does not, of course, indicate the absence of African practitioners of the art at that time, it is not until the turn of the century that we begin to find records and images specifically attributed to them and which provide us insight into the nature and purposes of African photography. To explain this, Nicolas Monti points to possible cultural impediments to the acceptance and propagation of the photographic medium, one of these being a superstitious misgiving with the camera and its magical abilities. This was a universally common phenomenon in the early years of photography. In Germany in 1839 the *Leipziger Stadtanzeiger* had qualified the idea of photographic reproduction of the human image as blasphemy, insisting that "man is created in the image of God and God's image cannot be captured by any human machine."[7] This, the Leipzig publication maintained, had been proven "by a thorough German investigation." Also, stock European accounts of superstitious responses to photography in Africa, narrated in nearly the same words in all cases, be it with the Khedive of Egypt or the Mulena Mukwae of the Lozi of South Central Africa, cannot be relied upon to provide us with a faithful representation of African attitudes to the photograph, and wherever open hostility developed toward the camera, it almost always had to do more with the invasive tactics of its European operators than with a peculiar African inability to understand or accept the medium. In our own times this has been the case among the Nuba of southern Sudan following Nazi propagandist Leni Riefenstahl's staged documentaries in the area in the 1970s.[8]

Monti does, however, point to a more relevant and crucial political and cultural impediment to the development and acknowledgment of African photography in the nineteenth century. Writing about the photographic documentation of European colonies in Africa, Monti notes in *Africa Then* that "the authorities who commissioned and financed a good part of the first photographic campaigns were, it seems, aware of the risk of 'natives' getting possession of this means of expression and using it as an instrument of subversion by showing the true conditions of their people."[9] It is noteworthy, meanwhile, that even in the face of opposition and active discouragement, Africans nevertheless took possession of the camera and the photographic process, and before the end of the century a good number, some of whose identities have come down to us, had established fairly successful and lucrative practices around the continent. These would include N. Walwin Holm, who established his studio in Accra in 1883 and would be admitted into the British Royal Photographic Society in 1897, later moving on to Lagos to establish a legal practice; George Da Costa, who began professional practice in Lagos in 1895; F. R. C. Lutterodt, who established his practice in Accra in 1889 but would eventually travel and practice all over Central Africa during the 1890s; as well as a handful of photographers who were active at the turn of the century in Johannesburg, Cape Town, and Addis Ababa, among other cities.

By the early twentieth century, photography was already a highly regarded profession all over Africa and studios existed in most cities that were established and run by

professionals, many of whom were familiar with developments and practice, especially in Europe. The case of George Da Costa, a highly successful administrator and salesman who gave up his position to study photography and establish a studio, is revealing. Described by Allister Macmillan in 1920 as "the ablest and best-known professional photographer in Nigeria,"[10] Da Costa was manager of the Church Missionary Society Bookshop in Lagos from 1877 until 1895, when he resigned and, having spent a sizable sum in training, took up photography, eventually becoming a photographer of remarkable achievement. Not only did the colonial government entrust him with the photographic recording of the construction of the Nigeria Railways, work for which he was equally acknowledged in London, in 1920 Da Costa worked with Macmillan on his *Red Book of West Africa*, occasionally battling the hostile elements, especially in northern Nigeria. It would be in order to point out here that Da Costa's work brings to us a representation of his times that is quite remarkable in its variance from that on which the popular imagination was fed and shaped outside the continent. Rather than a society of "cannibals" and "heathens," Da Costa's photographs of early-twentieth-century Africa led us to a cosmopolitanism steeped in awareness of other cultures, a world of burgeoning elite and savvy literati, a society of international merchants, high-flying attorneys, widely traveled politicians, newspaper tycoons, and society ladies, the same images we find in contemporary portrait painting of the period. Also remarkable is that photography, having had a head start on portrait painting in Lagos, where the earliest significant work in that genre dates only to 1906, avoided the reputation of the spoiling antagonist that it came into in Europe and was considered acceptable and adequate.[11]

In Freetown, Sierra Leone, the Lisk-Carew brothers set up a popular practice to cater to the needs of clients both local and expatriate. Of their business Allister Macmillan wrote in 1920: "There is probably no establishment in Freetown that is visited by more passengers from the steamers than that of Messres Lisk-Carew Bros. The reason of its popularity is because of its extensive stock of postcard views of Freetown and Sierra Leone." In Accra, J. A. C. Holm, son of N. Walwin Holm, now an attorney in Lagos, Nigeria, took over his father's practice. Holm, who is described by Macmillan as "an exponent of photography in all its branches," had joined his father's photographic studio in 1906 at age eighteen, eventually taking over the business in 1919.[12] Holm would produce several images of Accra and its elite for *The Red Book of West Africa* in 1920. Other than Holm's, a number of smaller studios applied themselves to the demands of the growing urban population with its burgeoning elite. Photography was lucrative, and the photographer enjoyed a unique sense of place within the community, having access to the people, understanding their peculiar needs and demands on the medium, and thus enjoying their confidence and custom. The African photographer was also better placed than the foreigner to provide his services within specific cultural frames that made these available and affordable. With their privileged knowledge and location, as well as their ingenuity, photographers were able to devise novel uses for the medium and to introduce the same within their communities and social circles.

By the early twentieth century also, these photographers enjoyed the trust and ac-

ceptance of not only their communities but of expatriates as well. The advent of newspaper publishing and journalism at the turn of the nineteenth century, and the growth of this industry as part of the nascent anticolonial struggle in the 1930s, gave African photographers the opportunity to expand their practices and to gain greater exposure and respectability. Government yearbooks and projects employed the services of photographers, and colonial functions and royal visits provided commissions. Whereas a publication like the Amharic weekly *Aimero* relied heavily on the work of Armenian photographers, others like the *Lagos Weekly Record* and the *West African Pilot* relied on African photographers for their images. Others like the London-published *West Africa Magazine,* begun in 1917, and trade journals like the *Nigerian Teacher* also used the work of African photographers for their illustrations.

In the decades that followed, master photographers such as Peter Obe in Nigeria, Peter Magubane in South Africa, Seydou Keita in Mali, and Mohammed Amin in Kenya would emerge. Obe, perhaps his country's greatest photographer of all time, not only produced work for numerous African publications and clients, but provided for foreign news and photographic agencies as well. With a decidedly aesthetic intent, Obe approached every photographic moment with the weight of his technical and visual sophistication regardless of its ultimate utility, private or documentary. Mohammed Amin earned the recognition and respect not only of his clients in Kenya, but also of the establishment in Europe who valued and sought his work, as well as important personages and leaders from around the world. Regarded as the most influential news photographer of his time, Amin died in 1996 in an airplane crash. Before his death he oversaw Camerapix, a vast archive that he founded in 1963 and that comprises his significant work produced over three decades and representing mastery in every genre of photography, as well as Africa's largest image and audio resource. He was knighted by the British in 1992 for his contributions to news photography and named Cameraman of the Year in Britain in 1969. Magubane, who with David Goldblatt stands as the finest and most significant South African photographer of their generation, has brought that country and its people to the world and enjoyed the reverence of the international photographic community. And so has Seydou Keita, who in the past decade has reemerged, like blues legend John Lee Hooker, as a master visionary comparable to only a few others in the twentieth century.

Just as the African condition in the late twentieth century is considerably defined by expatriation, so has the cartography of its photography metamorphosed and expanded. As cultural critics and historians are beginning to learn, it is not enough to look to the continent alone for its cultures, for its art and music and literatures; to do so is to sidestep a significant manifestation of its present, which is found all around the world in the form of expatriate culture. Among the continent's most important contemporary photographers belongs Rotimi Fani-Kayode, who in his brief lifetime produced enough work that over time he has become the most significant and influential British photographer of his generation. Fani-Kayode worked principally within the traditions of Yoruba photography and image-making, yet helped define the British gay aesthetic in photography for the 1980s. Since his death at the age of thirty-four in 1989, hardly any other British photographer has had an equal influence on

photography in that country. Unfortunately, a good body of Fani-Kayode's work was exposed to intervention and corruption after his death by a partner whose understanding of the image and of the photographic medium was essentially closed to the depth and criticality of meaning that Fani-Kayode brought to his art. Alex Hirst, who collaborated with Fani-Kayode while the latter was alive and inherited his estate, is a minor photo-artist himself, and has continued to manipulate and retouch many of the images left by Fani-Kayode, thus obliterating the unique aesthetic and cultural sensibilities that only Fani-Kayode could imbue them with.

In the 1980s and 1990s, practice no longer restricts itself to the photograph, and photography is once more defined not simply by the camera but within the broader frame of the photographic medium or new media, just as it was in the days of the hand-tinted photograph when the camera belonged in a larger process of photographic image-making, and just as it always has been for Africans. Among artists working with this new understanding are notable photographers and new-media artists such as Oladele Bamgboyé, who has worked in Europe and North America, and Gordon Bleach, who teaches in Eastman's Rochester and has worked in his own country in Zimbabwe as well as in South Africa. Bamgboyé, a descendant of the legendary Yoruba sculptor Bamgboyé and a distant protégé of both Fani-Kayode and the photographer and dancer Geoffrey Holder, whose work in photography is often mistakenly compared to that of Robert Mapplethorpe, brings his mastery of the entirety of the photographic media into explorations of the exoticized body, thereby closing off and placing photography's century-and-a-half long exploitation of the African body under crisis.

In addition to the named are hundreds of thousands of professional photographers across Africa attending to the photographic demands of their localities and who, together with the above, provide us with material toward the formulation of a theory of African photography. Stephen Prague observes, for instance, that "the large number of photographs available from individual Yorubas *[sic]* and from photographers' negative files form a vast visual data bank . . . (that) might be utilized in a number of ways."[13] Also, though for reasons of lack of proper attribution and the occasional dubiousness of contending and often better-known Western photographers, some of whom are known to have scratched out attributions from images and appended their own imprints, it is the turn of the late nineteenth and the early twentieth centuries that establishes for us the earliest body of verifiable African work in photography, we are able, nevertheless, to gain considerable insight into the general perception and application of the photographic medium by Africans before and after. And in these we find logical parallels to the West, as Prague equally points out about Yoruba photography, but, even more interesting, peculiarities also that define a different understanding framed by a divergent philosophical perspective on the questions that have hitherto occupied the discourses of photography.

Photography and Its Discourses

Since its birth, photography has been at the center of innumerable questions and contentions, most deriving from a rather peculiar Western inclination to view the photo-

graphic process as different and separable from the rest of the body of human techniques and processes of image-making. Yet as an image-making process it is difficult, even futile, to ascribe to photography any uniqueness beyond the facility of replication and miniaturization by which it enables us to make the transfixed image readily available and portable. In cultures where the multiple was already a long-standing artistic tradition that developed to meet the demands of the community, and portability was the norm rather than exception, even this repeatability was only convenient rather than unique.

Much has been made too in the history and criticism of photography about its indexicality or fidelity to reality. On this contemporary theorists of the medium remain as divided as its earliest commentators. For the intellectual and ruling circles of late Enlightenment Europe, photography proffered a mathematical exactitude of reality, a reducible, calculable mechanism for the scientific reproduction of nature. In *From Today Painting Is Dead*, Tristam Powell quotes the Victorian Lady Eastlake as remarking, "What are nine tenths of these facial maps, called photographic portraits, but accurate landmarks and measurements for loving eyes and memories to deck with beauty and animate with expression, in perfect certainty that the ground plan is founded upon fact."[14] Though we return to Lady Eastlake's comment presently, it nevertheless bears within it an element of a certain naive faith in the fidelity of the photograph that would pervade not only the aristocracy in the West but even more so, and with more dangerous and insidious consequences, the various institutions of science and the state. Resting on this supposed fidelity and transparency, whole disciplines came to rely upon the evidentiary potentials of the photograph, sociology appealing to it for concrete statistical purposes, anthropology for indubitable evidence of the evolutionary order of the human species, and, in extension, justification for its mission of salvage exploration outside Europe. Jurisprudence and the apparati of state control invented new systems of criminal cartography based on the consciously exaggerated faithfulness of photographic likeness, and the fundamental right to contest institutional truth was curbed by the supposed unimpeachability of the new tool.

Behind this rather essentialist and fundamentally flawed view of photography lay the myth of automatism, the rather interesting conviction that photography, unlike all the other techniques of representation, had, through its supposed substitution of the machine for the human hand, finally and thankfully ellided subjectivity and the fallibility of human agency. Writing over a hundred years after Lady Eastlake in 1971, the philosopher Stanley Cavell replicates this view with a deeper and more disturbing clinicality in his treatise on film and the photographic medium, *The World Viewed:*

> So far as photography satisfied a wish, it satisfied a wish not confined to painters, but a human wish, intensifying since the Reformation, to escape subjectivity and metaphysical isolation—a wish for the power to . . . reach this world, having for so long tried, at last hopelessly, to manifest fidelity to another. Photography overcame subjectivity in a way undreamed of by painting, one which does not so much defeat the act of painting as escape it altogether: by *automatism,* by removing the human agent from the act of reproduction.[15]

A few years later in "On the Nature of Photography," Rudolf Arnheim wrote of "the fundamental peculiarity of the photographic medium; the physical objects themselves print their image by means of the optical and chemical action of light," thus lending further philosophical authority to the concept of a mechanical, objective process devoid of the compromise of human intervention.[16]

However, like Arnheim and others who have propagated this idea, Cavell builds his assertions on a number of fallacies, among which is the assumption that there is a human inclination to escape subjectivity, when on the contrary every indication is that the proclivity of the human species is to challenge the veracity of that which professes objectivity and to seek beyond it. The second major fallacy behind Cavell's position, and which Arnheim claims to be the fundamental principle in his argument, is the assertion that photography removes human agency from the image reproductive process. Rather than sign the absence of subjectivity or human agency in representation, photography, though mechanical, is to the contrary first and foremost a human invention entirely dependent on human manipulation, from its beginning in the conception and manufacture of the photographic mechanism and its peripherals to the conclusion of the image-making process in the form of the photograph. A great deal of literature has already been devoted to this.

The myth of the triumph of reason in the Enlightenment, upon which Cavell equally rests his assumption that there is an a priori human proclivity for objectivity, survives only when we ignore the limited reach of the rationalist ideal and overlook the fact that at no moment in the history of the Enlightenment, from its beginnings to its demise in the age of high modernism (during which Cavell writes in 1971), was there a popular submission to the preeminence of the rational. Instead, through the ages the inclination and focus of the human will was always in the opposite direction, toward a recognition and acceptance of the impossibility of objectivity.[17] Thus when Lady Eastlake speaks of the photographic image, she speaks of it not as an objective reproduction of reality, but as an evocation, as a cartograph, a "map" whose acceptance rests upon the knowledge not that it is fact, but that its "ground plan is based on fact." And even when art critic John Ruskin speaks of the photographic image as "a portable" reality, he speaks not of an objective reproduction of reality or what Arnheim has described as "the manifest presence of authentic physical reality," but of a miniaturization—in other words, a new reality that differs, quite essentially, from that which it evokes, if only by virtue of its portability.[18] In essence the only phenomenological invariable of photography is not the fable of transparency and mechanical objectivity, but the materiality of the photograph, the creation in the photograph of a new reality, a new, independent, and concrete object on and in the form of paper or glass or any other of the innumerable surfaces upon which the photographic image may be placed, which then becomes part of reality rather than its replica.

More recent, and perhaps even more intriguing, is the contention that the history and appeal of the photographic medium lies principally in the uniqueness of its process. Trailing the argument for mechanicality, André Bazin wrote in *What Is Cinema:* "The essential factor in the transition from the baroque to photography is

not the perfecting of a physical process . . . rather does it lie in a psychological fact, to wit, in completely satisfying our appetite for illusion by a mechanical reproduction in the making of which man plays no part. The solution is not to be found in the result achieved, but in the way of achieving it."[19] In their 1975 essay "Photography, Vision, and Representation," Snyder and Allen note that "the use of a machine to lay down lines and the reliance on the natural laws of refraction and chemical change to create pictures are viewed as the decisive differences (between photography and other processes of picture-making)."[20] Yet this position, one observes, is indeed historically inaccurate because it fails to acknowledge the origins of the photographic process in the desire of the artist, whether the scene painter Daguerre or the amateur landscapist William Henry Fox Talbot, to achieve better, more personally or commercially viable results. It is noteworthy that Talbot had named his invention calotypy, or beautiful sketch, from the Greek *kalos,* and in introducing Talbot's process to the Friday evening meeting of the Royal Institution in London on January 25, 1839, the inventor Michael Faraday aptly described it as "the Art of Photogenic Drawing," not failing to place the emphasis on the product, the drawing. From the camera obscura to the camera lucida, the artist's frustration with the fleeting image, and the desire to capture and preserve the form produced through reproductive contraptions, remained the principal drive.

A second observation to the contrary is that, outside the minority sect of intellectuals and philosophers and the handful of practitioners who along the line have sought to position themselves apart from the greater camera community through uncertain professional claims and guises, general interest in the photographic process always was and remains in the result, the end product, and the desire to take control of the process is driven by this interest in the product and its use. At no time, not even in the much-hyped era of modernist autonomism, did the vocation of image-making rest on a preoccupation with the nature and relevance of processes in and of themselves as on the nature and value of the image. The efficacy and convenience of the photographic process, even the magicality that surrounded its early history, are subordinate to the true human appetite and fascination for the production of form, and the opportunity that photography provides for participation in the making of images. When a columnist wrote in *Scientific American* in 1862 that photography contributes to human happiness a "thousand fold more," it had less to do with a fascination for light and science and chemicals than with a human desire to make and acquire images. In discussing photography in Africa, it should be of interest to look at the foregoing contentions in the context of the continent and its traditions of image-making and consumption.

The Substance of the Image

One of the most naturalistic traditions of image-making in Africa, beside the royal portraiture of ancient Ife, is the Ako funeral effigy tradition of the Owo of western Nigeria, a tradition that, as Rowland Abiodun observes in *Yoruba: Nine Centuries of African Art and Thought,* may date to earlier than the sixteenth century. Not long after the death of an important personage among the Owo, a life-size effigy of the deceased

is attired in the dead man's or woman's clothing and either interred or allocated to a shrine in memory of the dead. There is an insistence on verisimilitude in the portrayal, and this demand for faithfulness to the physical likeness of the dead, it has equally been pointed out, has its origins in antiquity.

The earliest Western scholars of this memorial observance did not fail to dwell on the element of verisimilar representation, especially within a culture of great stylization in sculpture and in light of known traditions that refrain from the replication of likeness. Yet, Abiodun cautions us thus, and rightly so:

> The effigy with its Ako naturalism should not be judged for its photographic realism, but for its efficacy within the context of the Ako ceremony, which is . . . to make the end of this life, and the beginning of the next one, honorable and dignifying for one's parents, whose goodwill is needed by those still on earth.[21]

For this reason Abiodun has observed that the eyes of the effigies are always wide open, quite remarkably so, for the deceased to which they refer must keep awake on the other side, watchful over the living. To represent them otherwise would fail to emphasize this crucial element of the supplicatory act, and to do so is to run a risk of impeding the vigilance of the dead.

Despite its verisimilitude, Ako is not portraiture *as we know it*. Portraiture in the Western tradition may venture beyond verisimilitude into the fictive territories of distortion or hyperbole, but rarely invocation. Depending on the medium a portrait may veer between what we have come to describe, rather unwisely, as "photographic" realism and the borders of acceptable vanity. Yet it remains a recollection, the transfixture or registration of an instant that henceforth represents the past. Its phenomenological claims rest on its referentiality and terminality, and as a sign it is reflective. Even in its wildest departure from the frames of the verisimilar—as in nineteenth-century Western photo portraiture, when it was the portrait photographer's prerogative to incorporate various signs of historical or religious configuration to imbue the middle class with the hitherto aristocratic attributes of grace, wealth, enlightenment, and soulfulness—portraiture *as we know it* remains a marker of memory. In Ako, however, we find a different manner of portraiture: we find representation as anticipation. The verisimilitude we are introduced to is a mediated gesture between faithfulness and faith, between reflection and projection, a configuration of representation as both reflection and invocation beyond the limitations of transparency, for that which projects, that which anticipates and conjures, though faithful it may still be, is nevertheless no longer transparent, since to be transparent is to convey that which already exists, that which precedes rather than supersedes the agency of its representation—to remain, as it were, within the reaches of death. As a sign Ako is prolegomenal, and the essence of its verisimilitude is not indexicality or transparency but efficacy, the fulfillment of an intent beyond the materiality of the image.

This understanding fits within a broader aesthetic of essence, where the image is "true" as long as it efficaciously attends to the specifications of its application within an intricate matrix of cultural expectations. Whereas our conventional qualification

of such circumstance would be that the image is successful—that is to say, that it ful-
fills its purpose—within this aesthetic success also equates truth. In other words, the
image is truthful or accurate if it fulfills its purpose. And this success is not restricted
to the registration or indeed excavation of the phenomenological contours of the
subject through iconographic or iconological indexicality; it does indeed extend to the
supercession of the phenomenological and the substitution of the nonmimetic. Thus
an image, including the photograph, though it may not visually portray or refer to a
subject, may yet be applied to the representation of that subject as long as it sufficiently
encapsulates the perceived or intended attributes of that subject.

A good example of this we find in another Yoruba ritual, that of *Gelede,* where
matriarchal images are produced to reflect youth because the attribution of youth to
the elderly is flattering, and flattery as a lobbying strategy is the essence of Gelede. So,
though the image may refer to or be directed at an individual, it behooves the image-
maker to take the liberty to supersede the transparent and redefine faithfulness so as
to introduce what we might call the essential gesture. Where necessary, the image-
maker may depart entirely from the physically referential, in other words may employ
an image other than that of the object or target of ritual flattery for as long as it is
perceived to embody the spiritual essence of that target. Thus, whereas in convention-
al Western portraiture the search for *inner truth* in a subject may extend to distortion
and the mediation of the verisimilar but never so far as to depart entirely from the
confines of physically cognitive reference,[22] within the aesthetic that governs Gelede
in particular and Yoruba representation in general it is precisely such departure that
may constitute the necessary gesture toward successful or accurate representation.
The uniqueness of Ako within this aesthetic, however, is in the fact that this liberty is
contained by the need to produce an image that subjects may recognize and identify
with themselves. This in itself constitutes a different gesture, what we might refer to
as a *gesture of semblance.*

Ako introduces us to a philosophy of the image that invalidates the contest over
transparency or indexicality in the discourse of image-making, and one that is central
to our understanding of photography in Africa. The tradition of funeral effigies is
not restricted to the Owo and may indeed be found all over Africa, and it is revealing,
as it is understandable, that within this tradition of a gesture of semblance we find
one of the earliest applications of photography by Africans. As soon as a rapport with
the camera was reestablished in Ethiopia in the nineteenth century and photography
was popularized, the medium was placed at the service of funeral rites, and upon a
death the likeness of the dead would be retrieved, often replicated, and this would be
borne in the funeral procession. Citing Guèbré Sellassié's remarkable *Chronique du
regne de Menelik II Rois des rois d'Ethiopia,* published in France in 1930–1931, Richard
Pankhurst observed:

> It had been customary in funeral processions since time immemorial for mourners to
> display an effigy of the deceased, together with his horse and other valuable property.
> With the advent of the camera such articles tended to be supplemented—and the effigy

even replaced—by photographic portraits of the departed which mourners held high above their heads, while they wailed, ritualistically, and perhaps recounted episodes of the deceased's life and achievement.[23]

A notable occasion when this new prop of the mourning ritual was used was the funeral in 1906 of the governor of Harar and cousin of Emperor Menelik, Ras Makonnen, who was also father of the future and last monarch of Ethiopia, Ras Tafari (Haile Selassie I). Though the practice was observed within the aristocracy in the beginning, as the greater population had access to photography it became part also of the popular culture of mourning. Such application of photography was particularly evident during the dictatorship of the Dhegue in the 1970s and 1980s under Colonel Mengistu Haile Mariam, when the government presided over a decade of war and mass extermination similar to the decade of the missing in Latin America. Families carried the portraits of their missing and dead in processions and wailing rituals, and often to the sites of excavations of mass graves, where the photograph was not a mere effigy of the dead but also a totem of damnation.

Yet this practice had less to do with any greater faith in the accuracy of the photographic image or interest in the photographic process than with a recognition of its convenient delivery of an image. It is not unworthy of note that the photographic image was named *se'el-fotograf* in Amharic, a term that translates exactly as "photographic image" but also reminds us, in its specificity to two-dimensionality and reference to drawing and painting, of Faraday's "photogenic drawing." Ethiopian painter Wossene Kosrof, an Amharic speaker, indeed confirms that the singular word *se'el* could be applied to drawing, painting, design, and the photograph. Each without distinction is an image on a two-dimensional plane. Although within the realms of state politics in Ethiopia the evidentiary capabilities of the photograph would be called into service time and again, as already mentioned, leading first to the fall of the prince and heir-apparent Lij Iyasu in 1916 and later to the forced abdication of Haile Selassie in 1974, the broader understanding and application of photography was and remains rather referential and evocative. And though Iyasu was deposed supposedly on the strength of photographic evidence in 1916, several sources point to a popular conviction among the population that the implicated photograph was a forgery produced by an Armenian photographer in Addis Ababa at the behest of foreign intelligence operatives intent on the fall of the young prince,[24] thus signing not only the possibility of such discrepancy, but even more important a lingering Ethiopian distrust of the supposed indexicality of the photographic image.

Another Yoruba practice to the service of which photography was called provides further insight into the general African position on the question of the transparency of the photographic image. Among the Yoruba of the old Oyo Empire, the cult of twins is a prevalent practice that, according to records, dates to earlier than the nineteenth century. For unique dietary reasons the Yoruba have the highest rates of twin births in the world, and in earlier times the fragility of twins led to high infant mortality. For deceased twins, therefore, a practice was begun that British explorer

Richard Lander described in 1826 as one of "affectionate memorials." *Ere Ibeji,* or twin images, are images in honor of the dead that the living nevertheless tend and nurture as though they were the child in whose honor they are made. Originally these were made in wood, produced by a sculptor whom the priest appoints and, upon production, sacralized for its purposes. The twin mother would carry this with her in same manner as she would a living child, and cases are known where decades after the child's death, this image would be passed down through the family unto a succeeding generation. In recent times commercially produced plastic dolls have been sacralized and put to the same use, as John Picton has observed, a practice that in itself constitutes an important definition of the memorial image.

Even more relevant to our purposes is the employment of photography in the place of sculpture in this ritual memorial. It is not clear at what point in history the Yoruba began to use photographs as *Ere Ibeji,* but indications are that this may well date back to the late nineteenth or early twentieth century. A photographic image of the dead twin would be used in the same manner as a wooden *Ibeji* sculpture, kept in the altar to twins and brought out for rituals. Where there are no images of the twins, a family may have the sculpture made and then commission a photograph of the sculpture for convenience and better display in the home. However, where the human image is possible, no use or reference is made to the traditional wooden doll or effigy. Writing in his essay "Yoruba Photography" in 1978, Stephen Sprague had this observation to make:

> Photographs are often made of twins and other children to hang in the parlor with the photographs of other family members. Then, if a child dies, there is a portrait by which to remember him. The procedure becomes more complex when one twin dies before their photograph is taken. If the twins were of the same sex, the surviving twin is photographed alone, and the photographer prints this single negative twice, so that the twins appear to be sitting side by side in the final photograph. If the twins were of opposite sexes, the surviving twin is photographed once in male clothing and once in female clothing. Sometimes these two exposures are made on separate negatives, which must then be printed together . . . the photographer attempts to conceal the line blending the two separate exposures in order to maintain the illusion of twins sitting together in a single photograph.[25]

And yet greater complication occurs when more than twins are involved. In what Sprague considers an unusual case involving triplets, "the two brothers died and the surviving girl was photographed once as herself in girls' clothes and once in matching boys' clothes. . . . The photographer then printed the 'boy' image twice, once on either side of the girl, to give the proper illusion of triplets." The result, which is not perceived as a trick but rather as a normal responsibility of the image-maker, is the most beautifully conceived photograph possible, and the most significant comment on the substance of the photographic image.

From the onset, as we can see from this and other examples, the Yoruba associate photography not with objectivity, but with the possibility and necessity of illusion or

what we might otherwise regard as the fact of fiction. In the examples we have seen, the camera is first subordinated to the art of the sculptor through the use of photographic images of ritual sculpture in an interesting coalescence of fascination and disregard before it is finally brought into service as an extension of the image-maker's tools. In the cult of twins, the fundamental requisite for the application as well as for the effectiveness of the photographic medium is the redefinition of *objectivity,* or indeed the submission of photography to accepted definitions of objectivity—that is, the canonical rather than photographic *objective*—and the primacy of *faith* over faithfulness. By using the right apparel, the photographic image of the living twin becomes an image of the dead twin also. The reverse of this, which is to have the image of the dead that is taken either in their lifetime or on their deathbed represent them in a posthumous composition, would be acceptable in the West and has wide precedence in photographic history, but it would be unimaginable or considered fraudulent to substitute an image of a living kin for a deceased one, which is precisely what obtains in the Yoruba instances cited. And much as it may be argued that for the Yoruba the surrogate image remains that of the living twin—that is, the figure before the camera—what is important is not the figure in front of the lens but that which emerges after the photographic moment. The obvious intent is not to concede transparency or indexicality to the photographic image, but instead to recognize, underline, and utilize its nature as chimera.

In the 1980s Rotimi Fani-Kayode, who was of Yoruba ancestry, extended this tradition by applying photography to the imaging of Yoruba deities and principles connected with the cult of *abiku,* the cyclic changeling fated to repeat death and rebirth, and especially of the most engaging yet singularly photogenic deity of the Yoruba, the divinity of ambiguity and fate, Esu. While the representation of deities may be restricted to the mimetic translation of myth, the integration of convoluted iconic and philosophical principles into pantheistic visual representation—in other words, the generation of the iconic—demands fluid manipulation of the medium, even within the frames of canon. Few African divinities lend themselves to easy translation, and the employment of photography in the interpretation of the metaphysical rests on the premise that the medium possesses the flexibility to extend itself beyond mimesis, and sufficiently lends itself to the skill, and will, of not only the image-maker and the patron, but also of an intricate cultural matrix. In his re-creations of Esu, Fani-Kayode captured the physical and conceptual essence of the trickster god: mischievousness, ambiguity, multisexuality, indeterminacy, perpetual mobility, and unpredictability, all attributes that defy the confines of the mimetic trail and yield only to subjective intervention. Esu's smile/grin/grimace comes forth most unnervingly with the potentially wicked mischief of the divinity who deliberately sets friend against friend, violates his/her sibling in the presence of their mother, defies all prediction, and, most important, signifies the futility of absolutes, including the fiction of indexicality or visual truth.

For the Yoruba, therefore, the camera is not the detached mechanical contraption that supersedes human agency, as Cavell thought; nor is photography the peculiar

process in which "the objects themselves print their image by means of the optical and chemical action of light," as Arnheim would ludicrously put it.[26] Instead, photography offered the unique ease of combining possibilities of precision not readily available to the human agent with those of malleability required for the fulfillment of the essence of the image. Early in their acquaintance with photography, the Yoruba recognized and exploited the indispensability of human agency in the photographic process. In their use of photography, Yoruba photographers emphasize the affinity between photography and other image-making processes. A close look at one of the twin photographs that Sprague calls our attention to in his study, in which a female twin poses as a male to serve as a surrogate for her deceased male twin, indicates that the photographer manipulated the proportions in the photographs such that, though the images are of the same individual, the image of the female twin is smaller than that of the male. Through this simple yet highly ingenious technique, gender attributes and dissimilarities are codified, and the living twin's femininity is emphasized. In a second photograph, that of the triplets referred to previously, a different, even more sophisticated technique is employed. By a subtle change in the sitting posture involving the placement of the knees, the figure is made to look shorter in her female image than in the male. This way her brothers, for whom she serves as photographic surrogate, appear bigger and taller in the final print. Here we find no evidence whatsoever of a mythical "human wish to escape subjectivity . . . by *automatism,* by removing the human agent from the act of reproduction," as Cavell would have us believe.[27] Quite the contrary. There are no indications either of any concern for or interest in what Snyder and Allen describe as "the use of a machine to lay down lines and the reliance on the natural laws of refraction and chemical change to create pictures"[28] (a deconstructivist concept that, in any case, means absolutely nothing to either the average American or Yoruba maker or consumer of the photographic image). Instead, human agency is signed as an essential element of all image-making, including the photographic. Photography is regarded and employed in same manner as sculpture, and, as the Ethiopians indicate in their choice of vocabulary, painting and drawing. In these cultures photography is simply another process of image-making, a process of *making* rather than *taking.*

This understanding of the photographic as indistinguishable at large from the rest of the image-making processes, and in particular as manipulable rather than clinical, further manifests in a fundamental distrust of the photographic medium among the Yoruba and other African cultures, an attitude one might best describe as one of requisite ambivalence. As Sprague equally illustrates in his essay, the record of the camera in itself is considered inadequate unless it fits a frame of canonical specifications of representation governing all image-making without exception. In portraiture, including that of twins, for instance, the image in profile is considered inaccurate since it on one hand fails to register the totality of the individual's countenance and therefore of personality and being, and on the other introduces an element of distrustfulness or timidity to the person's character. Thus the camera in and of itself is incapable of articulating the contours of accuracy, and the responsibility to direct this instrument toward *truth* ultimately rests with its human operator, who is the real image-maker.

This returns us to the question of the significance of process in relation to the image. Again it is useful to recall, if only to dismiss it, Bazin's insistence in *What Is Cinema* that "the essential factor in the transition from the baroque to photography is not the perfecting of a physical process . . . rather does it lie in a psychological fact, to wit, in completely satisfying our appetite for illusion by a mechanical reproduction in the making of which man plays no part. The solution is not to be found in the result achieved, but in the way of achieving it."[29] Chinua Achebe makes a seemingly parallel observation when he writes in *Hopes and Impediments* of "the Igbo aesthetic value as process rather than product."[30] But there ends the analogy, for *process* in Achebe's reading of the Igbo aesthetic specifically implies the *act* rather than the *means* of making, or indeed the act as distinct from the means, since both are often of equal significance in the bid for efficacy. Whereas Bazin's theory rests on a precisionist equation predicated on scientific agency, that is, on the assumption that the application of a specific body or level of instrumentation would yield a calculable result with minimal human input, the aesthetic that Achebe articulates, on the other hand, places its accent on the details of the manual or human factor, on *making* rather than *registering*. Yet, much as the act is an essential element of the image-making process in Africa, it is nevertheless the product, the image, and its efficacy, its ability to satisfy demands largely unrelated to mechanical specifications, that ultimately count. Such is the condition of the image. And one could argue that this is essentially the case with either the photograph in the veneration of twins or the Amharic funeral procession, or Peter Magubane's photographs of mines and miners and Mohammed Amin's images of famine victims in Ethiopia, or indeed Fani-Kayode's images of the Yoruba deity of ambivalence. A preoccupation with the mechanical intricacies of the darkroom or the details of physics and chemistry and light has no place in the process and purpose of image-making beyond the striving for greater effectiveness.

From the foregoing one may attempt to articulate a theory of the photographic, where its essence resides not in the details and mechanics of reproduction but in the significatory possibilities of the emergent form. This we might call the substance of the image, for it is in the image, rather than the apparatus of its making, that the relevance of the medium is situated. The fallibility of this image is taken for granted, as is its subordination to the dictates of human agency, and this fallibility necessitates a frame of ambivalence. It is this ambivalence, often subsumed under the illusion of scientific verity in the West, that governs the production and consumption of the photographic image in Africa. Whether applied to the imaging of gods, to the rituals and logistics of mourning, or indeed in the recovery of the literal moment, photography is perceived as lacking in inherent integrity, and thus open and available to the whims of power. Rather than the innocent register of a literal configuration evacuated of the extra-aesthetic, the photographic image is rightly understood as a dominable site, the frames of which must be guarded and contested for. In the end that which levels the photographic with the rest of the image-making processes, namely its lack of integrity, also underscores its significance, its substance.

The Location of Meaning

It is within this framework that we can meaningfully approach two revealing incidents that call attention to an important aspect of the photographic image in Africa upon which one may conclude. These are Khedive Mehmet's attempt to locate himself behind the lens and take control of the photographic process shortly after the arrival of the daguerreotype, and the reaction of members of the Ethiopian court to Edoardo Ximenes's application of the camera in Abyssinia, both mentioned earlier. Monti informs us that Vernet frustrated the Khedive's initial attempts at photography by supplying or using suspect chemicals on the resulting photographs, which meant that the images failed to register. This act of subterfuge earned him access to the forbidden territories of the monarch's women's quarters, since his expert services had to be engaged for a more reliable second attempt. Beyond this voyeuristic license, however, the act also signaled the beginning of a contest between the African and the outsider for photography as a tool and for the photographic image. Obviously reluctant and displeased with the choice to grant Vernet access to the privacy of his wives' quarters, Mehmet also realized that, in bringing so manipulable a medium as photography to bear upon the body of another, the presence behind the camera must be one with that other, must share in a fundamental sense a certain identity with her, or else the photographic encounter becomes an act of trespass and violation. In other words, the Khedive's experience with Vernet initiated a struggle over authorship and its privileges, especially the details of power over the production of knowledge that determines the nature and uses of such knowledge. It was his awareness of these details and their ramifications that led the Khedive to retain all images and thus reassert his authority over them.

In *Africa Then*, Monti also mentions another incident in 1896 in which an Ethiopian nobleman protests the copious use of the camera by Ximenes, noting rather ruefully that Ximenes had "too much in his camera already" and wondering whether he wanted "to take away the whole country."[31] Not only was Ximenes taking his photographs during a period of great political sensitivity, namely the Italian campaign against Abyssinia, thus constituting an intelligence threat, but more important his respondent was not unaware of the seamless possibilities of the loose image. Both Mehmet and the Ethiopian nobleman identified the manipulable image as the site of significance in the photographic process. Both understood that the primary element in this process is not the mechanical but the human agent, and like the Yoruba and their photographers, both knew that the contest for meaning in photography must occupy itself with the image itself and its substance.

1996

Medium, Memory, Image

The Project of Memory

In the late twentieth century the project of memory became a preoccupying one, especially in art but also in other areas of culture. While it could be said with some degree of accuracy that the preponderant endeavors of modern art in the first half of the century, and indeed right through the 1950s into the 1960s, were experimentation and the desire to forget, the years following have certainly been characterized by a proliferate indulgence in the archaeology of memory and a persistent dredging of the past to salvage fragments under threat. This preoccupation exists amid a flurry of contradictory theory struggling to grapple with the seeming suddenness of myriad eruptions in cultural practice and discourse at the millennium. Strangely enough, the determination to locate peculiarities in the cultural ethic of the late century has led some to conclude, despite this preponderant indulgence in the project of memory, that the epoch will be remembered instead for its dedication to amnesia. In the main this deduction has relied on three principal factors. One is the emergence of digital culture, with its reputed tendency to cede the task of remembering to technology. This predilection Jean-François Lyotard addressed in his treatise *The Postmodern Condition* in 1979. The second factor is what has been theorized as the West's long-running determination—perhaps, more accurately, Germany's—to occlude or rise above the memory of Nazi terror. The struggle against memory in the period following World War II has generated a great deal of theoretical and narrative attention, from Theodor Adorno's famous yet flawed charge that, after the Holocaust, poetry (read art) is impossible to Andreas Huyssen's paradoxically subtitled study *Twilight Memories: Marking Time in a Culture of Amnesia*, which does contest the notion of an epoch of amnesia.[1] The full breadth of the debate over Nazi terror and the so-called culture of amnesia is one that we cannot possibly engage here.

Even so, failure to acknowledge the preeminence of the project of memory in the late twentieth century, hence the erroneous conclusion that the age is one of amnesia, is equally predicated on a third factor, which is a greater, amnesic predilection: namely, the will to ignore and thus forget the multiplicity of cultures and practices engaged in the recuperation of memory at the end of the century, and the tendency to deduce the state and location of culture, not from but in spite of this multiplicity. In other words, it is only by characteristic Occidental navel-gazing—by ignoring all interest and engagement in the project of memory except that which occurs, or fails to occur, within mainstream Western culture—that philosophy can arrive at the conclusion that the late twentieth century is an epoch of amnesia.

Fortunately, there has also been a considerable wealth of arguments against such a position, from within mainstream discourses as well as from so-called minority contingents. Some have again concentrated on manifestations within the dominant cultures of the metropolis, while others have ventured further to acknowledge and account for the project of memory within cultures aside from the dominant. In recent years scholars have devoted time to studying the engagement with remembrance among occupied or displaced cultures, first nations, and indigenous and Diaspora populations, as well as postcolonial polities. Although the greater bulk of debate in this regard still centers on the trauma of Nazi terror and mnemonic responses to it, some of the debate has also begun to reflect Native American, Diaspora African, Irish, and Aboriginal engagement with memory, among others.

All in all, what is missing from these discussions—what criticism appears incapable of grasping because of its growing tendency to preoccupy itself with surfaces—is a more studied understanding of the specific ways in which artists engage not simply in the recuperation or archaeology of memory but also with the nature of memory itself; how their choice of media, techniques, and strategies of execution reveal deep reflection on the vulnerability of memory, and how they translate their awareness of the nature of memory into enactable and visual tropes. Among those who acknowledge the preoccupation with memory in the late twentieth century, the tendency has been to dwell on what has been described as "musealization," or the emergence of a memory industry that manifests itself through the mushrooming of museums and memorials, which are, in a fundamental way, no more than part of the spectacle industry. At best these are only readily visible aspects of the project of memory, and the least interesting, hardly enough to support the conclusion that Huyssen and others seem to share: that the primary obsession of the age is a "desire to articulate memory in stone or other permanent matter."[2] Missing, then, is the awareness that a far more interesting aspect of the project of memory is the search among artists for a new medium to encode memory, because the engagement with memory no longer requires or relies on the permanence of medium (museum, public memorial, landmark), but on the medium's ability to structurally and tropologically encode the fragility of memory and our consciousness of this fragility. In other words, the essence of the project of memory is no longer simply the preservation of memory in the form of particular incidents and historical moments, but instead the gestural or conceptual engagement with

the structure and essence of memory itself. If we should ignore the state and historical or heritage societies, with their moneymaking municipal museums and landmarks, what do we learn about memory itself by looking at the ways in which artists struggle and dialogue with it, in full knowledge of its unreliability and treacherousness, its vulnerability to power, its frailty?

Though one must refrain from generalizations, it does appear that this structural and conceptual engagement with the nature of memory occurs most among artists within cultures and societies whom memory has failed in the past, whose collective memory has suffered repression or the threat of displacement or obliteration, whose distrust in recollection is most acute because they know best how unreliable memory can be. There is an indication also that this engagement is equally rooted in a desire to retain ritual enactment as the primary order of memory, as opposed to the delegation of memory to permanent, mediated, and depersonalized organs of remembrance. It is the intention here to look at the work of three artists from such locations in whose work one finds a relationship with medium, memory, and the image that is ritualistic, where imprints are made and repeated, history is broken down and serialized, and tools and techniques are chosen to parallel or reflect the structure of memory as a fragile entity. We shall look first at American artist Jacob Lawrence, whose work begins not in the memory-obsessed late twentieth century, but indeed in a different era, when the project of memory nevertheless still mattered to his place in history; then African sculptor El Anatsui and Australian artist Fiona Foley, both of whose tools and techniques aspire to replicate the configuration of history and to shore up against the perfidiousness of memory. In the work of these artists there is a conscious dwelling on the essence of ritual as an organ of remembrance, and on the ability of medium and image to plumb and echo the nature of memory itself, and in essence to do more than serve as mere reliquaries of memory.

Jacob Lawrence: The Migration Series

Jacob Lawrence stands alone as America's most significant history painter of the twentieth century. Not only does his grasp of history and his dedication to research—that most important tool of the history painter's vocation—stand him out among our century's practitioners of the genre, but his adoption also of the serial form, a device of narrative delivery taken more from the early years of the novel and cinema than from the precedence of William Blake, Francisco Goya, or the Mexican muralists, and his introduction of this essentially popular device into the exulted sites of history painting, place him among the most innovative artists of his time.

The Armory Show of 1913 in New York threw American painting into deep crisis, confronting an essentially conservative, indulgent, and inbred tradition with what was considered a wildly radical, eclectic, and almost profane assault on the sedate sites of Occidental culture. The vast show of European art, organized by a group of conservative artists in the spaces of the Sixty-ninth Regiment in Manhattan early that year, brought three hundred thousand spectators, many of whom would henceforth con-

sider mainstream American art inadequate and inordinately provincial. Torn between shock and fascination at the new art from Europe—and not entirely aware of or indeed enthusiastic about its deep indebtedness to the art of Africa and Oceania—American painters tried to demonstrate equal ability for a radical shift from the stymied classicism under which they labored. The result was a brief submission to the allures of modernism, manifest most significantly in the work of artists who gathered around the photographer Alfred Stieglitz's Gallery 291 in New York. But this romance was to be short-lived.

Frustrated and ill-equipped with the colonial access that European modernism had to revolutionizing sources outside its immediate geography, American artists soon succumbed to a backlash of conservatism, coded in a desire to return to the safe location of the "great American tradition." By 1913 even some of the most radical of the Stieglitz artists had returned to "American" painting, a new provincialist romanticism that challenged neither form nor media and sought fulfillment only in the form of mediated nostalgia. Replicating John Ruskin's provincialist theory in England, which advocated the manifestation of the indigenous spirit in art at the turn of the century, most American painters embarked on the invention of an American aesthetic defined by evocations of a pastoral heritage, especially in landscape and cityscape painting. Painters like Thomas Hart Benton employed new romanticist forms cobbled together from a mixture of pre-Raphaelite heroic naturalism and subsumed allusions to postanalytical cubism in works that celebrated American folklife. Edward Hopper engaged in an existentialist exploration of suburban America. Henry Tanner, though more familiar with the developments in Europe than most of his contemporaries, upon return to America retained a mediated High Renaissance style in his paintings of African American folklife.

Besides Stuart Davis, the only truly radical contingent in American art during this period with regard to innovations in form and departure from the European Enlightenment aesthetic were African American painters. While Caucasian artists in America radically opposed the modernist wave in Europe, a number of African American intellectuals and artists recognized parallels between their need for a distinct aesthetic, derived from and inspired by their historical legacy in Africa, and the project of the Euro-modernists, which rested on a less attached, formal allusion to Africa. The leading proponent of this aesthetic was the writer and academic Alain Locke.

Educated and widely traveled in Europe, Locke was familiar with developments in the art centers of Europe, especially in Paris, where he made frequent visits to ethnographic museums, especially the Trocadero. It was at the Trocadero that, having found African sculpture, Pablo Picasso informs us in his conversations with André Malraux and later with his mistress, Françoise Gilot, he discovered "what painting was all about," and the first significant work of modernism, *Les Demoiselles d'Avignon,* was born.

While in Paris, Locke was privy to the development of early modernist art. Building on this, his writings upon return to America in the 1920s provided African American artists with a theoretical framework for explorations into formal possibilities involving the incorporation of forms and ideas from Africa, not in the same mimic

manner as the art developing in Paris at the time, but with depth and attachment. Alain Locke was equally remarkable in his peculiar insistence on aesthetic configuration, on the nature and appeal of form as opposed to the location of meaning in social content.

The art that was produced around the new aesthetic proffered by Locke differed markedly in the main from Euro-modernist art to the extent that its references to works of African art were minimal and emotive rather than mimetic. Instead of mimicking African art as the European modernists did (Picasso, Georges Braque, Max Ernst, Paul Klee, and their friends), African American artists working within the frame that Locke suggested only elected Africa as a tangential referent. The modernism they propagated in the 1920s and 1930s was in several respects inventive, and where it directly referenced traditions elected Egypt or an African imaginary as a model, in line with the work of Meta Warrick Fuller, America's most remarkable woman sculptor of the nineteenth century.

In the works of Aaron Douglas and several others we find references to the art of Egypt, the silhouetted figure, the flat projection, the slit-eye of the mural art of Upper Egypt, the regimental posture. Douglas had arrived in New York as a young artist in 1924 and quickly made the acquaintance of Locke, whose 1925 anthology of essays, *The New Negro*, Douglas illustrated with great attention to the aesthetic that Locke proposed. In addition Douglas had been introduced not only to a wealth of African sculptures, but also to works by the Euro-modernists in the collection of art patron Albert Barnes of Philadelphia.

Douglas's work derived from an emotive rather than alienated or merely referential attitude to African forms, a reclamatory rather than appropriative approach. By 1925 he had evolved a graphic style of silhouetted and patterned imagery that would be echoed later by Henri Matisse's cutout patterns of the 1950s and in Picasso's work of the mid-1930s. We find, in fact, in some of Douglas's work from 1926 elements that prefigure the work of the precisionist Charles Demuth two years later. Douglas, more than most of his contemporaries, broke from the mythic American tradition that Benton and others pursued, same as Euro-modernism ruptured the European tradition. Though Douglas would be inaccurately excoriated along with others by the youthful Romare Bearden in 1934 for lack of originality and a progressive modernist inclination, he and Stuart Davis stand out among American painters of the 1920s as the only significant purveyors of a truly modernist attitude to form. And Douglas's work would eventually have far-reaching, if as yet largely unacknowledged, influence on the work of the outstanding young artists of the 1930s, among them Jacob Lawrence.

With the Great Depression in the 1930s emerged a strong inclination toward social realism in American painting, prefigured by Hopper's existentialist works of depopulated American landscapes, such as *Sunday Morning*, and very much formed by the strong intellectual influence of radical political contingents as well as developments in documentary photography and film. Artists steered their concerns toward the condition of the working class in a depressed America, inspired in part by the revolutionary

art of the Mexican muralists and supported by the Works Progress Administration Federal Arts Project under Franklin Roosevelt. In Harlem, the cultural center of African America since the mid-1920s, WPA artists gathered round the West 141st Street studio of painter Charles Alston, where workshops were conducted for young artists. The teenaged Jacob Lawrence began his study in the workshops in 1932, but by 1934 had moved on to work in Alston's studio and then on to the American Artists School on West Fourteenth Street in 1936.

It is hard to establish what might have inspired the teenaged Lawrence's emergent and determined interest in history painting, beyond perhaps Aaron Douglas's 1934 mural series *Aspects of Negro Life*. In 1936, when Lawrence began his first historical series, *Toussaint L'Ouverture*, the pervading preoccupation of American painting, as already indicated, was of the social-realist genre. Douglas's mural, however, combined the painter's radical form with a unique historical intent presented in serial form. It is noteworthy also that Douglas's studies for *Aspects of Negro Life* were executed in tempera on paper, a medium that Lawrence would adopt not only for his first historical series but for much of his work as a history painter. Douglas's work was, of course, installed at what eventually became the Schomburg Center, the site of Lawrence's research for *Toussaint L'Ouverture* and the epic series that eventually established him as one of the most celebrated artists of his generation, *Migration of the Negro*. Whatever his immediate influences, it is noteworthy that by the time he finished the forty-one-panel *L'Ouverture* series in 1931, Lawrence had almost fully formed the pillars of his career as an artist, namely a single-minded dedication to history painting, the narrative form, and a stringent formal language focused on signification without distractions or aesthetic elaborations. This tenacious preoccupation with history would be replicated half a century later in the driven work of Jean-Michel Basquiat, who described his own paintings not as art but as tablets, as Scripture. Although he is hardly recognized as a history painter, Basquiat, more than any other American painter of his generation, nevertheless stands alongside Lawrence as one of the finest practitioners of the genre.

Between 1938 and 1940, Lawrence had completed two other series: on the writer and abolitionist Frederick Douglass and on the icon of the first Negro migration to the north and conductor of the so-called Underground Railroad, Harriet Tubman.

Drawing on what he considered the most eloquent form for his project—simple, elementary colors, the silhouette motif, minimal figuration, the format of the miniature, and the popular media of the graphic artist—Lawrence stripped history painting of its grand formal associations without disassociating it from heroism. His period with the Alston studio and his studious approach to research provided him the opportunity to perfect his technique, intent throughout on discarding all dross and instead gaining mastery of form that was essentially modernist and yet supremely poetic in its austerity.

As he completed the *Harriet Tubman* series, Lawrence applied for a grant to facilitate his work on *The Migration* series. His intent, as stated in his application to the Rosenwald Fund, was to "interpret . . . the great Negro migration north during the

World War." Already going by the reputation he had acquired as a remarkable artist with a unique vision, he could count on the support of several well-placed figures in the art world, and most significantly on Alain Locke. Once he secured the funds, Lawrence pursued the preparation of the series with unwavering tenacity, completing the sixty panels between 1940 and 1941 with the assistance of another WPA artist, painter Gwendolyn Knight. Upon completing the series, Lawrence, as if with a self-evident sense of the historic import of his epic, married his companion Knight, and having renewed his grant set off for New Orleans, where he immediately began work on a new project, the *John Brown* series. From the moment of its completion *The Migration* series would assume a life of its own and confirm Lawrence's place in history.

In the sixty panels of the series, Lawrence traces the social and historical background of the great movement north by African Americans, the nature of the exodus, and its consequences for the migrants, their host society, and America. In the panels he deals with the conditions of the African American in the South at the beginning of the century, with segregation and racial violence, with the Jim Crow laws and the unfairness of the justice system toward the African American, and with the details of the migration north. Poignant and precise in his cinematic summation of these details, he set them out in text to accompany his images. Rather than illustrate the text, Lawrence's combination of image and text introduced a dimension that showed a unique flexibility toward history.

At an impressively early age, Lawrence was acutely aware of the fragility of memory and the necessity of emphatic inscription in the same way that Basquiat, in his own time and at the same age, recognized the need to reinscribe history over and over again, with an almost obsessive and evidently prophetic repetitiveness. Like Basquiat several decades later, the young Lawrence was fully aware of the vulnerability of knowledge and the perennial alignment of domineering and suppressive forces against memory. For Lawrence neither image nor text was sufficient to convey and preserve the epic memory that he chose to depict; neither was memory adequate by itself to register indelibly the epoch he addressed. In *The Migration* series, image and text underline each other in an insistent, iterative effort to place history outside the slippery sites of memory, to transform memory into the tangible, to imprint it on tablets. Lawrence equally prefigured artists like Lorna Simpson and Carrie Mae Weems, who, in combining the photographic image and text in their work, aim to magnify the eloquence of their signification and render the occlusive impossible.

Lawrence's combination of text and image refers the viewer back and forth from image to text with an oscillatory, metronomic insistence that allows no escape from a revelatory engagement. So would Weems's or Simpson's images several decades later. In looking at Simpson's *Water Bearer* today, its text registering the vulnerability of memory to willful amnesia, we are reminded of Lawrence's work half a century before. To reemphasize this intent, Lawrence, like Simpson today, elected anonymization and the obliteration of the subjective as a device to frame interpretation and disallow the distractive preoccupation with mimetic semblances. In *The Migration* series Lawrence's figures are faceless and appear generic, reduced to signs. In this way our

attention is masterfully directed to the theme of each frame, and ultimately to the uniting theme of the narrative. For instance, in *Panel No. 15,* perhaps one of the most evocative in the series, Lawrence depicts a lynching by posing a hurdled figure dressed in red against a vast, barren white landscape across which also falls a horizontal tree branch from which a noose dangles. Our eyes and our attention are effectively riveted on the figure, the noose, and the arid whiteness around and before the figure, but even more so the last two, for the noose is so positioned that to behold the whiteness in the background, *to behold whiteness,* is to behold the noose. Within this compositional frame, then, the figure is shown cowering not merely from the noose but more from its metonymic manifest: *whiteness.*

One of Lawrence's most amazing rhetorical devices, however, is his use of perspective, which is manipulated to produce scaffolds of signification unattainable through hyperbole. Through his use of perspective, Lawrence is able to zone in speedily and effortlessly on the locus of each narrative, to indicate hierarchical configurations as well as urgency and movement. By selectively distorting scale and aligning this distortion to meaning, he succeeds in registering the inequality of race relations and, at times, vulnerability and anxiety. This is particularly evident in three panels. *Panel No. 14* shows the unfairness of the justice system through the imposing figure of a judge looming above two cowering figures. *Panel No. 41* captures the towering presence of the penal system in the South and its brutal disposition toward the Negro and all those who aided her emigration. In *Panel No. 42,* Lawrence captures the equally looming stature of the law through exaggerated perspective that locates a towering law-enforcement agent above two migrant laborers.

It is remarkable too that the panels were conceived in format and scale that reference the stone tablet, the bronze plaque, and, perhaps most important, the cinematic frame during a period when the mural was a favored form, made popular especially by the Mexican modernists. The scale of Lawrence's panels, twelve inches by eighteen inches each, is highly unusual for the genre of history painting. Yet in installation they come together to constitute one of the largest history paintings ever assembled. In his choice of format, therefore, Lawrence radically sidestepped the tradition of the European Enlightenment, appropriated from the cinematic form, appealed to the ancient art of stone inscription, and prefigured late-twentieth-century installation practice.

Lawrence's panels do not overwhelm us. Instead they pull us in and, having done so, draw us through the trail of the artist's intent. They demand the intimacy of the close encounter: rather than offer momentary pleasure, they instead methodically speak to our knowledge of history and test the efficacy of our memory. They employ a beguiling yet radical form to articulate a crucial portion of the American experience in same manner that James Baldwin, by addressing himself to the African American experience, encompassed America's history and dilemma. Lawrence's election of history as a site of discovery and performance, peculiar as it appears in an epoch that is preoccupied with the exploration and interrogation of form, signified progress. His earlier series made a significant contribution to the process of locating the historical within modernism and to determining the possibility of narrative without recourse to naive provincialism.

His decision to predicate the memory of the Negro on the concrete pedestals of recollected history, on the site of struggle within the Americas rather than on the mythic glory of African ancestry, constituted a radical intervention at a time when the pressures of survival in America encouraged romanticism. His swift discovery of an appropriate form and his tenacious application of this form to his genre denote a remarkable sense of purpose and place as well as an incredible awareness of the weight of history. In his twenties, Jacob Lawrence had the clarity of vision to inscribe recent memory in forms that transform and preserve, and his mastery of form is evident in *The Migration* series. When we contemplate postmodernist practice and the deconstructionist preoccupation with memory and the reconstitution of fragmented history, we appreciate Lawrence's legacy.

Shortly after *The Migration* series was completed in 1942, it was acquired by two important institutions: the Museum of Modern Art in New York and the Phillips Collection. It was immediately celebrated as a great work and has had a remarkable exhibition history. Its tour through America in 1993 provided many with the opportunity to see this remarkable work reunited, and to appreciate in its totality the vision and talent of one of the century's greatest artists. The same year before it went on tour, Lawrence revised the titles and text of the series, renaming it *The Migration of African Americans* and replacing the extant referent "Negro." This way he not only brought the work up to date for the times, he also engendered it with the ultimate historicity: that quality of openness to revision and aversion to foreclosure.

El Anatsui: The Persistence of Memory

In the 1980s and 1990s El Anatsui emerged as perhaps Africa's most significant and widely recognized contemporary sculptor. In addition to performances and public works both in and outside the continent, he has held several exhibitions around the world and participated in numerous international collaborations and shows with Marina Abramović, Antony Gormley, Alfredo Jaar, and many other artists, some of whom have already been inducted into the canon of twentieth-century sculpture. Though Anatsui may still not claim such distinction for himself, he has nevertheless acquired considerable visibility through the quality and power of his work, as well as through his itinerancy, which has brought him and his sculpture to the notice of the art community in and outside Africa. He has taken part and won prizes in several biennials, including the Biennial of Venice, where he jointly won a first exhibitor's medal in 1990, and the sculpture Biennial of Osaka, Japan. His sculptures have found their way into private and public collections in several countries, and residencies abroad have become part of his regular schedule, though he continues to maintain an influential and much needed presence within the art community in Nigeria, where he has lived and worked for more than twenty years.

Anatsui began his career in Ghana, where he was born and where, as a college student in his early twenties in 1965, he was commissioned along with a few others to produce heraldic sculptures for the Organization of African Unity conference in

Accra. His art education was standard, steeped as it was in the canon of the academy. Figuration, anatomical accuracy, detailed knowledge in the traditions of medium—these were the tenets of the art curriculum that obtained in most art academies in Africa in the 1960s and indeed to this day. Much of the formal and conceptual up-heavals in art and art-making that characterized the twentieth century—such as the disregard for canonical adherence to figurative accuracy or faithful mimeticism, the abandonment of the science of perspective, the ascendance of earthwork and outdoor projects as opposed to studio objects, the demise of conventional portraiture—were hardly evident in those academies. Anatsui's early work manifests this academic background.

Not long after art school, however, his inclination for experimentation and alter-native languages began to reveal itself as he abandoned the legacies of his training and embarked on a literal journey of discovery that would eventually distinguish his sculpture and career as an artist. Upon completion of graduate work in Kumasi in the late 1960s, Anatsui took up position as sculpture instructor at Winneba College, where the highly reputed modernist sculptor Vincent Kofi had been an instructor. There Anatsui began to experiment with media other than the concrete and modeling clay he was used to in art school. Even more significantly, he began to redefine for himself the tenets of creative involvement by adopting ready-mades as the core of his work.

Another important aspect of Anatsui's career at this stage was his increasing incorporation of formal and conceptual elements from Ghanaian art traditions into his sculpture. At Winneba these elements became a defining attribute in his work. In addition to the ready-mades he used, which were mostly in the form of wooden display trays used by grocers and ware vendors in Ghanaian markets, Anatsui also used specific ideograms from the wealth of Akan writing and linguistic traditions. Among the Akan, writing comes in the form of ideography that is strikingly similar to Far Eastern calligraphy, albeit without the formal laterality of those scripts. The most popular form of this ideograph is known as *adinkra,* and may be found inscribed on everything from furniture and fabric to walking staff or the side-panels of public transit vehicles. Like Far Eastern scripts, Akan ideography is built around abstractions of nature—animals, leaf formations, human postures—all of which metonymically stand for idiomatic phrases and adages. These idioms, like spare aphorisms, encap-sulate common wisdoms as well as deep, philosophical deductions about life, history, society, existence, and the nature of the universe. In other words, Akan scripts retain the elements of condensed signification that are characteristic of all early scripts, and within their cryptic characters congeal whole narrative complexes that encode the social structures and cosmology of the group. Unlike what today remains of the Latin script, rid as it is of both history and symbolism, the Akan ideogram remains a mnemonic sign, a repository of memory and myth—myth as the codification of both history and norm.

For Anatsui the use of Akan ideograms in his work had two obvious purposes. First was to prioritize a particular formal language above another, in this case the nonfigu-rative over figuration. Inadvertently, this route of departure from figuration paralleled

developments in American and British painting, where the post-Bacon, post–abstract expressionist generation of David Hockney and the rest were equally incorporating inscriptions in their work, though hardly any parallels in sculpture readily come to mind, except with some of the conceptualists like Joseph Kosuth. A second reason why Anatsui adopted these scripts was to impose a specific cultural idiom on his work by pushing even further his formal departure from the tradition of the academy, a departure that was, in effect, a return to his own traditions. By incorporating clearly identifiable elements of Akan or Ghanaian graphic or visual traditions into his work, Anatsui in effect sought to subvert his essentially, culturally nondescript training, and in this way locate himself and his work in a different, preferable cultural space. One ramification of all this was that by the same token, Anatsui brought symbolic inflation to his work and imbued it with those histories, myths, and mnemonic inflections that are concisely encapsulated in the ideograms he inscribed on them. By looking at and reading his work, one could not only decipher a cultural and ideological predilection on his part, one could also engage the visual coda of an entire society's historical and social particulars. Anatsui's work with history and the collective memory, or what he would later describe as the collective unconscious, had begun.

In 1975 El Anatsui moved to the University of Nigeria, where he was attracted by developments in scholarship and the arts that ran along the same lines as he had begun to experiment with in Winneba. There too he found among the Igbo of eastern Nigeria a sculptural tradition in which inscription, abstract patterning, and the use of ideograms were central, and conceptualism rather than figuration was the norm. These elements were already pivotal in the work of a new movement in Nigerian art that formed around the figure of the painter and stained-glass master Uche Okeke.[3] In the late 1970s and early 1980s after his move to Nigeria, Anatsui produced mainly ceramic sculpture, beginning in 1978 with his *Broken Pots* series, which were first exhibited at the British Council in Enugu, Nigeria, in 1979.[4] In this and his subsequent series, *Venovize,* a group of more than 120 pots that he produced as an artist in residence at Cornwall College in Cornwall, England, in 1985, memory and remembrance were the preoccupying themes. According to the artist the *Broken Pots* series was inspired by the eschatological principle of death as regenerative rupture that is common among most African groups: the idea of death as not an end but as the moment before a beginning in a cyclical order, or what the poet Christopher Okigbo described as "a going and coming that goes on forever." The ceramic wares in *Broken Pots,* some of them fairly large, were built up from fragments and shards and held together rather tenuously with unsealed fissures to emphasize the essential fragility of the ceramic as material or object, which in turn metaphorically signifies the fragility of both memory and life. Memory may be fragile like a clay vessel, the artist seems to say with the pieces, but it is also resilient in that the fragments or shards last for generations and centuries, and could always be pieced back together if a people do not lose the pieces that make the puzzle. History may be treacherous, but the elements that comprise its ambivalent syntax are in themselves immutable and hardy, and could always be reassembled into fresh narratives. In *Broken Pots,* Anatsui figures his preoccupation

with recollection and history in a number of pieces that deal with what he describes as "intact *Chambers of Memory*," which are deeply buried reliquaries of communal lore and memory that underline a culture's sense of distinctness and history, as well as its understanding of the patterns of social manifestation.[5] As he once noted, it is these chambers of memory, buried like relics or shards in a heath, that "provide the grog of experience," especially when a society must retrieve and revive itself from decline to enable regeneration. We may interpret them as history beyond individual documentations of the past, history interred as a narrative of collective wisdom.

One important goal of the *Broken Pots* series was to remind the viewer that the relic is not only artifact but reliquary also, a reservoir of memory from which the past, like an encryption, may be decoded and reassembled into a narrative. Each one of the pots in *Broken Pots* is made to resemble an archaeological relic, an unearthed legacy of a past civilization, as the material residue of myth. By modeling them in this form, Anatsui created a visual conflation of the discourses of ritual, memory, and myth that points to a deep understanding of the nature of myth as transfigured history. Anatsui gives sculptural form to myth to relocate the site of memorial reenactment from ritual performance to aesthetic engagement. Because his ceramic sculptures metaphorize history in same way as ritual enactment, they become triggers for ritual experience. He elevates the fragment, the unwhole, because he recognizes the futility of absolute recollection. He also recognizes that memory is essentially fragmentary and that the purpose of history, ritual, and myth is to mediate this fragmentariness.

In one of the vessels, *Broken Chambers of Memory*, 1979, for instance, Anatsui references the ceramic-sculpture traditions of Nok, a ninth-century Niger Basin civilization in which terra-cotta figured prominently. *Broken Chambers of Memory* is close to a facsimile of a well-known Nok terra-cotta head. Unlike the Nok head, however, the Anatsui head is modeled to serve as both artifact and reliquary. It artificially reproduces fracture and dilapidation. It is also chambered and sealed so that it projects ruin not only on the fractured surface but within the enclosed space as well, where structural dilapidation is carefully factored. In almost replicating a specific artifact, Anatsui presents his object as a like repository of history, a *chamber* of memory, which is physically broken or fractured but symbolically intact. The artifact contains in itself the history and memory of a particular age, and its specific metamorphoses represent both its individual odyssey as an object as well as that of its culture of provenance. It is like a bottle with a message that bears a narrative of its journey as well as the hidden message within.

Although much dating has been carried out on the artifacts attributed to the Nok civilization, little is known about the people who produced them and under what circumstances and for what precise purposes they were produced. Archaeological work in other parts of the world led to elaborate reconstructions of societies and historical epochs about which little was known before the discovery of their material cultures. In the case of Nok, however, not only did the producing culture leave no inscriptions, its location on alluvial plains susceptible to erosion and the apparent predominance of nondurable architecture in the region have meant that little other than the sculptures

were preserved. In addition, it would be safe to observe that little serious scholarly interest in anything other than the mere artifacts from Nok has been forthcoming. Therefore, a Nok head points to us a civilization, knowledge and memory of which are mediated and compromised by time, even as it encodes a history specific to itself as artifact, as object—a history of utility, disposal, interment, excavation, reclamation, and re-presentation. It is an unbroached chamber of knowledge and information, reliquary of the lives and stories of the lost culture that produced it.

There is another history of the Nok artifact, however, that is more immediate because it introduces an equally significant factor into the picture, namely that of colonial incursion. In thinking of a Nok head, we are drawn to the fact the Nok terra-cotta were discovered in the process of mining in the Niger Basin, and mining, as we shall see in another instance later in this essay, was the locus of the most brutal manifestations of colonial exploitation and violence in the twentieth century. Upon discovery the Nok terra-cotta were hurriedly excavated, many of them lost to flooding and vandalism due to the exigencies of mining in the basin. The excavation of the Nok artifacts and the specific contexts of their recovery are emblematic of a larger history of colonial economic and ecological foray in Africa and other parts of the world, and this aspect of history is one that is of particular interest to Anatsui. A Nok terra-cotta is a sign, therefore, of history fractured not only by time, but also by outsider intervention—history inflicted upon. It is a broken chamber of memory, compromised by the circumstances of its passage from art to artifact, and not the least by the history of colonial infliction on the culture of its provenance. Anatsui evokes this rupture in his quotation of the head with his piece, *Broken Chambers of Memory*.

El Anatsui has mentioned that his affinity with clay owes somewhat to a certain Ewe facility with the material. He equally locates this facility within history and the migration myths of the Ewe:

> More significantly, too, the urge to manipulate clay could be regarded as an offshoot of the experience of my people the Anlo-Ewe in their history of migration to their present abode. They sought protection from a powerful king at Notsie (in present day Togo) who later refused to let them go. Notsie was fortified with strong, extremely thick clay walls which the Ewe had to break down in order to escape, by devising a plan whereby everybody had to pour all used household water at a designated portion of the wall for years till it was weakened. (I had seen the vestiges of these walls as a school boy.)[6]

His interest in clay he thus explains as the result of "collective unconscious and conscious forces at work, you might say."[7] The narratives of Ewe persecution under the tyranny of the king of Notsie go further than the preceding example. In their years of captivity the Ewe developed their skills in clay manipulation. This skill in itself became cause for further persecution, in one instance leading the king to request that the people make him ropes from clay.[8] Anatsui alludes to this in one of his Cornwall pots, *It Is upon a Model of the Old Rope That a New One Is Woven*, 1985. With time, clay became not only a craft medium for the Ewe, but also a commemorative one, the manipulation of which became a ritual. Because clay had become encrusted with the

silt of history, to handle it and mold it and turn it and transform it was to engage in a communion with that history also; to reiterate it, almost sensuously, almost painfully, almost defiantly, almost triumphantly. Working in clay became a performance of memory. To confront clay was to ritually engage walls, vassalage, and tyranny, to replicate strategies of survival and underline the persistence of memory.

However, this reiterative affinity with clay in Ewe culture, mediated and corroded as it is today, also comes to us occluded by the hierarchies of narrative language. Without direct access to these details as outlined above, the outsider who is confronted with a piece of Ewe pottery remains oblivious to the history in the sign. In his use of clay, however, El Anatsui repositions myth within the reach of broader cultural engagement and articulation, and thus leads us in. Through his work in clay and the conscious connections that they establish between form, ritual, and myth, we are brought into contact with narratives of collective experience otherwise outside our knowledge and grasp.

It is not only clay that Anatsui has employed to deal with the agency of history and the formation and mediation of memory. In fact, the medium he has come to be more closely associated with is wood, and in his use of wood he is able to convey, in the grain of the medium, the same skeins of history that his ceramic sculptures carry.

Exodus is a recurrent theme in Anatsui's engagement with history: movement, demographic fluidity, the seamlessness of borders, the visual and mnemonic impact of the mobile mass. In a series of works in wood produced in 1988 and dedicated to African history, Anatsui repeatedly returns to the significance of migration in this history and in the formation of Africa's political and cultural configurations. In one of the works from this series, *Crowd Awaiting,* for instance, the artist portrays a lineup of figures representing migrants. The work is arranged such that the viewer is placed at the beginning of the lineup—the Beginning, as it were, the moment of contemplation and decision when a group prepares to leave one location for another. Though we are able to identify this moment in the sculpture as the moment of the group's departure, we are nevertheless presented with an open-ended narrative in this piece. At one end of the work are signifiers of the myriad possibilities of causation. At the other we find tropes for the act of relocation and its consequences. When we look at the work we feel as if we are witness to the formation of a milieu, since every act of exodus inevitably constitutes the beginning of a new milieu for a group, the inception of a phase in the Diaspora experience. The moment before departure, before a group is forced to abandon its original provenance for the uncertainties of relocation, is also a point of rupture, a moment of breaking with the past and its embodying geographies, the passage of the present into history. What follows this is a new corpus of memory.

War, tyranny, the demands of mercantile or sedentary survival, a natural disaster— any of these may precede an exodus, but because history is consequent upon human action, it is the process itself, the act of movement, relocation, and the gamut of experience consequent upon that act, that creates as well as inscribes its history. In two other works from 1988 titled *Migration I* and *Migration II,* Anatsui represents this act in progress by depicting the masses in motion, an image that is recurrent in his work.

In these two sculptures, migration is imaged as both movement and inscription, as a social as well as an ecological event, a trace on human geography. In *Crowd Awaiting* the artist directs our thoughts to the beginning of a migration, the moment of flight. In the two *Migration* pieces he dwells on images of the exodus. However, in *They came at dawn, a crowd of unusually identical people . . .* , one of Anatsui's most engaging works from the 1980s, he shifts our gaze to the conclusion of the migration process, the moment of arrival. *They came at dawn* is a row of figures in wood, languid and weary, the expression on their countenances conveying a slight disorientation. In the sculpture, the migrant group appears apprehensive and insecure, bearing what appear to be offerings. The work captures the anxieties and uncertainties of a people's arrival in a new environment, an unfamiliar territory. One can almost sense an atmosphere of distrustful geniality as the immigrants stand close-knit, as if in anticipation of danger, as if negotiating for acceptance. In the work Anatsui again presents the germinal point of a historical phase, complete with its uncertainties and ambiguities. Migration is a momentous incident burdened with consequences for both the immigrant and the native. Often the consequences are tragic, as has been the case for numerous peoples in history, especially when the aim of the immigrant population is occupation rather than refuge. Colonialism was one such instance where the immigrant impinges on the world of the native and ultimately destroys it. On occasion, however, a symbiotic existence emerges between the immigrant and the native. Either way, history is thrust on a new course.

Anatsui's work on itinerancy and migration, which comprises a significant part of his oeuvre, is intended to draw our attention to the very nature of history. History remains largely ambivalent and unpredictable while the events and moments that eventually constitute and give it form are in progress. Each such moment, each act of inception, is a point of rupture, punctuation, an ominous interstice between convention and change. Each announces the beginning of a new passage, yet does not become history in itself except in retrospect, because history, after all, is only visible in retrospect. *They came at dawn* addresses one such moment, namely the moment of dissonance at the conclusion of a migration, when the immigrant unsettles the equilibrium of the host community. We are not let into the rest of the story, that is, beyond the moment of arrival itself. Do the immigrants eventually earn the trust of their hosts? Do they settle in, merge with the natives, integrate, transform as much as they are transformed, become part of the evolution of a new community, a new culture? Are they shunned, turned away, further displaced, or quarantined into the quarter of strangers? Do they engage in a confrontation with the natives? Do they proceed to sack, destroy, seize, and occupy? Do they impose themselves on their hosts or slyly transpose their own worldviews upon those of the natives? Do they rename that which is already named, that which is already there? None of these questions is broached or answered, but they are figured to be asked. The artist's offer is an ambivalent gesture.

When we consider the full title of this particular piece, *They came at dawn, a crowd of unusually identical people/They brought four little pots which they said are from each of the four corners of the earth*, which reminds us of the adoration of the magi in the

Christian narrative of the nativity, we are tempted to read into it a little more than an ambivalent reflection, perhaps a critique of cultural transgression. The four little pots in *They came at dawn* parallel the gifts of the three sages from the Orient; they are interpretive tropes, figures of divinatory insight, signifiers of oracular predilection and hierophantic privilege. Despite the countenance of the immigrants, their claims already point to a certain proclamation of superior genesis and *epistēmē*. They come bearing a history far larger than that of their hosts, knowledge from as far as the four corners of the earth, the breadth of which encompasses all things. They appear with evidence of infinite worlds engaged and conquered, with a claim to the mystery of totality. One immediately finds associations between arrival as imaged or evoked in this work and the moment of European arrival in the different lands that would eventually fall under the saber of colonial affront and conquest. The claim of these immigrants to mysteries *"from the four corners of the earth"* is no different from the West's claims of mastery of the universe, of science, history, civility, and the mystery of divine salvation, which were both logic and prelude to colonial assault and occupation. The arrival of these "unusually identical" people with their four vessels of knowledge and universal, oracular insight, therefore, strikes one as a historic and ominous moment.

Such visitations, however, need not be as historic as the moment of the colonial encounter or portend the same scale of violent disruption. They could manifest in other forms, the ethnographic expedition, for instance—small, hesitant, seemingly unobtrusive, and temporary—as was the practice throughout the twentieth century. Even more cynically, they could take the form of such contemporary practices in the culture industry as cross-cultural artist "residencies," quite popular in the visual arts, whereby a group of artists who come from different parts of the world descend on a community as part of a "project," usually billed as collaborative. When such projects take place in communities or locations outside the West, they are often indistinguishable from the ethnographic encounter. Despite their stated intentions, parties often arrive content in their knowledge of the world and ready to read and interpret the world of their hosts through the grid of that knowledge. With ethnographic expeditions, the implications and consequences can be far-reaching; take, for a celebrated twentieth-century example, the arrival of the ethnologist Margaret Mead among the people of Samoa in 1925, the immediate result of which was her book, *Coming of Age in Samoa,* which was published in 1928 to wide acclaim in the West. As revisionist scholarship has shown in recent years, a notable example being the work of Derek Freeman (*Margaret Mead and Samoa*, 1983, and *Margaret Mead and the Making of a Heretic,* 1996), Mead arrived in Samoa with fully formed preconceptions regarding the great scientific debate of the day, namely the role of nature versus nurture in the formation of human character. Coming from the nurture, or cultural determinist, school of thought, she then proceeded to use the Samoans to confirm her preconceptions, albeit that her "evidence" was the most transparent of hoaxes laid on her by a group of young Samoan girls. Nonetheless, Mead's inaccurate conclusion that sexual license is prevalent among the young women of Samoa (for which reason adolescent crises do not exist among the people of Samoa) would ultimately and infinitely alter

universal views and images of a culture that has little or no means to correct those images or salvage its reputation. Mead could be compared to the immigrants in El Anatsui's sculpture, who appear already bearing predetermined notions. And though this determinism may not alter the internal world of the visited, it nevertheless could disturb, unsettle, or irreversibly distort outside perception of that world, as happened in the case of Mead and the Samoans.

As previously mentioned, a more benign form of this visitation is the contemporary "project," some of which Anatsui himself has participated in over the years. In fact, *They came at dawn* seems to presage rather uncannily one such project in Central America, the Arte Amazonas project in which Anatsui participated several years later, in February 1992. Organized by the German Cultural Institute, Arte Amazonas brought a number of artists from different nations to provide an artistic response to the environmental vulnerability of the Amazon Basin in three locations in Brazil. Involved in the project were international artists such as Antony Gormley, Marina Abramović, Alfredo Jaar, and others, as well as a number of Brazilian artists, including the sculptor Emmanuel Nassar, who came from the south of Brazil and considered himself almost a stranger in the Amazon. As usual with most such projects, the artistic response of the people of the Amazon themselves was not elicited. In both his participation and work for Arte Amazonas, Anatsui viewed the project with ambivalence, not ignoring its essentially transgressive nature and the manner in which it replicated, albeit on a small, seemingly benign scale, the Caucasian invasion of the Amazon and the eventual pacification of the Americas. He seemed to regard the participants in Arte Amazonas as no different from the crowd in *They came at dawn*, interpreters from four continents presumably bearing with them a superior aesthetic wisdom and understanding that it is their prerogative to present. Irrespective of the results, which often fall short of the stated goals, it is not lost on us that every such visitation is an intrusion on a vulnerable locality, and to some degree a violation of a geography that cannot refuse. To this extent the Amazonas project was an almost comic repetition of history, in the sense that history repeats itself not as tragedy but as comedy. The visitation was a reaffirmation of colonial license, and seemed to reiterate the narrative of invaders rather than that of the Amazon and its peoples.

Anatsui addresses itinerancy and migration not as phenomenon but as a continuous historical process, an integral element of the human condition. He considers it necessary to recognize and trace the path of "historical factors/forces as they metamorphose and unfold continually from what one can describe as a raw physical state to very complex subtle ones."[9] In the Arte Amazonas project this subtlety manifested as an incursive visitation in the guise of artistic homage. In Anatsui's *Visa Queue*, 1992, a sculpture in which the artist represents the late-century movement of peoples from the rest of the world to the West, we are introduced to a different manifestation of "historical forces as they metamorphose," from the raw to the subtle and complex. The visa queue in the title refers to the impossibly long lines that are typical at Western embassies in cities throughout the postcolonial world today, of people applying for visas to leave their countries for the West. In the sculpture, which comprises a long,

winding line of diminutive figures in wood, Anatsui's subject is demographic reloca-
tion. This relocation is induced neither by adventurism, or the will to discover and
conquer, as in colonialism, nor through forceful uprooting and translocation as in the
slave trade. Instead, this exodus is brought on by the methodical, economic strangula-
tion of societies and nations by the West, which is part of its globalization scheme and
the rise and triumph of global capital. Because such societies and nations are increas-
ingly impoverished and ruptured to the extent that they can no longer sustain their
populations in relative comfort and social stability, and because in most instances
these societies have already shifted into induced consumerism but have not developed
parallel, internal mechanisms to satiate their altered needs without looking to the
West, there is a new wave of desperate attempts to migrate to the West at the end of
the twentieth century. Even on continents like Africa, where populations had to be
forcibly removed to the West in the past, today those populations voluntarily engage
in a desperate struggle to make that journey, to offer their labor under conditions that
may not differ remarkably from those that obtained under the old arrangement. They
battle at the embassies to offer themselves for a new kind of slavery in order to escape
the conditions of their own societies. This desperation to vacate, which is in turn
vigorously fought against by the West, is the subject of *Visa Queue*. The history that
Anatsui evokes in this work, then, is not history performed through exorcist reenact-
ment or ritual commemoration, as in his ceramic sculptures, which is history in the
service of memory and regeneration, but history manifested as tragicomic reiteration,
history as an absurdist loop. It is a history of fragmentation and collapse, again due to
an encounter between cultural and social forces.

In El Anatsui's work fragmentariness addresses not only the mediation of time
upon memory, but also the disruption and fracture of history by outsider intervention.
The *Broken Pots* series speaks to social and structural dilapidation and decay, and to
the collapse of cosmological and eschatological systems. But it also speaks to the agen-
cy of transgression. It addresses causation as not only natural and deterministic or as
a temporal imperative, but as historical also. It calls to mind the pertinence of Chinua
Achebe's deposition that each society must discover "where the rain began to beat" it.
Anatsui, an avid reader of the novelist, indeed often refers to the invocation and treat-
ment of history and causation in Achebe's fiction and those of other contemporary
African writers such as Ayi Kwei Armah and Ngugi wa Thiong'o. Anatsui observes
that these writers "are writing beyond fiction" to discover where "one is coming from
to be in a better position to chart where he should go, or even where he is going."[10] He
pays significant attention to the fact that, while change is incumbent on time, fracture
is incumbent on forces not always aligned to natural transformation. In the case of
Africa, the most significant and disruptive of these forces was colonialism. In engaging
Africa's history with colonialism, Anatsui employs both formalistic and figural tropes,
including medium and technique. Perhaps his most effective trope for colonialism is
the power saw, which became his signature tool in the late 1980s.

Typically a logging tool, which may be used on occasion for outlining in wood also,
seldom has the power saw been employed as a principal tool in sculpture, especially

on the scale that Anatsui would employ it beginning in the 1980s. Having stumbled on the idea while in residence in Cummington, Massachusetts, in 1980, Anatsui came to consider the detached and ruthless savagery that the power saw epitomizes, its inclination to "tear through" wood, as a powerful metaphor for historic vandalism: rough, persistent, dispassionate, arbitrary, and unsparing, irredeemably rapacious as it gorges its object.[11] For Anatsui, the ruthless destructiveness of the power saw became analogous to the savage aggressiveness of colonial incursion in Africa, its devastating speed an apt metaphor for what he calls "the hassling, rat-racing hypertensive pace of present day living" that is colonialism's aftermath.[12] In most of Anatsui's sculpture beginning this period, the power saw acquired an inflictive symbolism in both its action and the trace that it leaves, so that the chain saw tearing through the flesh of the wood symbolically reiterates the vandalism of the colonial experience, while the jagged scars it leaves on the wood call to mind the fissures and scars that attest to the colonial experience in Africa. In *The face of Africa's history,* a sculpture in wood from 1988, for instance, a section of controlled scriptural patterning and surface treatment achieved with small carving tools is contrasted with another of rough and arbitrary gouging inflicted with the power saw, thus creating a comparative text in a chronology of dichotomies. In the piece Anatsui seems to contrast an era of organized civility, presumably precolonial, with a subsequent one of arbitrary savagery, an age of organic harmony with one of transgressive dissonance. Anatsui intends the work to invoke history itself: "History—the face of a continent that has been battered—that still has ways of remembering."[13] While such dichotomies may appear too direct and almost lacking in complexity, Anatsui is nevertheless able to evoke the violence of the colonial encounter as well as call to mind the savaged body and consciousness that are its legacies in the postcolony.

Beyond the trauma of the colonial encounter, Anatsui is in fact just as invested in an exploration of the location of history in inscription, in text, and in recognizing and understanding the role of colonialism, not only in privileging text, but also in denying its existence, and thus the existence of history, in Africa. Leading on from his earlier interest in the ideograms of the Akan and the graphic forms of the Igbo, and especially after visiting an exhibition on writing in Africa at the French Cultural Institute in Lagos in the 1970s, Anatsui subsequently devoted himself in the late 1970s and the 1980s to the discovery and study of African writing systems with the intention to arrive at a rhetoric of refutation and acknowledgment in his work. The discoveries that he made in his personal investigation of text in Africa convinced him that "the plethora of writing traditions (in Africa), ranging from the ancient hieroglyphics to recent ones, either of secret or open societies or invented by inspired individuals, tends to belie the impression that has been created vis-à-vis Africa and writing."[14]

The immediate manifestation of this discovery was the series *The Face of Africa's History,*[15] begun in 1986 with *When I first wrote to you about Africa . . .* and somewhat prefigured by a ceramic piece, *Writing on the Wall,* 1979. In *When I first wrote to you . . .* and the rest of the series, Anatsui focuses on the place of text in a discounted history.

At the same time, he anthologizes his imagery, drawing not from a singular script or writing tradition, but from several simultaneously, thereby destabilizing and effectively occluding the syntax of the text. In effect, he undermines the privileging of text and questions its designation as the location of history. In a 1988 interview Anatsui states, "Even if there were no history without writing, the truth remains that we had writing."[16] In essence, while recognizing the relationship between memory and text, Anatsui nevertheless posits that memory persists beyond text, beyond the frailties and inconsistencies of inscription, beyond the ambivalence and machinations of the written word. In *When I first wrote to you . . .* he defines history as essentially elliptical, as a tableau with holes, a perforated scroll, the imperfection of which not even writing effectively remedies. In another work in the series, *Fragments and background story,* he further underlines this inherent and essential incoherence, as indeed he does in a subsequent series, *Patches of History,* produced in 1992–1993.

From 1990 onward, Anatsui's work on the theme of text and history constitutes a critique of writing and its predilection to occlude. Against the historicist tradition of collapsing writing and truth into one, Anatsui presents the written word as equally obscurantist and detrimental to memory and recollection. The ambivalence and suspiciousness of text is, of course, underlined by the histories of several cultures and especially by the colonial experience in many parts of the world where text was itself revealed to be a phenomenon of dubious agency and a tool of political and cultural duplicity. The triumph of Reason and the consolidation of Occidental Enlightenment led to writing being instituted as the absolute site of memory and history. Michel Foucault reminds us how the ultimate site of the esoteric in sixteenth-century Europe is not the spoken word but the written word. Writing, he notes, became "the active intellect, the 'male principle' of language. It alone harbors truth."[17] This primacy of place easily cohered with the predicament of text as the ultimate locale of Judeo-Christian mythology. Writing became an indispensable tool of Christian evangelism, the primary, indispensable instrument not only for disseminating Christian rhetoric, but also for the social and cultural stratification that created a conducive environment for that rhetoric. Besides providing "proof" for the existence of God and the location of civility, the "infallible" text was equally employed in the validation of colonial power and the pacification and co-option of opposition. That which was written could not be faulted. Text was the truth and truth was the law, although in reality this construction of text was merely virtual, meant for the consumption of those against whom text testified.

Even in the light of its duplicitous role, and indeed in the face of contemporary appropriation of writing as a performative site, notions of the infallibility of text have survived. Writing about the burning of books in First Dynasty China by Emperor Shi Huang Ti, builder of the Great Wall, for instance, Jorge Luis Borges repeatedly referred to the incident as "the rigorous abolition of history, or rather, of the past."[18] In other words, Borges collapsed history and the past into the written word, in the same manner that Derridaist postmodernism seems to have collapsed reality into the text. Yet

the valorization of text we find here, that is, the elevation of text to the status of the essence and totality of truth, history, and the past, was never universal. In fact, within cultures where the ambiguity of truth itself and the impossibility of the categorical imperative were recognized, writing was always associated with concealment and thus regarded with appropriate ambivalence. Also, writing was rightly associated with hierarchy and ultimately with the policing of general liberties, an association that indeed explains Shi Huang Ti's attitude to and destruction of sacred texts. Regarded as an unreliable and duplicitous agent, writing could not constitute an appropriate locale for the collective memory. In *Then came writing*, 1990, Anatsui tries not only to contrast the fragmentariness and variegation of history with the obfuscating orderliness and coherence of text, but also to dislodge text as the residence of absolute memory. He conceives of reality and presents it as complex, multivalent, and deeply uneven, a convolution upon which writing struggles to impose its syntactical coherence and linear rectitude so as to create a simulacrum of logic.

Then books obscured the real story, another piece from 1990, eventually draws a line between text and truth, between reality as lived and the virtuality of written narrative. One obvious object of the work's multiple references is ethnography and its textual reconstruction of the world. Another is the colonial novel and the travelogue, a genre that for reasons of authorial glibness and perhaps the exigencies of its generative circumstances is characterized by an inclination to deform and misrepresent the realities of its setting. Even the title of the sculpture, *Then books obscured the real story*, takes aim at the role of writing in the misrepresentation of reality, African reality, and history, examples of which may be found in the so-called early African novel—the works of Joyce Cary, Karen Blixen, and, some would argue, Joseph Conrad—and all of which placed the African a notch beneath civility. Through the piece Anatsui looks at what Chinua Achebe has described as the "violence inevitably done to the image of despised people" through the agency of writing.[19] While suggesting that, rather than reveal or register, text in fact obfuscated and occluded aspects of Africa's history—"the real story," as he puts it—Anatsui does not proffer a counternarrative as much as point to the ambivalence of all narrative, and particularly to the obliterative potential, indeed proclivity, of inscription, especially when placed at the service of power. Text, therefore, is at best a poor, unreliable, and dubious substitute for memory.

El Anatsui's engagement with memory is comprehensive, for not only does he engage the processes and vehicles of retention and recollection, even more important, perhaps, he also points to vulnerability as a condition of memory. Ultimately, in order to better serve collective memory, Anatsui elects ritual over writing, the reiterative over the delimitative, the communal over the totalitarian, the open over the circumscriptive. Using the example of Africa as his source, he leans toward the performative as residence for memory while suggesting that history be dissociated from a form, namely writing, that is fundamentally aligned against consensus. It is for this reason that he returns us time and again to the ritual and the sacral, to reenactment, for only through these does memory persist among those whose history provides reason to treat the written word with due caution and suspicion.

Fiona Foley: Medium, Memory, Melancholia

> "A melancholy history of loss forms my memories."
>
> —*Fiona Foley,* Tyerabarrbowaryaou, *1992*

In the 1990s a new wave of interest is visiting indigenous Australian artists, that is, distinct from the voyeuristic, exoticist interest that Aboriginal art drew from Western culture brokers in the 1970s and 1980s. This new wave is built on the rather uncomfortable recognition that the cultures of indigenous Australians continue not merely in the form of the sand and bark paintings much loved in the West, which collectors scrambled to accumulate at tourist prices and made an industry out of in the past, but also in forms that belong with the most advanced and avant-garde—if that word still makes sense—of contemporary art. Though residues of the voyeuristic are detectable still, say, in the rather discomfiting, mercantilist, and neo-Oceanist hype around the art of the nonagenarian Emily Kngwarreye, there is a gradually developing recognition of these artists as artists and not as ethnographic curiosities and foils for Caucasian modernity. At the center of this new interest too are a number of women artists and experimental filmmakers whose works no longer show in the ethnography or craft museums but in modern art galleries and spaces around the world. Among these is Sydney artist Fiona Foley.

Foley works in several media, but mostly in pastels and installations, and recently with photography. Although she works occasionally in forms possibly associated with "Aboriginal" art (and I place the term in quotes here since its exact meaning is still debatable even within Australia itself, and hardly shorn of associations that are no longer generally acceptable), Foley not only steps outside the type at will, she indeed resents the manner in which "Aboriginal" art is theoretically homogenized and synonymized with dot-painting and dreaming.[20] Through her media and her work she addresses aspects of personal and collective experience, what she describes as "the sense of loss" after the genocide and deprivation that her people, the Badtjala of Fraser Island, suffered in the course of European incursion in the South Seas. Foley's art, she notes, is driven by a "custodial responsibility" toward this legacy and her determination to facilitate as well as register the persistence of memory, especially in the face of a growing, conciliatory desire among Australians for obfuscation and erasure.

At the turn of the twentieth century the Badtjala were driven out of their ancestral island abode by Caucasian settlers, and most of them killed in a series of massacres that were carried out with the aim to annihilate them. Whoever among the Badtjala was not shot or driven into the shark-infested seas of the Pacific was forced into Christian missions on the Australian mainland, where, throughout the 1930s and 1940s, a policy of violent "whitification," or what Tasmanian artist Ian Anderson has described as the policy of "fuck 'em white," was carried out on them. Through racial transgression often applied in the form of rape of Aboriginal women, and through the often brutal and unrelenting imposition of Caucasian culture and values, the Badtjala, like other indigenous peoples of the South Pacific, were nearly severed from their cultural heritage. Aboriginal children were brought up to ignore or deny, or indeed to

have no knowledge of, their ancestry. They were denied contact with the land, their deities, and their sacred places. At the end of the twentieth century only remnants of these cultures survive, and it is with great pain but much courage and resilience that, strand after strand, the descendants of the Badtjala now reconstruct their culture.

The resilience of the Badtjala is long-standing, as illustrated by the legend of "Banjo" Henry Owens, the last Badtjala to be taken from Fraser Island in the 1930s but who, time after time, returned to Fraser Island, defying the violence of his Caucasian captors. In her art Fiona Foley iterates Owens's repeated return, his stubborn reclamation of country and roots, his tenacious grip on memory, and his struggle against history. Especially in her pastel drawings Foley repeatedly projects remnants and strands that lead to her past, among these the figure of the dingo, the canine who was company for the Badtjala in precolonial times, and the feather of the cockatoo, a bird peculiar to Fraser Island and the adjoining bay of Cooloola.

Once an intimate companion for humans and a permanent party in hunts as well as the domestic space, the dingo witnessed the racial cleansing of the island at the beginning of the century, and today the canine wanders alone through the savanna and the rain forest, highly suspicious of humans, bearing in its mournful eyes a record of what happened to the people. As a most evocative and unique metaphor, the loneliness of the dingo encodes the savage depopulation of Fraser Island. Foley adopts the dingo as both guardian spirit and signature, and though many may not notice it, the recurrence of the dingo in her work reiterates that inescapable question permanently inscribed in the animal's eyes: what happened to the Badtjala? In Foley's work the dingo is a witness as well as a trope, a reliquary of largely discounted memory, an interrogatory loop. Unobtrusively but repetitively registered, the dingo is a sign of the occasionally faint but indelible line between the Australian settler and the indigenous people, the unbroachable interstice between the one and the other, the crack in the facade of the country's new multicultural rhetoric and its demand for collective amnesia. The dingo is the silent figure that calls history to account.

The colorful feather of the cockatoo, which equally appears in Foley's work, especially from the early 1990s, not only echoes the above, it also relates to the peculiar diversity in the climate and vegetation of Fraser Island, perhaps the only place on earth where three climatic regions fall within the boundaries of a tiny sand island. There is a reference too to the colored, undulating sand cliffs of Rainbow Beach on the east coast of the island. The center of a Badtjala legend and subject of Foley's *Coloured Sand*, 1993, the colored sand cliffs record the antiquity of male transgression and sexual violence against women. Once, it is said among the Badtjala, a young woman was betrothed to an elderly man without her consent. Dissatisfied with the arrangement and intent on pursuing her right to choice, the young woman began an affair with the Rainbow. One day the elder found the two lovers in their hideout and, irate with jealousy, hurled his boomerang at the Rainbow, cutting him in two. The severed Rainbow fell from heaven, his remains splattering on the cliffs and staining them forever. The sand cliffs became a women's site, a shrine to female defiance of male domination. The

El Anatsui, *Serwa Akoto, Legendary Beauty of Ghana*, 1975. Wooden plaque. Courtesy of the artist.

El Anatsui, *Broken Pot II*, 1979. Manganese body, 30 x 50 x 40 cm. Courtesy of the artist.

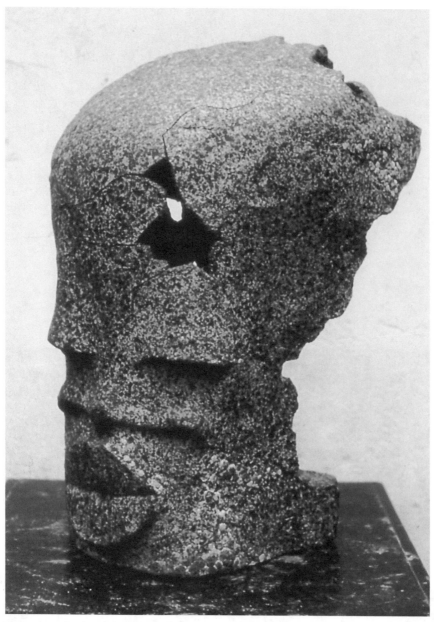

El Anatsui, *Broken Chambers of Memory*, 1979 (frontal view). Terra cotta, 40 x 29 x 27 cm. Courtesy of the artist.

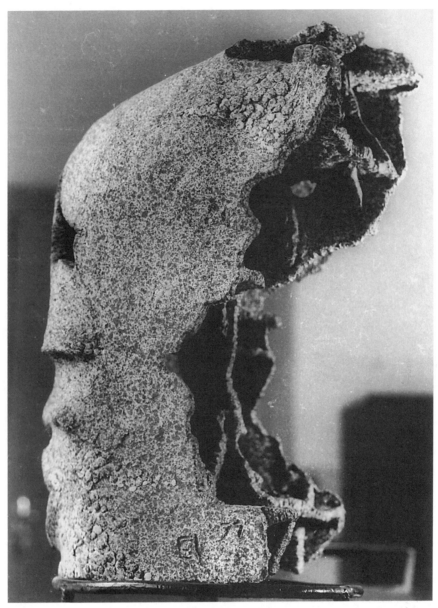

El Anatsui, *Broken Chambers of Memory,* 1979 (profile). Courtesy of the artist.

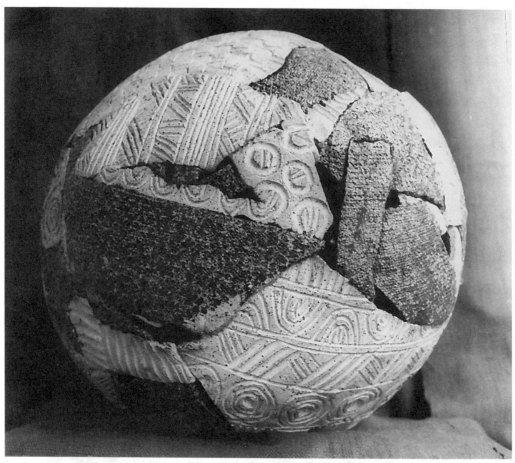

El Anatsui, *We de patcham*, 1979. Manganese body, 43 x 43 x 42 cm. Courtesy of the artist.

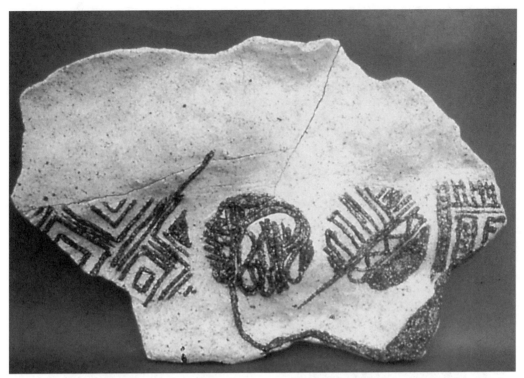

El Anatsui, *Writing on the Wall II,* 1979. Terra cotta plaque, dimensions variable. Courtesy of the artist.

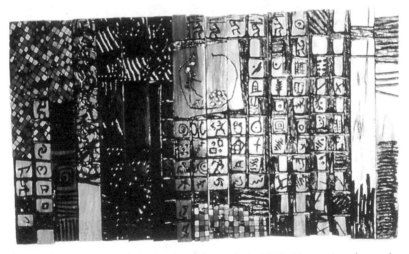

El Anatsui, *Writing and Contents of Open Pot,* 1989. Pigment and wood, dimensions variable. Courtesy of the artist.

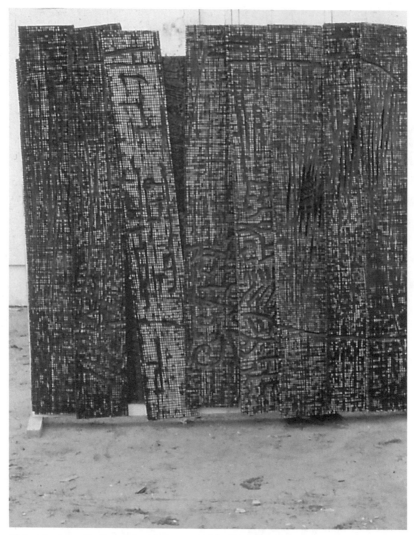

El Anatsui, *Invitation into History*, 1995. Wood and tempera,
182.9 x 182.9 cm. Courtesy of the artist.

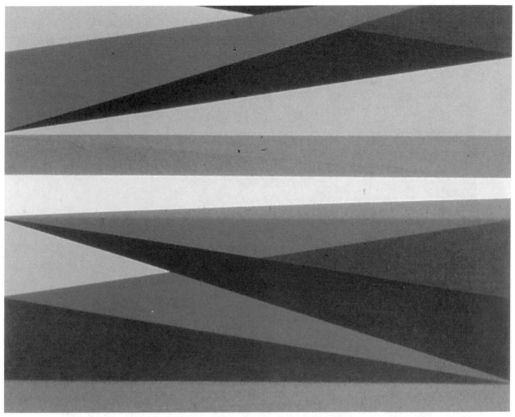

Odili Donald Odita, *Light Blue,* 2000. Acrylic on linen, 50.8 x 76.2 cm. Collection of Charles Riva. Courtesy of the artist.

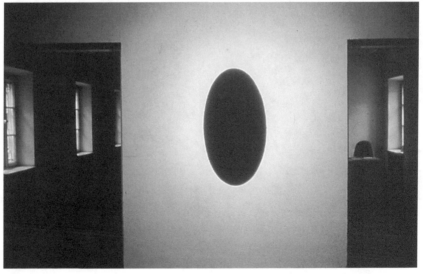

Odili Donald Odita, *Mirror,* 1999 (installation view). Pigment on wall, 24 x 50 inches. Galeria Arsenal, Bialystok, Poland. Courtesy of the artist.

Ghada Amer, *Cactus Painting* (detail), 1998. Cactus Elongatas y Verdolagas, 70 x 70 m. Courtesy of the artist and Deitch Projects, New York.

Ghada Amer, *Untitled (black series 1),* 1999. Acrylic, embroidery, and gel medium on canvas, 86.5 x 127 cm. Courtesy of the artist and Deitch Projects, New York.

Ghada Amer, *Untitled (yellow redheads),* 1997. Acrylic, embroidery, and gel medium on canvas, 30.4 x 30.4 cm. Courtesy of the artist and Deitch Projects, New York.

Julie Mehretu, *Arcadia and Bushwick Burning,* 2000 (left panel). Ink and acrylic on canvas. Diptych, each panel 48 x 60 inches. Courtesy of the artist and The Project, New York and Los Angeles.

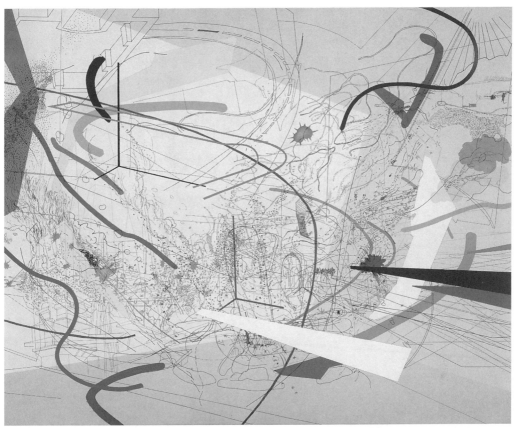

Julie Mehretu, *Arcadia and Bushwick Burning,* 2000 (right panel). Ink and acrylic on canvas. Diptych, each panel 48 x 60 inches. Courtesy of the artist and The Project, New York and Los Angeles.

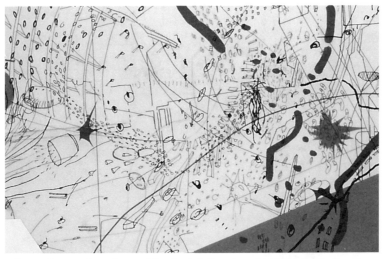

Julie Mehretu, *Arcadia and Bushwick Burning,* 2000 (detail). Courtesy of the artist and The Project, New York and Los Angeles.

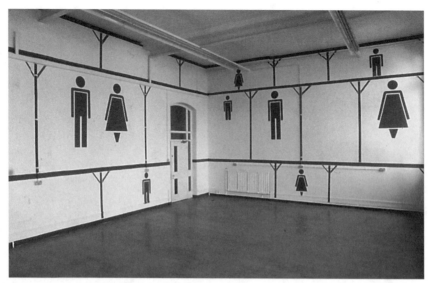

Mary Evans, *Wall Hanging,* 1995. Craft paper on wall, 5 x 10 x 8 m. East International, Norwich. Courtesy of the artist.

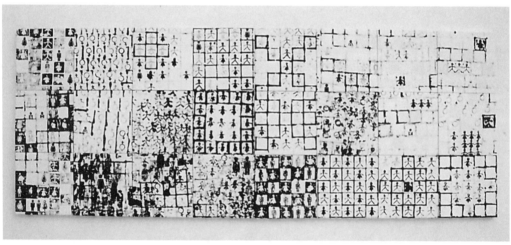

Mary Evans, *Chaingang,* 1993. Screen painting ink on canvas, 150 x 400 cm. Photograph taken by H. Pelk. Courtesy of the artist.

cliffs have recently returned to the custody of the Badtjala, who struggle to protect it against often-male tourist trespass.

The cockatoo feather in Foley's art therefore registers both environment and myth, both the physical and the spiritual, both the visual and the political. Set against her often deep blue backgrounds, the cockatoo feather sits like the island itself against the sea. In her paintings it is also often shown in descent, singular and fragile, like a speck of memory caught in midair. One is disturbingly reminded of a shot bird, from which a lone feather descends as evidence, as a sign for the violence visited upon it. It is a fragment of the owning body, a metonym that registers its owner's fate and survives to give perpetuity to that body's memory. By seizing the feather in descent through Foley's paintings, we reclaim its origin, just as the artist seizes fragments of a mediated history, in an act of recuperation and rehabilitation, for restoration.

Foley's use of pastel is itself significant in that the medium, often denigrated and occasionally consigned to women in "male-stream" art history and practice, succeeds perhaps more than any other in capturing the fleeting, as well as codifying the fragility and vulnerability of, memory. Whereas in the past pastel was sealed into the pigeonhole of the frivolous drawing-room medium, and contemporary artists employed it merely as an underhand medium for the playful act of "disruption"—the so-called subversion of tradition and return to materiality—Foley projects the medium beyond even the orthodoxy we find in Mary Cassatt's domesticities, for instance, or the transfixion of the transient we find in Edgar Degas's pastels. In Foley's work, as in the work of Jean-Michel Basquiat, pastel is not just a medium but a figure of signification also. As a loose and fragile medium, pastel is vulnerable to vandalism and defacement. Yet properly preserved pastel is also one of the most durable media in art. Chalk and conté drawings have survived from prehistory in caves and on rock surfaces. With pastel, and unlike the equally fragile graphite, there is, in fact, no deletion without trace because every effort to erase it leaves a mark behind. Pastel, therefore, is a paradox of frailty and permanence, delicacy and resilience. Like history, pastel writes to fragility, transience, and impermanence on the one hand, to survival and perpetuity on the other. Pastel replicates history's vulnerability to distortion as well as the impossibility of perfect erasure. And like Basquiat, Foley uses the medium to register the alterity of history and inscription in the same way El Anatsui uses ceramic to sign the fragility of memory.

Foley's pastel technique is of significant interest. Whereas traditional pastel techniques emphasize swiftness and deftness with a light touch and a certain transparency wherefore the background or support is allowed to come through as part of the color scheme, as we find in Degas, Foley stains her support with the medium. She lays out her color, then persistently, methodically, almost painfully rubs it into the support. Again we are reminded of Basquiat, who, though he was clearly interested in the graphic qualities of pastel, nevertheless underlined his even greater interest in the medium-as-trope by repeated inscription, by a methodical process of emphatic and persistent application, an insistent reiteration, writing over and again as if and indeed

to register his consciousness of the permanent threat of desire to elide. In same manner, Foley painstakingly rubs her pastel into the support with identical consciousness of the delicacy, even futility of inscription, and therefore the will to preclude complete elision. In her application of pastel we find an apparent desire to leave a persistent stain, to preclude erasure without trace.

Foley's pastels remind us of the brittleness of collective memory and the frailty of history. They also remind us of the artist's own struggle and that of her race to retrieve fragments of a vandalized history, to retrieve morsels of memory from the ashes of this history, to survive fracture, as it were, to remember. Her medium becomes both an allegory and a moral. In her careful approach to it there is a constant reminder of the thin glass that stands between the picture and the vandal, between beauty and the beast. We are reminded not simply of the fragility of a delicate artistic medium, but also of our own vulnerability to violence and annihilation, a condition that is palpably underlined today by the uncertainties and eccentricities of the digital age with its pseudodemocratic license to transgressive power and privilege.

As used in Foley's paintings, pastel equally reminds us of that most delicate of structures, our environment, which, respected and carefully tended, is eternally sustaining, while under neglect could disappear before our eyes. Fraser Island, Foley's ancestral country, is an impermanent structure of shifting sands set precariously on the seabed like a pastel on its support. But the island survived millennia under the careful custody of its original inhabitants. In the last 150 years, however, ecological and political transgression has repeatedly undermined this delicate system. The island has come under threat time and again, protected feebly from vandalism like the glass that keeps the pastel drawing from touch. For a whole century the logging industry depleted the unique vegetation of the island and almost irreparably affected its delicate ecology. Then came sand mining in the 1960s, which not only destroyed the fragile geology but also polluted the island's creeks and lakes. Titanium residues from the prospects of the Queensland Titanium Mines Pty between North Spit and Eurong still pollute the waters of Eli Creek and parts of Seventy-five Mile Beach. Despite the vigorous campaigns of the original peoples of the island and conservation groups, leading to an international legal battle and the cessation of sand mining on the island in 1976, the Queensland government secretly renewed the leases of one mining concern in 1984.[21]

Yet it is tourism, perhaps, that poses the greatest threat to Fraser Island today. Hundreds of four-wheel-drive vehicles and Hell's Angels bikes, thousands of campsites, irreverent campers and their litter, tourists who try to feed the dingoes—all are locked in constant opposition to the renewed custodianship of the Badtjala and the government conservation department. Fraser Island remains like a pastel drawing: fragile and vulnerable, yet imbued with an inherent tenacity. This Fiona Foley evokes in her use of pastels.

In her earlier work Foley recorded aspects of Badtjala culture in stylized drawings of ceremonies, rituals, and sacred sites, using only the layouts of performance sites for her imagery. Though she avoided paintings of dreamtime and song lines, she took naturally to the bird's-eye perspective that gave her works a schematic peculiarity

uncommon in the work of other artists from the region, which may be categorized as conceptual art. In many of the drawings we find interplays of forms and shapes that call to mind the paintings of Uzo Egonu, or indeed Paul Klee. Equally important to the discussion, in Foley's work from the period each shape bore symbolic weight, each line encoded or alluded to a historical or cultural concept. There was none of the faddist doodle-and-scrawl of much contemporary Sydney art, and Foley has remained conscious of what she refers to as "depth," in other words, of historical relevance, in her work.

In others of her work she refers to specific historical moments and incidents, among them the legend of Eliza Fraser, wife of British naval captain James Fraser, whose cargo vessel *Stirling Castle* was wrecked north of Fraser Island in 1836. The people of the island took Fraser and his wife; Mrs. Fraser was kept with the women and made to observe their ways and to work with them. She would later narrate tales of her "torture" and the "cruelty of the natives" after she was recovered by the British, and in the years that followed would make much money in lecture fees in England, speaking of her "experience." Although Captain Fraser died of starvation, according to a British magazine report issued shortly after his death, his wife would insist in her narratives that "the savages" cruelly murdered her husband. In 1838 George Ivy of London published a book of Eliza Fraser's tales as told to John Curtis, which stirred up much indignation in England. As John Sinclair has written, "The lives of the Fraser Island Aborigines changed irrevocably after the survivors of the *Stirling Castle* stumbled ashore." What followed was a century of not only Caucasian incursions and forced settlement, but also one of calculated annihilation and displacement of original inhabitants, much akin to the annihilation of the original populations of the Americas.

Foley keeps a photograph of the woman for whose spouse Foley's ancestral home was renamed and whose landing on the island of her people brought a cruel twist to their history. In some of her installations and other conceptual work she has engaged this aspect of her history by interrogating Eliza Fraser's misrepresentation of the Badtjala and her exploitation of a disputed history. At the same time, Foley also keeps a colonial photograph of an unknown Badtjala young woman, which we find in her 1988 series, *Survival*. The Badtjala woman, photographed in the characteristic, voyeuristic pose of period ethnography, is shown partly naked and inconvenienced, indicating that she might have been photographed without consent. She is also depicted in a manner that would present her as a racial stock, as typical of the savage races. This received image Foley plays off the immaculate, white-clad image of Eliza Fraser. By juxtaposing and interacting with the two women, she elicits the subtle politics of presence and absence, of speech and silence, of the written and the emotive, of the validated and the discounted. As an idea for an exhibition in 1994 Foley came up with the title *I had none of the language,* a direct reference to the loss of the Badtjala language earlier this century, but, even more so, an oblique reference to the unsettling binary of inscription and erasure that Eliza Fraser and the unknown Badtjala woman represent. Eliza Fraser's loquacious narratives, juxtaposed with the silence of the unknown Badtjala woman, remind us of the immense power of self-absolution

that speech accords those who possess it. Despite her story of "ordeals," Eliza Fraser's bonneted, smiling face radiates triumph. In photographs from the period Mrs. Fraser is fully clothed in the apparel of Victorian decency and civility, having been rescued from the claws of barbary, as it were, and restored to humanity among her own. Her story is presented as one of triumph, not only of the individual over danger, but also of Christian decency over savagery, of civility over barbarism, of Europe over the natives. The young Badtjala woman, on the other hand, beautiful and full of the strength of youth, nevertheless carries a sadness in her eyes that bears a story more tragic, more disturbing, yet denied cognition. She represents memory discounted because it exists not only outside writing but equally outside the validation of power. She "had none of the language" to relate her side of the story to the rest of the world. The image of Fraser's that comes down to us is a publicity photograph, which in itself is a system of power and hegemony, constructed as it often is through collaboration between sitter and photographer to ensure that the former is manifestly subjectivized. The image is part of a privileged and self-validating narrative, a narrative empowered into history. The photograph of the Badtjala woman, on the other hand, is a tourist photograph, a postcard image, in which the camera is deployed as a tool of invasion rather than acknowledgment of subjecthood. The image in the photograph is that of a curio, an object of desire and unmediated visual access, an anonym and a trophy of colonial transgression. It is the visual manifest of a composite system of displacement that works by peculiarizing and commodifying its object, effectively placing her in a tropic quarantine. What is signified in the image itself is a structure of cultural access that places the native at the disposal of the Outsider.

But that is one reading, for even in the silence of the anonym the negation of privileged representation is still recognizable, located not in denotation but in connotation, in the simultaneously unacknowledged, the parallel yet absent narrative. And this, though it does not mediate the violence of privileged gaze, nevertheless registers that gaze and places it on record, thus writing to a different history. In every image there are multiple narratives both apparent and subtextual, as well as multiple agenda. There is the agenda of the image-maker, which includes the apparent and the merely implied, and into the frame of which the unintended also often spills. However, in every image there is also a parallel agenda, that of the image itself, which is to register the process of its making. The image of the Badtjala woman, like Eliza Fraser's, eventually subverts its maker's intent by encoding in its structure the processes and details of its realization. When we look at it, we find both the desire as well as the privileged location of the photographer, and also the resentment, unwillingness, and defiance of the sitter. We find an element of the survival that Foley implies in her series, that is, transcendence of the intended state, so that the woman in the picture projects more than an anonym, more than the available native, more than the silent object of colonial voyeurism, because in the end her presence in the photograph, her image, negates all that it is intended to represent. Because it truthfully registers the circumstances of its making, albeit outside of immediate cognition, it becomes a trap for the narrative that it is intended to illustrate, the trap that recurs in one of Foley's fist-in-the-face

pieces, *Eliza Fraser Heads for Trouble*, 1991. In the installation piece, which employs a real mousetrap, a black figure stands over the trapped image of Eliza Fraser, head down, held between the jaws of the contraption—caught, as it were, between the jaws of her own narrative. There is a ring of triumphal rhetoric in the work in question as the black figure looms above the captive Mrs. Fraser, but more significant is the way in which the mousetrap becomes a trope for history, and the image an accomplice and a witness. Foley has worked repeatedly with mousetraps, and in her work the mousetrap is both medium and figure, reiterating the condition of the image as arrested memory, as inherently unalterable. With the trap as trope she reminds us that even as artifice the image undermines and overrules its own alterity.

Foley sees herself as a reincarnate of the young Badtjala woman in the photograph discussed, a reincarnate who equally restores speech and language to the anonym and repositions her story on the site of cognition. This she identifies as her responsibility as an artist, as a producer of images and situations. Foley recognizes the power of the documentary image and the photographic medium, and was always drawn to video and the short movie. But she seems to have found her strength in the photograph, and her recent work continues her quest for the most eloquent medium for pursuing effectively the discourse of recollection and interrogation that she began with the images of Eliza Fraser and the Badtjala maiden. In 1994 Foley presented *Badtjala Woman*, a photographic installation at the Roslyn Oxley9 Gallery in Sydney, in which she actually entered the character of the Badtjala maiden.

In the installation she presented an approximation of the colonial image into which she inserted her own image in place of the original Badtjala woman, assuming the exact posture and simulating the condition of her Badtjala ancestor. She placed herself in the position of the consumed native, the silent object of outsider gaze. She nativized herself, and there is neither precedent nor ready parallel in contemporary art for the subtlety of her autoexoticism, or its effective evacuation of the polemic edge, and of that anger and violence that Frantz Fanon deposits as the inescapable, self-defeating condition of the Other.

In *Badtjala Woman* Foley replicated the silent, vacant stare of the objectified Other, the Other as an object of Outsider desire, the native denoted as savage yet desired for pleasure. Lodged between desire and possession is the body, which is the embodiment of history and memory. Proffered to us, this body speaks to memory before and after its violation. Its rhetoric is devoid of violence, yet the image and the body it represents speak to the violence to which it remains subject. For in Foley's photographs the Other makes herself available, exposes herself, invites our gaze only to reenact the original gaze, the original violence perpetrated on her. She does not disrupt this gaze nor does she return it. She recognizes that it is impossible to return the invasive gaze, and that that which purports to be a return gaze is only mimicry. Rather than return it, then, Foley forces the gaze to a blink, exposes it to itself. Looking at the pictures we recall E. M. Forster's frustrated synopsis of India and the native body: "She calls 'come' . . . But come to what? . . . She is not a promise, only an appeal." We recall also Jacques Lacan's deposition on the alienation of the subject in the Other, which echoes Forster

most tellingly: "[S]he is saying this to me, but what does [s]he want?" Foley's exposed body is neither promise nor appeal. She relocates herself at the disposal of Outsider desire to elicit its intent and to fragment its facade of coherence and linear clarity. She makes herself vulnerable if only to emphasize her enduring vulnerability.

Foley avoids a prosaic narrative of the historical and instead enacts a performative reclamation of time. Through self-flagellation, through the deliberate resubmission of her body to the violent gaze, she reinstates the memory that must neither be discounted nor displaced. She speaks to the persistence of memory, to the burden of history. For her, time does not heal all wounds. Like a boomerang, she springs history in a loop and returns it dangerously to the unsuspecting source.

In another example of her photographs, *Native Blood,* 1994, which is part of her *Urban Nomad* series, Foley emerges from the role of the incarnate and begins to titillate transgressive desire. In the hand-painted photograph, Foley poses herself reclining, naked to the waist and decked with bead- and cowry-shell necklaces. She is clad in a pair of what appear to be sports pants, atop which she is also wearing a raffia skirt. These she finishes off with designer platform shoes, which are delicately hand-painted with a highlight of yellow as if to draw attention to them. Two iconic figures are fused into one here; Foley reclaims the place of both the mistress reclining, the ultimate if problematic deification of the white female in post-Enlightenment art, as well as the mistress's handmaid, the dark lady in the picture who is the inseparable negation of the reclining nude. In her attire and posture there is a certain echo of Paul Gauguin, especially in *The Noble Woman (Te Arii Vahine),* 1896, but here Foley is not simply the exotic *negre célèbre* we find in Gauguin's painting, for she is both auteur/voyeur and the *objet regarde.* In other words, she constructs the frame of her own display to engage a history in which she was hitherto merely the displayed. In this carefully crafted photograph Foley begins to remind us of Josephine Baker, the ultimate autoexotic, as if to ask, How do you like me now? Foley adds the touch of color to the monochrome photograph as an almost exaggerated mark of artifice, to remind us that the image is a theater of enactment without authenticity beyond the hidden traces of its making; that outside that unalterable circumstance it registers in spite of its maker's intent, every image is a construct. Also, Foley interferes with the photographic medium to denote its materiality, its paradoxical nature as both object and language, as both art and document.

In the *Urban Nomad* series, perhaps inappropriately titled since her themes are distinct from and far more pertinent than the popular title suggests, Foley becomes a performer, the image and its creator, the author and the text. She is both director and model of her staged images. Of course, she does not resolve the problem of technical control and its interventionist privileges; that is, she does not account for the problematic interstice between directorial instruction and technical execution since she is not, in fact, involved in the technical processes that produce these images. However, she establishes herself upon the image by acting further upon the photograph after it has been processed, by hand-painting it, albeit selectively and discreetly, as if to insist that it is incomplete without her manual finish, which is her ultimate imprint of validation

and endorsement. By painting over the photograph, she reintroduces her sense of the element of making, of artistic infliction. By the same token, by taking charge of the formulation of her own image, even as she appears to perform on the theater of expectation, that is, as the exotic, she fully subjectivizes herself. She is no longer simply the object: she is the subject, the "I" with all its implications and ramifications. The gaze she receives she invites. She is no longer acted upon; she acts upon us.

Born in 1964, Foley studied art and art education in colleges in Sydney. She then spent a period among the people of Ramangining in Australia's Northern Territory, where she worked with artists in workshops and cooperatives. Since 1992 she has lived and worked in Sydney, for a period as curator of the Aboriginal collection at the Museum of Contemporary Art. In the past few years Foley's work has shown in major exhibitions in Europe, North America, and the Far East, as well as in important Australian spaces. She has equally executed a number of important public commissions and may be found in major collections in Australia. With each show and each new series, we find strength and depth in Foley's work that is distinct from the vacuity that seems to define postgrunge art in Australia and millennial art as a whole—strength and depth that go to establish her as one of the major artists of the 1990s.

Fiona Foley's work validates what we may call a *custodial* aesthetics, by which the artist conceives of herself as custodian of collective memory, responsible for and dedicated to the recollection, reconstruction, and restitution of a hitherto fragile and vulnerable history. Even more important, her work and methods reveal a desire to pursue this custodianship, not through the relegation of memory to permanent reliquaries, but through a ritual engagement with medium and image, through careful orchestration of techniques that do more than preserve memory; transforming the image or concept into an active, oscillatory entity that draws us into the ritual vortex of memory and recollection, whence to reexamine our understanding of history as given, and perhaps our complicity in the manipulation of history and memory to the advantage of power.

Medium, Memory, Image

Three artists, three cultures, three histories separated by time and geography yet connected by a common preoccupation with history and the project of memory. Jacob Lawrence breaks up history painting in the same manner that his culture in the South fragmented and drifted north, away from terror and trauma. He introduces serialization in order to register history as a transitory narrative rather than a giant moment in time, and he uses gouache in favor of oils, the modest scale in favor of the monumental, to reflect the fact that, though historically and collectively monumental, the exodus of the Negro from the South was nevertheless the personal narrative of humble individuals rather than mythic heroes—families, mothers and their children, modest folk seeking safety and the guarantee of freedom.

El Anatsui uses clay, a material with historical resonance for his culture and ritual particulars that fit in the reenactive tracing of memory. He uses the power saw for its

ability to replicate the nature and structure of terror, as well as to leave marks reminiscent of the scars of trauma. He replicates the jaggedness of history and memory in charred wood sawn over and apart with the industrial brutishness of the power saw, again reminiscent of the brutishness of colonial incursion. And he dissembles and dislocates text to dislodge it from the pedestal of truth upon which Western civilization, and especially the Enlightenment, has placed it. Fiona Foley uses pastel, readymades, and photography to reenact the past, sometimes in replication, at other times in reverse, as a way to elicit its convolutions and duplicities. She employs strategies and techniques that allow her to slip into the past so as to labor to live it anew, so as to own it and better understand it, so as to reroute it back to the present.

In all three instances we read the narrative in the image whose apparent purpose is to conserve memory, but we also read the nature and constitution of history and memory in the medium, the technique, and the detail strategies of execution that each artist applies to the act of remembrance. There is no desire to preserve memory in stone memorials and monuments, indeed no desire to invent or construct a mythic past. There is no desire to erect a spectacle. Instead the evident goal is to turn the project of memory on memory itself: to register its inherent ambivalence.

1995–1996

Represent'n:
The Young Generation
in African American Art

I N LOOKING BRIEFLY at the works and careers of a handful of African American art-
ists who have come to prominence in the past decade and a half, I wish to intro-
duce them under the rubric of a unifying cultural moment, the post-soul, post-
funk epoch of the late twentieth century, or what we now call the era of the Hip-Hop
Nation. Hip-hop, of course, emerged slightly earlier in New York in the late 1970s, but
it was not until the 1980s that its underlying politics, aesthetics, and various manifes-
tations and ramifications could be articulated as a coherent epochal system. Having
emerged in the form of the street music, poetry, and drama of the cosmopolitan inner
city, it ultimately became clear that hip-hop was not merely music and poetry and
graffiti and break dancing, but a philosophy and ideology of uncompromising visibili-
ty and evident presence, what in the language of the nation we call "represent'n" or
"maintain'n." The etymology of the term is simple and revealing. As the nascent street
dramas of the late 1970s spread across New York from Queens to the Bronx, and disc
jockeys from different parts of the city began to congregate and stage sound-system
standoffs in neighborhood parks, a spirit of healthy competition emerged whereby
performers not only presented themselves and their skills but also began to represent
their sections of the city. Thus the great "Old School" call "Brooklyn in da House!"
would indicate that a contingent from Brooklyn was holding the stage. To represent,
therefore, was not only to prove oneself—and hip-hop in its purest form demanded
the highest levels of excellence—it also meant defending the honor of the 'hood
through creative excellence and bravado: proving oneself and standing one's ground,
or "maintain'n," but doing so with the consciousness of a proud cultural ambassador.
In time represent'n would be overtaken in the music arenas of hip-hop by "rollin'," or
making money, an individualistic enterprise characterized by cutthroat competition,

rivalry between contingents on the East and West Coasts, involvement in the international drug trade, and wanton violence. But that was later.

For our purposes, let us stay with the original spirit and language of the culture, or what one might call the "Old School." In this spirit and language, to represent is to manifest excellence, confidence, panache, versatility, familiarity with your terrain, and the ability to project and command both visibility and staying power. It also implies a consciousness of background and community, an awareness of where you are coming from and what you are bringing with you, and the knowledge that the essence of your project is to broach the gateway of history. Which is why, in time, the good hip-hop DJ would always begin his or her act by acknowledging or giving props to those who came before, then proceed, in the words of rap artist and entrepreneur Sean "P. Diddy" Combs, "to make a little history." To represent, then, is to place history on a continuum from the past to the present unto the future.

The four or five visual artists reviewed here not only belong to what may be referred to as the hip-hop generation, having grown up in the post–Black Power era and come into their own in the last decade or so in a seemingly different, postmodern, multicultural America, they also command the visibility and panache that represent'n implies. They are children of the late civil-rights era, born in the 1960s but only vaguely familiar with the struggle and conditions of that era. They grew up with Detective Shaft and the Blaxploitation movies of the 1970s, but also with Alex Haley's *Roots*. They watched Bruce Lee and his kung fu movies, and Spike Lee's *School Daze* and *She's Gotta Have It* and *Do The Right Thing*. They saw disco rise and fall, and watched as their friends and contemporaries buried soul with the defiant pyrotechnics of rap.

These artists speak to history and to their community in their different ways, and remind us inevitably of artists who came before them. In presenting them, I concentrate on how these artists relate to hip-hop "Old School" master Fab Five Freddy's fabulous summation of postmodernism and the hip-hop aesthetic, namely, to "take a bit from here and a bit from there and bring them all together . . . yet not forgetting history." I pay close attention to how the artists have fared with regard to their understanding and use of history, and their relationship to the past and to the collective memory of not only their community, but also the American nation as a whole. In the process, I place this evaluation against the background of not only history itself, but of other artists whose careers prefigure this generation. Inevitably, I dwell longer on certain key issues and am sketchy with others. It is my hope, however, that the reader is left with an understanding of the questions and issues engaging this generation of artists and their strategies for contending with those questions and issues.

No discussion of the hip-hop generation can be considered accurate or complete that does not begin with its first prominent artist, the painter Jean-Michel Basquiat. Born in New York in 1960, Basquiat grew up in the mid- and late 1970s as a direct participant in the founding of hip-hop. A street performer, DJ, graffiti artist, and fine navigator of his cultural turf, Basquiat eventually made his way into history as an icon of the painting revival in New York in the 1980s. He would also become the most commercially successful African American artist of the late twentieth century.

Basquiat's greatest strength—which was, ironically, least appreciated in his short lifetime—was his obsession with and debts to history, African American history. In his lifetime and even more so after his death, Basquiat was portrayed as a wild, primitive, self-destructive, evil genius who lived and produced without self-articulation or clarity, and finally succumbed to fame and the overwhelming pressures of a more civilized environment. Even from within the African American critical establishment, appreciation of Basquiat's personality and production has occasionally pointed in this direction. In the book accompanying her exhibition on the image of the black male in American art in 1994, Thelma Golden regurgitates conventional wisdom about Basquiat. "It remains debatable," Golden wrote, "what Basquiat, as artist, knew or seemed to understand intuitively."[1] In the same book, *Village Voice* critic Greg Tate voices a more personal observation of Basquiat, namely, of the alienated young artist divorced from community. "My presence, and that of other black brothers," wrote Tate, "was the absence in his life."[2]

Yet the truth, as I have noted elsewhere, is that there is not a single artist of Basquiat's generation in whose work we find a deeper sense of history or a firmer grasp of his or her place in it. Like Jacob Lawrence before him, Basquiat was one of the most important history painters of the twentieth century. But he was also the David Hammons and Bob Thomson, the Spike Lee before there was Spike Lee, the irrepressible arbiter of the past and the present, the grand master of the dozens, the ultimate player. A voracious reader and inimitable connoisseur of jazz, Basquiat saw his place through the prism of the African experience in America, which led him to identify most closely with figures such as jazz innovator Charlie Parker and boxing champion Joe Louis, on whom he expended great understanding and compassion. In his paintings Basquiat broached such important subjects as the dilemma of black police officers, the economic foundations of the European colonial project as well as the indelible traumas they left behind, America's historical intolerance for the black male, and a clear articulation of his own relationship with mainstream America as emblematized by the American art establishment. Basquiat was, in the most positive light that it may be understood, what W. E. B. DuBois referred to as a race man.

When in his painting *Joe Louis Surrounded by Snakes* he depicted the boxing legend as a victim of vested interests who was ultimately robbed not only of his life's earnings but also of his dignity by the individuals and country he enriched and honored, Basquiat painted the history of his race as well as his personal narrative. The theme of Basquiat's *Joe Louis Surrounded by Snakes* is the perpetual problematic and irony of black progress from slavery to indenture in America. As the heavyweight champion of the world, Joe Louis made a fortune. He donated more than a million dollars to the American war effort during World War II, and interrupted his professional career at its height to enlist in the army and fight in the war behind the American flag. Yet as an African American who had to depend on others for the breaks that made his career, Louis was forced into contracts and deals that left him indigent at the end of that illustrious career. Treacherous and unscrupulous managers blatantly cheated on him, investors diverted his investments or failed to attend to them, and accountants

failed to pay his taxes duly, the devastating result of which was that he was bankrupted by the U.S. Treasury and stripped of his life's belongings. Such was the level of Joe Louis's poverty in his later years that to earn a living he worked as a bellman in a Florida tourist hotel (and was eventually rescued from this job by Muhammad Ali). Yet Louis's case was not at all peculiar, but instead typified the fate of countless African Americans in the sports and entertainment industries whose experiences with managers across the race divide were akin to the prior experience of slavery, and may be characterized as labor received but not duly remunerated. Indeed so severe and common was this problem that a foundation called Blues Aid was established in 1994 to raise funds in support of countless African American bluesmen across the country who ended up indigent after long careers of making and selling records without seeing the returns from their labor. In *Joe Louis Surrounded by Snakes,* Jean-Michel Basquiat addressed the issue with metaphorical depth that demonstrates an articulate sense of location within history, rather than mere savage intuition. A decade after Basquiat's death at the age of twenty-eight, the singer Prince returned attention to the issue Basquiat addressed in *Joe Louis Surrounded by Snakes* when he (Prince) painted the word "Slave" on his face to represent his relationship with the music-recording industry.

Some have interpreted Basquiat's obsession with Joe Louis, Charlie Parker, and others like them as a mere identification with their celebrity and visibility, represented in the leitmotiv of the crown in his paintings. According to Golden, "Basquiat identifies with these athletes, their prowess, and their stardom, which seems so analogous to his own." However, this is only a shallow and hardly perceptive reading of Basquiat's project, for what Basquiat saw in Louis and Parker was not mere celebrity but a history of hardship, shortchanging, and inevitable tragedy based on race, which he clearly identified with because it was his own fate too. It is noteworthy that although Basquiat equally respected other preeminent African American figures, such as Miles Davis and Muhammad Ali, he did not expend the same fervor evoking them as he did Louis and Parker. They and others like them may have had experiences no less difficult, but they also withstood the burden of the cross; they survived. They were stars too, but Basquiat's preoccupation was not with stardom. Instead, his concern was the tragic fate of those who could not survive the historical burden of race. He paid homage again and again to those who, though they fought, nevertheless fell; those who were taken up but ultimately brought down; those whom America celebrated yet ultimately humiliated. The Joe Louis in Basquiat's painting is not simply the star of the ring and momentary hero of the American folk imagination. More significantly, it is the Joe Louis who gave everything and yet went down.

When Basquiat re-placed the crown on Charlie Parker's head, he was not rubbing up against celebrity, for the crown is not merely a crown of gold; it is also a crown of thorns. Basquiat was fully aware of Parker's personal history and ultimate demise, and he had a theory of Parker's life and fate with which he could identify. After all, though Parker was perhaps the most innovative American musician of his time, with name recognition and celebrity and enough output to create a posthumous industry, he was

nevertheless once thrown out of a Manhattan, New York, club that was named after him, and would die at age thirty-three, penniless and broken like Joe Louis. Basquiat's references to Charlie Parker were his way of pointing to history and saying to America, It was like this not so long ago. Still is.

The protagonist in *Joe Louis Surrounded by Snakes* is Basquiat too, surrounded by his dealers and collectors and hangers-on, certain in his mind that in that company he was not together among friends but alone among enemies. The image of snakes in Basquiat's homage to Joe Louis comes from the black urban metaphor of America as a jungle in which the black person, especially the black male, is caught in an endless and deadly struggle for survival. This metaphor is very much a part of African American language and lore, and may be found repeatedly represented in the work of Thornton Dial, for instance. In the early 1980s, it became the central motif in the most cogent, most widely disseminated essay on America from the post–Black Power generation of urban African American youth. Describing Ronald Reagan's America in their 1982 song "The Message," rap artists Grandmaster Flash and the Furious Five sang, "It's like a jungle sometimes / It makes me wonder / How I keep from going under."[3] This song, with its powerful images of a besieged youth treading the edge, surrounded by impossible pressures and justifiable paranoia, was part of Basquiat's repertoire as a DJ, and fed into his choice of imagery and his visualization of history. In other words, we find in Basquiat's works, when we care to read them carefully, an artist speaking in the language of his period about the proclivity of history to repeat itself.

Basquiat described his role as an artist as that of a scribe, an interpreter and chronicler of events, an inscriber of his moment as well as heir to his past. In both his work and his life, he represented not only through the phenomenal visibility that he achieved, but also by anchoring in history to maintain in the present. He prefigured the superstardom of Ice T, Eazy-E, and Tupac Shakur, but he did in art what those three did in music, namely, represent large and clear on the persistence of the crucifix and the crown of thorns as part of the paraphernalia of black genius.[4]

In Basquiat's wake several other artists have emerged who represent in the same manner and with the same attitude to history and the creative calling, among them photo- and installation artist Lorna Simpson and conceptual artist Glenn Ligon. Born the same year as Basquiat, Lorna Simpson emerged in the late 1980s and eventually became one of the most accomplished American photo-artists of the late twentieth century. In her early works, she dealt with the nature of language and memory, especially as they define and determine race and gender relations, attitudes, and perceptions. Dovetailing into the feminist art movement in the late 1980s, she brought a particularly incisive, perceptive, and deep yet playful awareness of the intricacies and potency of language to contemporary American art that transcended the predictability of Judy Chicago or Jenny Holzer. Simpson combined the winning formal strategy of the grand scale with the minutiae of deconstructive engagement, and into the matrix she wedged history and politics with reverberating ambiguity.

Most of Simpson's works in the late 1980s and early 1990s dwelled on the space of uncertainty between words and their meanings, as between statement and intent,

but the preoccupation went deeper than apparent: Simpson used her juxtapositions of images and language to investigate disparities in the weight and worth of speech in American history and culture. She built into her works a distinct awareness of race, class, and gender as determinants of this worth, reminding us how a woman's word may or may not carry the same weight as a man's, depending on the circumstances, and how a black person's word never did carry the same weight in America as did a white person's.[5] This we find in a work such as her *Waterbearer* (1986), which the author bell hooks discusses eloquently in her essay "Facing Difference: The Black Female Body."[6] In *Waterbearer* a woman's memory is put in question and ultimately disregarded, with the consequence that her trauma is perpetuated and magnified. In another work, titled *Magdalena* (1992), Simpson presents a pair of male shoes and another of female shoes. Two accompanying groups of texts read, "At her burial I stood under the tree next to her grave . . . when I returned the tree was a distance from her marker." Mysterious yet profoundly disturbing, the text wraps around the images like the turbines of a nuclear reactor, threading imagination through the chamber of the work until it explodes with insinuations and meaning. How, one wonders, for instance, did the tree move from the grave? What or who might have moved the grave marker? What history of access and control over the protagonists' lives does the work and its insinuations speak to? In what ways does power play on memory?

In other instances, Simpson showed how individuals under pressure or in compromising or difficult circumstances might even be complicit in the language and power game that circumscribes their existence, as we find, for instance, in another one of her works from 1986, in which an immigrant young woman of Caribbean origin claims to come from Canada rather than from her native Haiti. "Maries said she was from Montreal," read the text accompanying images of the young woman's seated lower body, "although she was from Haiti." Though little further context is provided, other than that the young woman's attire suggests she is a schoolgirl, the viewer is nevertheless led into the labyrinth of the immigrant experience and psyche, where the need for acceptance and convenience may necessitate self-denial or reconstruction, even rejection. The complexities of history and the present that may lead a young Haitian immigrant to claim Canadian origin, of course, range from a distant, oft-masked colonial mentality of self-deprecation to more immediate and pressing circumstances and the desire to survive the inconveniences of the host country, all of which leave their mark and remind us of Chinua Achebe's statement that "the psychology of the dispossessed can be truly frightening."[7]

In other works, Simpson has investigated the meaning and politics of hair texture in American culture, the gender disparities in the equation of labor and skill, the ludicrousness yet potent element of stereotypes in American culture, the abuse of the black body, the intimate spaces of black women's sorority, and the endangered status of the black male. Hardly any other American artist of her generation has dealt with such a broad and deep panoply of contemporary questions with the same clarity and needling sophistication. In each work Simpson approaches her theme with a sobriety that makes it impossible to miss the wealth of implications that her equally

open-ended frames make possible. Her juxtaposition of text and image, which she cuts and mixes and interpolates in classic hip-hop fashion, and the fact that she often obscures the countenance of her figures both work to focus the viewer's attention on the situation she sets out to deconstruct. There is little distraction, and in many instances her images are in black-and-white, yet she is able to avoid nonchallenging or unsophisticated polemic or dry pedantry.

In more recent work Simpson has shifted her themes to even more subtle investigations of the intimate, personal terrain with highly ambivalent suggestions of eroticism, but the body of work she produced from the mid- and late 1980s to the early 1990s remains exceptional in contemporary American art. Irrespective of her subject matter, there has been one constant in all her images, the black figure, present and central and sensitively positioned at the heart of a black woman's reading of history and her country.

As props to the "Old School," Simpson mentions James van DerZee and Roy De Carava, master interpreters of African American life, as sources of inspiration. Van DerZee's life work was dedicated to the preservation of the dignity and humanity of the black subject in the face of great trials and vicissitudes. Between them these two photographers straddled the twentieth century, capturing and reconstructing black lives and extenuating their inherent beauty, strength, and poetry. With this legacy behind her, and her mastery of the critical languages of her time, Lorna Simpson continues to maintain on the stage of contemporary American art, prodding, questioning, investigating, instigating, reinscribing, revealing. Represent'n.

And so has Glenn Ligon, an artist who was also born in the same year of 1960 in the Bronx, New York. Ligon made his most visible appearance in the early 1990s with his unique form of stenciled tableaux on which he reproduced selective texts from media reports, speeches of historical figures like Muhammad Ali, or the writings of prominent authors such as James Baldwin. Ligon's formal strategy was very much in the hip-hop tradition of sampling, whereby a DJ assembles riffs, beats, or fragments of lyrics from diverse sources to produce a mix, over which an emcee[8] may then lay down his or her rhymes.

For his textual samplings, Ligon also chose a technique with an important history, a technique that referenced cottage letterpress printing or stenciling, not simply for its peculiar visual character, but also for its emphasis on textuality, and even more so for its associations with African American literary history. It was the letterpress that helped frustrate the attempts of numerous slaves to run for freedom, because as the earliest, truly mass-media technology in America, it made it easy for the owners of runaway slaves to circulate information about their escapes, which often led to their recapture across wide distances. On the other hand, it was the letterpress that also made it possible for the earliest slaves to acquire the forbidden skill of literacy, with which they were able eventually to reconstruct their own narratives. Thanks to the letterpress, a whole genre of slave narratives was born, beginning with that formidable instrument of the abolitionist movement, Olaudah Equiano's *Interesting Narrative*, published in London in 1789, which contributed more than any other work of literature to the

abolition of the slave trade. In America the letterpress made it possible for the earliest African American writers such as Phillis Wheatley to produce works of literature to challenge white notions of genetic inferiority on the part of the Negro, and thus provide solid ground for the latter's claim to equal humanity. The letterpress was, therefore, complicit in protracting as well as undermining the predicament of the African slave in America, which made it particularly significant that Ligon should choose it as a medium for his work.

For reasons of its strong textuality, Ligon's technique was able to underline the import of words, their weight and might, their ability to save or destroy, to redeem or condemn. This he achieved by delineating words in his works, making them stand one after another just as they are made or uttered, each alone and on its own until, ultimately, it smudges and disintegrates and merges with the rest. In some of the works, what begins with clarity eventually fades into indecipherable ambivalence, as if to parallel the transformation of thought from words to language and words from sound to meaning: expression through opinion to dogma. This isolation, juxtaposition, and ultimate agglomeration of words proved particularly effective for Ligon's purpose, which was to exhume the hidden treachery of language in the same manner Lorna Simpson did, but with a closer interest in text itself.

Ligon's methods combined a keen interest in contemporary events in America, a consciousness of history, and a studied knowledge of poststructuralist investigations into the nature and deconstruction of text. In one of his earliest, significant works, the *Profiles* series from 1990–1991, Ligon explored and drew attention to the manner in which identities are manufactured and projected on individuals, and how vulnerable objects of such projection might owe their freedom, their reputation, or even their lives to the manner in which those constructs are fashioned and why. In 1990, eight New York inner-city youth were charged with a news-making rape at Central Park in Manhattan. As these young men were arraigned before the courts, the *New York Times* ran a profile on each, in which they were mostly portrayed as good boys with healthy backgrounds who had strayed along the way. In his work, Ligon took excerpts from the *New York Times* profiles and played with the words to reveal the politics behind the particularly well-timed media intervention, whose purpose was to project humanity on the young men. One could compare the *New York Times*'s not-so-subtle intervention for mercy with *Time* magazine's deliberate darkening of O. J. Simpson's face on its cover a few years later, the opposite purpose of which was to demonize the subject even before he was allowed the right to free trial and judgment by his peers. In each instance a careful arrangement of graphic elements, be they type or images, become potent means of intervention in their protagonist's engagement of confrontation with public opinion, a point that Ligon sought to emphasize in his *Profiles* series.

Another definitive example of Ligon's work in the early 1990s is his 1993 collaboration with Byron Kim, an installation called *Rumble, Young Man, Rumble*. The work consists of a professional boxing punch bag hung in the middle of the exhibition space. On the punch bag, Ligon and his friend printed excerpts from statements made by Muhammad Ali at the height of his service as a Muslim minister in the 1960s.

The text is displayed in a manner that forces the viewer to circle the bag in order to read it properly, thus physically playing out a typical Ali performance in the ring. At the same time, this interactive, performative ritual engages the reader in a disturbing drama as he or she struggles with the discomfiting nature of Ali's statements about whites and whiteness. Again through his strategies, Ligon succeeds in making the reader, especially white readers and those who may not share the views expressed by Ali, to reenact the ambivalence that mainstream America was forced into in its relationship with the heavyweight champion in the 1960s. You may be uncomfortable with Ali's utterances or the implications of his views as expressed in those excerpts, yet you are held in the aura of the man, as if locked in inescapable engagement with a ritual figure. In *Rumble, Young Man, Rumble,* Ligon and Kim are able to personify Ali in the printed punch bag: solid, present, unavoidable, and ready to take your finest jab and still rumble. In the work Ligon and Kim also pay homage to one of the finest exemplars of the defiant spirit of the African in America, an individual who was willing to give everything to say, I am. Ligon's props parallel those of hip-hop performers who frequently sample Ali's speeches in their music, as if to reinforce and strengthen their own statements with the grog of history. Like them, Ligon seemed to be saying, Here is where it's at, where I'm coming from. I may not be there still, the artist seems to say—for the times may have changed—but I share in the spirit, the resilient and defiant stance that made it possible for the African American to extract the promises of country and constitution from the American nation.

Which brings us to yet another work by Ligon, his escaped slave impersonation, *Runaway.* As an avid reader of African American literature and student of history, Ligon has always demonstrated a deep fascination for the harshness and cruelty of the conditions under which his ancestors lived as slaves in America, and by the seeming miracle of their survival. This, according to him, led him to imagine what it might be like if we were to be transported back in time, if he were to be in the place of those who came before him. As a result of his curiosity, he struck upon the idea of creating a simulacrum of that condition by casting himself in the place of a runaway slave. In the tradition I mentioned earlier, upon the escape of a slave, the owner would print and post bounty bills in neighboring counties describing the physique and temperament of the runaway slave, and offering a reward for the slave's capture. To share the removed trauma of this experience, Ligon enlisted his friends to help couch the posters in the language of the day. In essence he said to them, "Suppose we were back in the time of slavery, and I was a runaway, how would you describe me?" Using the period woodcut and letterpress format, he printed a series of bounty notices from their responses, complete with a reward on his head.

Ligon's reenactment had multiple purposes. For one, the exercise was a ritual of exorcism, a ritual of acknowledgment and empathy in which the artist seems to imply that if only we could feel a little of the pain of slavery, we might better understand and appreciate. In the post-civil-rights era, a certain level of freedom is to be taken for granted by Africans in America. We may go on the front of the bus, or wake up in the morning and get in the car and cross state lines with relative ease and some guarantee

of safety. We often shop where we wish, and often work at jobs of our choice. These are rights, of course, rather than privileges. Such little freedoms are not to be grateful or apologetic for. Yet only thirty-five or forty years ago, just the span of a generation, these minute freedoms could not be taken for granted by any black person in these United States. Rewind to 150 years ago and imagine yourself lacking in these basic freedoms, whatever your race, your life entirely at the mercy of another who might whip you or trade you or keep you as chattel, even kill you if so wished. Imagine spending a lifetime planning and plotting and patiently enduring, waiting for the chance to break free of such bondage. Imagine that one morning, treacherous fortune smiles on you and for once you are on your way to freedom; an uncertain future fraught with danger, yes, but a promise, nevertheless. Imagine that you are a runaway slave, thirty hounds on your trail, five counties on the watch for the slightest sign of your whereabouts, a certain fate of torture beyond compare, even death, awaiting you should you be captured and returned to your owner. For those whose ancestors were on the other side trampling the marshes with hounds on the loose, imagine that I were your runaway slave. Often the history of the injury that Africans suffered in America is discussed and represented in abstract terms, in words and images detached and distant from our emotive realms. It was this abstraction and detachment, which often prevent us from fully appreciating what terrible burden of history this nation must bear, that Ligon set out to undermine with one little suite of circumstances and reenactments, by saying to his friends, "Suppose that I, Glenn, were your runaway slave, what would you say of me?" In *Runaway* Ligon achieved something that we may find only in literature, in the work of Baldwin or Ralph Ellison or the writers of the slave narratives, something that resists the glib and surface of art, namely the ability to pull the Other into the vortex of a shared history of tragedy and wrong.

Yet Ligon's bold, sophisticated, and sensitive engagement with history and the present, or Simpson's, does not represent the full spectrum of strategies, approaches, or attitudes evident today in the work of young African American artists. On the contrary, there are artists among this generation who have made their name and earned visibility and patronage by threading on the rim of the very history and community Ligon and Simpson honor and reembody. In fact, the greater brouhaha that has attended the work of young African American artists in the past two or three years has been generated by the work and ideologies of those other artists whose position on history and African American subjectivity seems to revolve around the reintroduction, replication, perpetuation, and marketing of injurious stereotypes of African Americans on questionable and poorly articulated grounds of the validity of satire and self-criticism.

And just as the introduction to Simpson and Ligon began with a brief notation on their precursor, Jean-Michel Basquiat, our understanding of the difficult nature of the work of these other artists is helped by casting our minds back to *their* precursor, the artist Robert Colescott. Colescott, an African American artist, enraged the black community in the 1970s because he reproduced or used Jim Crow caricatures of blacks in his paintings. Though Colescott's purpose was irony, his work produced a different, perhaps unintended irony when it was embraced and rewarded by the mainstream

American art establishment, which chose the artist as the first African American to represent the United States at the Venice Biennale. In recent times, Colescott seems to have been rehabilitated even by African American critics who struggle to understand his quest, albeit with hindsight. However, these positive revisionist gestures seldom reach beyond catch phrases such as *bitter irony, parody,* and *satire* without deep and competent engagement with Colescott's work and legacy. One may amply illustrate the problematic nature of Colescott's artistic engagement with history, especially in the 1970s, by reading one of his more recognizable images, the painting *George Washington Carver Crossing the Delaware,* from 1975. In the painting, Colescott depicted a boat party on a river, made up of what is often referred to as coon figures, that is to say, cartoon characters with exaggerated black features such as thick red lips, huge eyeballs, and silly demeanors, such as may be found in popular white depictions of African Americans before the civil-rights era. At the head of the boat party is a central character dressed in a colonial military uniform, also depicted in the same cartoon style. Given the grand composure and scale of the central character, the viewer is left without doubt that the figure is intended to represent the main protagonist of what, for all intents and purposes, is a history painting. That protagonist is George Washington Carver, the eminent scientist, who is nevertheless visually and metaphorically merged with the figure of another George Washington, the general and founding father after whom the scientist was named and who historically crossed the Delaware. As with Colescott's other work, the stated intention of this particular painting was to confront American master narratives and stereotypes, especially as they relate to African Americans, and critique them through satire. The same argument is employed today to explain or justify the preoccupation of young artists who recycle and recirculate deprecatory racist representations and icons from the past, irrespective of whether they succeed or fail in their employment of irony and satire. For when we pay close attention to artistic reproduction or employment of social stereotypes, we find there is only a thin line between the irony it intends or translates to the viewer and the mere perpetuation of the stereotypes. In other words, a painting that reproduces unacceptable images of a group, though it may be intended to make the viewer think critically about such images and their inappropriateness or unacceptability, may in fact simply reinforce the stereotypes and make them seem harmless and acceptable. By bringing a certain reading to Colescott's *George Washington Carver Crossing the Delaware,* we could demonstrate how it might come short of inducing in the viewer a critique of American history or the racist imagination, and instead do considerable damage to their knowledge and appreciation of African American history and America's collective memory.

Although the figures in the painting are brown coon characters, to anyone who is familiar with the myths of the American nation the title of the painting nevertheless evokes recollections of the brave deeds of General Washington on one of his successful, historic campaigns during the American War of Independence. However, given the general ignorance of history that plagues especially young people in America, few would be able to interpret this painting as anything but a "coonification" of the

historical event at best, and at worst a desecration of the memory of a founding father. Few, especially among young Americans, black or white, would be aware that there is in fact a real Dr. George Washington Carver in American history, the precise fellow whose memory Colescott's painting signifies on.

Born in Diamond, Missouri, in 1864, George Washington Carver left the plantation where he was born and found his way to Minneapolis, Minnesota, at the age of ten, and eventually supported himself through school, earning a degree from Iowa State University in 1894. He was appointed to the faculty of the college while he worked for and obtained higher degrees in systematic botany. In 1896, at the age of thirty-two, he was appointed director of the Department of Agricultural Research at Tuskegee Institute, where he developed several hundred industrial and domestic uses for peanuts, sweet potatoes, and soybeans as well as a new type of cotton known as Carver's hybrid. At the height of Jim Crow inequities in the American South, Carver went into the fields to teach southern farmers new ways to improve the quality of their soil, and encouraged them to grow other crops besides cotton. This led to the growth of peanuts as the mainstay of the agricultural industry in the South and to the survival of the industry after the Negro migrations to the North and the collapse of cotton. In the words of journalist Philip Waterstone, "One man saved the entire agricultural industry of the South, George Washington Carver." In 1940 Carver endowed a foundation for research in natural sciences at Tuskegee with his entire life's savings. In 1943, his birthplace was designated a national monument. That is the George Washington Carver of history: scholar, inventor, outstanding innovator, philanthropist.

Let us look at other significant figures in science that fit the stature of George Washington Carver, and how they are customarily constructed in the American popular imagination or their memories perpetuated in American lore. One such figure is the physicist Albert Einstein. Every year more young people are taught to discover Einstein and find inspiration in not only his genius but his modesty. New books are written about his extraordinary talent, new research and literature generated about his sensitivity and wholesomeness. More recently even his love letters have been published, not with the aim to humiliate or tarnish his memory, but rather to further humanize him. One does not advocate hagiography, but we must agree that insofar as certain individuals have contributed significantly to our understanding of our place in history or the universe, insofar as some have contributed to our body of knowledge or our advancement toward a better world, insofar as some have demonstrated the incredible strength and magnitude of the human spirit, such individuals not only deserve our acknowledgment, but serve also as inspiration for the rest, especially the young. This recognition is amply illustrated in the continuing construction of the image of Einstein in the popular imagination. Outside science, one may consider Abraham Lincoln. Even as less hagiographic narratives of Lincoln's life and accomplishments emerge to straighten earlier accounts, the aim remains to present to us and to future generations the story of one man who, frail and human as any other, nevertheless contributed to the survival of his country and to the good of others. Let us look at General Robert E. Lee, commander of the Confederate Army who fought in defense

of a position that many even in his own time found indefensible. History has come to celebrate Lee and his talent as a soldier and a leader of men.

Now let us compare the deference that is customarily paid to these men to the image that emerges from Colescott's *George Washington Carver Crossing the Delaware*. When we look at the painting, we do not see the George Washington Carver of history, the accomplished scientist and inventor of more than two hundred products and machines, the George Washington Carver who saved the agricultural mainstay of the American South by developing and encouraging alternatives to cotton. We do not see the George Washington Carver who inspired me, as a ten-year-old boy growing up in rural West Africa, to work hard and dream big and always seek possibilities for both selfless service and personal glory. We do not see George Washington Carver the man, by himself and in his own right, an American icon and national treasure. What we see instead—what Colescott's painting offers us in the name of satire and in place of the true George Washington Carver—is a coon figure riding a rickety boat in the guise of General Washington, with a raftful of jeering Sambo figures egging him on. The viewer who is less inclined to deep, critical meditation on irony may wonder: Where in Colescott's painting is the inventor, the educator, the philanthropist who gave his whole life to saving American agriculture, and his whole life's savings to education and philanthropy? Where is the American icon? Effaced.

In place of the historical George Washington Carver, Colescott's painting presents a spoof on another historical figure, a laughable shadow image that, though it is supposed to mock the ludicrousness of racist claims on history, simultaneously defaces a pillar of African American history. For the viewer who is less inclined to dig beneath the surface or project a deep criticality on the work before him or her, Colescott's painting merely assassinates George Washington Carver and leaves a comical, satirical fictional character on his grave who has the potential to mislead generations of young people in search of knowledge and the facts of history. A legitimate claim could be made that while trying to call one history to question, Colescott defecated on another and on the memory of a good man.

Surely a number of pertinent arguments can also be made in Colescott's defense: First, as a work of art, a painting is not to be read literally, since often its purpose is to transcend the literal and signify at the level of the metaphorical. Second, the nature of satire is that it runs the risk of easy misinterpretation, and many will miss the point of *George Washington Carver Crossing the Delaware* because they lack the patience or visual literacy to read beneath surfaces.

However, it is in fact the last point that makes all adventures into satire, especially the kind that Colescott pursued, rather treacherous. It is the slippery nature of satire that makes it crucial that the artist who elects satire as an idiom tread carefully to avoid misinterpretation, especially since misinterpretation almost always defeats the purpose of satire. In satire, a valley of death lies between intention and perception, between the goal and its realization, between the sign as conceived and the hidden signified, because, in the end, there is an element of serendipity inherent in all signification: the possibility, always, of unintended ramifications. With these in mind, one may

then ask, On what grounds may *George Washington Carver Crossing the Delaware* be considered successful as satire? Who is the object of the satire? What is the connection between that object and Carver's reputation and memory? How does the satirical engagement with the object ameliorate the potential of disdain on the person and legacy of Carver, who is not, after all, the object of the painting's satirical critique?

At the level of broader cultural ramifications, we may ask, how does the resurrection of debilitating racial imagery in visual culture serve to correct the prejudices that inform such images, or compensate for the historical damage done to those who are impugned by them? How does the reintroduction of such imagery rehabilitate history or constitute a useful and effective critique of the past and the present?

It may be taken into consideration that Robert Colescott introduced his coon images of black folk at the height of the Black Power struggle, when the black community was struggling to consolidate the gains of the civil-rights movement as well as deal with the terror of state violence. Colescott painted his images of ball-eyed and thick-lipped stove-black women, saying, "I Gets a Thrill Too When I See De Koo," in 1978 when Andrew Young was the American ambassador to the United Nations, and black women were recording unprecedented statistics in higher education and professional employment. In the name of satire, Colescott fed the American imagination with denigrating images of black people right when the country was beginning to contend with the truth of the humanity and wholesomeness of the race. It is debatable at best, but some would opine that Colescott rose in the midst of the affirming struggle of his people and said to America and the world, "We's sick today, Massa," and called it artistic criticality. Others would contend that such insinuation is lazy and incompetent at best, and at worst, outright disingenuous because it fails to grasp the critical essence of Colescott's work, even if that essence is not particularly self-evident.

The lingering question, then: How did Colescott's paintings succeed as a critique of the American dominant narrative, while at the same time replicating the visual registers of that tendency as well as impugning the memory of an African American historical figure?

That is a question that stays on our minds as we engage the work of the next young artist who has followed in the footsteps of Colescott, albeit with arguably less sophistication: Michael Ray Charles. Charles, who is in his thirties, has come to some prominence in recent years for recycling stereotypical Jim Crow iconography such as coon imagery and minstrel figures in his work. He produces paintings that resemble old minstrel bills and posters, complete with blackface and exaggerated lips. Sometimes the images are laced with poorly signed text in coon speech. Charles not only reproduces old scenarios and found minstrel memorabilia, he also interprets current events and prominent African American icons in coon form. These are served up plain and devoid of any discernible critical context.

Michael Ray Charles was born in Lafayette, Louisiana, in 1967, at the tail end of the civil-rights movement. After earning a degree in art from the University of Houston, he obtained a job at the University of Texas in 1993, where he still teaches. According to Charles, he received a little Sambo figure as a gift from a friend while he

was in graduate school, and after having investigated the image, began to "sample," or incorporate, Sambo figures in his work. The first such work he made, a drawing, quite tellingly was a pseudo–social realist commentary on American labor practices that he sought to critique by placing Sambo figures on the factory floor. The figures, presumably, represented the working class, and his choice of metaphor for the working class was a racist caricature of African Americans. Over the next few years Charles collected such memorabilia: placards, watermelon treats, cans and jars, and so on, and began to reproduce them as a routine. In his argument, producing more of these racist images and objects is his way of reminding the viewer that racism still exists in America. In his words, although it appears that much has changed in America, what has happened is that "we're not looking at grotesque caricatures anymore. We're looking at Deion Sanders smiling next to a Pepsi can." And his answer to this deadening of sensitivity is to make more Sambo images and sell them to wealthy, mostly white collectors and museums for display in their homes and public collections.

Quite predictably, in the same manner that the mainstream American art establishment has valorized Robert Colescott since the 1970s, so has it scooped up young Charles and valorized him. As Catherine Arnold points out, less than six years after leaving art school, Charles became "arguably the highest flying Texas artist to emerge in the '90s." His reproduction and marketing of racist imagery has stirred controversy, and Charles has soared on the sail of this controversy to move his career and endear himself to a clientele that cannot wait for him to make the next painting of Aunt Jemima and Watermelon Man for them to acquire. This is the extent and nature of Charles's critique of the persistence of racism in America. He plays the enormously treacherous terrain between claimed deconstruction of stereotypes and their perpetuation, and not without reason. He makes a living from making and selling denigrating images of himself.

Rather astonishingly, a good deal of the appreciation that has appeared in support of Charles and his enterprise buys into the argument that by producing and circulating new Sambo images, he is, in fact, critiquing racism: astonishing because it is incomprehensible how that could be the case, and inane because such argument misrepresents the truth of satire as a social device. Satire may not be equated with self-mockery or the replication and perpetuation of self-deprecating imagery that merely reinforces injurious attitudes from the culture or class that is the subject of critique. Without careful contextualization and extrapolation, a stereotype does not become a critique of stereotypy through mere repetition or quotation. Imagery so staunchly embedded in certain political or cultural agenda do not turn in on themselves by simply being reproduced and reinserted in the popular imagination, especially because they do not create the critical context or platform for their own deconstruction. In other words, the act of deconstruction is an intellectual and critical exercise subsequent to the image, and an active rather than passive or incidental engagement, so that unless an offensive historical trope is consciously deconstructed or disemboweled, then carefully and analytically relocated so as to reveal its underlying political or cultural machinations as well as implications, simply reproducing it only reinforces and perpetuates

those machinations. Without the deft but conscious and, most important, evident or apparent critical repositioning, it may be argued that such imagery, like a genie, is best left in the bottle.

Playing with stereotypes is like playing with fire; it either burnishes or it burns. One of the most high-profile attempts in recent times to resurrect racial stereotypy in the form of blackface and black minstrelsy and to transform it into critique is in the 2000 film *Bamboozled* by director Spike Lee, otherwise a true master of the ambivalent subject. However, Lee's attempt collapses on itself in the last quarter hour of the film like a fine sandcastle because he is unable to tow it across the narrow yet steep gorge between stereotypy and critique.[9]

Lee begins *Bamboozled* with a definition of satire, delivered in the voice of one of his protagonists, Pierre Delacroix, who tells the film audience that satire is a "literary work (read art) in which human vice or folly is ridiculed or attacked scornfully (or) . . . derision or caustic wit used to attack or expose folly, vice or stupidity." It would be difficult to describe Michael Ray Charles's appropriation or sampling of racist iconography in those terms, or argue that it evinces sufficient intellectual dissembling as to turn it into a critique of stereotypy or a commentary on the resilience of race-determined prejudice in America. Compared with Lorna Simpson's treatment of the stereotype in American notions of the African American, Charles's regurgitations of race-imbricated imagery seem undigested and unanchored. When a wealthy, white Texan collector buys one of Charles's Sambo paintings, for instance, he does not see in them a lacerating challenge to either his residual racism or that of his ancestors. What he sees, one contends, is an African American validating historical images of his own denigration and that of his race. Which is just as well, for the collector no longer has to denigrate the blacks. The blacks now have one of them to denigrate them. When young people without sound grounding in the history of race and imagery in America—which is to say, most young people in America—are exposed to Charles's paintings, they are not induced to engage in a critique of racist imagery, and may only be expected at best to respond with indifference because they cannot comprehend it, or to find them intriguing, and at worst to treat them with mirthful dismissal.

Michael Ray Charles's quotations of blackface and Jim Crow imagery may therefore be related in some sense to gangsta rap. In the worst examples of gangsta rap, positive musical or cultural elements from the past, like beats, are sampled or quoted, then subverted by being dubbed over with negative lyrics, thus producing an overall negative or problematic but nevertheless marketable product. In Charles's paintings negative images from the past are sampled and either presented without evident intervention or worked over without sufficient critical deconstruction, with the same results that a highly problematic but nevertheless marketable product is made available to a certain clientele that is open to such imagery.

As mentioned earlier, Michael Ray Charles's paintings have enjoyed patronage and publicity from the American mainstream, which appears invested in the imagery and self-construction that he offers. Not only is it widely patronized by collections in Charles's native Texas, it has also found a ready market in the gallery districts of

New York, where the artist is represented by the influential Tony Shafrazi Gallery. Interestingly enough, his work may be among the least formally sophisticated examples of a burgeoning genre in African American art that seems to guarantee mainstream excitement and patronage, a clear throwback to the mainstream excitement with the work of Robert Colescott in the 1970s. In more recent years, other young African American artists with varying degrees of formal or conceptual sophistication have found mainstream support, even instant celebrity and mainstream commercial success, by sampling historically racist imagery in their works. These include Kara Walker, perhaps the most sophisticated and controversial of them all, as well as Ellen Gallagher and Laylah Ali.

Kara Walker found instant success by creating original images based on southern popular literature and lacework, which presented controversial challenges to received notions of race relations in the American South and implied black complicity in master-slave relations, especially with regard to sexual exploration and exploitation. Perhaps because these were seen to counter African American recollections of such relations they were immediately adopted and valorized by the mainstream. Gallagher and Ali equally met success, both by reproducing Sambo figures or blackface in their drawings. Gallagher's early drawings claimed an intention to reveal lurking prejudices in the latticework of contemporary American society by barely hiding such images in otherwise seemingly pure, formal experiments that reminded the viewer of the work of Agnes Martin, and the images were inserted with such subtlety that the unknowing viewer was drawn in, whereupon to discover them. Beyond the formal appeal of Gallagher's drawings, it is questionable to what extent this strategy or literally hidden agenda worked toward fulfilling her larger critical or social intention, but the presence of these historically charged and hardly dissembled images excited much positive reception from the art establishment, which seemed fixated on them. Ali's use of Sambo figures is arguably less sophisticated, both conceptually and formally, and the reasonable success she has enjoyed may only be explained by this mainstream fixation on the manageable occurrence of racist imagery in contemporary African American art.

A question arises, therefore, as to why the American art establishment is invested in the deployment of these images and tropes in African American art. It is a question that deserves serious engagement and therefore would require a separate essay, but briefly, one suggestion is that in some of the instances noted here, such imagery is employed or translated in a manner that makes them easily masticated, contained, or consumed, which is to say that whatever morsel of critical agenda may exist in the works or artists' minds is easily evacuated, dismissed, or simply ignored because it fails to resist such response. Another is that it appeals to a residual instinct or desire within the broad American psyche, even as it comes with a claim to critique. It may well be that what reveals itself, even within the often liberal circles that readily glamorize artistic resurrection of such imagery, is an unconscious resurfacing of unprocessed and thinly repressed notions, which makes it difficult to subject such imagery to proper, critical engagement under which it may show its truly problematic nature.

At any rate, a difference emerges, then, between the artists that we saw earlier,

artists who engage history to understand and identify with their legacy and the unfin-
ished business of communal recuperation from the traumas of the collective experi-
ence of Africans in America, and those who look to the same past and merely strip and
reproduce it for a ready, contemporary market. Glenn Ligon looks at history and with
a shudder says, "It could have been me who was down in the dungeon: *it was indeed
I who was down in the dungeon.*" Michael Ray Charles looks at the same history, but
is unable to translate it and therefore merely commodifies it, which leaves the viewer
wondering, who is the joke on?

Of the young generation of African American artists, therefore, there are those
who sample and cut to the past, but at best are unable to invest it with critical rele-
vance for the present, and at worst merely reproduce and reinforce its darker aspects.
Then, there are those who may be designated as truly represent'n, who seek visibili-
ty but with self-reflexivity and depth. They represent and maintain and have their
feet planted on the solid foundation of history without becoming prisoners of either
the past or the market. They represent in the original tradition and aesthetic of the
hip-hop nation, which is to take a bit from here and bit from there and bring them all
together to create something new, without forgetting history.

1999

The Burden of Painting

AMONG THE CENTRAL IGBO of West Africa, the legend survives of a mythic painter named Asele, master of the body and mural art of Uli, who was so good and astute in her art that she trounced her contemporaries in the land of the living and went on to repeat her feat in the land of the spirits, whereupon she was retained as a painter to the gods. Among the living her legend passed into myth, and her name was revered and celebrated in poetry and song. She was placed on a pedestal in lore and the popular imagination normally reserved for great war commanders, legendary wrestlers, and poets. Generations of painters looked to her as to a patron saint who embodies the ultimate attributes of the consummate artist.

Asele, in turn, may have acquired her extraordinary skill as a painter from the foremost artist of all, the divine painter Ala, goddess of Earth, art, and moral rectitude, who introduced painting into the world when she lovingly decorated the body of her devout messenger, the python, and turned him into a living work of art. So beautiful was her handiwork that the python was made sacred, never to be killed but instead to be admired and venerated as he is to this day.

The myth of the painter is an important one as we contemplate the place and burden of painting in contemporary culture. It reiterates the significance of painting among the arts and underlines the preeminence it has continued to enjoy in discourses on art. Its election of painting rather than sculpture or pottery, for instance, designates a place of centrality to the art, as it does to image-making as a practice. It also apotheosizes the painter and reserves for her a location of prominence shielded from the uncertainties and vulnerabilities that have otherwise come to dog her profession in our time and perhaps in other cultures. This apotheosis is the more significant because it is sacred, because it is bestowed on the painter not by mere mortals but by divine appointment.

Both myth and apotheosis belong in a thought system in which image-making did not suffer the disorienting trauma of a fall from grace, for it is this fall from grace that has plagued it—and painting in particular—in the West, and in time has created uncertainty and ambivalence around its purpose and relevance. Myth and apotheosis point to a moment and cosmology common to all ancient cultures before the ascendance of Christianity and the philosophies of its progeny, where the role of the painter is neither uncertain nor mitigated. This is both explicated and reinforced by the mythic link between the form and origins of society itself, between the mortal painter and divinity. In ancient Greece this divine election was conferred on stone masonry and sculpture, and this difference in form is not without its significance.

After her accomplishments in the land of the living, Asele proceeded to the land of spirits to compete with the finest painters in that realm. We are left in no doubt as to the importance of painting, not only among humans but across cosmic realms also—across the divide between the mortal and the supernatural. In the broad scheme of the universe, painting and the painter are acknowledged and canonized, and the significance of image-making is inscribed as both embellishment and compliment to divine creation.

Ala, the goddess and grand patron of all arts, is not only a painter herself but an indulgent aesthete, who seeks obeisance not in blood or with burned offerings, but with demands that her devotees tender instead an offering of beauty, an elaborate gallery of images and lavish decorations known as Mbari. Every so often as a community prospers and finds reason to show its gratitude to the divine painter and the gods, it engages the most renowned artists within its means and bids them erect a gallery in the goddess's honor, wherein Ala is depicted in all her splendor, joined by her consort, Amadioha, deity of thunder and the heavens, and surrounded by her children as well as the entire pantheon of divinities and their messengers, attendants, and cronies.[1] Each figure is elaborately attired or decorated, and this divine company is set against a background of colorful, abstract murals with metal and mirror insets.

Contrast this celebration of painting and image-making with the austere disavowal of the same that we find in a different thought system, one that has held a devastating sway over painting as a form and practice in the West for several hundred years. In the Hebrew Scriptures, the creator issues a stern sanction against images and image-making in the second commandment of Moses with the following words: "Thou shalt not make unto thee any likeness of anything that is in heaven above, or that is in the earth beneath."[2] As with vengeance, such preoccupation is designated in no uncertain terms as the preserve of God, which no human may breach without severe consequence. Earlier on in the Scriptures mentioned, the children of Israel incur the damning wrath of God when, forlorn and abandoned in the desert on their way out of Egypt, they beckon Aaron, the jeweler and brother of the prophet, to make them an image they may worship. Contrary to the system in which the painter goddess demands an offering of images, most important of which is her own, Aaron and his people, beholden as all mortals are to images and the image-maker, are made to suffer damnation for the failure of their ways.

Of course, for centuries this peculiar, proscriptive tenet had no place or meaning in the aesthetics and cosmologies of the majority of world cultures, its pernicious dogma of divine narcissism finding as its domain only a small band of nomad cultures. However, once it took hold in the West and spread across its dominions, it would become the pivot around which the practice of painting and image-making would revolve, setting up a narrow bandwidth of extremes within which Western society and artistic practice have oscillated for more than a thousand years. In time the tenet has coalesced and ossified around one of many questions, namely the appropriateness of the desire to reproduce God's creation. The manifestation of this desire, which Greek philosopher and anti-aesthete Plato named "mimesis," has been at the center of the most important debates about painting for several centuries. And although some may believe this question was settled once and for all by modernism, and therefore no longer has relevance, the evidence is, of course, to the contrary. At the core of debates over the picture plane, painterliness, the death and resurrection of minimalism and color-field, and the death and return of painting itself are those enduring questions: Is it the purpose or prerogative of painting to imitate nature? Is it within its bounds to seek to reproduce that which already exists? Is painting an original creation or a mere embellishment? Is it indulgence embroiled and implicated in the pretentious machinations of the elite classes or is it a potent social act? Today, the West and its global dominion may have escaped from the strictures of the biblical sanction against images, and instead immersed themselves in a deluge of images. And yet the residues and aftertaste of centuries of entrapment in the hold of that sanction remain, and its call on the limits and responsibilities of painting are to be found in the restrictive nature of debates and discourses around painting—the perpetual preoccupation with what is and what is not, what must and what must not.

In a brilliant introduction to his own paintings in 1929, D. H. Lawrence attributed the preponderant mediocrity of English and American art over the preceding two centuries to a fundamental social shortcoming, namely Puritanism and the dread of beauty and wholesomeness.[3] This fear of the wholesome Lawrence described as a "mystic terror of consequences," which he traced to the end of the sixteenth century, when Europe underwent a "grand rupture in the human consciousness, the mental consciousness recoiling in violence away from the physical, instinctive-intuitive."[4] This terror would lead to a determined disavowal of all that is robust, rustic, or sensuous, all that is natural, and would manifest itself in an intellectual severity in art, especially in painting, as well as a general, social malaise of mild philistinism and servitude to the intellect. Lawrence ultimately located the source of this malaise in the fear of the sexual. His Freudian diagnosis, of course, belongs in his day, but the deeper roots of this loathing, which was manifestly religious in its formulation, projection, and technologies of perpetuation, is in that ancient, biblical damnation of image-making. Not only did painters produce work that, rather than have passion or soul, was so fastidiously possessed of mechanical wizardry, viewers also came to painting inured by the malaise.

The consequence of this alternately subtle and vehement disavowal, and the

deadening of aesthetic awareness that comes with it, is the dislodgment of the image-maker, the painter, from the secure pedestal accorded her in other cultures and earlier times. The myth of Asele typifies the opposite, for within the cosmological and cultural structures that the myth represents, painting and the painter occupied a secure niche beyond threats of abrogation or disregard. From within this niche the painter fulfilled her responsibilities to the gods and exercised her freedom in her responsibilities to patron and self. If painting as we know it should be in crisis today, it is in part because the painter and the art of painting have slipped from this cosmological niche. The perennial return to the question of painting's uncertain future—a question that in societies like the one described here would be irrelevant and beyond contemplation—points to the tragic vulnerability of the painter in our time. Severed from claims to divine appointment, and indeed debarred almost entirely from the succor of popular election and celebration, the painter today must endure the loneliness of her calling.

True, the cult of the painter survives, but that cult is one built not so much on the merits and primacy of the art, or indeed on society's high regard for either the practitioner or the form, as on the wily artifices of the modern celebrity market. Unlike in the Igbo myth, the modern painter is venerated not so much for her superlative skill or her ability to compete with the spirits or command the respect of her community, but for her astute ability to lever herself into and navigate the intricate paths of the visibility machine. Yet rather than ameliorate her vulnerability, the inherent treacherousness of this preoccupation and terrain emphasizes it instead. Nary does it happen today that the painter is transfigured and transported into mythology for subsequent generations, except on the strength of her eccentricity or her voracity for the limelight.

This vulnerability may appear even more palpable for the contemporary painter working outside the buffered geography of her provenance. As the painter struggles to find her place in modern society and to justify her calling, such struggle is often compounded by innumerable other realities, which, in the case of those who work outside of their own cultures, may include the vagaries of itinerancy and a multiple consciousness of self.

In many ways this is the reality that contemporary African painters bring to their practice. In the main the most visible among them work in expatriation, where their location in the cosmopolitan milieu is as conspicuously precarious as it is deeply imbricated in an often tangled density of dispositions. As they shift from the certainties of origin and negotiate their place in a new epoch, the tradition of ambivalence toward the image and the image-maker here discussed, and its broad implications, become as much a part of their heritage as those embodied in the Igbo myth. Yet it is proper to observe that such artists bring to their practice and their construction of the self a ready reference and background in the living, cultural memory of their societies of origin.

By availing herself of the broad traditions and mythologies embedded in this cultural memory, the contemporary African painter is specially enamored to contribute fresh ideas and positions to both the practice of image-making and to global

discourses on the fate and burden of painting. For instance, in addition to outlining a more favorable disposition to the preoccupation with images, the legend of Asele and the beauty-seeking predilection of the painter goddess, Ala, reveal certain philosophical positions that could also inform contemplation on the condition of painting. First, they point to a consciousness of and longing for the beautiful, which validates beauty for its own sake without the strictures of meaning. In the essay referred to earlier, D. H. Lawrence observes that the bourgeoisie in Europe—and this may be said unequivocally of museum patrons in New York—come to painting in the quest for "cerebral excitation" rather than the plain, sensuous joy of an encounter with beauty. Such obsession with the cerebral is couched in the pretensions of a search for meaning and recalls innumerable anecdotes on the frustration with modern painting. On the contrary, it is clear that when Ala, the goddess, decorated the body of her messenger, the motive was to produce that which is sensuous and pleasurable. This act defines a chthonic liberty in the purposes of painting, for if the primary act of the first painter should be to produce beauty for its own sake, then certainly a terrain devoid of inhibitions is made available to the artist.

There are further instructions here for the contemporary painter. A great deal of the debate around painting has concerned itself with a preposterous dichotomy between painting and so-called decoration, that is, that which preoccupies itself with embellishment. In much criticism and especially in art-market gibberish, a painter is all too often dismissed as "decorative." The irony of such observation, which is reminiscent and indeed born of that old discomfiture with beauty, is its failure to acknowledge that all painting, in the end, is driven by the will to embellish or enhance, whether physically or conceptually, that which already exists. The patterned, nonfigurative painting, which at face value speaks to no hidden idea, is as much about embellishment or enhancement as is the engaged painting on the vagaries of war. While the one elects to offer a moment or environment of beauty in the immediate, the other is concerned with the absence and desirability of beauty in the larger scheme of things.

The Igbo divine painter chooses body decoration as the first act of painting, with the aim of eliciting the same pleasurable response given by the Hebrew god who, at the end of each day of his week of creation, looked back at his handiwork and "saw that it was good."[5] In the much restrained language of the King James translation of the Hebrew Scriptures, at the end of the week, the creator god "saw every thing that he had made, and behold, *it was* very good" (emphasis originally in the King James Version).[6] Both divinities, including the latter, who would in the book of Exodus banish humans from the preoccupation of image-making, recognized the generation of pleasure as a valid purpose for art. For centuries early societies indulged in the manufacture of robust and concupiscent images of obvious sensuous or decorative aim. In other words, the superior derogation of the decorative, which has plagued the painter's conscience in the past few decades, defines an era of prevalent inhibition not distinct from the one that D. H. Lawrence described in his essay. This deserves to be interrogated and discarded.

The contemporary African painter who pays close attention to the traditions

discussed here is liberated from the inhibitions of hierarchizing dichotomies, equally bearing in mind that Asele, the legendary painter at the center of our references, was herself not only a muralist but a body painter also, and it was on account of both preoccupations that she was retained by the gods. Even so, such a painter is almost certainly conscious of the inherent multivalence in the nature of the image, almost always aware of the image's capacity to speak simultaneously to both the sacred and the seemingly profane, to appear decorative without losing its vehicular agency. She is aware that in this multivalence resides the redoubtable power of painting. And though this awareness is not peculiar, it is nevertheless lodged in the recesses of the painter's mind, providing avenues of freedom and enabling a surefooted disposition to the condition of painting.

We find this disposition most clearly in the work of African painters like Ghada Amer, Julie Mehretu, Mary Evans, and Donald Odita, all of whom methodically employ technologies of the sensuous in their construction of otherwise highly charged social and historical messages. Whether it is Amer's occasionally disturbing reflections on social and historical inhibitions and their effects on a woman's attitude toward the self, or Mehretu's contemplation of the social implications of itinerancy and urban rootlessness, these are most exquisitely wrought in a masterly command of medium and technique reminiscent of Asele. Evans reminds us of the goddess Ala, able to draw viewers close, even endear them to equally difficult moments and issues through her undeniably seductive patterns and decorative motifs. Odita engages us with his studies of color and color-field painting, yet his interest in "color" is both visual and conceptual, both formal and metaphorical. His paintings resonate with disarming plays on optical pleasure, yet speak to serious philosophical questions around color and human relations. These artists are not inhibited by uninformed disavowals of the decorative, but recognize instead, as did the divine painter of Igbo lore, the power of beauty in painting.

The myth of Asele has yet another relevance for the contemporary non-Western painter whose theater of practice is the West. As noted earlier, it speaks to the desirability of transit and transcendence across borders and realms of origin. It is a potent and inspiring metaphor for the aspiring painter who is able through mastery of her art to levitate herself unto new planes and theaters of practice. Through mastery of her art Asele transported herself to the theater of the spirits. Her ability to engage such unfamiliar territory—which is in many respects reminiscent of what I have described as "the terrain of difficulty" (see "Art, Identity, Boundaries")—and command it with enough redoubt to earn the commission of the gods speaks to artists who come to the heart of the global from "elsewhere." It has a particular resonance for artists like Amer, Evans, Mehretu, and Odita, all of whom were born in Africa but have made their living and located their practice in this terrain of difficulty. Asele's contests with the spirits on their own turf are an apt metaphor for the condition of artists who must contend with the redoubled challenges of practice and contestation in a most challenging environment. That these artists have brought their skills to bear on our under-

standing of the location of painting at the turn of the century in turn speaks to the longevity and enduring relevance of painting as a form and practice.

As we look again at myth, it does appear that the burden of painting in all its forms and predilections is to compliment divine creation, and to provide something to which we might look and say, *it is* very good. That burden is light and bearable.

2000

Brave "New World"

Forsaken Geographies: Cyberspace and the New World "Other"

WHILE ON A CONFERENCE TRIP in Mexico in 1993, I witnessed an incident that reminded me of the deep paradox of our existence and perceptions of progress and triumph at the turn of the twenty-first century. In the lobby of a three-star hotel in the heart of Guadalajara, a scantily attired child, hastily painted in the colors of an indigenous performer (having perhaps done the makeup himself), made gestures toward staff and visitors. He was six years old at most, possibly five, and he was there because he was not in school. He was there because he *could not* be in school.

For all the time I was in Guadalajara I had made a point to count how many indigenous people were on the streets, in cars commuting to work in the busy traffic of an early city morning, walking the corridors at the national university of technology, shopping along Pablo Neruda Avenue. This is an old habit, one that I have had use for in every new city that I visit so as to map properly each city's contours and configurations, to better anchor and more securely locate myself. As a consistent outsider in most places, I have grown to search for little pointers that others take for granted, little indicators that are often lost on the typical traveler. No matter how cosmopolitan I may think myself, it is nevertheless frightening and lonely to be alone on a midnight train from Düsseldorf to Nuremberg; one is forced by nature, by the instinct the evolutionary processes of our forging have imbued us with, by the instinct to search for safety and survival, to look for strength in numbers. I search for signs that create for me an illusion of belonging, the illusion of an imaginary community. One such sign is the demographic pattern of a city, the peculiar axes of delineation and bonding. In Guadalajara I searched for the indigenous people not out of tourist voyeurism, but in desperate need of an anchor. I noticed only a few, and the little boy in the lobby whose story I here narrate was among them.

149

The boy made gestures but he did not speak, which is not to say that he *could not* speak. Evidently, he could only motion and gesticulate to the audience in that hotel lobby because he did not have their language—*our* language. Someone offered him money, which he rejected, and at this point a member of the staff drove him from the lobby. As the boy fled, the fellow turned to us and explained what the painted boy wanted all along. All he wanted was drinking water.

I begin with this story because it is about communication, or the failure of communication. It is also about location and privilege. It is about power and its proclivity for insensitivity. It is about priorities also. It is about our propensity to misunderstand, and in the process demean those who, through the unfortunate circumstance of their location and background, cannot lay claim to the same privileges of language and disposition as ourselves: due to our predilection to be so engrossed and lost in our own worlds, we consign all others outside those worlds to absence. In our piety, some of us offered the little boy money. Yet he had two fundamental needs more crucial than money: water and the ability to communicate this most basic need to others. Among us, both conferees and tourists, there were probably dollars in the thousands, state-of-the-art digital equipment, expensive clothing, innumerable degrees and diplomas, millions of miles in travel and adventure, a good deal of enlightenment, and wide knowledge of the arts and letters. There was goodwill too, and charitable disposition. Despite this bounty, none of us appeared readily disposed to provide two things for a gesturing child: water and understanding.

To that child the entirety of our discourses as conferees in *his* city, the entirety of our theories and enunciations, the entirety of our debates and intellectual flirtations did not matter. To him nothing of our disputations over the nature and merits of a digital revolution, nothing of the increasingly mushy language of cybernetics and its discourses, nothing of the orgasmic cant of university professors and obscenely well-paid research cadres who present themselves as the messiahs of the new age intent on leading us to the discovery of a new body, not any of it mattered above that fundamental need that we take for granted, namely the need for such indispensable basics of life as drinking water. In this essay I will touch on Africa and on the culture of digitization, as well as the implications of the latter for the millions of Africa's children and adults for whom the idea of cyberspace is, in all truth, more yet ironically less than virtual. But I will come to that. For now I will dwell on the little boy of Guadalajara and the implications of a disembodied, detached, and self-obsessed, self-consuming new world that creates little room for his needs and circumstance.

Compared to most countries in the world and despite perennial fluctuations in its fortunes, Mexico is a wealthy nation, and though it rhetorically belongs in the so-called Third World, it is nevertheless much more than a figurative extension of the First. Statistics indicate that all Mexican citizens above the age of fifteen can read and write, and that this literate number constitutes 87 percent of the Mexican population.[1] In the context of global computerization and the digital revolution, Mexico is not a complete outsider. Its numerous scientific and technical universities are equipped and staffed with digerati who are not only conversant with the technicalities of computer-

mediated communication, but who also provide network services. Along with the more basic technologies of electronic mail and optic-fiber or satellite communication, the country's educational institutions and private locations boast a number of file-transfer protocol servers and mirror sites. The country has been a beneficiary in technological exchanges with the United States, involving the movement of thousands of units of computer equipment. With Argentina and Brazil, Mexico has 90 percent of the computer technology in the whole of Latin America.[2] It is almost logical, therefore, that Mexico is often invoked as central to the information "revolution" in Latin America. Such disposition is unimaginable in all but perhaps one nation in Africa.

In cyberist rhetoric, Mexico should already be the theater of great freedoms on the frontiers of a new world where its peoples not only have the liberty to traverse the universe and erect communities across national and cultural boundaries, thus invalidating the restrictive structures of an old world, but also possess the power to effect the transformation of that old world and all that constituted it, including their own bodies and realities. Mexicans should already be able to transcend the demands of their own bodies, the mundane demands of everyday living and survival, as part of the new global community, where, as John Perry Barlow has promised, the mind is "uploaded into the Net, (and) suspended in an ecology of voltage as ambitiously capable of self sustenance as was that of its carbon-based forebears."[3]

For the seemingly more realistic advocates of the digital revolution, the people of Mexico should already be part of an empowering restructuring of society that enables them to participate in the running of their own affairs as well as those of their country; they should already be enamored of a new democracy, an outbreak of irresistible translations and transgressions, a new liberalism sustained because it cannot be contained. The frontiers of challenge for them should be in the arena of the definition of a new reality, a mind-sizzling, cybergasmic truth that is able to free them from the constraints of the old order and of life itself as we know it. In the Mexico of this cyber imaginary, there ought to be no place for a painted, half-clad six-year-old with grass in his hair standing in a hotel lobby, alien to his world, desperate among strangers, futilely gesticulating for drinking water, unable to communicate his quest and his thirst to an impatient, insensitive Other world.

Cyberspace and the Persistence of Reality

That a cyberworld of wonders already exists and that it extends to Mexico there is no doubt. Whether it can deliver on all of its promises as "the world rendered as pure information," where we "feel augmented and empowered (and) our hearts beat in the machines," as Michael Haim has written, is another matter,[4] and one of less urgency to me. What is of interest is that in the presence of this great world of new consciousness, where the old reality becomes a Jurassic Park, our single most needling problem as a species is that the old reality, the reality of physical bodies with needs and desires, the reality of hunger and thirst and ignorance and vulnerability to disease, in truth refuses to give way. Despite our enthusiastic efforts to redefine reality, to push the

frontiers of experience and existence to the limits, to overcome our corporeality, to institute a brave new world of connectivities and digital communities, nature and its structures and demands still constitute the concrete contours of reality for the majority of humanity. And this nature is not just "a *strategy* for maintaining boundaries for political and economic ends," as Allucquère Rosanne Stone has claimed.[5] This nature is a reality that manifests itself in the concrete form of hunger and thirst, in the absence of appropriate language, in the desperation of a child gesticulating for drinking water. This nature is not a mere *category* as some have claimed. This nature is a truth.

On the university campuses of Mexico, ten thousand computers may buzz still and a million fiber-optic wires crisscross. Virtual communities may sprout where citizens shop online or relieve their sexual tensions away from demanding partners. Professors with time on their hands may download graphics packages and with these alter digitized images of themselves in the belief that by so doing they also alter their bodies. Students may indulge in the fiction of new identities, a practice as old as the human race itself despite vainglorious ascription of novelty to what, fundamentally, is only a new form of masking. Those who can afford the luxury may sit before their screens and fantasize about virtual food and digital aromas. Yet these remain the indulgence of a privileged few, and bring no alteration whatsoever to the concrete fate of the millions of Mexico's children and citizens who must battle a different pre-occupation: namely, the struggle to survive each new day and meet the demands of a real world.[6]

Cyberculture in a Deprived World

I dwell on the boy in Guadalajara because his case resonates for me as an African and an outsider in the West, because it has relevance for the African condition in the cyber age. I dwell on him because he is a reminder of the implications of our complicity in the erection of a new frontier, even as we claim to have destroyed all frontiers; it has implications for our role in the construction of a new border beside existing borders, a new line of demarcation that he and many millions more like him may not cross.

In the foreword to Steve Talbott's investigation of the implications of the Internet, *The Future Does Not Compute,* California publisher Tim O'Reilly makes a simple, almost frighteningly definitive declaration: "Computers are with us," O'Reilly states, "whether we like it or not."[7] There is an irony lost on most who associate the new world of cyber reality with unmitigated independence and freedom, which is that no matter how much we extol its virtues, no matter what extraordinary possibilities for freedom we ascribe to it, no matter what new languages and registers we invent to describe its uniqueness and omnipotence, cyber reality and the phenomenon of computer-mediated communication depend irretrievably on one inevitable condition: the computer or digital portal. Incidentally, while O'Reilly's statement holds an unavoidable element of truth, computers are not, in fact, with *all of us.* Computers may be part of the reality of thousands of children, even hundreds of thousands, in California and Detroit and New York, but for the child on the streets of Lagos and

Mexico City and the South Side of Chicago, computers are *not* a ubiquitous part of reality. Without this component, without this point of entry, this concrete and material *interface,* cyberspace and its myriad promises and excesses do not exist. This is the alternate reality of the geography that I invoke, the geography that the child pleading unheeded for drinking water represents.

Like Mexico in Latin America, the leading country in information technology in Africa is South Africa. Not only does the "new" nation of South Africa boast a history of participation in digital networking longer than most, it is today at the forefront of the more advanced forms of this technology. These include an admirable number of network communities and an appreciable presence on the improved interfaces of the World Wide Web, as well as a string of transfer protocol servers and service providers. Its virtual communities are part of the global network of cyber communities. Its government has a national policy on information technology, and in May 1996 the country hosted a United Nations–sponsored international conference on computer-mediated communication. Like Mexico, South Africa is not a complete outsider to cyberspace.[8] Yet South Africa's digital revolution is the preserve of the hubs of industry, commerce, and education, and these constitute a minuscule, albeit powerful, sector of the country. For the rest of its population, for the millions who have only just emerged from a century of segregationist disadvantage, for those who wait still for the promises of a new, liberal democracy to be fulfilled, the allures and discourses of cyberspace are nonexistent. For those millions, the question is not whether the computer is favored or resented. The fact is that it does not exist, and the reality within which their daily lives are defined and spent has no room as yet for a digital nirvana. Their worry is not over the inconsequence of nature and the body in a digital utopia; their most elemental worry is for the survival of nature and the sustenance of the body.

According to experts, while "many of the white one-seventh of the South African population enjoy incomes, material comforts, and health and educational standards equal to those of Western Europe, in contrast, most of the remaining population suffers from the poverty patterns of the Third World, including unemployment and lack of job skills."[9] This remainder of the population falls outside the statistic enabled to be part of the new world of cyberspace and digital reality. For this remainder, which unfortunately constitutes the majority of South Africa's population, subsistence, basic health care, and access to elementary amenities such as electricity and drinking water constitute the priorities of existence. For them the laudable benefits of the digital revolution in no manner compare to the promises of their real revolution, which till the present have remained short of fulfillment. Here the facts of *categories* and *strategies* are real; they affect the individual's chances of daily survival.

For the majority of South Africans, the repression and violence of the past decades and the deprivation and disillusionment of the present imbue existence and reality with a concreteness and depth of meaning evidently difficult for the purveyors of cyberist discourse to grasp. In the same manner that Vivian Sobchack invites Jean Baudrillard to experience "a little pain to bring him to his senses, to remind him that he has a body, *his* body,"[10] the history of South Africa's majority qualifies any

suggestion to depart from reality, or to dismiss it as "only a temporary consensus . . . a mere stage in the technique," as Nicole Stenger has described it, as unbearably obscene.[11]

The advent of virtuality and cyberculture in South Africa is particularly interesting, for not only is this culture sited in the midst of a larger society marked by the unimaginable poverty, deprivation, and despair still evident in the townships of Durban and Johannesburg and the arid villages scattered across the country, it is also circumscribed by the persistence of minority white privilege amid a disadvantaged black majority. The emergence of a minority within a minority, which cyberculture introduces to this polity, and the further withdrawal of this enclave of privilege from the harsh realities of a population for which liberal democracy has proved big on promises and thin on delivery, symbolically underlines an incongruence that is characteristic of cyberism in particular and of posthumanist notions of progress in general. In a country with a history of repression, cyberspace reinserts the culture of insensitivity while further dislodging the disadvantaged from the scaffolds of power. Electronic mail and the Web browser, with all their inarguably positive potentials, nevertheless become veritable tools for the construction and fortification of an Other world, outside the borders of which everything else is inevitably consigned to erasure and absence. In connective South Africa the majority of the population fit most perfectly into that category of the inconsequential revealingly known in cyberspeak as PONA. They are, indeed, a *people of no account.*

Yet South Africa is the most prosperous, most promising of African nations. Compare it, if you may, with Kenya in the East, another country with a certain proximity to the industrial world, if only through its famed tourist industry and its highly educated and cosmopolitan middle class, but one whose entire budget revenues of $2.4 billion in 1993–1994 fell short of South Africa's defense budget for the same year, $3.2 billion (which is only 2.8 percent of South Africa's GDP for the year). Despite supposed political stability for nearly twenty years, Kenya's per capita national product approximates only 25 percent of South Africa's. Under the circumstances, and with an external debt of $7 billion, allocations to education, communication, and social infrastructure are incommensurably lower in Kenya, which means that only an even more minuscule, almost infinitesimal sector of the population has access to the facilities of telecommunication and information technology. In the race toward a global digital revolution, even Kenya has no place.

And Kenya is not the most impoverished of African nations; quite the contrary. Compare it in turn with Somalia, "one of the world's poorest and least developed countries,"[12] where 70 percent of the population are nomadic and decades of internecine warfare have destroyed not only the fabric of the economy but, with specific relevance to our discourse, the entire public telecommunications system also. Compare Somalia with Chad, another African nation where a cycle of civil wars has equally destroyed the most basic social and technological infrastructure.[13] Though no reliable current statistics exist, 1995 estimates indicate that Chad has a 48 percent literacy rate, only one thousand working telephone lines for a population of more

than eight million, and no Internet provider. The telecommunications system is best described as primitive. Compare Chad with Liberia, long one of the continent's most stable polities where, for the past decade, unfortunately, civil war has equally destroyed not only the economy and infrastructure, but hundreds of thousands of lives also. Available statistics place the literacy level in Liberia at 38 percent, one of the lowest in the world, with 80 percent of the population existing below the poverty line, 70 percent of them unemployed. For over a decade in Liberia, school-age children exchanged chalk and board for automatic weapons and submachine guns and fought in a bitter civil war. There were no computers in schools. There were no schools at all.[14]

For these countries and their citizens, deprivation is an almost unshifting reality, and within the matrix of this reality the assertion that "computers are with us" and that the world is on the brink of a great cybergasmic explosion is a fallacy. It does not reflect the world as *we* know it. In the end, cyberculture is a dependent phenomenon, reliant on the relative mitigation, if not absence, of deprivation. The accessibility and relevance of cyberspace are dependent on the ability to transcend the constraints of basic subsistence, the privilege to take certain fundamental dispositions for granted. Within the geographies mentioned, however, as within those of rural Mexico, India, and the American inner city and outback, deprivation is an unmitigated presence that forecloses access to the entry points of cyberspace. These are territories where reality persists, the localities of the Other of our new world. These are the geographies forsaken in the jargon of cyberist discourse.

If the computer or digital interface is a condition for cyberspace and cyberculture, computer literacy is a condition for successful use of the computer. This new literacy, the ability to understand and manipulate the accessories of computer-mediated communication, in turn relies on the condition of the old literacy, the ability to not only read and write, but to do so functionally. This basic skill, unfortunately, is not available to all. In Africa, the distribution of literacy varies from countries with levels competitive with other regions of the world to those where the literacy level dips below 30 percent. While, for instance, South Africa registers a literacy level of 76 percent, which is among the highest outside the highly industrialized world, Mali, though literate from age six upwards, nevertheless has a national statistic of less than 19 percent literacy. In Somalia and Ethiopia the figure is 24 percent, in Egypt 48 percent. For many of these countries even the statistics are unreliable, since significant portions of the population are transient either as nomads or as migrant labor, thus not only falling outside the reach of census records, but also precluding the occurrence of any significant levels of literacy within. In all, such demographic constituencies, together with those officially registered in national statistics, constitute a sizable mass of illiteracy across the continent.

In countries with traditionally relatively high levels of literacy, like Nigeria, Kenya, and Ghana, perennially deteriorating economic and social conditions have exacerbated rather than reduced illiteracy, thus putting earlier efforts toward mass literacy on a reverse. For instance, Kenya's already mentioned external debt of $7 billion, an infinitesimal figure for most societies in the West, is nevertheless thrice the size of

its entire expendable annual revenue. Under such constraint, allocations to education, especially at the crucial primary levels, are invariably low, in some cases much lower indeed than the national-defense allocation. The implication is that practically millions of people in these countries lack the basic ability to read and write. Where traditional literacy is nonexistent, computer literacy is logically precluded. And when we remember that the literate in the countries I have mentioned, though they may be more functionally literate than the majority of America's literate population, for instance, nevertheless have no access to advanced forms of communication technology, and thus are less likely to have access to computers, then can we begin to understand the nature of the gulf between these geographies and the pockets of privilege that constitute the global cybercommunity.

Rather than peculiar, the African condition is, in fact, representative of the crisis of illiteracy and deprivation that currently exists not only in the so-called Third World, but within the highly industrialized regions of the world also. In Brazil a government-estimated 17.7 million people are illiterate. In India the official figure is 168 million. In the United States, though official surveys claim a staggering national literacy rate, experts nevertheless point out that "nearly 90 million adults or approximately 47 percent of American adults are at the two lowest levels of literacy."[15] According to a report published by the Ohio *Daily Reporter* in 1995, and backed by the authority of Chall, Heron, and Hilfer, "27 million adult Americans cannot read the simplest texts and street signs."[16] In central Ohio alone, "91,000 people have a literacy disability."[17] For these and other millions of world citizens, the requisite skills for access to cyberspace are lacking, thus ensuring that they remain on the outside of our brave new world. Across the boundaries of conventional geopolities, a grand territory of disadvantage grows, a huge, global digital underclass and a new world of Otherness that spreads from the inner cities and villages of Midwest America to the refugee communities of Southeast Asia, oblivious to the advantages and threats of our digital revolution and in turn excluded from the registers and details of our discourses.

Cyberculture and the Brave New World

The reputation of the digital superhighway as the greatest, most efficacious cultural manifestation of the democratic ideal since the printing press and photography is today almost generally accepted among those who have access to its myriad opportunities. The equally frightening negativities and shortcomings of this emergent territory have increasingly come under the competent scrutiny of many concerned critics, among them such eloquent scholars as Mark Derry and Mark Slouka, each of whom has in the past year produced an excellent critical assessment of cyberculture and new information technologies.[18] I come to the investigation of cyberculture not as an adversary, however, but as a humanist whose background in the deprived geographies of the world necessitates sensitivity to cultural and political machineries that discount those geographies. While others may contemplate the exciting technological challenges of this new phenomenon and speculate on its awesome possibilities, I am

nevertheless driven to recognize the reality of the absence of billions around the world who share my background, and therefore belong in the disturbingly huge category of the discounted.

Much as it may provide multiple routes of interzonality to many, cyberspace nevertheless remains the preserve of a statistically negligible fraction of the world, unable yet, and indeed unwilling, to undermine the fundamental boundaries within and without that separate the powerful and privileged from the less powerfully disposed. Increasingly we find that the greatest shortcoming of cyberculture is not that it occasionally provides disreputable freedoms and liberties, but that its facilities of participation and fulfillment are unavailable to the majority; that it is foreclosed to certain geographies, and there is a general unwillingness on the part of the privileged to account for the unrepresented. Cyberspace, as we have seen, is not the new, free global democracy that we presume and defend, but an aristocracy of location and disposition, characterized, ironically, by acute insensitivity and territorial proclivities.

To remember that the vast majority of humanity, both outside and within the highly industrialized world, have no knowledge whatsoever of this new platform of liberties, to speak less of access to it, is to underline not only the esotericism of certain discourses, but also to call our attention to the challenges of forsaken geographies and silent territories, populations and denominations on a new margin of our own creation—those races condemned, as Gabriel García Márquez ominously observes, to one hundred years of solitude with no respite on earth. It is to underscore the true nature of cyberculture as a territory of privilege, and to remind us of dominions which, though left behind in our march into a new age and a new millennium, nevertheless remain to invalidate our claims to progress.

In calling attention to the condition of Africa and the other territories, if only briefly, my intention is not to present an indiscriminate critique of cyberculture and the exploration of cyberspace, but to caution against the amnesiac tendency of cyberism, the inclination to escape into cyberutopia and by so doing ignore the responsibilities of technology to society. My goal is to challenge all those who possess and understand this new technology to apply greater seriousness and humanism in exploring means to extend the numerous, practical possibilities of this technology to the greater majority of humanity.

Reading the June 6, 1996, edition of the *International Herald Tribune,* I was attracted to a news photograph of Henry Ford III riding in the prototype of the motorcar his great-grandfather, Henry Ford, drove in 1896. To many at the end of the nineteenth century, the invention of the automated moving machine was an epitome of the creative capabilities of the human species. It was celebrated by poets and entrepreneurs alike. Over the course of the twentieth century, however, the technologies of automated mobility have found their enduring appeal in our ability to make their numerous possibilities and benefits available to the greater majority. This in itself owes to the vision and realism of those who, instead of configuring the automobile into an icon of privileged utopia, embarked upon a real course of democratizing its possibilities. Henry Ford pledged to make the motorcar available to all. In Germany the

National Socialists designed an affordable automobile named for common folk, the Volkswagen, which would seem an irony of history to many. Today not everyone may possess an automobile, yet almost everyone has access to some form of mass transit based on this technology. Such is the challenge that faces us as members of the inarguably elite community of new information technology.

Some would argue, perhaps, that such advanced technologies may not, after all, be of interest or indeed even necessary to certain sections of society or regions of the world, and could infer the justification for such a position from my arguments and statistics. Such a position, however, only underlines a liberal tendency not only to create and perpetuate underclasses, but also to assume a right to speak for such constituencies. Clearly, for billions of people around the world, cyberspace and connectivity may not be a priority, as has been demonstrated here, but surely a technology as versatile and increasingly domineering as cybercommunication holds inevitable possibilities—and consequences—not just for the minority that presently accesses or controls it, but for everyone who exists in a world it is set to rule. One such area of possibilities is education. This is perhaps most pertinent at the formative stages of learning, when every child should have the right of access to the best our civilization and species can offer. The child in a refugee camp without schools may have greater need for more basic structures, such as safe shelter, clothing, and nourishment, but she has no less right to, or ability to grapple with, the facilities of digital or connective learning should those be made available to her even in her circumstances. And while a country devastated by war may have a more immediate need to restore its telecommunication system than to achieve instant connectivity, it would nevertheless be wrong to preclude such a possibility or fail to recognize its ultimate desirability and use in a connected world. In other words, while the logistics of such infrastructures may yet defy present circumstances and capabilities in certain societies, it is nevertheless little justification to subscribe to development theories that offer rudimentarism as the logical condition of the less industrialized.

Our responsibilities begin, perhaps, with recognition, taking into cognizance the precise nature and reaches of the technological revolution of which we have become enthusiastic purveyors. Rather than consume ourselves with the vain and insensitive rhetoric of cyberutopia and the deconstruction and reconstruction of bodies, genders, and rarefied *epistēmē*, we should perhaps define the concrete, positive gains of cybertechnology, recognize the relative inaccessibility of this technology at present, and ultimately outline and pursue a strategy for making these gains available to as many as possible, wherever they may be. It is my belief that while this does not necessarily distract from the wilder, more narcissistic explorations of cyberspace upon which many of us are already embarked, it should certainly preoccupy us once more with technology's premier raison d'être, which is to serve the cause of greater human development.

1996

On Digital "Third Worlds": An Interview

THE FOLLOWING INTERVIEW was conducted in the summer of 1996 by Christian Hoeller, editor of the Austrian art magazine *Springer,* following my presentation at the Fifth International Cyberspace Conference in Madrid, Spain (see "Forsaken Geographies and the New World 'Other'") that year. The interview was conducted by e-mail.[1]

CHRISTIAN HOELLER: In your contribution to the Fifth International Cyber Conference in Madrid, you made a quite strong and compelling point about the "New World Other" of cyberspace. The argument in brief is that the glorious promises of cyberspace do not apply to large sections of the world population, especially in Africa. What do these "new world borders" exactly look like and where particularly are they felt most strongly? Do they really coincide with the old borders between First and Third Worlds?

OLU OGUIBE: I think that your question may be answered from the back. The borders amplified by the cartography of cyberspace are not exactly new; they are the old borders of class and disposition long identified by numerous schools of sociopolitical thought that cut across national and political boundaries and thus specify a different geography, a human geography.

 The "Third World" of cybertechnology and cybertheory, what I have referred to elsewhere as the "Digital Third World," is a global territory that runs through what I consider the virtual—that is to say, simulacral—borders of the present First/Third categories, ultimately exposing the ludicrousness of these delineations. In other words there are, in truth, no First and Third Worlds along lines of physical

geography; these categories are rather socioeconomic, and it is the homogeographical borders that are replicated in the politics and cartography of cyberspace.

At the conference in Madrid, Guillermo Gómez-Peña repeated a familiar yet most pertinent call to discard the old categories of so-called First and Third Worlds. What he meant, I believe, is not to ignore or dismiss the chasms between the wealthy, industrialized nations and the poorer, less industrialized societies, but that we redefine them—that we recognize that the Third World is not Africa or Latin America or Portugal, for that matter, but those as well as populations within the very belly of America and England and the rest of Europe. The point is to recognize that the real "Third World"—and that's a term I consider somewhat inappropriate and misleading since it is often misplaced outside the context of its invention within the politics of the cold war—is a global zone that comprises the deprived neighborhoods of the United States from California through Chicago to New York as it does Madras and Chad.[2] Granted, the dichotomies between the highly and the less industrialized worlds are of enormous and quite decisive relevance in many respects, yet the specific factors that define individual lives are not determined entirely by those dichotomies.

Though it may surprise some to know, there are individuals who own fleets of private jets in Lagos, Nigeria, as there are those who have access to the most sophisticated, available digital hardware in Aracataca, Colombia. For a period in the early 1990s, an appreciable percentage of my generation in Nigeria was made up of merchant bankers who relied on global cellular communication for their business transactions. They needed and had access to state-of-the-art digital technology while living in the so-called Third World. This is the point I make: namely that access to advanced technology may be affected, but it is not necessarily determined, by the specifics of the physico-geographical. The Other is not out there; the Other is the brother.

In the specific case of cyberspace, this Other is not just the young man in Liberia who, for reasons of incessant civil war, is already in his late teens and has had no appreciable education; the Other is also the student at the University of Illinois at Chicago who is unable to take advantage of the technology at his disposal because an upbringing of deprivation in the villages of the American West may have left him with a serious case of technophobia. He is the fellow at the neighborhood bodega in New York who knows the computer only as a word; who has no bank account either, and therefore has no access to even the computerized interface of the cash-vending machine that so many take for granted today. These are not aliens deserving of expatriate pity. These are the intimate Others of our discourse, the Others that cyberist rhetoric ignores.

Some would prefer, of course, that we moved on rather than spend much time flogging this issue, and they must have a point too, difficult as it is for me to find that point. Yet there is no harm in dealing with one of the most crucial shortcomings of a facility with such obvious potentials and for which so much more has already been claimed.

HOELLER: One of your demands is the extension of digital technology and facilities to the "forsaken geographies." What are your expectations for bringing the Internet to the "underdeveloped" parts of Africa? In other words, will the extension of cyberspace help meet the demands of the real, starving world there? If yes, through which means will this be realized?

OGUIBE: Regarding the extension of connectivity or new information technology beyond its present borders of preponderance, if you take my answer to the last question into account, you would find that my argument is that rural Africa is no greater priority, perhaps, than urban Chicago or rural America. In reverse it is my argument, also, that the wild claims made for connectivity and cyberspace with regard to their supposed ability to transform existence and reality—the idea of cyberspace as panacea—are preposterous, even ludicrous, and particularly so within certain contexts and polities. For some locations, instant connectivity is not only impracticable, it is largely irrelevant in the present also, and it would be a significant mistake to take my call for a desire to present the Internet as an all-purpose solution to societies torn apart by war or caught in famine, be they in Liberia or Croatia, though it is my conviction that such societies must hasten to sort out their difficulties so that they too can get there with the rest and take advantage of whatever good this phenomenon has to offer.

Every society has its priorities, of course. This does not in any way remove the fact that there are positive, practical ways in which new information technology can be of use to the dispossessed or to societies in distress. After all, information and communication are the fundamental essence of cyberspace, and efficacious transmission of knowledge is crucial to the survival and progress of all societies. Already there is ongoing research into cheaper, more practicable forms of connective technology appropriate for the peculiar circumstances of certain societies, and by this I do not mean crude or putative technology. If the information community had the will, we could place such facilities at the disposal of those societies where fiber-optic or other forms of traditional, connective infrastructure are currently not feasible, for instance.[3]

HOELLER: Don't you see the danger that a mere quantitative extension of cyberspace will be just another act of (economic) colonization by the West, especially when enacted by huge Western corporations? Aren't cybertechnologies the tools of some privileged, hegemonic few over an underprivileged majority, be it in South Africa or in the U.S.? My query is whether it will not automatically widen the gap between over- and underprivileged just because it is a technology of power.

OGUIBE: There is a danger in every undertaking, whether it is space exploration or the introduction of new technologies, and every technology is an instrument of power, but this does not necessarily qualify it as evil. Technology is not evil; humans are. And so I hesitate to buy into the hysteria over the possible use of technology as a

tool of hegemony over a prostrate majority because it dismisses responsibility. The world's majority has as much responsibility to possess technology and the power attendant upon it as anyone else. I made the point at the conference in Madrid that the triumph of the European colonial project owed quite significantly to Europe's possession of superior firepower and advanced military technology, arguing that perhaps the ravenous details of the colonial encounter might have been mediated had there been an equal mastery of that technology on all sides. I use this only as an analogy, but one that I consider most relevant here.

To call attention to the absence of certain polities from cyberspace is not to absolve them of the responsibility to resolve and transcend whatever constraints might account for their absence in order to place themselves on a par with the rest. The answer is not to resign and continue to reside in some third locale. The challenge, I believe, is to invalidate present hierarchies by marching boldly and determinedly alongside the rest. Certain excuses are becoming rather facile, and it is only proper that each society address seriously those factors and inadequacies that place it on a margin and at a disadvantage in relation to others.

HOELLER: A question about cyber ideology: Isn't it a huge privilege of Western intellectuals to make those entire liberal and libertarian claims about the destruction of all frontiers an endless connectivity of the "World Spirit"? It rather occurs to me as an intellectual masquerade of an aggressively expansive and despotic capitalism. What do you think?

OGUIBE: No, not exactly. The bogey of an expansive and despotic capitalism is itself, in some sense, an essentialist liberal creation. Ironically, the nature of cyberist claims reveals also the deep political naivety of the intellectual class and its self-destructive proclivity toward inadvertent complicity, or sometimes outright duplicity, in the so-called free market project. Individuals like Esther Dyson are good examples of the duplicitous elements in this arrangement.[4] I do not consider it a case of masquerading, but rather one of inherent and deep insensitivity and self-centeredness within the business of intellect. This is not to dismiss the dangers of naive and irresponsible intellectualism, or what Christopher Norris has aptly referred to as "uncritical theory," but rather to place it in context.[5] It is the historical paradox of the intellectual class, after all, that the responsibility to articulate and champion both emergent despotism and its negation ultimately falls on it. You would notice that it is intellectuals too who are leading the rising challenge to vain cyberism.

HOELLER: Are the massive promises of cyberspace put forward by J. P. Barlow, Sandy Stone, and the like worth pursuing anyway?[6] If you think of the claims about multiple identities, the leaving behind of the body and gender boundaries, an endless connectivity, and so on, which of these would you consider as serious and which as nonsense? Which of these ideological points could be most useful for the "wretched of the earth"?

OGUIBE: I think most of the claims are nonsensical, quite frankly, but that does not make them irrelevant. People must exercise the freedom to plumb their imaginations. It is our experience, in fact, that such stretches of the imagination have inspired innumerable advancements in science and technology, and led to concrete inventions that ultimately improved our reality. What is insidious is not that sci-fi enthusiasts and frustrated intellectuals are finding a new outlet for their fantasies in cybertechnology, but that these are presented as the certain and inevitable condition of our collective future. Now, that's silly as well as dangerous—dangerous because it diverts attention from more serious and useful explorations into the potentials of this phenomenon.

HOELLER: A point you also made in Madrid was that it is equally necessary to criticize power structures within the Internet. So it seems as if there is not just a border between lucky and forsaken geographies but also one entirely within the Net: between those with just more and better resources than others. Where exactly do you see this second frontier? A related point: How do you view the still-current racism, sexism, homophobia, and so on among "Netizens"?

OGUIBE: The question of borders within the Net could be addressed from numerous angles since difference, dissent, and demarcations occur at several levels. On one level there is the distinction between those who enjoy recognition on the Net and those who are literally ignored for reasons of either being new on the Net, being considered not nearly relevant, or indeed for reasons of their identity and geographical location. This is the question of visibility. In a study around Bourdieu and the question of power with regard to computer-mediated communication, Elizabeth Lane Lawley calls attention to the prominence and privileges enjoyed by those who possess a certain reputation or stature within the Net by virtue of longevity, savvy, location at the forefronts of cyber discourse or of sheer, brutish self-promotion. Lawley notes that those who have "a 'history' on the Network" are placed "in positions of authority" and "both seniority and celebrity" are rewarded.[7] It is not mere irony that Sandy Stone refers to herself as the goddess of cyberspace; the truth is that she and people like her command enormous visibility on the Net that is not enjoyed by too many others.[8] Divine appellations may not be appropriate for such individuals, true, but certainly there are sacred cows of cyberspace. Another manifestation of persistent borders is the replication of real-life bigotry and prejudices on the Net. I must say that I find the use of the Net for extremist nationalism somewhat less threatening than the perpetuation of subtle racism in real life, borne out of socialized ignorance and insensitivity.

In Madrid I made reference to what I consider my little misunderstanding with Yahoo and how this led to its very determined exclusion of my URL from its search engine. My version of this rather minor yet quite revealing incident begins with an e-mail that I sent off to Yahoo in November 1995 shortly after I was introduced to the Net, in which I pointed out that their compilation of writers, which was a most admirable pioneering effort at the time, failed most fatally for having no place

whatsoever for writers of color. In 1995 there were already quite a few black Nobel Prize winners in literature, not to mention Pulitzer Prize winners and a horde of very significant, very well-known writers of color who may not fit those categories, but not one of those writers appeared on the list. Quite inadvertently, Yahoo was practically creating a racially exclusive literary canon on the Net, and one felt one had a duty to remind them that it would serve no meaningful, positive purpose in this regard to keep the Internet white, as it were. It would be more useful that an Arawak or African American schoolchild with access to the Net is able to call up the index of American fiction and find the gamut of that literary tradition rather than merely Euro-American writers. Obviously the reminder did not go down too well with the staff at Yahoo, although to their credit their index did improve shortly after.

By recalling this in Madrid, my purpose was not to complain but to illustrate one manner in which the hierarchies of visibility, representation, and privilege are transferred from real space to cyberspace. A brief exploration of the Net would quickly reveal the manner in which sections of society with a history of erasure or violent misrepresentation continue to fall victim to these in cyberspace, and how the things that have kept us apart in real life have resurfaced in that supposedly sanctified new territory of the connected.

Bigotry on the Net should not come to us as a surprise when in real life black churches are being set on fire across America. It would be unrealistic to expect the Net to be free of sexism or racial prejudice because Netizens, after all, are real people and not Sandy Stone's "virtual bodies." In these circumstances, therefore, the challenge to the forces of tolerance is that they step in and utilize the same facilities of connective access that bigots now seem quite astute at to their own advantage.

HOELLER: You claim that cyberspace can be the route to "interzonality," a realm beyond firm territorial frontiers. What exactly do you mean by interzonality? How is it related to what other postcolonial theorists call "Third Space"?

OGUIBE: There is little doubt that cyberspace and connectivity provide access across national boundaries, and skeptics are steadily converting to this conviction. For those who inhabit the indeterminate territories of Megapolitania or those who are condemned to expatriation or exile, there is little doubt that we are able on occasion to step into locations and polities from which we are barred, thanks to the facilities of the Internet.

As a political exile as well as a national of a country whose citizens are demonized all over the world, I am permanently in between worlds, caught in what I have described elsewhere as a "terrain of difficulty," neither free at home nor accepted abroad. I am best placed, therefore, to appreciate certain peculiar advantages of connectivity. It may be revealing to note that after the conference in Madrid in June 1996, I was unable to leave the country on my way to England,

and was placed under security interrogation at the Madrid airport until my flight was gone, making it necessary for me spend another night in Spain before I could leave. With connectivity, one is able to avoid such obstacles while remaining effectively joined to others. It is this kind of interzonality, where one does not require eight weeks to obtain a visa or risk invasive body searches at points of entry, that I am interested in.

I am not sure whether it is the same as the "third space" of postcolonial rhetoric. In any case the concept of a "third" locale is not one that I warm up to. I think the megapolis of indeterminate nationality, the interzone of mediated allegiance, is the condition of our times, and advanced connectivity is contributing significantly to the ascendance and consolidation of this megapolis.

HOELLER: Is interzonality actually a reality for those who left Africa, or is it rather a construction of those who have long migrated to the West? How can the dwellers of the "silent territories" be heard within this interzone (obviously, it cannot be done via a predominantly Western framework)? I know this is a very huge question, but I would be happy if you gave just a few hints.

OGUIBE: I am not quite sure what the argument is, especially if you recall that parts of Africa are appreciably connected and therefore firmly located on the global digital cartograph, while, as I have repeatedly pointed out, a good portion of the population of Wien is probably not. In other words, leaving Africa is neither a condition nor a guarantee for connectivity or interzonality. However, I am presently studying the interesting phenomena of cybernations and cyberdiasporas, the fact that the interzone provided by cyberspace is mediated by the inescapable persistence of real locations, national boundaries and allegiances, and the peculiarities of dislocation. Cyberdiasporas—that is, Net presences established by individuals and communities living in expatriation—have become an important route through which territories on the outside of connectivity find representation in cyberspace. I am keen to discover how these virtual nations cope with their unmediated vulnerability even in cyberspace.

HOELLER: Does this not raise the old question/problem of who does the representation, they themselves or somebody else (the expatriated)? There seem to be problems with both alternatives.

OGUIBE: It does, of course, and I brought up this question in Madrid also (see "Forsaken Geographies: Cyberspace and the New World 'Other'"). Yet there is a certain difference between the expatriate and what has been described as the "intimate Outsider," that is, the sympathetic Outsider who designates herself representative. Obviously, there is a shade of difference between genealogical filiation, involvement, and empathy. The cultural debates that go on in cyberspace among Nigerians or Kenyans in exile are, no doubt, different from the contemplation of

the Nigerian or Kenyan question by Americans and Europeans, no matter how well meaning and positively intended the latter are. Without the filiation (from the Latin *filius,* son) that legitimizes the expatriate's privileged claim to his country and community, representation is *almost* unacceptable.

HOELLER: One of your arguments concerns the place of African artists in the West, which you call "a terrain of difficulty." How would you describe this terrain in terms of surveillance, peripheries, etcetera? It seems as if the work of African artists is usually reduced to their "origins," ethnicity, and so on. Do you see any viable strategies for overcoming this persistent reductionism?

OGUIBE: The details and challenges of Western resistance to the idea of progress for others is one that we cannot possibly do justice here, and I would rather refer readers to my work in this area, part of which, obviously, you are familiar with (see "Art, Identity, Boundaries: Postmodernism and Contemporary African Art"). Briefly stated, the art and intellectual establishments in the West circumscribe African cultural production with what I have referred to as "the demand for identity" (see "Art, Identity, Boundaries"). In other words Africans are required to stick to certain specifications of imagery and representation, which in the minds of the West truly represent its Arcadian imaginary of Africa. An artist like myself who is working in new media and at the forefront of conceptual practice is dismissed as "too Western" if not "white" while beer-parlor sign writers and doll makers are adopted as the true, authentic African artists. You are supposed to have lost your Africanity, whatever that is, for the simple reason that you work with digital technology rather than sheepskin or brown paper and gouache donated by the Anthony Caro Foundation.

This is, of course, quite offensive. I lived in London for six years and have traveled round the world, and I can point to thousands of rather beautiful and quite accomplished beer-parlor signs in every city from London to Munich to Copenhagen, none of which is presented in exhibitions as representative of contemporary British or European art. When it comes to Africa, however, it is signs like these and their makers that are flown over and presented as quintessential representatives of contemporary African art. This is not only evidence of bad taste, it also points to a clear, racist inclination to identify Africa with signifiers of essential subalternity.

A barbershop sign from Africa is considered good, authentic African art by critics, historians, and the market in the West, but a barbershop sign from England is not regarded as quintessential, contemporary British art. The implication of this for practitioners like me is that we are treated with resentment and disregard, and often effectively ruled out from narratives and expositions of contemporary culture. And this is propagated by not only galleries and dealers but also by other significant sections of the Western art establishment, such as critics, curators, and acquisition channels.

Two of the most reputable art publishers in the world, Abrams of New York and Thames and Hudson of London, have issued a new book on contemporary African art put together by André Magnin, a French culture broker who has stated in print that African artists are only worth their salt if they received no education, and this book is filled with barbershop signs and rather poor examples of folk and naive art. Hardly an artist working in the international contemporary mode, such as conceptual or new-media artists or indeed anyone who worked within international modernism, is included, apparently because they received education. According to Thames and Hudson's historian of contemporary African art, the message in effect is that Africans are supposed not to be educated.[9]

On the other hand, in 1995 I completed a monograph on El Anatsui, one of the continent's most important contemporary sculptors, who has shown at almost all the international biennials in the past decade and has worked alongside artists from Antony Gormley to Marina Abramovic in addition to winning an honorable mention in Venice in 1990 and the Kansai Sculpture Prize in the Osaka Biennial in 1995. Yet nobody would either give this artist a proper solo exhibition in a decent space in the West or publish the monograph on his work. This is the nature of the terrain we occupy for committing the crime of not swinging atop trees.

This is the terrain that I refer to as the terrain of difficulty, and I doubt that I have an answer to the question of how the West may overcome perspective on Africa other than that it ought to overcome it if it must redeem its own claims to civility. A society that promotes and consumes art from elsewhere that it would otherwise consider of doubtful quality were it produced within its own boundaries is not particularly sensible or civilized, obviously.

Clearly there is a challenge here for all facets of the art and critical establishment, from galleries, collectors, and dealers to the art media and its advertisers, to step out of the current primitivist desire for fetishes of subalternity and begin to see every good artist as appreciable, collectible, and exhibitable, irrespective of their supposed origins or the color of their skin. Ironically Clement Greenberg had a rather simple critical formula that we all ought to reconsider and perhaps return to: "Good, bad," said Greenberg in an interview with Robert Burstow in 1992, "good, bad, that's all." Now, we could spend a lot of time on what is "good" and what is "bad," but the color of an artist's passport should have nothing to do with it.

HOELLER: This brings me to my last subject: multiculturalism. It occurs to me that multiculturalist ideologies in the West often operate on a very superficial level. They even become the basis of a new kind of racism, a racism that acknowledges difference while at the same time leaving economic conditions completely untouched. The "hegemonic multiculturalists" sometimes have a liberal stance toward "the other" while staying in complete economic control. What do you think?

OGUIBE: I agree completely. Not only do many purveyors of multiculturalist rhetoric retain economic primacy, they retain discursive control also, and it is this

that I dealt with in my lecture in Rome in 1995 (see "Art, Identity, Boundaries: Postmodernism and Contemporary African Art"). Some would argue that this is the case in Australia, for instance, where multiculturalist rhetoric has become an entrenched part of mainstream political-speak, even as it is regarded with skepticism by the less privileged citizenry. Multiculturalism becomes one of two equally suspect things: an empty signifier for those who mouth it or a dangerous, political threat for those who loathe it. For another instance, within academia in America a great deal of multiculturalist rhetoric is driven by careerism, and the danger is that genuine voices of multiculturalist discourse, those who are involved because their lives are circumscribed by the effects of intolerance based on difference, are occasionally drowned out by the rat-race, liberal pretensions of career opportunists. You find that many people in the American academy maintain a prominent distance from activist political engagement and instead reduce very serious issues to the confines of the text. Not only are real battles decidedly avoided, the excessive rhetoric that masks this evasion nevertheless attracts vicious, extremist right-wing backlashes.

That is the quandary in which multicultural discourses in America are caught now, with the right often battering down on a supposed radical intellectual contingent that, in fact, departed its radical tradition long ago and escaped into the labyrinths of the text. However, there are solid arguments to be made for multiculturalism still, and none of the foregoing is good enough reason to dismiss it entirely.

1996

Connectivity and the
Fate of the Unconnected

As we cruise on the ether of staggeringly rapid advancements in science and technology, especially information technology, cultural practitioners are challenged in innumerable ways to articulate our moment in history as well as to define their place and vision as creative individuals in relation to these developments. Information technology today has become the backbone of social and cultural interaction on a global scale, spurring social codes as well as political, economic, and cultural imperatives beyond the farthest reaches of prior predictions. Concomitant upon this, new forms of artistic and broad cultural expression are emerging, some of them built around new opportunities for the convergence of science and culture on the one hand, and of diverse polities and cultures on the other. Alongside these are other forms and strategies concerned with the mass-media potential of new information technology and its abilities to traverse traditional confines and broach new and previously unimagined frontiers. In certain respects it could be said that perhaps humankind is headed for that "unified language for the multiverse of cultures" that Marshall McLuhan predicted for the information age.[1]

From its own intricate history of evolutions between the late 1960s to the present, a dominant strand of this technology has emerged in the form of the Internet, an amalgam of networked information systems that today connects several million users and producers of digitized information around the world. This elaborate global electronic architecture, with its vast numbers of content providers, analysts, and consumers, also offers real-time interactivity across vast geographical expanses, enabling individuals to engage in an instantaneously reciprocal exchange on a level that is almost irreplicable with any other media. In his day, McLuhan had observed the endearing intimacy of the microphone and its unique ability to empower the individual pitched against the vast arena of mass-communication networks. Today such intimacy is amplified

several times over for privileged participants in this new digital network, or Net, because of their ability to reach incomparably more recipients and correspondents, but even more especially by their ability to engage in simultaneously interactive conversation on a scale that was unimaginable two decades ago. The Internet has become the voice rediscovered: speech visualized and magnified for the digital age.

For cultural practitioners, the Net functions on several levels. As a medium it can be manipulated to realize an entirely new category of cultural products and situations. It also functions as a vehicle for the conveyance, distribution, and critical evaluation of cultural forms and contexts, both traditional and new. Third, the Net enables communication and collaboration between content producers within and outside the cultural arena. It also serves as a means of information and commodity exchange—in other words, as an increasingly important element of the global trade in cultures.

One nonnegotiable fundamental of this new social and cultural geography is that to participate, operate, or practice within it, one must first gain entry into it. Despite the preponderance of registers that dwell on the supposed virtuality of interaction and environment on this network, its architecture is nevertheless an archaic one that is largely based still on the primitive virtual communication concept of two cans and a connecting string. The sustaining principle remains that, at any given time, two or more individuals are connected, in the most material of senses, through a cable and terminal. Thus, only by access to an interface through which one physically attaches unto this network is it possible to become an active participant in the intricate, global community that it has spurred.

In the heady excitement with which the network is often narrated, sight is sometimes lost of two crucial facts. One is that there is no network unless one is connected to it, unless one is a part of it. The second is that the said condition in itself implies a whole other array of equally intricate social and historical conditions, an elaboration of exigencies that hinges on factors and circumstances that are largely unconnected and beyond the control of the network itself. As the digital network began to spread beyond the confines of its origins in cold war military counterintelligence and paranoia, the fervor of its elevation to a mass media was summarized in a popular epithet by one of its earliest propagators, Nicholas Negroponte. The epithet was "Simply connect." With or without intention, this little injunction, and other like rhetoric, created the impression that all it took to become part of the new information age, and to partake in its new language of digital communication (commerce was yet to enter the picture) and exchange was to up and *connect*. Just as quickly, the new rhetoric of advocacy whirled up, creating in its wake an exponential body of literature that in the main affirmed, as indeed it continues to, the exhilarating potential of the new medium. Soon it became—at least in the rhetoric of this advocacy—that only those who are connected, those who belong to the community of the network, truly represent our moment in history. The rest were dismissed as persons of no account.

In time, however, most have come to acknowledge that the requisites of entry into this network involve more than simply *connecting*. Many now recognize that connectivity carries with it a string of conditionalities, and to connect, the average

individual must meet these conditionalities, most of which many are ill disposed to fulfill. In other words, despite the admonition to *simply connect,* only a tiny fraction of humanity can, including artists.

Often the predilection is to couch this discrepancy in purely geopolitical terms, that is to say, some tend to believe that only in certain parts of the world are individuals unable to attain connectivity. Almost inevitably, sub-Saharan Africa, Southeast Asia, China, and Latin America come to mind. The premise upon which this conclusion is often reached is that in the named polities, prerequisites of the network infrastructure, such as telecommunications, either do not exist, or exist in a largely compromised or mediated state. Although this is true of many such areas, the realities and conditionalities of connectivity are nevertheless more elaborate and complicated.[2] In addition to an operational and fairly reliable telecommunications infrastructure, connectivity also requires that the individual have requisite skills as well as privileges of social and economic location to gain access to the network system. In addition to the basic condition of having access to a computer or terminal, these also include a certain level of literacy, because unlike television or radio, the Internet is still mostly what I call a literacy-dependent medium, requiring a comfortable disposition to or familiarity with text. It is this conventional literacy, or familiarity with text, that in turn enables the individual to acquire or develop the requisite skills for computer-mediated communication, or "computeracy." In most cases the absence of the former makes it virtually impossible to acquire the latter, effectively precluding the individual's access to the network. It is safe to say that until platforms and modes of interactivity on the Internet can be accessed or engaged by manipulating a few buttons in a handheld remote control, as with television, conventional literacy and concomitant computeracy will be essential for anyone to enter or navigate the network.

Closely related to this is the psychological disposition of the individual to new and fairly complex technology. Many are debarred from the network by their fear or loathing of technology. Exceptions notwithstanding, in many instances technophobia is not unrelated to lack of proper education or early and adequate exposure to technology, or the absence of social conditions necessary for individuals to develop a healthy and rewarding relationship with new technology. A great number of people in the most industrialized nations thus are as unlikely to *simply connect* as are many in the less developed regions of the world, a fact increasingly supported by emerging statistics. Such individuals are effectively unable to function either as producers or consumers of content in the network. To this extent, despite the increasing numbers of networked individuals, and despite hyperbolic claims to the contrary, the digital network or Internet is yet to become a full-fledged mass medium like radio, television, or print journalism, since large numbers of people remain outside its reach. In this regard, the Internet falls short of the borders of the utopian imaginary.

The discrepancy can be spatially or demographically delineated, such that individuals from certain communities, social strata, geographic locations, even faiths are less likely to have an appreciable presence in the network than others. This is certainly the case with the less industrialized world, and the fact that Africa lags behind in levels

of connectivity may be attributed to the factors mentioned earlier. Even so, the same obtains within highly industrialized nations, although disparities are considerably mediated by such factors as the existence of advanced communication infrastructures, and, most important, by access subsidization, especially from the state. We find a good illustration of how state intervention may considerably mediate such disparities in one of the early forms of digital networking, the French government-sponsored Minitel, which brought networked communication to one in every four French homes between 1984 and the early 1990s before its popularity declined. Conceived in 1978 and introduced to the French public in 1984 by the state-owned French Telecom, Minitel was a networked delivery system of video content and service based on the established residential and public-telephone infrastructures that Telecom already had in place. Packaged as an extension to regular telephone service, Minitel presented a new service of appreciable appeal, especially when, at the height of its popularity, it was taken over by the sex industry and turned into a marketing vehicle for soft-sex pornography and voyeurism. Opposed to this would be the example of China, where state intervention through surveillance and other means is reported to impede citizens' access to the network. In its more recent form, state and corporate inducements in highly industrialized nations take the form of subsidized access at work or school. As statistics reveal, the greater percentage of networked individuals in America and Europe have access only at work or school, and a considerable proportion of such users are otherwise unable to afford regular connectivity at home or by themselves. Needless to say, those sections of the citizenry who are less represented in the workplace or at school do not fare too well with access to the digital network.

A divide emerges, then—what we may call the digital divide—between those who belong within the network and are thus able to partake of its numerous advantages[3] and those who are unable to fulfill the conditionalities of connectivity. It is increasingly evident that as we connect, we become part of a new ethnoscape, what one might call a netscape or cyberscape, where information and individuals circulate and bond into a new community.[4] As this community broadens in spread and significance, we are effectively implicated in the relativization[5] of the rest who remain on the outside of its borders. Inconsequential as it might seem, this situation nevertheless has broad cultural implications, not only for individuals and groups already in the network but even more so for those others who exist on the outside.

For one, populations on the outside are effectively excluded from the myriad conversations taking place in this enclave of power and privilege, some of which have significant bearings on or consequences for their condition or well-being. As a result the network often breeds representation within itself on behalf of such polities. By default it readily locates or fabricates voices within who assume the authority to speak for the Other, since, quite often, parties and individuals are not in short supply who would ride on the event to appoint and delegate themselves as representatives of the absent. Today such individuals and groups abound across the capillaries and nodes of the Net: lone campaigners and makeshift pressure groups, organizations of concerned friends and self-appointed revolutionaries, messianic figures coming to the rescue of the help-

less, anarchists in search of preoccupation, and activists left over from failed causes and eager to find new ones that might assuage their passion to serve. Sometimes, a genuineness of purpose is behind these acts of self-delegation. At other times the driving passion fails to rise above a self-righteous desire to attract attention or find prominence through such acts of supposed good intention. Often there is little or no contact, communication, consultation, or mechanism for reciprocal exchange between such delegate voices and the constituencies they elect to speak for on the Net. Like free agents, they inhabit the nooks and crannies of the Net and engage in innumerable activities and negotiations on behalf of groups and cultures that are essentially unable to deny or withdraw the authority that such representatives appoint unto themselves.

Whatever the intents or contexts are, humanitarian or otherwise, certain crucial questions are raised, nevertheless, other than merely the ethics of representation.[6] Among them is the issue of the apparent vulnerability of the unconnected. Within the vast territories of the Net, populations on the outside obviously do not possess the privilege of agency because they can neither speak on their own behalf nor exercise control over the dynamics and dialectics of the network. While they may and indeed do have agency within their own spaces and lives as a critical attribute of their existence, this agency is, however, impacted on when a new force such as the Net emerges with the ability to encroach upon that space.[7] With its enormous capabilities as an emergent global social system, one is forced to ask: Might the network perhaps further disenfranchise or incapacitate these populations already battling their way out from under the avalanche of progress and its debatable consequences by moving the posts of modernity even as they struggle to grapple with it? Has the network made it easier for entities and individuals privileged to possess its empowering devices to displace such populations by appropriating their voices and purloining their identities in an arena from which they are effectively debarred? Given the relative ease with which participants in the network can generate and disseminate information, sometimes on a bewilderingly vast scale, has this medium entrusted some of us with the power to fabricate and disseminate possibly fictive and potentially injurious constructs and narratives of the Other to the rest of the world, when such populations have no equally enabling devices to encounter, evaluate, critique, challenge, or seek to invalidate images and representations of their selves and their state of being? If the Net empowers us to possess the voice or invent the narrative of the absent, does it not by so doing also enable us to scar the body of the absent?

A case from outside cyberspace may indeed illustrate quite cogently the dangers that this power of self-delegation portends. In April 1996, a white South African artist and curator staged an exhibition at the South African National Gallery on the history and material culture of the Khoisan, one of the country's indigenous peoples. The largely ethnographic exhibition, which featured mostly archival images and documents on European colonial affront on and near extermination of the Khoisan, nevertheless involved strategies of construction and realization that caused offense to the group. After viewing the exhibition, a representative forum of the group, the Griqua National Conference, denounced the exhibition, describing it as a "questionable and

active contribution to furthering the marginalization of the first nations of Southern Africa."[8] While pointing out the curator's failure to consult the group, and the absence of Khoisan participation in what was an exposition of and about them, the forum condemned "non-indigenous people's persistence in hijacking and exposing our past for their own absolution." Another forum of the Khoisan, the Hurikamma Cultural Movement, equally condemned the exhibition as "yet another attempt to treat brown people as objects."[9]

A considerable body of literature already exists on this debacle.[10] As a demonstra-tion of the importance of agency on the part of the represented, the critical response and intervention of the Khoisan succinctly defined and positioned the event itself, as well as erased the authority to represent, which the curator had, arguably, involun-tarily appropriated unto herself. Irrespective of intentions, genuine or not, hers could no longer be mistaken for a voice for or on behalf of a group to which she did not belong. This crucial intervention was possible, however, only because the group was aware of the exhibition in question, had access to it, and therefore had the opportunity to witness, engage, and evaluate it. Let us imagine a like situation where, contrary to these conditions, the discourse in question is staged on the network, in a virtual gal-lery, for instance, or worse still, in any of the several thousand limited-access forums now operating on the Net. Further, let us imagine that the group, whose bodies and history are paraded, is also unconnected. Let us imagine that they have no route to the information disseminated on and about them, supposedly on their behalf or in their perceived best interest. Not only would they have no opportunity to engage that information, worse still they would have no way to register, as the Khoisan most force-fully did, their disapproval and disdain.

In effect the digital network provides a new corridor of infringement and tres-pass that the infringed may not always be privileged to broach. Within this corridor, opportunities abound for misfeasance, even maleficence. With such rampant and unbridled possibilities at the disposal of the networked, is it the case, perhaps, that the unconnected are set up for digital violation?[11]

Today the network is not only a powerful ethnoscape, it has also become a for-midable knowledge system. Its repositories of information are complemented by the ready accessibility of content providers, experts, and quacks. Once ensconced in the intricate relays, addictions, and cushions of the network, many increasingly rely upon it for information and knowledge of the world beyond their own door. Information gathered on the Net becomes our readiest access to other cultures and sections of society as it inveigles us in the lazy preoccupation of going through its portals of voices and informants for our knowledge of the unconnected. More often than not, despite voiced skepticism, such information is taken by many on face value. Indeed, the truth-value of information gathered from the Net is reinforced rather misleadingly by its essentially textual proclivity and in turn by the text's historical and scriptural association with truth, especially in the West.[12] Today many are quick to site informa-tion from the Net as authoritative, but even more disturbing, they are quick to turn to it rather than look outdoors. With this in mind, one cannot help but wonder: Should the network continue to displace other knowledge systems as it seems bound

to? Should its participant-citizens continue to tune in to it as their *priori* source of information, especially information on those who are considered otherwise remote and inaccessible because they are unconnected? Might it not become a barrier instead of a bridge? Might it not preclude proper and meaningful contact and exchange by encouraging the false notion that we know the Other and that the Other is part of the new global community we take for granted? Might it not impede rather than facilitate our reach for genuine interaction across social and cultural divides by creating simulacral rather than real contact and exchange? Somehow, one wonders, in the end, might the Net not come between us and the Other that we do not know?[13]

Not to be ignored is the fact that the global information infrastructure has become perhaps the most significant mechanism for the ongoing process of globalization. If traditionally we understood this process to comprise principally the dissemination and imposition of Western culture and cultural products around the world accompanied by a reverse, unidirectional cash flow to the West, we must now also factor in an exponential traffic in downloaded goods from beyond the perimeters of the West. In other words, it is valid now more ever to speak of a truly global traffic in cultures and cultural produce.[14] The global information network in all its forms and manifestations is a formidable channel for this traffic. It is estimated that $327 billion worth of goods will be shifted via Internet alone by the year 2003.[15] With trade occurring through other global communication networks factored in, this statistic rises to an even more astronomical figure. Of the goods and services involved in this global trade, an increasingly substantial portion consists of cultural products, especially objects of material culture. This too has its implications for populations on the outside of the network.

First, for as long as they are unable to gain entry into the network, such populations are effectively debarred from exercising control over any significant aspects of this traffic, albeit that a sizable portion of the goods circulating in this trade is obtained or purloined from within their territories. In the absence of any such participatory agency, not only are they relegated to exclusion in the hierarchy of transactions, they also are increasingly precluded from any substantial part of the proceeds from their own material culture. Even more disturbing is that as the accessibility of these products becomes more apparent, so does the desire grow to locate, acquire, and circulate them without significant involvement of those on the outside. So does the desire to obtain and own them without the traditional encumbrance of physical travel and transportation, or the bargaining intercession of labor.

For instance, the number of Internet sites dedicated to the market in African art objects has exploded from single digits a few years ago to several hundred in the past year (1998–1999), and the indication is that such sites and the trade they ply will continue to grow. Some of the objects traded on this network marketplace are of little historical value. Others are of immense cultural and historical import, and often these are obtained illicitly. It is tempting to think that the open platform on which a good deal of this exchange now occurs would improve the chances of monitoring illicit trade in cultural products. One must point out, however, that this is not necessarily the case. On the contrary, through the numerous secret passages that the Net provides,

dealers and collectors are even more able to trade in objects, exchange information, or hatch conspiracies aimed at further depleting the material cultures of Africa and the rest of the world, which are then funneled into institutions and private collections in the West.

On an ethical level, we are faced with an explosion in renewed desire in the West to locate and consume the Other in the form of material and visual symbols, without the moral or social responsibilities contingent on a physical encounter with that Other. Entire worlds, geographical and corporeal, are opened up for the privileged to explore and possibly purloin and ravage without once having to leave the comfort of their home office or confront the possible ramifications of their adventures. On purely social and material levels, this desire to locate and consume the Other exposes such populations to the unscrupulous machinations of agents and traders desperate to satiate a growing demand. In effect, unwitting peoples whose material cultures service this demand are made more vulnerable to plunder than ever before, thanks to the driving machinery of a networked but unregulated exchange system. Moreover, because they remain on the outside of this powerful system, they are left largely at the mercy of players in an intricate game outside their realms of comprehension or agency.

These are some of the realities that the Net constitutes for those who are unable to *simply connect*. Not only are they relegated on the outside of a powerful, global machinery, they are equally laid bare to the rapacious potentials of this machinery. A question then arises as to what can be done to correct or ameliorate this situation, and this is a question that must engage not only those who debate the merits and future of the Net, but those who propagate expansion of the network society also. We began this brief exploration by observing that the global digital network has become an inescapable part of the machine of progress at the millennium. It is the logical conclusion to a century of relentless assaults on the fort of knowledge and the frontiers of possibility. Whatever its demerits, it is nevertheless irreversible. We also observed ways in which cultural practitioners may put it to use, indicating that it may not be approached only as a system to loathe or condemn. Indeed, for those who are already situated within it, its myriad possibilities make it a most endearing facility for survival in a new age. To contend with the realities outlined previously, therefore, we may look in only two directions.

The first solution is to encourage a different kind of activism within the network itself, an activism that aims to engender a culture of sensitivity and responsibility within the Net. There is a nascent if inchoate morality already developing in the network, and this could be extended to include awareness of and a conscionable relationship with those who are on the outside. This is an area where artists and other cultural practitioners could play a useful role corollary to their tradition in regular society. Not only do they need to inject a certain criticality into their own practice with regard to the place and fate of the unconnected, they could also help to raise the awareness advocated here across the platform of the network. Additionally, though the issue of regulations within the Net remains moot, even incendiary, it is valid to suggest that the network, like any other community, be subject to a level of enforceable regulation

to protect individual freedoms within and outside its constituencies. Such a social apparatus recommends itself most especially on the evidence that the alternate strategy of individual self-regulation most favored by the network community has not worked, and cannot possibly sustain so vast and variegated a human system. The idea of the Net as a sacred corridor of limitless freedom is not only ludicrous but dangerous also, as its history amply and cogently demonstrates already.[16] A combination of cultural and political work, and a negotiable modicum of statutory regulation, is needed to contain the predatory proclivities of the network.

The second, inevitable challenge is to engage those sociopolitical, cultural, and technological strategies that will bring a greater proportion of humanity into the new, global community of the networked. In the few years since discourse began to develop around the implications and prospects of connectivity, especially with regard to the unconnected, it has become customary for some to pose it against supposedly more pressing concerns, such as global hunger, material deprivation, and disease. The question is often asked: Is it appropriate or realistic to preoccupy ourselves with extending connectivity to the deprived masses instead of first improving their social and material condition? However, what such approaches do is to arrange the condition of the underprivileged in a hierarchy of priorities. This rhetoric of invented priorities is a mistake insofar as it fails to acknowledge that the conditions in question are not implacable, but only testimonies to a global lack of will to address easily containable blotches on our claims of progress. It is widely acknowledged, for instance, that the United States alone has the resources to feed all its citizens as well as to provide for a substantial percentage of the rest of the Americas. At the same time, America has the know-how, and wealth among its privileged, not only to address subsistence needs, but those of education, basic social convenience, and connectivity also. Even so, great stretches of the American outback live in unimaginable poverty, with turn-of-the-twentieth-century learning facilities for the young and little or no connectivity. Clearly, a nation of such strength, even in its moments of difficulty, can address all of these needs at the basic level without strain. So can any other nation with the will. The human race already possesses the means and technological know-how to provide food, literacy, and global information network access to the majority of humanity without necessarily prioritizing one need above the other; without placing connectivity and hunger needs diametrically, without seeking to address one only after the other. We will need to apply those means and wherewithal to these tasks.

As long as some remain outside the burgeoning new world that the new global information network has introduced, and as long as the balance of power is in favor of this new world, it is impossible to achieve that "unified global field of awareness" that McLuhan called for.[17] Ultimately, we will have to contend with not just the possibility or viability, but also the necessity of a cohesive digital age whose fundamental technologies are at the service and disposal of not only the few but the greater majority of the human race.

1999

Notes

Prologue

1. Olu Oguibe, *"Double Dutch* and the Culture Game," in *Yinka Shonibare: Be-Muse* (Rome: Museo Hendrik Christian Andersen and the British School in Rome, 2001), 34–43.

2. David Theo Goldberg and Ato Quayson, *Relocating Postcolonialism* (Oxford: Blackwell Publishers, 2002), xvii.

In "The Heart of Darkness"

1. Francis Fukuyama, "The End of History," in *The National Interest* (Summer 1989); later expanded and republished as *The End of History* and *The Last Man* (New York: Free Press, 1992).

2. See Ngugi wa Thiong'o, *Moving the Center: The Struggle for Cultural Freedom* (London: Heinemann, 1993).

Art, Identity, Boundaries: Postmodernism and Contemporary African Art

1. Thomas McEvilley, *Fusions: African Artists at the Venice Biennale* (New York: Museum for African Art, 1994).

2. New York artist Bakari Ouattara was born in Ivory Coast but has lived and worked in France and the United States since the 1980s.

3. See Julia Kristeva, *About Chinese Women,* trans. Anita Barrows (New York: Urizen Books, 1977; reprinted 1986).

4. Frantz Fanon after Aimé Césaire, "The Fact of Blackness," in *Black Skin, White Masks,* trans. C. L. Markmann (London: Pluto Press, 1986), 131.

5. Roland Barthes, "Inaugural Lecture, Collège de France," in *A Barthes Reader,* ed. Susan Sontag (London: Jonathon Cape, 1982), 460.

6. Peter Hitchcock, "The Othering of Cultural Studies," *Third Text,* no. 25 (Winter 1993–1994), 11–20.

Play Me the "Other": Colonialist Determinism and the Postcolonial Predicament

1. Fred Brathwaite in *Shooting Star: The Life of Jean-Michel Basquiat* (London: 1990), Geoff Dunlop, director, United Kingdom, Channel 4, Pal-Video, 52 minutes.

2. Chinua Achebe, *Home and Exile* (New York: Oxford University Press, 2000), 72.

3. Since this essay was written, Zaire has changed its name to Congo. I have kept the original name to preserve the integrity of the essay.

4. "Massa," a corruption of "Master," was a term of respect for whites in the colonies and was required of the natives. "Mungo" is a pejorative for whites and may have derived from the name of the British explorer Mungo Park.

5. T. K. Biaya, "Popular African Painting as Social Drama in the Western Media," *Nka: Journal of Contemporary African Art,* no. 4 (Spring 1996): 50–53.

6. Ibid., 53.

7. T. K. Biaya, "Popular African Painting as Social Drama in the Western Media," *Nka: Journal of Contemporary African Art,* no. 4 (Spring 1996): 50–53. "Mundele" is a popular term for a white, civil servant man.

8. *Maîtres des Rues: Les Peintres du Zaïre* (Belgium: 1989), Dirk Dumon, director, Jean-Pierre Jacquemin, coproducer, Cobra Films, VRT, Center of Audiovisual, Brussels, color, 16 mm, 54 minutes. It is interesting that a documentary film on painters should be titled *Lords of the Streets,* a term usually reserved for gangsters and hoodlums. The title also evokes William Golding's novel of innate chaos and natal cruelty, *Lord of the Flies.*

9. Biaya, "Popular African Painting as Social Drama," 51.

10. Ibid. English translation by T. K. Biaya.

11. Chinua Achebe, *The African Trilogy* (London: Picador, 1988), 177.

12. Ibid., 175.

13. Amitava Kumar, "Louder Than Bombs: What's So Hot about Indian Writing?" *Transition,* no. 79 (1999): 88.

14. Author of *The Last Harmattan of Alusine Dunbar,* a tour de force of narrative skill and imaginative dexterity deserving much greater attention than it has received.

15. The quotation from Chinua Achebe refers to the image of Africa in Léopold Sédar Senghor's work.

Nationalism, Modernity, Modernism

1. A. D. Galloway, "Missionary Impact on Nigeria," *Nigeria Magazine,* special issue (October 1960): 63.

2. Uche Okeke, "History of Modern Nigerian Art," *Nigeria Magazine* 128–29 (1979): 103.

3. Sir Edward Cust, "Reflections on West African Affairs Addressed to the Colonial Office" (London: Hatchard, 1839).

4. Quoted in Dapo Onabolu, "Aina Onabolu," *Nigeria Magazine,* no. 79 (December 1963): 295.

5. George Fowler in Aina Onabolu's visitors' book, Lagos, August 13, 1938.

6. Akinola Lasekan, "Western Art on African Shores," unpublished manuscript, University of Nigeria, Nsukka, 1966.

7. G. A. Stevens, "The Future of African Art: With Special Reference to Problems Arising in Gold Coast Colony," *Africa: Journal of the International Institute of African Languages and Cultures* (1930): 150–60.

8. Sir Edward Cust, "Reflections on West African Affairs."

9. Frantz Fanon, *The Wretched of the Earth* (New York: Penguin Books, 1967), 191.

10. Rey Chow, *Writing Diaspora: Tactics of Intervention in Contemporary Cultural Studies* (Bloomington: Indiana University Press, 1993), 29.

11. Reverend Glover, Record of Sunday Service, Roman Catholic Mission, Esa Oke, Western Nigeria, September 8, 1935.

12. In *Black Skin, White Masks* (London and Sydney: Pluto Press, 1986), Frantz Fanon dangerously simplifies the colonial conundrum when he writes: "There is a fact: White men consider themselves superior to black men. There is another fact: Black men want to prove to white men, at all costs, the richness of their thought, the equal value of their intellect" (12). Partha Chatterjee magnifies this argument when she argues that "nationalism . . . seeks to represent itself in the image of the Enlightenment and fails to do so" (*Nationalist Thought and the Colonial World: A Derivative Discourse* [London: Zed, 1986], 17). The problem with these overdetermined positions is that they rivet almost solely on the psychoanalytic by reading native appropriation as mere aspiration rather than necessary empowerment for the peculiar challenges of the colonial predicament.

13. Much of the credit for this must go to the detailed but mostly unpublished and largely unacknowledged work of Nigerian art historian Ola Oloidi, which nevertheless has provided the documentary basis for the genealogy of modern Nigerian art. See Kojo Fosu, *Twentieth Century*

Art of Africa (Zaria: Gaskiya Corporation, 1986); Susan Vogel, *Africa Explores: Twentieth Century African Art* (New York: Museum for African Art, 1991); and Jean Kennedy, *New Currents, Ancient Rivers: Contemporary African Artists in a Generation of Change* (Washington, D.C.: Smithsonian Institution Press, 1993).

14. Ola Oloidi, "Constraints on the Growth and Development of Modern Nigerian Art in the Colonial Period," Arts Faculty Seminar, University of Nigeria, Nsukka, unpublished, 1986, 2.

15. Aina Onabolu, "The Lonely Beginning," artist's notes, unpublished, 1922.

16. Aina Onabolu, "My Pioneering Efforts," artist's private document, August 27, 1937.

17. Oloidi, "Constraints on the Growth and Development," 29.

18. Sir Edward Cust, "Reflections on West African Affairs."

19. J. Holloway, "Dear Aina," letter dated October 4, 1910, archives of the Onabolu family.

20. Fanon, *Black Skin, White Masks,* 12.

21. L. Richards, April 3, 1919, letter in the collection of the Akinola Lasekan estate.

22. Ibid.

23. Onabolu, "Aina Onabolu," 295.

24. In Achebe's *Arrow of God* the chief protagonist, Ezeulu, explains sending his son to join the white man thus: "When we want to make a charm we look for the animal whose blood can match its power. . . . And our fathers have told us that it may happen to an unfortunate generation that they are pushed beyond the end of things, and their back is broken and hung over a fire. When this happens they may sacrifice their own blood" (*The African Trilogy* [London: Pan Books, 1988], 456). In Wole Soyinka's *Death and the King's Horseman* (New York: Norton, 1975), the same conviction made Elesin Oba, charioteer for his clan, send his son Olunde to study overseas.

25. See Vogel, *Africa Explores.*

26. See letter to the Education Department, Lagos, by K. C. Murray, November 4, 1937, soliciting that "Mr. Onabolu on whose request I have been brought be given every possible cooperation which will encourage him to train more boys in Lagos." *Papers of K. C. Murray,* Archives of the National Museum, Lagos.

27. Oloidi, "Constraints on the Growth and Development," 29.

28. Ibid., 114.

29. Steven Sack, *The Neglected Tradition: Towards a New History of South African Art, 1930–1988* (Johannesburg: Johannesburg Art Gallery, 1988), 10.

30. Ibid., 10.

31. T. Cousens, *The New African: A Study of the Life and Work of H. I. E. Dhlomo* (Johannesburg: Ravan Press, 1985), 253.

32. Sack, *The Neglected Tradition,* 11.

33. P. Savory, *Gerard Bhengu: Zulu Artist* (Cape Town: Howard Timmins, 1965), 10.

34. Although Sack contends that of the early artists only Mohl had any influence on South African art (see *The Neglected Tradition,* 15), there is an obvious presence of Sekoto in the work of Ephraim Ngatane, one of the most engaging artists of the late 1950s and early 1960s who, though he studied under Sihlali and Skotnes of the Polly Street Center, pursued a muscular style quite distinct from that of Polly Street. Ngatane died tragically young in 1971.

35. F. McEwen, "Personal Reflections," in *Contemporary Stone Carvings from Zimbabwe* (Yorkshire Sculpture Park, 1990), 27.

36. Ibid., 30.

37. M. Shepherd, *Contemporary Stone Carvings from Zimbabwe,* 18.

38. Ibid., 19. Emphasis is mine.

39. F. McEwen, "Return to Origins," *African Arts* 1 (Winter 1968).

40. Ibid., 26.

41. Ibid., 26.

42. Ibid., 27.

43. The Oshogbo experiment. For the updated hagiography on this, see Ulli Beier, *Thirty Years of Oshogbo Art* (Bayreuth: Iwalewa, 1991).

44. Ibid., 6.

45. Ibid., 6.

46. S. Sack, *The Neglected Tradition,* 12.

47. *The Natal Advertiser,* June 9, 1936, quoted in ibid., 1.

"Footprints of a Mountaineer": Uzo Egonu and Black Redefinition of Modernism

1. According to Rasheed Araeen, "Uzo Egonu was perhaps the first person from Africa, Asia, or the Caribbean to come to Britain after the War with the sole intention of becoming an artist" (*The Other Story: Afro-Asian Artists in Post-War Britain* [London: The South Bank Centre, 1989], 86).

2. Although the South African Ernest Mancoba had gone to Paris in 1938, and would be followed not long after by another South African, Gerard Sekoto, neither of these artists may be said to have left an appreciable mark on practice in the locales of their abode or indeed produced work of a nature to earn the visibility that Egonu and his colleagues in England did.

3. For the timeline on these developments, see Araeen, *The Other Story,* 128–41.

4. Amilcar Cabral, *Unity and Struggle* (London: Heinemann, 1980), xxii.

5. Paul Buhle, ed., *C. L. R. James: His Life and Work* (London: Allison and Busby, 1986), 107.

6. See Olu Oguibe, *Uzo Egonu: An African Artist in the West* (London: Kala Press, 1995), 19.

7. Ibid., 19.

8. See Olu Oguibe, "Uzo Egonu: Twentieth Century Nigerian Artist," doctoral dissertation, University of London, 1992.

9. As has increasingly been pointed out, the strictly vacuous and formalist definition of modernism that has come to dominate our understanding of the epoch is at best a myopic aberration that misrepresents the history, purposes, and nature of modernism. For the latest exposé on this question, see David Craven, "The Latin American Origins of 'Alternative Modernism,'" *Third Text* 36 (1996): 29–44. If we pay close attention to Craven's narration of modernist history and his acknowledgment that the term itself was first used by the Latin American poet Rubén Darío, under whose subsequent influence in Spain and Barcelona in particular Pablo Picasso produced his earliest modernist work, we may indeed conclude that the modernism later propagated in America by Greenberg and the formalists is the "alternative," a fringe corruption of true modernism.

10. Arguments such as may be found toward the end of the century in the teachings of the Afrocentric school of American thought belong to and are obviously derivative of this dichotomy of racial gifts. See, for example, the work of such authors as Molefi Asante and numerous others, especially beginning in the 1970s.

11. V. Y. Mudimbe, *The Invention of Africa: Gnosis, Philosophy, and the Order of Knowledge* (Bloomington: Indiana University Press, 1988), 84.

12. See Léopold Sédar Senghor, *Nation et Voie Africaine du Socialisme* (Paris: Presence Africaine, 1961).

13. Léopold Sédar Senghor, "We Are All Cultural Half-Castes," First International Congress of Negro Writers and Artists, *Presence Africaine,* special issue (1956): viii–x.

14. André Breton in Franklin Rosemont, ed., *What Is Surrealism?* (New York: Pathfinder, 1978), 259.

15. Césaire in particular was closely allied with the rest of the influential modernists, including Picasso, who illustrated his fourth book, *Corps Perdue.*

16. Everlyn Nicodemus and Kristian Romare, "Africa, Art Criticism, and the Big Commentary," *Third Text,* no. 41 (1997–1998): 53–66.

17. Interview with the artist, South Kenton, November 1989.

18. See Oguibe, "Uzo Egonu."

19. Hiltrud Streicher, "Reflections of Uzo Egonu: Contemporary Nigerian Artist, Interviewed by Hiltrud Streicher," unpublished manuscript, 1966, revised 1975, 8–9.

20. Ibid., 30.

21. Ibid., 30.

22. Léopold Sédar Senghor, "Cultural Roots and the Modern African Artist," excerpts from "L'Esprit de la Civilisation ou les Lois de la Culture Negro Africaine," in L. S. Senghor, *Prose and Poetry,* ed. and trans. John Reed and Clive Wake (London: Oxford University Press, 1965), 77.

23. Ibid., 76.

24. Oguibe, *Uzo Egonu,* 52.

25. For a detailed discussion of this point, see ibid., 64–78.

26. Oguibe, interviews with the artist, November 1989.

27. The appeal to Igbo linguistic traditions in Chinua Achebe's novels in English, for instance. Achebe has been credited with doing for the novel in English what James Joyce did for it earlier in the century by inflating it with the energy and peculiarities of literary and speech patterns from his own heritage. Both Joyce's and Achebe's use of English represents significant modernist projects, each denoting the localization and humanization of modernism. The 1960s also witnessed the emergence of the boom generation in Latin American literature, and their popularization of phantasmagoria and formal convolution, both defined as peculiarly Latin American.

28. Uzo Egonu, "On Myself and My Work," notes for a speech, 1970. Published in *Egonu, 22 Prints,* exhibition catalog, 1985.

29. Rasheed Araeen, "Conversation with Aubrey Williams," *Third Text,* no. 2 (1987–1988).

30. Harold Rosenberg, "Art and Political Consciousness," in Rosenberg, *Art and Other Serious Matters* (Chicago: University of Chicago Press, 1985), 288.

31. The only significant social element evident in British modernism in the 1960s would be found in David Hockney's introduction of the gay question into his work, which, for the greater part of the decade, anyhow, was produced in America. Not until the political upheavals in America and not until the movements that spearheaded the civil-rights campaign made their appearance in Britain, especially in the form of the Black Panther Party, did British artists begin to deal with pointed social or political issues. The earliest examples of this revival, found in the work of such immigrant British artists as Rasheed Araeen, occur in the early 1970s at the advent of postmodernism. Much of the work, such as Araeen's, was also inspired by black American art and aesthetics.

Photography and the Substance of the Image

1. See Gilbert George, *Photography: The Early Years* (New York: Harper and Row, 1980), 25–26.

2. See Allan Sekula, "The Body and the Archive," in Richard Bolton, ed., *The Contest of Meaning: Critical Histories of Photography* (Boston: MIT Press, 1989), 344.

3. Nicolas Monti, ed., *Africa Then: Photographs 1840–1918* (New York: Alfred A. Knopf, 1987), 6.

4. Ibid., 171.

5. Richard Pankhurst, "The Political Image: The Impact of the Camera in an Ancient Independent African State," in Elizabeth Edwards, ed., *Anthropology and Photography, 1860–1920* (New Haven and London: Yale University Press, 1994), 234.

6. Ibid., 234–41.

7. See John Tagg, *The Burden of Representation: Essays on Photographies and Histories* (London: Macmillan Educational Books, 1988; Minneapolis: University of Minnesota Press, 1993), 41.

8. James C. Faris, "Photography, Power, and the Southern Nuba," in Edwards, *Anthropology and Photography,* 216.

9. Monti, *Africa Then,* 8.

10. Allister Macmillan, *The Red Book of West Africa* (London: Frank Cass and Company, 1968).

11. The earliest portrait painter in Lagos was Aina Onabolu, whose first known studio portrait was painted in 1906. Onabolu would go on to produce portraits of many of the city's nobility during the next six decades.

12. Monti, *Africa Then,* 166.

13. Stephen F. Prague, "Yoruba Photography: How the Yoruba See Themselves," *African Arts* 12, no. 1 (1978): 59.

14. Tristam Powell, "Fixing the Face," in David Bowen Thomas, ed., *"From Today Painting Is Dead": The Beginnings of Photography* (London: The Victoria and Albert Museum, 1972), 10.

15. Stanley Cavell, *The World Viewed* (Cambridge: Harvard University Press, 1971), 21, 23.

16. Rudolf Arnheim, "On the Nature of Photography," *Critical Inquiry* 1, no. 1 (1974).

17. Despite the centrality of the "truth" principle in modern Western religion, even Christianity is founded on faith rather than empirical certitude. In Paul's letter to the Corinthians he emphasizes the primacy of faith, i.e., acceptance of that which is not seen or proven—in other words, the antithesis of empiricism—which is, after all, the basis of all religious preoccupation and ultimately the primary human disposition.

18. See Arnheim, "On the Nature of Photography," 159.

19. André Bazin, *What Is Cinema,* volume 1 (Berkeley and Los Angeles: University of California Press, 1967), 12.

20. Joel Snyder and Neil Walsh Allen, "Photography, Vision, and Representation," *Critical Inquiry* 2, no. 1 (1975): 143–69.

21. Rowland Abiodun, "The Kingdom of Owo," in Drewal, Pemberton III, and Abiodun, *Yoruba: Nine Centuries of African Art and Thought* (New York: Center for African Art, 1989), 104.

22. At least not until modernism when acquaintance with African notions of representation radically impacted Western ideas of portraiture and enabled certain streams of expressionism in portraiture such as we find in Picasso, Bacon, and de Kooning, none of which may be rightly considered conventional.

23. Pankhurst, "The Political Image," 234.

24. Ibid., 234–41.

25. Prague, "Yoruba Photography," 57.

26. Ibid., 58.

27. Cavell, *The World Viewed,* 21, 23.

28. Snyder and Allen, "Photography, Vision, and Representation."

29. Bazin, *What Is Cinema.*

30. Chinua Achebe, "The Igbo World and Its Art," in Achebe, *Hopes and Impediments: Selected Essays 1965–1987* (London: Heinemann, 1988).

31. Monti, *Africa Then,* 7.

Medium, Memory, Image

1. See Andreas Huyssen, *Twilight Memories: Marking Time in a Culture of Amnesia* (New York and London: Routledge, 1995), 253.

2. Ibid., 253.

3. In the late 1950s, art students at the College of Arts and Science, Zaria, under Okeke's leadership, formed a group known as the Zaria Art Society and issued a manifesto in which they dedicated themselves to what they described as the principle of "natural synthesis." According to this principle, artists would research and incorporate into their work formal and symbolic elements from within their indigenous art traditions while retaining whatever is useful from the Western tradition. This was very much in line with the search for a new cultural identity in the immediate postcolony and would eventually form the ideological and formal bases of modern Nigerian art from the 1960s onward. In the early 1970s Okeke became chair of the art department at the University of Nigeria, Nsukka, and there he and his students founded what is now known as the Uli School. In the work of the Uli School, primacy is given to elements from the painting traditions of the Igbo. See Uche Okeke, *Art in Development: A Nigerian Perspective* (Nimo: Asele Institute/ Minneapolis: African American Cultural Center, 1982); Simon Ottenberg, *New Traditions from Nigeria: Seven Artists of the Nsukka School* (Washington, D.C.: Smithsonian Institution Press, 1997); and Olu Oguibe, "El Anatsui: Beyond Death and Nothingness," *African Arts* (Summer 1997).

4. See Oguibe, "El Anatsui."

5. El Anatsui, *Sculptures, Photographs, Drawings,* catalog of exhibition at the Goethe Institut, Lagos, 1982, 5.

6. El Anatsui, private correspondence with the author, 1990.

7. Ibid.

8. El Anatsui, *Venovise,* catalog of exhibition at Cornwall College of Further and Higher Education, 1995.

9. In Chika Okeke, "Slashing Wood, Eroding Culture: Conversations with El Anatsui," *Nka: Journal of Contemporary African Art,* no. 1 (Fall/Winter 1994): 34.

10. In El Anatsui and Olu Oguibe, "Sankofa: Go Back an' Pick: Three Studio Notes and a Conversation," *Third Text,* no. 23 (Summer 1993): 45.

11. El Anatsui in unpublished interview with Eddy Udenta and Olu Oguibe, Nsukka, 1988.

12. El Anatsui, *Pieces of Wood,* exhibition catalog, 1987, 10.

13. Interview with Udenta and Oguibe.

14. El Anatsui in correspondence with the author, 1990.

15. To be distinguished from the earlier work, *The Face of Africa's History,* which is only one piece in the series of the same title.

16. Anatsui and Oguibe, "Sankofa," 48.

17. Michel Foucault, *The Order of Things: An Archaeology of the Human Sciences* (New York: Random House, 1970), 39.

18. Jorge Luis Borges, "The Wall and the Books," in *Labyrinths,* ed. Donald A. Yates and James E. Irby (New York: New Directions, 1964), 186.

19. Chinua Achebe, *Hopes and Impediments: Selected Essays* (New York: Doubleday, 1989), 19.

20. Much of the literature in the past on art by indigenous Australians has revolved around the concept of dreaming and so-called dreamtime, and formal representations of these concepts through the unique but not universal style of dot-painting on tree bark and colored sand painting on the ground, to the exclusion of much else. Only recently have scholarship and criticism begun to attend to other forms of contemporary indigenous art, especially those produced in what is often referred to as Western media or techniques and those that do not match the types.

21. For a detailed study of these matters, see John Sinclair, *Fraser Island and Cooloola* (Ure Smith Press, 1990).

Represent'n: The Young Generation in African American Art

1. Thelma Golden et al., *Black Male: Representations of Masculinity in Contemporary Art* (New York: Whitney Museum of American Art, 1994), 38.

2. Tate in Golden, *Black Male,* 118.

3. Grandmaster Flash (Joseph Saddler) and the Furious Five, featuring Melle Mel and Duke Bootee, from *The Best of Grandmaster Flash,* 1982, Sugar Hill Records.

4. Tupac Shakur visualized this metaphor on the cover of his last album, *Makavelli: Don Kiluminati,* where he shows himself crucified at Golgotha. For his verbal articulation of the condition itself, listen to his earlier album, *Me against the World.*

5. The subject of Harper Lee's 1960 novel, *To Kill a Mockingbird.*

6. hooks, *Art on My Mind* (New York: New Press, 1995), 94–100.

7. Chinua Achebe, "The Empire Fights Back," The McMillan-Stewart Lectures, Harvard University, December 10, 1998.

8. The disc jockey is an American invention born at the intersection of radio and recorded popular music in the early and mid-twentieth century. Formerly a radio personality whose job was to play or spin popular music on vinyl discs, the DJ would depart radio in the era of disco and enter other avenues of popular entertainment, like clubs and parties, where his record playing or "disco" equipment rapidly replaced live music, beginning especially in the 1970s, but where he nevertheless brought his expansive knowledge of popular music. On occasion such events, especially parties, may be introduced by an emcee, or master of ceremonies, whose role seemed to delineate the spheres of operation, with the DJ minding the music machine and the emcee taking custody of the public-address microphone. This relationship would ultimately define the structure of hip-hop music, with the DJ "spinning" the music on the turntable and the emcee minding the

microphone and providing the lyrics or "rhymes." The mic-wielding emcee would become the front man of rap, often obscuring the DJ as succinctly captured by rap musician Nasir Jones (Nas) in his hit, "One Mic."

9. Interestingly enough, Lee provides an introduction to a catalog of Charles's paintings, *Michael Ray Charles, 1989–1997: An American Artist's Work* (Houston: Blaffer Gallery, 1997).

The Burden of Painting

1. Such galleries are pledged to other gods as well, but the most elaborate are always in honor of the Earth goddess.

2. Exodus 20:4, *The Holy Bible: King James Version* (London: Eyre and Spottiswoode), 91. This injunction and its ramifications within the specific context of Hebrew art has led to considerable debate and even to the myth of "the artless Jew." It is important to note, as we have here, that it was not always strictly observed. See, among others, Kalman K. Bland, *The Artless Jew: Medieval and Modern Affirmations and Denials of the Visual* (Princeton and Oxford: Princeton University Press, 2000); Ezra Mendelsohn and Richard I. Cohen, eds., *Art and Its Uses: The Visual Image and Modern Jewish Society* (New York and Oxford: Oxford University Press, 1990).

3. D. H. Lawrence, "Introduction to His Paintings," in *Selected Essays* (Middlesex: Penguin in association with Heinemann, 1954), 307–46.

4. Ibid., 308.

5. Genesis 1:10–31, *The Holy Bible: King James Version,* 1–2.

6. Genesis 1:31, ibid., 2.

Forsaken Geographies: Cyberspace and the New World "Other"

1. This chapter was originally presented as a paper at the Fifth International Cyberspace Conference, Madrid, June 1996. Some of the statistics have changed, but the patterns remain largely the same. Source: World History Project, 1996.

2. Jarice Hanson and Uma Narula, *New Communications Technologies in Developing Countries* (Hillsdale, New Jersey: Lawrence Erlbaum Associates, 1990), 99.

3. Letter in *Harper's Magazine,* no. 289 (August 1994): 5.

4. Michael Haim, "The Erotic Onthology of Cyberspace," in Michael Benedikt, ed., *Cyberspace: First Steps* (Cambridge: MIT Press, 1991), 61.

5. Allucquère Rosanne Stone, "Will the Real Body Please Stand Up," in Benedikt, *Cyberspace,* 92–99.

6. Carlos Fuentes's "Plea for the Poor of Latin America" was originally published online at http://www.latinolink.com/opinion/fue1120e.html.

7. O'Reilly in Talbott, *The Future Does Not Compute: Transcending the Machines in Our Midst* (Sebastopol, Calif.: O'Reilley and Associates, 1995), xv.

8. See the South Africa Internet Directory at http://os2.iafrica.com.

9. World History Project, 1996.

10. Vivian Sobchack, "Baudrillard's Obscenity," *Science-Fiction Studies* 8, no. 55 (November 1991): 327.

11. Nicole Stenger, "Mind Is a Leaking Rainbow," in Benedikt, *Cyberspace,* 56.

12. World History Project, 1996.

13. See http://www.odci.gov/cia/publications/factbook/geos/cd.html for a survey of telecommunications in Chad.

14. For a comprehensive survey of connectivity in African countries, including Liberia, see http://www.odci.gov/cia/publications/factbook/geos/li.html.

15. Anne Byers, "National Adult Literacy Survey Overlooks Rural Illiteracy," *The Rural Clearinghouse Digest on Rural Literacy* 1, no. 1 (December 1993). See http://www.personal.ksu.edu/~rcled/publications/literacy/nals.html. A survey conducted for the National Institute for Literacy in

Washington, D.C., by Professor Stephen Reder of Portland State University puts the figure at 51 percent at the national level, 57 percent in Alabama. See http://www.nifl.gov/reders/reder.htm.

16. Bill Ransom, "Illiteracy Is a National Crisis," *The Daily Reporter,* September 27, 1995. Ransom refers to *Adult Literacy: New and Enduring Problems* by J. S. Chall et al.

17. Ibid.

18. See Mark Derry, *Escape Velocity: Cyberculture and the End of the Century* (New York: Grove Press, 1996), and Mark Slouka, *War of the Worlds: Cyberspace and the High-Tech Assault on Reality* (New York: Basic Books, 1995).

On Digital "Third Worlds": An Interview

1. Original interview published in German as "Die Neuen digitalen Weltgrenzen," *Springer* 3 (1996): 8–10.

2. A disconcerting tendency among many anticyberist scholars is to interpret my example here along strictly racial—and indeed racist—lines and to point to Harlem, New York, as an instance of the Third World within the First World. This is quite blind and misleading because Harlem is no more deprived, if indeed it is, than Appalachia. It is lazy sociology, at best, to think instantly of the inner city when thinking of deprivation spots within industrial nations.

3. I am aware of research in Spain and Portugal into the possibilities of short-wave communication as an alternative to more expensive satellite or traditional copper-cable technology, and ways in which less industrialized communities could use these to jump-start their connectivity and avoid the huge obstacles of finance and time that more traditional technologies involve. It must be noted, unfortunately, that there does not appear to be commensurate willingness on the part of certain societies, especially in the far poorer nations, to embrace the huge potentials of these remedial explorations.

4. Author of *Release 2.0: A Design for Living in the Digital Age* and founder of the media firm Edventure Holdings, Dyson became chair of the powerful Internet Corporation for Assigned Names and Numbers, ICANN, a California not-for-profit that exercises absolute control over Internet dot-com domain names and Internet protocol or IP numbers, under contract from the U.S. Department of Commerce. During her tenure, ICANN was mired in alleged procedural irregularities.

5. See Christopher Norris, *Uncritical Theory: Postmodernism, Intellectuals, and the Gulf War* (London: Lawrence and Wishart, 1992).

6. *Wired* columnist and former Grateful Dead lyricist John Perry Barlow and Allucquère Rosanne (Sandy) Stone, founder and director of the Advanced Communication Technologies Laboratory, perhaps best known for her 1991 essay, "Will the Real Body Please Stand Up?" in Michael Benedikt, ed., *Cyberspace: First Steps* (Cambridge: MIT Press, 1991), 81–118.

7. Lawley, "The Sociology of Technology-Mediated Communication: An Initial Exploration," online publication (http://www.itcs.com/elawley/bourdieu.html), 1994.

8. Since this interview was first published, power relations on the Net have changed dramatically and have eventually come to rest with financial rather than intellectual capital. The idea of a "goddess of cyberspace" is now truly ludicrous.

9. See André Magnin and J. Solillou, eds., *Contemporary Art of Africa* (London and New York: Thames and Hudson/Harry N. Abrams, 1996). Since the appearance of this interview in *Springer,* Thames and Hudson has published another volume in its World Art series, *Contemporary African Art* (Sidney Littlefield Kasfir, 1999), which attempts to remedy some of the implications of Magnin's book.

Connectivity and the Fate of the Unconnected

1. Marshall McLuhan, "Culture without Literacy," in *Explorations: Studies in Culture and Communication,* no. 1 (Toronto: University of Toronto, 1953), 117–27.

2. In "Forsaken Geographies: Cyberspace and the New World 'Other'" I demonstrate that the

social and material contexts of nonconnectivity transcend traditional geopolitical delineation and may just as easily be found in the highly industrialized nations as in the so-called Third World. See Olu Oguibe in *Frequencies: Investigations into Culture, History, and Technology,* ed. Melanie Keen (London: Institute for International Visual Arts, 1998).

3. What William Gibson calls "legitimate operators" in his 1984 sci-fi novel *Neuromancer.*

4. In his work on modernities, Arjun Appadurai makes a distinction between what he terms mediascapes, or arenas for the circulation of information, and ethnoscapes, or spheres where individuals circulate. However, the arena of the network functions not simply as a platform for the circulation of information or signs, but as a place for the circulation of individuals and the formation of new ethnicities also, hence my preference for the term ethnoscape or netscape. See Appadurai, *Modernity at Large: Cultural Dimensions of Globalization* (Minneapolis: University of Minnesota Press, 1996).

5. In his book *Globalization* (London: Routledge, 1995), Malcolm Waters argues that in a globalized culture, different and disparate ethnicities and communities are forced to position and define themselves in relation to one another within a unified global configuration. What differentiates this relationship from that which exists between the network and the unconnected is that they are not unified into a singular global configuration, and as the network becomes a dominant force in global power relations and exchange, and as individuals turn to it more often for validation and a sense of belonging in the postglobal age, the less visible, less powerful world of the unconnected is relegated and forced to define itself, or be defined, on the outside and beneath this dominant ethnoscape.

6. Quite interestingly, while cultural activists and advocates of the Net are quick to point to "successful" representations of less privileged communities on the network, such as Commandant Marcos's use of the Net to globalize the cause of the indigenous people of Chiapas, Mexico, what is rarely broached is under what moral authority such representations are made, and what ethical questions are raised by salvage ventures, such as the Chiapas campaign and Commandant Marcos's Guevarian messianism among the indigenous people. Some might want to draw a line between the Marcos Net campaign and the declaration of war against Iraq and China in July 1998 by an American hackers group known as LoU, or the Legion of the Underground. According to LoU, their plan to hack into and destroy the communications infrastructure of these two countries was in support of human rights and victims of human-rights violations. It took the critical intervention of seven other hackers groups to discourage LoU in its self-delegated mission by pointing out that this kind of cultural or political activism on the Net (now known as "hacktivism"), when taken to irresponsible extremes, could have unintended, devastating consequences on innocent victims. In the case of Iraq such an attack could have paralyzed what is left of the country's already beleaguered public-health system, leading to the deaths of hundreds of women, men, and children. Yet the fundamental principle is not particularly different, namely assumption of the right to represent or self-delegate on behalf of a group—in this case the supposedly oppressed masses of Iraq and China—without consultation or consent.

7. In "Desiring the Involuntary," Jonathan L. Beller writes about "involuntary forces" possessing the ability to "break the integrity of the subject," an expression that most aptly describes the potential impact of the network on the inherent agency or subjectivity of individuals and communities who cannot connect. See Beller in *Global/Local,* ed. Wilson and Dissanayake (Durham: Duke University Press, 1996), 197.

8. See *Weekly Mail and Guardian,* Johannesburg, April 19, 1996.

9. Ibid.

10. See Okwui Enwezor, "Reframing the Black Subject," *Third Text,* no. 40 (1977): 21–40.

11. Though we cannot possibly deal here with all the numerous other examples of this situation, one may point out quickly that such violations are perhaps most evident with one of the most powerful enterprises on the Internet: pornography. A good deal of the pornographic material traded or exchanged on the Net belongs to a category known as "user posts," some of which comprise genuine images of unsuspecting individuals photographed in private or compromising circumstances and

transmitted on the Net. Sometimes pooled under "voyeurism," many of these are obtained through discreet minicameras planted in such unlikely places as the floors of public elevators or in public conveniences to capture compromising images of unsuspecting victims. There is no gainsaying the gender bias in this preoccupation; often the market for pedophiliac images is serviced by such devices, too. Again, the unconnected are more vulnerable since they have no means whatsoever to detect such infringements on their person. The fundamental ethical problem of encroachment on individual privacy that these practices raise does not in any particulars differ from that raised by another practice that is equally enabled by the Internet. Here I mean the invasive use of Web cams in new-media art, where artists photograph or videorecord unsuspecting individuals on street corners, public-transit terminals, even public conveniences, and transmit the images on the Web. Though some may consider it moot, it is my contention nevertheless that such practices may not be excused on grounds of creative license.

12. For a brief investigation of the persistence of the literary or textual mindset in general approaches to hypertext and cyberspace, see Michel A. Moos's reading of Marshall McLuhan, "McLuhan's Language," in *Media Research: Technology, Art, Communication,* ed. Moos (Amsterdam: G+B Arts International, 1997), 140–66.

13. Of course, physical contact and exchange in themselves may not constitute infallible guarantees against the violation of the Other, as history shows. However, direct contact between people has its place. It seems to me particularly frightening that the concreteness of such contact, its shortcomings and uncertainties notwithstanding, should be replaced by severance and withdrawal into the virtuality of interfaces and symbols, of signs taken for wonders. One may also point out that in those historical instances when contact bred tragedy rather than understanding—slavery, colonialism, the conquest and decimation of first nations—there was little reciprocal exchange in evidence, the same absence of reciprocal exchange that increasingly characterizes the relationship of the networked to the unconnected.

14. It is pertinent to note that traffic rather than circulation is a more appropriate term for the movement of cultural products and producers in this milieu because, despite the incredulous escalation in the volume of this traffic, it nevertheless remains in line with the traditional pattern of product-profit flow in the global capitalist system. Capital remains in the hold of the West and dictates the terms of trade, be they in labor, the cheap produce that flows from outside to the West, or the cultural consumables that flow in the opposite direction. The most significant change in the age of the new global information network is the traffic in intellect and intellectual produce from the periphery, manifested particularly by the growth in India's information technology market, which is dedicated to software engineering for the American information technology industry. Recent improvements in speed and bandwidth capacity on the global information network have further made this exchange more traditional and efficient in the sense that they have made it possible to avoid a reverse flow in labor demographics by enabling labor to remain in its original location outside the West, where it feels more content on its low remuneration and does not constitute a social or political problem for the West. The intellectual goods are pipelined to the West for branding, packaging, and marketing. The prevailing relations are now quite parallel with patterns in the garment, electronic, and other manufacturing industries, where capital locates and exploits cheap labor and materials in Hong Kong, Singapore, Taiwan, and the rest of the Far East and Latin America to produce at far-below market value and maximize profits without direct social or contractual responsibility to labor. In effect, intellectual property has been added to the long line of material and cultural produce that the Indian subcontinent has supplied the West since the dawn of global capitalism, but the terms of trade remain the same: remuneration remains below market value for both labor and product in the West, and net profit still returns to the West. At best a new set of middlemen are generated to intercede between capital and labor and create the impression at home of a new injection of wealth. In real fact, there is no "circulation" of goods and wealth per se, only an invariable unidirectional flow of the separate entities.

15. This figure is credited to Oliver Smoot of the Information Technology Industry Council.

16. In "Imaginary Homes, Imagined Loyalties: A Brief Reflection on the Uncertainty of

Geographies," in *Interzones: A Work in Progress,* eds. Zaya and Michelsen (Taba Press, 1996), I appear to question any breaches of freedom on the new information superhighway (the Net). However, the specific object of my reservation in the essay is the transfer of traditional geophysical or national borders that breach the interzonal essence of the Net, or statutory interventions that infringe conventional freedoms, such as hate activities or criminal behavior. The idea of the Net as a free-for-all no man's land where anything goes, including activities that breach the rule of law or infringe the safety and basic freedoms of others, is, of course, as unrealistic as it is repugnant.

17. Marshall McLuhan, "The Agent Bite of Outwit," *Location* 1, no. 1, (1963): 41–44.

Previous Publications

"In 'The Heart of Darkness'" was originally published in *Third Text* 23 (1993). It also appeared in *Art History and Its Methods,* ed. Eric Fernie (London: Phaidon, 1995).

"Art, Identity, Boundaries: Postmodernism and Contemporary African Art" was originally published as "Un discorso di ambivalenza: il pensiero postmoderno e l'arte contemporanea africana," in *Arte Identita Confini,* eds. C. Christov-Bakargiev and L. Pratesi (Rome: Carte Segrete, 1995). It also appeared in *Africana* (Rome: Sala Uno, 1996) and *Nka: Journal of Contemporary African Art,* no. 3 (1995).

An earlier version of "*Double Dutch* and the Culture Game" was published in *Yinka Shonibare: Be-Muse* (Rome: The British School in Rome, 2001).

An earlier version of "Nationalism, Modernity, Modernism" was published as "Reverse Appropriation as Nationalism in Modern African Art" in Rasheed Araeen et al., *The Third Text Reader on Art and Culture* (London and New York: Continuum, 2002).

An earlier version of "'Footsteps of a Mountaineer': Uzo Egonu and Black Redefinition of Modernism" was published in *Black British Culture and Society: A Text Reader,* ed. Kwesi Owusu (London and New York: Routledge, 1999).

Earlier versions of "Photography and the Substance of the Image" were published in Clare Bell et al., *In/Sight: African Photographers 1940 to the Present* (New York: Guggenheim Museum/Abrams, 1996) and in *The Visual Culture Reader,* ed. Nicholas Mirzoeff (London and New York: Routledge, 2002).

Sections of "Medium, Memory, Image" were previously published as "Jacob Lawrence: The Migration Series" in *Nka: Journal of Contemporary African Art,* no. 3 (1995); in "Medium and Memory: Fiona Foley," *Atlantica* 12 (Winter 1995/1996); and in *Third Text* 33 (1995/1996).

"The Burden of Painting" was previously published in *Five Continents and One City: Third International Salon of Painting* (Mexico City: Museo de la Ciudad de Mexico, 2000).

Earlier versions of "Forsaken Geographies: Cyberspace and the New World 'Other'" were previously published in *Trade Routes: History and Geography,* ed. O. Enwezor (Johannesburg: Greater Johannesburg Metropolitan Council/The Prince Claus Fund, 1997), and in *Frequencies: Investigations into Culture, History, and Technology,* ed. Melanie Keen (London: Institute for International Visual Arts, 1998).

"On Digital 'Third Worlds': An Interview" was originally published in *Springer: Hefte fur Gegenwartskunst* 2, no. 3 (1996).

"Connectivity and the Fate of the Unconnected" was previously published in *Relocating Postcolonialism,* eds. David Theo Goldberg and Ato Quayson (Oxford: Blackwell, 2002); in *Fama: A Joint Edition of Frakcija and Maska* 1, no. 1 (2001); and in *Social Identities* 5, no. 3 (1999).

Index

and *Migration* series, 92–98; memory as
fragmentary, 101; persistence of memory,
98–110; search among artists for medium to
encode, 91–92
Mexico: in context of global computerization
and digital revolution, 150–52; modernists
in, 97
micromanaging of non-Western artists' work,
xiii–xiv
migration: Anatsui's work on, 104–7
Migration, The, series (Lawrence), 95–98
Migration I and *Migration II* (Anatsui), 103–4
Mills, Irving, 43
mimesis, 141
mimetic realism: Onabolu's pursuit of, 51–53
mimic colonial: notion of, 50
mining industry, colonial, 102
Minitel, French government-sponsored, 172
Mission to Kala (Beti), 32
modernism, 7, 8, 182n.9; British, 70–71, 183n.31;
centrality of African sources to, 67; classi-
cal African art as model to redefine African,
58–59; cultural nationalism as integral
aspect of European, 63; development of
early modernist art, 7, 8, 93; globalpolitik
and, 68–71; humanist sensibility within, 68,
70–71; localization and humanization of,
183n.27; Negritude and, 63–64; new, 58–59;
new, background to, 60–63
modernity: denial of, to Africa or cultures other
than the West, 4; nationalism and, 50–53;
quest for, 53–58
Mohl, John, 55, 56, 58
Monti, Nicolas, 74, 75, 89
Moore, Henry, 70
Mosquera, Gerardo, 43
Mudimbe, V. Y., 62
multiculturalism, 167–68
Mungo (white client of African artists), 22–24,
26
Murray, Kenneth C., 53–54, 56, 57
museums and memorials: mushrooming of, 91
Musician (Mancoba), 58–59
myth: of painter, 139–40; as transfigured his-
tory, 101

Naipul, V. S., 25, 31
Nash, Paul, 70
Nassar, Emmanuel, 106
National Gallery of Rhodesia, 56
nationalism: meganationalism, 5; modernity

and, 50–53; new, 58–59; nostalgia and,
64–68; reverse appropriation as, 47–49
Native Blood (Foley), 118–19
"natural synthesis": principle of, 184n.3
Nazi terror: determination to occlude or rise
above memory of, 90
Neglected Tradition (Sack), 54–55
Negritude movement, 59, 62–64; Egonu and,
65, 66; modernism and, 63–64; significant
moment of articulation for, 62–63
Negroponte, Nicholas, 170
New Negro, The (Locke), 94
news photography, 77
New Subjectivism: Art in the 1980s, The (Kuspit),
20
Ngatane, Ephraim, 181n.34
Nigeria: art education in, 47, 48, 52–54; civil
war in, 36; collapse in late 1960s, 69; Owo of
western, 81–83; rise as miracle nation, 36–37;
war between Biafra and, 69
Nkrumah, Kwame, 7, 61, 62
Noble Woman, The (Te Arii Vahine) (Gauguin),
118
Nok civilization: ceramic-sculpture traditions
in, 101–2; Egonu's studies of, 67, 68
No Longer at Ease (Achebe), 27–29
Norris, Christopher, 162
Nosei, Anina, 18
nostalgia: nationalism and, 64–68

Obe, Peter, 77
objectivity: a priori human proclivity for, 80;
redefinition of, 86
object of exoticist fascination: artist as, 12
Occidental individualism, 3
Odita, Donald, 144
Ofili, Chris, 34, 42–43
Oguibe, Olu: interview with Hoeller, 159–68
Okeke, Uche, 100, 184n.3
Okigbo, Christopher, 100
Okri, Ben, 31, 37
Oloidi, Ola, 51, 180n.13
Onabolu, Aina, 7, 51–54, 56, 58, 59, 183n.11
Onabolu, Dapo, 53
"On National Culture" (Fanon), 49
Ono, Yoko, 39
"On the Nature of Photography" (Arnheim), 80
O'Reilly, Tim, 152
origins: extra burden of, 21
Oshogbo, Nigeria: Betts and Beier's workshops
in, 57

Olu Oguibe is a visual artist, award-winning writer, scholar, and independent curator. His works have been shown in numerous solo and group exhibitions around the world, and he has curated exhibitions for major institutions and venues, including the Tate Modern in London, the Museo de la Ciudad in Mexico City, and the *latere* of the Venice Biennial. He is the author of *Uzo Egonu: An African Artist in the West, Reading the Contemporary: African Art from Theory to the Marketplace,* and three books of poetry. He is currently a senior fellow of the Vera List Center for Art and Politics at the New School in New York and associate professor of art, art history, and African American studies at the University of Connecticut.